Jewish Women Pioneering
the Frontier Trail

Jewish Women Pioneering the Frontier Trail

A History in the American West

Jeanne E. Abrams

NEW YORK UNIVERSITY PRESS
New York and London

NEW YORK UNIVERSITY PRESS
New York and London
www.nyupress.org

Library of Congress Cataloging-in-Publication Data
Abrams, Jeanne E., 1951–
Jewish women pioneering the frontier trail : a history in the
American West / Jeanne E. Abrams.
p. cm.
Includes bibliographical references and index.
ISBN-13: 978-0-8147-0719-7 (cloth : alk. paper)
ISBN-10: 0-8147-0719-X (cloth : alk. paper)
 1. Jewish women—West (U.S.)—History. 2. Jewish women—
West (U.S.)—Social conditions. 3. Women in Judaism—West (U.S.)
4. Judaism—West (U.S.) I. Title.
HQ1172.A27 2006
305.48'8924078—dc22 2006013983

New York University Press books are printed on acid-free paper,
and their binding materials are chosen for strength and durability.

Manufactured in the United States of America

10 9 8 7 6 5 4 3 2

Contents

Acknowledgments

One of the distinct pleasures of completing a book such as *Jewish Women Pioneering the Frontier Trail* is the opportunity to thank the many wonderful colleagues, friends, and family members who have contributed to the project in such a variety of ways. First, although he is no longer with us, for nearly twenty years the late Dr. John Livingston served as an inspiring colleague, teacher, mentor, exacting critic, and dear friend; he encouraged my professional endeavors beginning with my first foray into publication as a graduate student, and I am grateful for his abiding faith in my capabilities. I am especially indebted to Dr. Frederick Greenspahn, Dr. Ava F. Kahn, Dr. Alan Kraut, and Dr. Jonathan D. Sarna, colleagues who have been extremely generous in sharing their time and knowledge, for their very gracious willingness to read and critique each of the chapters in the book. I am particularly grateful for their perceptive comments and suggestions, which undoubtedly enhanced the manuscript. Any shortcomings or mistakes in the manuscript are, of course, my responsibility alone.

Jennifer Hammer, my editor at New York University Press, has displayed unflagging enthusiasm for the project since its inception, and her impressive editorial talents have helped strengthen my prose and sharpen my focus. I am most grateful her for highly professional yet warm and gracious manner. A book such as this makes significant use of primary sources, and I have been assisted by many very able archivists and librarians around the country. I particularly want to thank several who went far beyond the call of duty to provide me with an amazing array of documents. They include Aaron Kornblum of the Western Jewish History Center at the Judah L. Magnes Museum in Berkeley, California; Judith Margles at the Oregon Jewish Museum Archives in Portland, Oregon; Kevin Proffitt, Senior Archivist, and his staff at the American Jewish Archives in Cincinnati, Ohio; and Nan Cohen at the University of Washington Libraries in Seattle. I also extend

my appreciation to the interlibrary loan staff of Penrose Library at the University of Denver whose diligence and persistence provided me with access to many print materials that were often hard to locate, including monographs, dissertations, and historical newspaper articles. I am also grateful to Dr. Judith W. Rosenthal for sharing valuable information and materials about her grandmother, Bella Weretnikow Rosenbaum, with me.

At the University of Denver, Nancy Allen, dean of Penrose Library, and Dr. Gregg Kvistad, former dean of Arts and Humanities and now former provost, were enthusiastically supportive of the project from the beginning. I am very grateful to Thyria Wilson, my colleague and assistant at the RMJHS and Beck Archives, for taking over many technical responsibilities so I could devote more time to the research and writing of this book. In addition, I thank the Jewish Women's Archive in Brookline, Massachusetts, for awarding me a 2003 Research Fellowship to support the writing of an essay on early Colorado Jewish women who played an important role in philanthropy. That project sparked my broader interest in Jewish women in the American West. Some portions of the original essay appear in a different form in this book.

Over the years, a number of dear friends and family members have served as great sources of encouragement as active cheerleaders and sounding boards, and I am most appreciative of their support and care: Mrs. Kate Abrams, Peryle Beck, the late Dr. Michael Osband, Marjorie Hornbein, D'vorah Gasner, Rifkah Grossman, Dr. Barbara Unger, Esther Pollack, Leah Wolf, Bernice Zussman, and Hermine Blau. My late parents and father-in-law, of blessed memory, Gilda and Isidore Lichtman and Isadore Abrams, would have been very proud to see this volume in print. Finally, and most importantly, I have been exceptionally blessed with a very supportive and loving family, including my husband, Lewis; my children and their spouses, Yehudah and Esti Abrams, Chaim and Chaya Abrams, Avraham and Chaya Malka Abrams, and Yocheved and Avrohom Bender; and many beautiful grandchildren, who have made all my endeavors worthwhile.

Introduction
A View from the West

Frances Wisebart Jacobs was a young bride of twenty in 1863 when she accompanied her new husband by covered wagon from Cincinnati to their first home in Central City, a burgeoning silver boom mining town about thirty miles west of Denver, in the Colorado Territory. In 1870, the Jacobs family relocated to nearby Denver, where Bavarian-born Abraham became active in business and politics and Frances soon became an icon in the area of philanthropy, becoming known as Denver's "Mother of Charities." In 1887, Mrs. Jacobs, along with Reverend Myron Reed and Father William O'Ryan, organized a federation of Denver charities that was the forerunner of the Community Chest, which, in turn, evolved into the modern, national United Way. Especially concerned with the plight of tuberculosis victims, Frances was also the primary impetus behind the founding of the National Jewish Hospital for Consumptives, which opened in Denver in 1899.[1]

Born in a small shtetl in the Polish province of Posen and arriving in America in 1872, Anna Freudenthal Solomon journeyed first by train and then by stagecoach to Las Cruces, New Mexico, from Pennsylvania with her husband and three small children in 1876. After a short time they set out once again, this time in a four-wheeled buckboard open wagon bound for the primitive village of Pueblo Viejo in the Arizona Territory. While Anna's husband, Isadore Elkan, built a successful charcoal supply business, Anna not only ran the family dry goods store and raised their six children, but also later operated a thriving hotel in the town that was eventually renamed Solomonville in honor of the family.[2]

Mary Goldsmith Prag arrived in San Francisco from Poland in 1852 at the age of five, traveling by steamer with her family by way of the Isthmus of Panama. Her father was a *shochet,* or ritual slaughterer of kosher meat. He became active in Sherith Israel congregation, first

established in 1851, and it is there that Mary probably met her future husband, Conrad Prag, one of California's "forty-niners." She would later become a respected and popular religious-school teacher at both Sherith Israel and Congregation Emanu-El. Mary became a vital force both in the Jewish community and in the field of general education as a teacher, vice-principal, and finally as the first Jewish female member of the San Francisco Board of Education. Her daughter Florence Prag Kahn became the first Jewish congresswoman in the United States.[3]

Fourteen-year-old Seraphine Eppstein moved to Denver in 1875 from St. Joseph, Missouri, where she was born to parents of German descent. Married at the age of seventeen to prominent Denver Jewish business-man Edward Pisko, she was widowed at an early age and threw herself actively into community volunteer work as a president of the Denver Hebrew Ladies' Benevolent Society, as president of the local chapter of the National Council of Jewish Women (NCJW), and through involve-ment in settlement work with Denver's east European Jewish immi-grants. She later served as a vice-president of the National Conference of Jewish Charities and as a member of the national board of the NCJW. Like a growing number of educated Jewish women at the turn of the century, she used her volunteer experience as a stepping-stone to a professional position. With the opening of National Jewish Hospital (NJH), she soon took on a demanding job as a paid traveling fund-raiser for the new hospital. Before long, her fund-raising success and or-ganizational talent pivoted her into a central role at the institution, and in 1911 she became executive secretary, or director as we would say today, of NJH. At its helm, Pisko was probably the first Jewish woman in the United States to assume the position of chief executive of a na-tional institution.[4]

As the above stories demonstrate, Jewish women in the West were a highly diverse group. These four talented women, who excelled in the areas of philanthropy, administration, business, social and political re-form, and education, effectively blazed new trails for Jewish women as they expanded the contemporary definition of women's place. They are representative in many ways of the larger story of the multifaceted roles Jewish women played in the highly multicultural world of the American West. As one of the smallest groups among western female immigrants, Jewish women were unusual in their disproportionate public visibility, and although they were rarely revolutionary, they often opened new

doors of opportunity for themselves and future generations in a region that allowed them "a place to grow."[5]

Even in remote outposts of the western frontier at the turn of the century, Jewish women learned to adapt to the physical environment and struggled to maintain some semblance of Jewish tradition and build Jewish homes. In 1911, Clara Sky lived with her family on a homestead in a small Jewish agricultural colony near Chugwater, Wyoming, where the Jewish population consisted of only thirty-one families at its height. When a late-spring snowstorm prevented the delivery of matzah (unleavened bread) for Passover, she simply improvised and baked her own.[6] While the role of Jewish women of the era within the synagogue was circumscribed, they often pioneered organized public Jewish life. For example, in the mid-1870s, the Jewish population of Cheyenne, Wyoming, was about forty. It was a woman, Bertha Myers, the wife of a successful German-born dry-goods merchant, who in 1875 organized the first Jewish religious school in the city. Bertha also founded and served as president of the Cheyenne Jewish Circle, the town's first Jewish women's organization, which in turn precipitated the establishment of Cheyenne's Congregation Emanuel in 1889.[7]

The image of the West has always loomed large in the American imagination. As historian John Livingston noted in *The Jews of the American West,* the West has often been regarded as "the most American part of America," and American Jews, in particular, "have behaved as if the West, whether frontier or postfrontier, has been 'the most American part of America' for them, too." At the same time, however, Livingston noted that American Jewish history "has been heavily weighted toward the older metropolitan centers of the East and Middle West," and he looked forward to a significant shift.[8] Yet, well over a decade after Livingston's book, serious historical scholarship in the area has remained limited, with some notable exceptions that focus primarily on California's Jews and several important essays by historians William Toll and Ava Kahn on Jewish women.[9]

No scholarly book has been published to date that focuses exclusively on the lives of Jewish women in the American West. Jewish women have also been largely invisible in more recent multicultural studies of western women, primarily because they have been lumped together with white, middle-class women rather than perceived as a separate minority group. Yet, as one observer has asserted, "Jewish people were an

integral part of the western story, and the West is an integral part of the increasingly recognized and better understood American Jewish experience."[10] To more fully understand the American Jewish experience, the vital role of Jewish women in the West needs to be illuminated as well. Moreover, we cannot really understand the history of the West without examining the history of all types of western women. These women's perspectives can provide us with a fuller, more nuanced, sense of life in the West, and help us to move beyond old stereotypes of western women as merely "gentle tamers," often portrayed as nearly invisible, at best few in number, and confined to a sentimentalized vision of white, Protestant women who serenely brought social order to the region by their very presence.[11]

In order to bring balance to the larger picture of the American Jewish women's experience, it is imperative that we examine local and regional stories with their special circumstances and patterns within a comparative national framework. This is a central goal of this book. Jewish women and men in the western states of Arizona, California, Colorado, Idaho, Montana, Nevada, New Mexico, Oregon, Utah, Washington, and Wyoming played an integral role in the region's economic, political, social, and cultural growth and development. More than five thousand Jews poured into California in search of opportunity within five years of the beginning of the Gold Rush in 1848, joining members of diverse religious and ethnic groups. After 1858, when most of the California mining sites had already been appropriated, gold seekers migrated to new strikes in Colorado, Nevada, Montana, Idaho, and Oregon. Jews also fanned out across other nearby states and by 1920 numbered around 300,000 in the West. For a time, cosmopolitan San Francisco was the site of a very significant Jewish population in terms of numbers and activity. At the close of the 1860s, the percentage of Jews living in the San Francisco community (who numbered about 15,000 at the time) was higher than that of New York City's, although this phenomenon was short lived.[12] Because the Jewish population in the West was smaller than in the East, spread across a wider and more varied geographical terrain, and significantly more integrated into the local diversely populated communities than were Jews in the East, the Jewish experience in the West was distinctive in many ways.[13] Given their often relatively small numbers within communities, their influence was significant and they pushed public boundaries in ways their eastern counterparts did not.

There are many examples that illustrate the distinctive nature of the West for Jews and the ways in which they made the most of their new-found opportunities. In Utah it was the Jews who were looked upon as "gentiles" by the largely Mormon population. Yet, as was common in most western states, Jewish men and women in Utah were leaders in local business, and a Jewish governor was elected to the state in 1916. Polish-born Anna Rich Marks arrived in the Utah Territory around 1870 and, notorious for her quick hand on the trigger of a gun, aggressively became a wealthy businesswoman in an area traditionally considered men's domain, with large real estate holdings and the principal interest in two mines.[14] The nation's first Jewish governor, Moses Alexander, was elected to office in Idaho in 1915. Jewish immigrant Joseph Simon was elected a United States senator in Oregon in 1898, and Colorado's Simon Guggenheim served as a United States senator (1907–1913) forty-one years before an eastern state chose its first Jewish senator, New York's Herbert Lehman. Western historian Earl Pomeroy has also pointed out that in the region "where immigrants established themselves economically, they also established themselves politically."[15] In fact, at least fifty Jewish mayors had served in towns located in virtually every western state before the turn of the century, demonstrating both an unusual degree of Jewish acceptance and the high level of Jewish civic engagement. Although this political pattern was similar in the South, albeit on a more modest scale, it was not typical of the Northeast, and New York City did not have a Jewish mayor until Abraham Beame was elected in 1974.

The high percentage of Jewish political and business figures in both the West and to a lesser degree in the South suggests that community size may have played a vital role in acceptance of Jews by their gentile fellow citizens. Unlike the heavily populated urban centers of the East, in frontier towns, where inhabitants often knew each other on a first-name basis or at least by sight and Jews were respected as visibly contributing citizens, overt anti-Semitism seldom flourished.[16] An amusing story about Louis Sky, an east European immigrant homesteader in Chugwater, Wyoming, at the turn of the century, illustrates this point. Although Sky spoke mainly Yiddish, was immersed in Yiddish culture, and faithfully read the New York daily *Forward* from cover to cover after it arrived by mail to his home, his outgoing personality made him popular with his gentile neighbors. When a local Ku Klux Klan group was formed in Chugwater, he was enthusiastically invited to join even

though the other members knew he was Jewish. Because he had acquired a reputation as a fine speaker, even though English was not his native language, it was thought he could be an asset to the organization. Local Irish and Swedish hired hands brought on temporarily to assist with the yearly harvest enjoyed Clara Sky's gefilte fish and kreplach, a Jewish delicacy of dumplings filled with cheese, ground meat, or chicken.[17]

Mining was instrumental to the early development of the pioneer Jewish community in the West, although only a relatively small number of Jews were actually miners themselves or owned shares in mines. Many more were suppliers to the miners, sometimes serving as peddlers, traders, or more often as small shopkeepers or clerks in nascent settlements. Most achieved only modest success, but as one writer put it, "The big moneymakers of the gold rush were men who realized the fortunes to be made in selling supplies."[18] Before long, stores run by Jewish merchants and family members in search of work and wealth flourished on the main streets of most western towns. However, by the turn of the nineteenth century, "health seekers" rivaled "wealth seekers" in the West, particularly in Colorado, California, New Mexico, and Arizona. In Denver, two national Jewish hospitals, the National Jewish Hospital and the Jewish Consumptives' Relief Society (JCRS), were created to treat tuberculosis. They not only pioneered the sanatorium movement in the West, but were on the cutting edge in medical developments across the nation. Jewish women were instrumental in providing both leadership and financial support for both institutions.

Jews settled throughout the West, and the pattern of Jewish communal development was remarkably similar wherever they located in the region. Often, young unmarried men arrived first and, out of necessity, formed rudimentary Jewish burial societies, organized benevolent groups, and gathered together for a minyan, or communal worship. Most Jewish communities, however, stabilized and established firm roots only as Jewish men married, often importing brides from the East or even as far away as Europe, and after children were born. And, of course, even in the early years, some men arrived in the West accompanied by family to join members who had set out before them. In Europe, even in the face of severe adversity, the Jewish family and religious traditions frequently served as a source of strength, and it was no different in America, where Jews drew on these kinship networks and traditions for support and assistance.

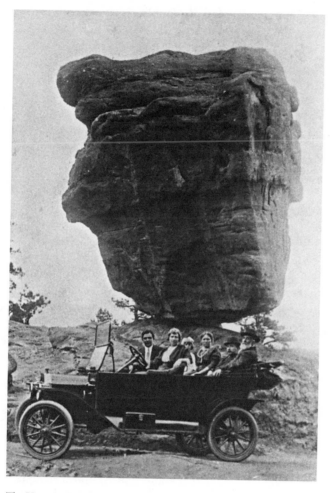

The Hayutin Family at Balanced Rock near Colorado Springs, Colorado, c. 1914. (Courtesy of the Beck Archives, Penrose Library and CJS, University of Denver.)

Only a relatively small number of Jews in the West were involved in ranching, farming, or in Jewish agricultural colonies like Utah's Clarion, Oregon's New Odessa, or Washington's Equality Colony; most western Jews were urban dwellers. In contrast, the Upper Midwest had a significantly higher involvement in homesteading and farming among Jews.[19] While Jewish men in the American West were soon generally involved in the infrastructure of *city* building, many middle-class Jewish women

were engaged in a parallel, but also public track of *community* building, often drawing on female networks as well as political and economic connections. This emphasis on community development was especially important in an era when social services were not provided by government agencies but primarily by volunteer religious and ethnic groups. As scholar William Toll has asserted, "The welfare demands of life on the urban frontier would in fact require young women to assume major communal responsibility."[20]

Despite their distinction as a religious minority, pioneer Jews in communities throughout the West were generally viewed as a stabilizing influence that upheld morality and order in new settlements as well as bringing a measure of culture to the rough frontier. Moreover, in a "still unstructured and totally new society," diverse Caucasian newcomers including immigrant Jews were welcomed more warmly as Americans on a par with the native born than in any other region of the country.[21] Jewish women, most of them members of a developing middle class, were particularly lauded for their contributions to their families and the community at large, more than fulfilling early contemporary ideals of women as morally superior nurturers within the accepted "cult of true womanhood." Some were the wives, daughters, and sisters of the members of a merchant elite with the means and leisure time available for prominent involvement in civic life and social welfare issues, largely through work in women's clubs and organizations. But many more Jewish women performed daily work within their households that not only often contributed to family income but also played a part in the foundation of philanthropic institutions, houses of worship, schools, and libraries that helped civilize the raw West and constructed communities where social order and family life could flourish. Historian Susan Armitage has pointed out that western women often worked "behind the scenes to lay the groundwork for community projects" or persuaded influential male community leaders to lend their support.[22]

Jewish women were not only activists who made contributions to the West's overall development, but they also contributed fundamentally to the development of Jewish communal life throughout the region as well. In western cities and towns, and in small communities in particular, Jewish women played an especially critical role in sustaining Jewish identity by helping to build and maintain specifically Jewish institutions such as synagogues, religious schools, and Jewish charities and preserving and transmitting Jewish religious practices, many of which were

centered in the home—probably to a greater degree than in any other religion. As Jewish men in America became preoccupied with commerce, Jewish women increasingly provided the ties to Jewish tradition. For example, in the small town of Vernal, Utah, Clare Steres Bernstein's family were the only Jews, and she recalled that it was her mother who went to great lengths to make sure the family kept a kosher home and scrupulously prepared the house for Passover while her father struggled to eke out a living.[23]

In Europe, Jewish tradition had dictated that, ideally, men would engage in Jewish learning of sacred texts and that women preside over the religious sanctity of the home through the supervision of children, the preparation of kosher food, and personal acts of charity and kindness that provided social welfare and extended outward into the Jewish community. As sociologist Ewa Morawska notes, the Jewish tradition of *tzedakah* served as "a link between the public (institutions) and private (family) sphere of the religious lives of East European Jews, and it had been the women, or women's charitable works, precisely, that made this connection."[24] In the face of poverty or in households where men were engaged primarily in learning, women also developed respected and expected roles as breadwinners, augmenting family income through a variety of business activities.[25] In Europe, traditional halakah (Jewish law) also governed every aspect of Jewish life from prescribed foods, prayers, and the celebration of the Sabbath and holidays to business practices, interpersonal relations, and the distribution of charity.

But Jews found that in pluralistic, secular America, religion was largely a matter of private choice, and many emphasized the broad ethical and communal rather than ritual aspects of Judaism. As one contemporary Orthodox Jewish critic observed: "In America any [man] may cut himself off from his community, taking no part in it whatsoever."[26] In other words, as historian Naomi Cohen put it, having achieved emancipation in the United States, "legally the Jew had the option to determine how Jewish he wanted to be."[27] Although some Jewish women in the West adhered to Jewish halakah and tradition to the best of their ability despite the unique challenges of the frontier environment, many others modified practices to accommodate what they perceived as practical or modernized adaptations to fit American and western life. However, to both groups, even to those who were not particularly observant, issues of Jewish religious education, synagogue affiliation, and the celebration of central Jewish customs and rituals, such as

lighting Sabbath candles and the holidays of Rosh Hashanah (the Jewish New Year), Yom Kippur (Day of Atonement), and Pesach (Passover), were of major importance as they served as tangible connections to their co-religionists and were a means of maintaining a Jewish communal life as well as a way to insure Jewish continuity that could be transmitted to their children. Moreover, in America, Jewish holidays and the Sabbath were increasingly seen as an occasion for family cohesion and togetherness as well as religious celebration, an opportunity in which Jewish women could promote the Jewish heritage in a religioethnic context.

Because society in the frontier West in the early years was relatively fluid, with a more open and pragmatic class and social structure, women in general as well as Jews appear to have been accorded more power and opportunity than their counterparts in other areas of the United States, and they were welcomed as partners in the building of a new social order. Historian Earl Pomeroy has observed that "newcomers were especially welcome in the nineteenth-century West, above all in villages and towns ambitious to become cities. Elites were less jealous of their turf and more hospitable to strangers in new and expanding communities than in old ones."[28] Moreover, the heightened level of ethnic diversity in the region, particularly on the Pacific Coast, encouraged acceptance. As Eldon Ernst has noted, "All of the United States is a story of immigration. What distinguished the Far West is the degree to which a wide variety of peoples came from many places to build new societies in relatively free cooperation and competition."[29]

Timing may have been the most crucial factor that differentiated the experience of western Jewish women from their sisters in other regions. Many Jewish women and men arrived in the West just as settlements were being founded or soon after, and a number of historians have emphasized the striking correlation between pioneer status and social, economic, and political integration of Jews.[30] For example, eminent historians John Higham and Moses Rischin have both noted greater social mobility for Jews in the West than in older parts of the country between 1850 and 1900.[31] Largely because of their early arrival and involvement in new communities, in the ethnic hierarchy of the early West Jews often took a prominent position. Indeed, in many western states, "merchants [and their families] replaced landowners as the elite class."[32]

However, even though "Jews found more acceptance in the West than in other regions of the country," they still "exhibited a strong sense

of special character and Jewish consciousness."[33] For example, although finding Jewish mates in the early West could be challenging and some Jews assimilated completely by either intermarrying or by totally abandoning their Jewish identities, in the nineteenth century intermarriage among Jews living in western urban centers and small towns was no more prevalent than elsewhere in the country, and many Jews still supported their own religious and cultural institutions, when they could have easily blended into the larger society.[34] Jews were an integral part of the story of life in the West, a complicated history of the interactions between diverse peoples and cultures, reflecting adaptation and accommodation as well as conflict between immigrants and natives and conquest of indigenous peoples; examining the story from multiple viewpoints broadens our scope.

Although anti-Semitism in the region was certainly not entirely absent, it was relatively muted, particularly in the years before World War I. When anti-Semitism increased in America in the decades after the Civil War in the late nineteenth and early twentieth century, western cities were not entirely immune. However, because of the prominent pioneer status of many Jews in early communities in the West, its effects were minimal. Most western Jews felt very comfortable in both the Jewish and secular world. In a frontier environment that welcomed those who could make a contribution, Jewish acceptance was generally a given. As Utah Jewish pioneer Fanny Brooks, who first traveled by wagon train to California with her husband Julius in 1854, later recounted to her daughter of her journey: "We were all just like one big family, dividing . . . joys and sorrows together." Fanny and Julius were the only Jews in the party, which numbered at least one hundred wagons. A resident of Salt Lake City, where the wagon train party wintered, declared that seventeen-year-old Fanny "was the first Jewish woman to cross the plains."[35]

Early on, Jewish women in the West became leaders in *both* the Jewish and general community in the establishment of voluntary associations and benevolent societies, initially founded as self-help groups, which soon transitioned them actively from the private to the public sphere. Although Jewish women's benevolent groups were not unique to the West, as virtually every town and city around the country with even a modest Jewish population had them, western versions may have afforded some of their members a wider scope of operation. Smaller populations encouraged residents, both Jewish and non-Jewish, to band

together in mutual support in times of sickness and hardship and to work together in public causes as well. Jewish women forged bonds with fellow Jews as well as with people of dramatically different cultural heritages. A case in point is Frances Wisebart Jacobs, whose prominent role as Denver's "Mother of Charities" cut across class, gender, and religious lines. Similarly, in 1879, Flora Langermann Spiegelberg organized the first nonsectarian school for girls in Santa Fe, New Mexico, just a few years after she arrived by stagecoach; she recalled that her family received yearly gifts of fruit and flowers from Santa Fe's Catholic archbishop Lamy to mark the Jewish holiday of Rosh Hashanah.[36] From Santa Fe to Seattle, Denver to Dallas, San Francisco to Salt Lake, and Portland to Los Angeles, Jewish women made their presence felt. As one historian has observed, "The unique characteristic of the frontier is that its newness loosened the constraints under which women lived in more established areas and offered them a variety of opportunities."[37]

Jewish women in the American West were not merely a passive "civilizing influence," but active participants in the growth and development of the region. Their private and public lives were central to the maintenance of both Jewish and general institutions that were building blocks in the foundation of community in cities and towns throughout the West. Even in tiny hamlets, mining camps, and in more remote areas like the unforgiving stark landscape of states like Montana, Jews were among the first settlers in embryonic towns. For example, Jewish burials took place in Helena, which was established in 1864, as early as that first year. In 1868 the Jewish population numbered over fifty, and later Jewish women were active in planning and forming a synagogue, which the local newspaper described as a "credit to the Israelites as well as the city of Helena."[38] Local lore even suggested that the town was named after a western Jewish woman who had impressed some residents in the nearby mining settlement of Virginia City by her "many kind acts and personal popularity."[39]

As the years passed, particularly after 1890, not only were western Jewish women actively involved in the more private sphere of family and religion, but they were increasingly visible in the public sphere in developing and sustaining numerous community institutions. All this is not to say that Jewish women were not active in all parts of the country, but they appear to have been disproportionately visible in the West considering their modest numbers. Some women became active in business,

and in the West this sometimes meant not only working in the family business in a husband and wife partnership, but actually running it, harkening back to the European tradition where many Jewish women were the economic backbone of the family. Mary Ann Cohen Magnin is a good example. Born in Holland and raised in London, in 1875, at the age of twenty-seven, she journeyed by steamship with her husband and seven children from London to San Francisco. Combining her talent for fine needlework with an outstanding business sense, she founded I. Magnin and Company in 1877. A micromanager with an eye for innovation, she, and not her husband Isaac, for whom the business was named, was the guiding genius behind the upscale women's clothing store. Similarly, in Portland, Oregon, Jeanette Hirsch Meier played a key role in building Meier & Frank into a successful dry-goods store in the 1870s, and after her husband's death in 1889 she presided over the largest department store in the Northwest.

With the passage of women's suffrage, Jewish women also became involved in politics, but philanthropy was an area of particular influence, often focusing on issues directly related to women and children. Indeed, philanthropy on one level was actually a political tool that often combined Jewish religious and family values with broader communal responsibilities. Propelled, in part, by a religious and ethnic culture that emphasized social responsibility and charitable activities as an imperative based on justice rather than mere altruism, it comes as no surprise that Jewish women in America were often at the forefront of social reform in their local communities. For many women, philanthropy in the Jewish and general community actually became a primary vehicle for their ethnic and religious expression, a way to assert their Jewish identity. For German Jewish Reform women, in particular, philanthropy was one of the most powerful and accepted ways in which to express their Jewishness in the public culture,[40] demonstrating that they were both good Jews and good Americans in a country that valued and highly respected voluntary associations.

Even though the composition of early American Jewry was predominantly Ashkenazic (German-east European), the culture of Sephardic Jews of Spanish and Portuguese background dominated the early small Jewish community in America. The year 1654 marked the beginning of an organized Jewish presence, when a group of twenty-three Dutch Jews sailed into the port of New Amsterdam (later New York) from Recife, Brazil, recently recaptured by Portugal, in an attempt to escape

the long arm of the Inquisition. Soon American Jews fanned out in commercial ventures in urban port cities along the East Coast and Sephardic Jews, generally traditional in religious practice, occupied an elite position within the Jewish community.[41] Jews from German-speaking lands in central Europe began to immigrate to America in substantial numbers in the late 1840s, and this wave is commonly referred to as the German immigration, although some came from areas other than Germany. While they had certainly endured very significant religious, social, and economic discrimination in Europe, under the influence of the Enlightenment's emphasis on universal natural rights some had been able to take advantage of, or at least aspired to, educational and cultural opportunities. It was in Germany that the Reform movement first made inroads in "modernizing" Jewish religious observance in an attempt to gain better acceptance in the host culture, although significant numbers of traditionalists remained. For example, German Jewry produced both Isaac Mayer Wise, the leading progenitor of the Reform movement in America, as well as Isaac Leeser, early champion of traditional Judaism at Philadelphia's prestigious Sephardic Mikveh Israel Congregation. Political and economic upheavals and the promise of a better life in America stimulated an influx of central European Jews in the second half of the nineteenth century, many of whom rapidly acculturated and achieved at least some degree of economic success. Some of these immigrants had already been exposed to moderate religious reform in Europe that had incorporated vernacular sermons and decreased emphasis on ritual, and as they followed the determined path to Americanization and social acceptance, many modified religious practices even further.[42] Although Hasia Diner has maintained that the distinction between "German" and "Russian" Jews in America has been overstated, it is still a very useful convention in examining the Jewish migration to the American West.[43]

East European Jews were visible in America from colonial times, but increasingly harsh discrimination and overt physical threats through pogroms in Russia unleashed a floodgate of immigration after 1880. Dissension between east European Jews and central European Jews was evident even back in Europe, where German Jews had often viewed their co-religionists as unenlightened, backward traditionalists and east European Jews had viewed the German Jews as assimilated and irreligious. The Enlightenment was slower to affect the more traditional east European Jewish communities, ruled as they were by Jewish law and

custom and isolated as a "people apart" from the host Russian and Polish societies through discrimination, often by government design. East European Jews viewed themselves as a nation and a culture as well as a religion, and many looked to Zion as the ultimate national and religious homeland.

As an aspiring middle class in America, and desiring to make their religious observance more compatible with Protestant customs, German Jews often eliminated practices such as the strict kosher dietary laws and added such embellishments as organs, choirs, and mixed family seating, which were common in Protestant worship. As Leon Jick astutely pointed out, "conformity with American behavior" was one of the central goals of the German Jewish immigrant American community between 1820 and 1870.[44] The American German Jewish community also remade its group image by redefining themselves no longer as a nation but as full Americans in all but religion. Tied to this concept was the rejection of Zionism by many Reform Jews (notable exceptions included Judah Magnes and Louis Brandeis), who felt this ideology reflected an unacceptable dual loyalty and declared that America had become their "Zion."[45] With the arrival of large numbers of east European Jewish immigrants, the conflicting world and religious outlooks often prompted increased tensions between the two groups. Although the German Jews who had become established in America viewed the plight of their east European counterparts with sympathy and a sense of obligation, they also regarded these new immigrants, with their "outmoded" religious customs, different language, dress, sometimes radical politics, and Old World ways as a source of embarrassment and possibly as a threat to their acceptance in American society.[46]

Initially, Jews of predominantly "German"[47] origin set their sights toward the American West, and later east European Jews found their vital niche in all western states as well, although a significant number of east European Jews were visible pioneers in the region from the very beginning. In San Francisco, for example, in 1851, early Polish Jews founded the Sherith Israel congregation, and in the same month Jews from central Europe established Congregation Emanu-El, both beginning as traditional synagogues. In smaller settlements with tiny Jewish populations, German and east European groups often worked well together out of necessity, but in larger towns and cities, antagonisms were more obvious. In Denver, dissension between the German Reform Jews and the Orthodox east European immigrants resulted in the creation of

two major, nationally supported, tuberculosis hospitals. And for many years, the Seattle Jewish community struggled to integrate three Jewish groups—German Reform Jews, predominantly Orthodox Jews from eastern Europe, and an Orthodox Sephardic community—each of which created separate institutions.[48] Of course, as in all regions of the United States, over time many of these distinctions faded away.

For all three groups, however, the West beckoned with opportunity. East European immigrant Minnie Landman recalled that in 1907 she and her family "took the train to the Promised Land" [of Wyoming].[49] For those Jews fleeing anti-Semitic restrictions, overt prejudice, and even outright violence directed against them in Europe, the West appeared especially promising. Few Jews immigrated or migrated directly to the West, often settling first in New York or other urban centers on the East Coast, or in small communities in the Midwest or even the South before ending up in the West. This mobility was another characteristic of the western experience, which had a significant impact on Jewish women in the West, who often moved with their families through many locations before finally settling in a permanent home. This "step" migration, as Ava Kahn has pointed out, often gave these Jewish immigrants the social, language, economic, and acculturation experience that enabled them to take leading roles in the West soon after they arrived.[50]

Jewish women frequently found themselves not only in a new physical environment but in multiple new communities where they had to work very hard indeed to create a place in which they could raise their children in what they regarded as a civilized backdrop and plant new seeds for a Jewish community. But like other western women of different ethnic and religious backgrounds, some learned to adapt and become innovative. Despite new challenges, many Jews were able to retain their cultural and religious identities as they became both westerners and Americans. The wives of Jewish farmers in Republic, Washington, at the turn of the century lived hard lives, with women papering the walls of their cabins with newspapers to keep out the cold and carrying water to the house from the nearby creek for cooking. Yet the daughter of one of the farm families remembered that "we observed all the Jewish holidays. I have never seen a more beautiful *Pesach* conducted to this day than in our little log cabin four miles from any neighbor, right in the middle of the woods."[51] Stories like these reveal that together with men, Jewish women nurtured and constructed a distinctive Jewish identity on the frontier.

A central question in this book is in what ways the nineteenth- and early-twentieth-century West offered a unique environment for Jewish women that allowed them to assume more public and pivotal roles than their counterparts in the East and in other regions of America. The American West has served as a powerful symbol in the American imagination. Was this symbol of the American ideal of an open environment with wide open spaces, characterized by independence and unlimited opportunity, merely a myth? Some historians have argued that the opportunities, liberalism, and innovation of the West were short lived, primarily limited to a white middle class, and that the pioneers were really trying to replicate the society they had left behind as quickly as possible. However, others have maintained that the West provided women in particular more flexible paths than they had in other areas of the country where communities were governed by fixed, more rigid social and class rules. As one writer put it, the region offered the opportunity for women to "breathe a little easier."[52] Perhaps the celebrated individualism associated with the American West impacted Jewish women significantly, for as Sandra Myres has maintained, in the final analysis the western experience was "a human experience in which all —men, women, and children—participated as individuals."[53] And if the frontier was indeed not as open as has been commonly thought, was the myth as powerful as the reality, or even more powerful?

Perhaps a better way of framing the question is to examine how western women shaped new social, economic, political, and religious roles for themselves. For Jewish women and, indeed, women in general, the West certainly provided new opportunities. By the turn of the nineteenth century, Jewish women in the West were reconfiguring and expanding their roles beyond the scope of the "women's sphere" in education and new professions. For example, in 1901 Bella Weretnikow Rosenbaum became the first Jewish woman to practice as an attorney in the state of Washington, while another young woman, Felice Cohn, attained the same distinction in Nevada in 1902; she also became one of the first women in America to practice law before the U.S. Supreme Court.

Women in the American West led the nation's women's suffrage movement, and in most western states they organized to exert influence in gaining the right to vote. As early as 1869, full suffrage was approved for the one thousand women residing in the Wyoming Territory, and the Utah territorial legislature granted full voting rights to women

in 1870. Women in Colorado were enfranchised nearly three decades before the ratification of the Nineteenth Amendment to the Constitution in 1920. As early as 1893, women's suffrage was approved by popular male vote through a state referendum in Colorado, making Denver the largest city in the United States at the time where women could vote. Historians are still wrestling with the complexities that allowed western women to be enfranchised long before most eastern women. However, recent studies suggest that organized female activism as well as regional politics, western race relations, populism, and progressive reform were all crucial factors.[54] Jewish women were among leading supporters of the suffrage movement in the West. Their numbers included Belle Fligelman Winestine in Montana, who served as the assistant to Jeannette Rankin, the first woman elected to Congress in America; Selina Solomons, president of the San Francisco Votes-for-Women Club in California; Felice Cohn in Nevada; and Frances Wisebart Jacobs, Seraphine Eppstein Pisko, and Ray Morris David, director of the Denver Jewish Aid Society, in Colorado.

The last decades of the nineteenth century marked increasing visibility for Jewish women, especially after the founding of the National Council of Jewish Women (NCJW) in 1893 at the Chicago World Exposition Jewish Women's Congress. Local "sections" or chapters soon sprouted throughout the United States and afforded largely middle-class women an important channel through which to exchange ideas across America and further expand their public sphere. A number of Jewish women from the West had been represented at the event, and two, Ray Frank of Oakland, California, and Carrie Shevelson Benjamin of Denver, Colorado, even appeared on the formal program as speakers, although most of the presenters were predictably from Chicago or New York City. Ray Frank, a journalist and educator who had already earned a national reputation for delivering remarkable sermons on Jewish topics in a number of synagogues on the West Coast, was asked to give the opening prayer at the Women's Congress as well as a paper on "Woman in the Synagogue." Denver's Carrie Shevelson Benjamin delivered a public address on "Woman's Place in Charitable Work—What It Is and What It Should Be," and returned home to become the first president of the Denver chapter of the NCJW.[55]

Although women in the West shared in the NCJW's initial commitment to Jewish education and later to social reform, the western version had a distinctive flavor. Historian William Toll has pointed out that

Jewish settlement-house supporters in the West were significantly different from their sisters in the East, reflecting a more pragmatic slant and the region's celebrated emphasis on individualism. Settlement houses often opened as offshoots of local sections of the NCJW in western cities such as Portland, Seattle, Denver, and San Francisco and were run by volunteers with experience in benevolent organizations. In the West, these women concentrated on charity relief and provided skills to aspiring immigrant wives and mothers rather than initially hiring professionally trained resident social workers with more lofty broader reform and educational goals.[56]

This book will demonstrate that in many ways the Jewish women's experience in the West fostered significant opportunities for expanded female roles. At the same time, the lives of Jewish women in the West clearly intersected, were influenced by, and sometimes paralleled Jewish life elsewhere. The next chapters will focus on the important role of western Jewish women in establishing both general and Jewish communities in growing towns and cities; their major involvement in philanthropy as founders and leaders in benevolent organizations and social welfare institutions; changes within the Jewish community brought about by the arrival of larger numbers of east European Jews and issues of Americanization; and participation of western Jewish women in business, education, politics, and the workplace with the rise of professionalism and increased opportunities for women at the turn of the century. Jewish women in the West did not operate in a vacuum. They learned from their Jewish counterparts throughout the West and from relatives and friends with whom they retained contact in the East, Midwest, and South. As transportation improved and became more affordable and easier, many Jewish women were surprisingly mobile when it came to traveling, visiting family, or sometimes taking part in cultural, social, or political conferences around the country. Frances Wisebart Jacobs set to work founding Denver's first free kindergarten after returning home from a National Council of Charities meeting held in San Francisco, where she had viewed a successful prototype firsthand.

Jews who migrated to the American West in the nineteenth and twentieth centuries encountered unprecedented opportunity and acceptance as pioneer community builders who helped construct basic institutions, and Jewish women were quick to take advantage of their circumstances. Jewish women in the West broadened the definition of "women's sphere" to showcase their considerable organizational skills and diverse talents,

influenced by local needs and circumstances. Like other western women, they enlarged "the scope of woman's place" and countered previously held prevailing eastern arguments about the parameters of a woman's sphere.[57] These Jewish female pioneers of diverse backgrounds synthesized the Jewish, American, and western values they had developed, and in the process they helped shape the contours of the future of western towns and cities as well as the American Jewish community.

1

From the Old Country
to the New Land
"Going West"

Hanchen Meyer Hirschfelder and Fanny Brooks were two of the earliest Jewish women who made the often harrowing journey to the American West in the 1850s, and we are fortunate in that both left rare written records of their experiences. Both women were born in central Europe: Hanchen in Karlsruhe, Bavaria; and Fanny in a small Prussian village near Breslau. After marriage at a young age, they joined their husbands in immigrating to America. Within a short time after arriving in New York, both set out with their husbands for the West. Fanny traveled to Nebraska by train and then ultimately on to California, going part of the way by wagon train over the famous Oregon Trail in 1854, on a trip that took many months. Hanchen journeyed by steamship from New York City in 1856 on what appears to have been a three- to four-week semi-luxury cruise, passing through the Caribbean and Panama before arriving in San Francisco, which she deemed "after NY . . . the most beautiful approach in the world."[1]

The journey to the American West for those who sailed directly from Europe around Cape Horn by clipper ship or through the Isthmus of Panama by a combination of land and sea travel was fraught with uncertainty and could last over six months in the 1850s. Those who came overland from the eastern United States by wagon train, stagecoach, ox-drawn cart, horse, or even in some cases by foot, found the journey equally challenging. But from the beginning, Jews eagerly joined men and women of other ethnic and religious groups in the migration west in search of opportunity, and indeed many Jewish women would shape new lives for themselves and their families in the region. Some were American born, more were European immigrants who had settled in the East, South, or Midwest before migrating west, and a surprising

number came directly from Europe. The promise of freedom, economic success, and adventure in the American West appeared especially attractive for many immigrants, including Jews. This appeal seems to be reflected in population statistics of the times. Between a fourth and a third of the population in the western states were foreign born before the turn of the century, a higher proportion than in any other region of the country based on census records for the period.[2]

Jews from German lands in central Europe began to arrive in America in significant numbers during the 1830s, but the second and larger immigration came after 1848. Disillusioned over the unfulfilled promise of equality in Germany as evidenced in the failed democratic European revolutions of the era, as well as the increasing lack of social opportunity and deteriorating economic conditions, some Jews were part of a larger immigration to America in search of a more favorable environment. In many areas of central Europe they were discriminated against by laws that restricted them from higher education, professions, and many trades, and in Bavaria, specifically, Jews were limited in the right to marry and settle. In America, Jews could hope to become citizens and own land, significant aspirations generally denied to them in Europe.

About 250,000 German-speaking Jews took part in this great wave, often as part of a "chain migration," in which relatives and *landsleit* (fellow townspeople) assisted and often followed one another in making the journey to a new land, forming Jewish merchandising networks that stretched from the East to the West Coast of the United States. Possessing some degree of education and skills in commerce, they arrived in America at a particularly opportune time when their experience was in great demand, often beginning as pack peddlers or petty traders, and fanning out across America to establish small businesses and Jewish communities and to develop a German Jewish middle class.[3]

Jews in eastern Europe had for centuries survived under harsh czars, with extreme religious persecution and economic restrictions that often resulted in severe poverty. Forced to live in small towns, or shtetls, in the Russian Pale, they often eked out a living by craftwork or petty trading and developed their own rich culture, informed by long-held Jewish religious traditions and values. Although east Europeans Jews had always been found in relatively small numbers in America since colonial times, these figures began to increase in the 1860s and 1870s. More extreme conditions, such as the restrictive 1882 May Laws, which limited movement even within the Jewish Pale of Settlement, and violent

pogroms and grinding poverty exacerbated by industrialization and resultant dislocation, pushed larger numbers of east European Jews out of Russia beginning in the 1880s. Highly motivated, these Jewish immigrants came to stay, with only a small number returning to their places of origin, in contrast to other immigrant groups such as Italians, many of whom were nicknamed "birds of passage" because of their high rate of return.[4]

Living in often inhospitable environments, both Jews from German-speaking lands as well as east European Jews had for centuries been forced to rely on their own communities for assistance and direction. Although the Jews from central Europe as well as those from Russia and Poland were accustomed to interacting with the outside community, separate Jewish religious, charitable, and educational institutions had long been part of their tradition, and Jewish pioneers in America soon continued this practice while at the same time integrating into the broader culture.

Between 1881 and 1914, over two million Jews emigrated, mostly in family groups with a very high percentage of women. Between 1899 and 1910 alone, Jewish women entering via New York made up 43.4 percent of the Jewish immigration.[5] The overall calculation of females among the Jewish emigrants was 45 percent, nearly half of the total number, and only Irish women, many of them single, emigrated at the higher rate of 55 percent.[6] For many, America, and soon the American West, offered the dual golden promise of escaping dire conditions and providing new opportunities for the future, a chance to connect with a country as well as a community. There were health reasons as well. Although Americans with respiratory difficulties had long been urged to move to warmer, drier climates to improve their health, by the 1880s the numbers increased significantly. At the turn of the century, many east European Jews also migrated to the West in search of better health after contracting tuberculosis in congested urban centers in the East.

The stories of Hanchen Meyer Hirschfelder and Fanny Brooks help illuminate the Jewish women's perspective on the journey west. In Fanny Brook's case, her memories were later recorded by her daughter, Eveline Brooks Auerbach, who became a female western Jewish pioneer in her own right and married Jewish merchant Samuel Auerbach of Salt Lake City in 1879. Fanny's husband, Julius Brooks, had been apprenticed to a weaver as a teenager in Prussia, worked a few years for a tanner, and then tried his hand at peddling in Breslau before deciding to seek his

fortune in the New World in 1847. Apparently concerned about the availability of kosher food, as according to his daughter he was "very religious" at the time, he packed his own food for the ship's voyage as he had been told that the menu on the boat ran mostly to bacon and ham. Julius Brooks found modest success in New England, where he opened a small store. He returned to Silesia in 1852 for a visit, and his tales of America captivated his niece, the fifteen-year-old Fanny Bruck (Julius and Fanny both later Anglicized their common surname to Brooks), the well-educated and cultivated daughter of German Jewish parents, who spoke German, French, and some English. As far as Europe, stories of rich strikes in the California Gold Rush and tales of the rugged beauty of the western terrain drew Jews among other immigrants. Fanny was eager to join Julius in the adventure, and the pair married the following year.[7]

While most people on the voyage to America, including Julius, were seasick, the gregarious Fanny seems to have enjoyed the three-week trip, easily interacting with the other passengers on board; she recalled that she was "sorry when they arrived at Castle Garden."[8] After several months in New York City they journeyed to Galena, Illinois, and from there to Florence, Nebraska, where the following spring they joined a large wagon train bound for the West. The wagons were packed, filled with food staples and household supplies, and each individual over the age of eight was allowed one hundred pounds of luggage. The cost of the wagon trip across the plains was about $65 per person. Ten people were assigned per wagon, and men and most women were obliged to walk the daily trip, generally averaging about thirteen miles. Although life on the trail was filled with demanding work, Fanny Brooks does not appear to have been daunted. Men and women sometimes shared tasks, although traditional gender roles were often in evidence, with women usually in charge of cooking, washing, and cleaning.[9]

Fanny proved to have a deft hand with the mule teams, which responded best to her taking the reigns, but she was stymied at first by having to bake bread, having had little cooking experience growing up in an apparently well-to-do household where she was pampered. Fanny did not make any reference to any particular Jewish observances in her recollections of the journey. The only Jewish woman in the group, she appears to have bonded easily with the other women who offered advice and support. Fanny's fluency in several languages was probably a valuable asset in the multiethnic environment both on her journey and after her arrival in the West. Many years later, Fanny recalled many of

the details of the trip, including the fact that the party forded many deep streams, filling wagons packed with provisions with water and soaking clothing that frequently had to be hung out to dry. Before long, the weather grew colder, food became scarce, and illness stuck. Tragically, Fanny and Julius's infant son died along the route.[10]

Like so many other western pioneers, they continued on after many delays, and finally arrived in California in the spring of 1855. Julius opened a general merchandise store in the supply town of Marysville, home to about one hundred Jews. Business was not good, and of the three children born to the couple there, another child, this time a daughter, died, reflecting the high infant mortality rate of the time. Their daughter Eveline was born in the mining camp of Timbuctoo in 1859, where Julius tried his hand at selling mining supplies. Before the family finally settled in Salt Lake City, where they at last met with business success, they also lived for a time in San Francisco and Portland, Oregon, where they interacted comfortably with Chinese residents, and in Boise, Idaho. Although devastated by the deaths of two more young sons and sometimes suffering from poor health, Fanny seems to have regained her early vitality in Salt Lake, demonstrating great resilience in the face of personal tragedy. Only one of her six children, Eveline Brooks Auerbach, survived past early adulthood. In Salt Lake, Fanny took in boarders to supplement the family's income, cooked and sold meals to large numbers of travelers, and later oversaw a successful millinery shop. Fanny Brooks was an important presence in both the Jewish and general community. By speaking with Mormon leader Brigham Young in a face-to-face meeting, she personally influenced him to allow Mormons to resume trading with the "Gentiles," which included Jews, after an 1868 edict was issued forbidding Mormons to conduct business with non-Mormons.[11]

Hanchen and Emanuel Hirschfelder were apparently German Jewish immigrants of means because their steamship voyage from New York to California was made in some style, not typical of the majority of journeys to the West at that time, although traveling by ship was the preferred method of transportation by most Jews. In a letter written back home to her mother and siblings in Germany, Hanchen mentioned that they traveled first class and that they had to "settle" for the lower of the two levels in that class as the better accommodations were already filled. Even so, the "lower saloon" on the ship in first class cost $200 per person, a very considerable sum at the time. On board, the passengers were

served by free black waiters and servants and "the passengers were filled with gaiety." Hanchen described the scenery along the way in great detail to her mother, and reported that she was popular with the other passengers on the ship, which traveled about 280 miles per day. She also noted that there were several other Jewish families on board and that "Our 'Day of Atonement' [Yom Kippur] which was on the 9th, we spent very well. However, on the next day I felt somewhat weak."[12]

On October 14, 1856, Hanchen and Emanuel Hirschfelder landed in San Francisco and Hanchen reported "I liked it very much."[13] Emanuel opened a successful clothing store in Downieville, California, and Hanchen gave birth to three children before she died at the young age of thirty-two.[14] Hanchen's death reminds us, once again, how precarious life was in the early West. From her letters, it appears that Jewish traditions and connections were important to her. We know from newspaper reports that Yom Kippur was observed in Downieville in 1857, and it is probable that Hanchen and Emanuel participated in services there. Hanchen was also likely to have participated in social events and civic functions in the local community, which welcomed the contributions of cultivated Jewish members. After her death, she received a Jewish burial in the Jewish cemetery in Marysville.[15]

Hanchen Hirschfelder's journey west seems remarkably tame when compared to the story of another young Jewish woman who set out from Philadelphia in the mid-nineteenth century to join her future husband. Rebecca Phillips first sailed to the Isthmus of Panama. From there, while traveling by donkey across rugged mountain terrain to board another ship on the Pacific side, she was reputedly kidnapped by a group of Central American Indians before being rescued. She finally arrived in San Francisco to marry her cousin Alexander Phillips. Two of their daughters later married early Jewish pioneer businessmen in Seattle, Washington, once again demonstrating the emerging Jewish commercial network that existed in the West.[16]

In May 1855, Helen Levinson, a young unmarried woman in her teens who would later become Mrs. Joseph S. Newmark, set out from the Prussian province of Posen in the company of her older sister, Mina, to join their brothers in California. In her memoirs Helen later recalled, "I adored the free land, America, and looked forward to the trip and the re-unification with my dear ones." Although "we women were seasick the first days," the voyage improved and "we arrived in New York in the daytime, and the entrance along the harbor was very beautiful."

After two weeks in New York, joined by a brother, the two sisters traveled for ten days by ship to Nicaragua. Although the tropical surroundings were beautiful, they were plagued by mosquitoes and threatened by a drunken wagon driver. Deciding to continue by foot, they found "the sand under our feet was so hot we could barely step on it." Finally, boarding the ship *North Light,* Helen and Mina continued on to San Francisco, where the young women arrived exhausted, but delighted to be reunited with other family members.[17] Similarly, Mary Goldsmith Prag recalled her trip to America as being a draining one. She and others in the party became ill as they crossed through Nicaragua, and, like Rebecca Phillips, Mary Prag also made part of the trip on the back of a mule, but in her case, as a young child perched in front of her father. The family continued on to San Francisco by steamer, where "a thousand passengers were crowded into accommodations intended for four hundred."[18]

For those Jewish women already settled in America, the trip West by ship could also be long, but often pleasant. In December 1852, Rosa Newmark (a distant cousin by marriage to Mrs. Joseph S. Newmark) and her six children made a sea voyage to California. They left New York City on the *Carrington,* and after four months on the ship, which traveled around Cape Horn, arrived in San Francisco in April 1853 to be greeted by her husband, Joseph. Myer Newmark, the fourteen-year-old son of the couple who later became an attorney, kept a journal of his trip, and he recorded that the family, highly observant, marked the Jewish Sabbath on board by "praying and reading."[19] In less than two years the family relocated to Los Angeles, where the devout Joseph Newmark served as a lay rabbi and Rosa founded the city's first female philanthropic group, the Ladies' Hebrew Benevolent Society.[20]

Some women traveled by land, some by sea, and many combined the two modes of transportation. In 1857, Delia Stern Fleishhacker traveled to Virginia City, Nevada, from Albany, New York, with her husband Aaron, first by steamer and mule through the Panama route, and then by wagon from California. The discovery of the rich Comstock Lode in the area would for a time make Virginia City a bustling metropolis. Aaron and Delia operated a grocery and dry-goods store in the mining town, and the energetic Delia helped deliver babies born to miners' wives. Before long, the couple, who would become the parents of eight children, moved to San Francisco, where Aaron Fleishhacker opened a thriving box company with a windfall from a miner he had

grubstaked.[21] Ricka Saft Schayer, born in Kempen, Prussia, in 1847, sailed by ship to America and later endured a seven-week journey by covered wagon to the Colorado Territory in 1865. Over a decade later in 1878, merchant Nathan Falk of Boise, Idaho, traveled to Germany to find a bride and returned via Panama with his new wife, eighteen-year-old Rosa. When Rosa arrived in Idaho, wolves and bears still roamed the area, and in 1882 the front page of San Francisco's *The Jewish Progress* reported that an Idaho woman had fended off a bear with her parasol.[22] In the mid-1860s, Yetta Kohn arrived in New Mexico with her husband via the Santa Fe Trail. As a widow, she moved in 1902 to Montoya, New Mexico, with her four children to homestead, operated a mercantile store, and became the matriarch of a successful ranching dynasty.[23]

Rosa Katzenstein also made a long journey west in the late 1860s, combining several sea voyages with overland travel before reaching her destination. Born in Baltimore, at the age of twenty Rosa married Philip Drachman in New York City in April 1868. Less than two weeks after the marriage, the couple began a six-month journey that would ultimately take them to Arizona. Philip Drachman had migrated to the West in 1854 and became a naturalized citizen in 1860. Beginning as a peddler, by the mid-1860s he was a rising businessman in search of a wife.[24] The new couple sailed to Panama on the appropriately named steamer *Arizona,* but Rosa probably did not realize how many segments their trip would entail before they actually entered the Southwest. Rosa and Philip crossed overland to the Pacific in a wagon, and once there they boarded the *Senator* and sailed once again, this time north to San Francisco. In a few weeks, they boarded yet another ship to head south again to Los Angeles, then took a stagecoach east to San Bernardino, where they arrived after a "hard day's ride over very rough roads." Several months later in mid-October 1868, Rosa joined Philip in a horse-drawn conveyance, stacked with their supplies, headed for Tucson. She later recalled in her memoirs that "the first night we camped out and I could not sleep on account of the howling of the coyotes. . . . When we were ready to start in the morning, I looked for my sunbonnet, which was made of straw with ruffles of gingham. All I could find was the ruffles—the horse had eaten the straw."[25]

In November 1868, Rosa Drachman finally arrived in the town she would call home, reportedly at first one of only three Anglo women living in Tucson. She reported that she "started housekeeping without a

stove," and that the small community viewed the nearby Apaches as a constant threat: "The Apaches were so bad it was not considered safe to go out of the city limits. Men always carried arms." Still, Rosa came to love Arizona, where she spent the "happiest years of my life."[26] The family business, a saloon named the Postoffice Exchange, was later described by the local newspaper as exhibiting an "air of tone and elegance." When Philip died in 1889, Rosa Katzenstein Drachman continued running her late husband's cigar store and saloon while raising their ten children on her own.[27]

Anna Freudenthal Solomon's personal account of her journey to New Mexico also revealed the many challenges most Jewish and gentile women encountered heading west. Born in Posen in 1841, Isadore Elkan Solomon had immigrated to America in 1858 and established a livery business in Pennsylvania, where he became a United States citizen in 1865. In 1871 he returned to Europe to visit his parents, and before the trip was over he had found a bride, Anna Freudenthal, the daughter of Jewish shopkeepers in a nearby village. Soon after their 1872 wedding, the Solomons traveled to eastern America from Krushwitz, a small town in Prussian Posen (an area which had formerly been part of Poland), but economic success in the East was elusive. Encouraged by some of Anna's relatives who were already settled in the West, in 1876 in the often quoted phrase from Anna's memoirs the couple "sold everything we possessed except our three children," and set out for New Mexico. The trip was long and difficult, and after they came to the end of the railroad line in La Junta, in the Colorado Territory, they "had to travel by stage, packed in like sardines day and night for six days." In Las Cruces, New Mexico, the family found the "best" house in town, but Anna recalled "I could not help having tears come into my eyes when I saw the mud floors and the mud walls." Yet demonstrating her remarkable spirit and adaptability, she wrote that within "days I had the house looking nice and comfortable."[28]

Anna's husband, Isadore Solomon, soon moved the family again to start a charcoal company in the village of Pueblo Viejo in the Arizona territory deep in Apache land, where Indian attacks were frequent. This time Anna faced an even more grueling and often frightening trip in a buckboard wagon, piled high with some of their possessions and accompanied by a Mexican clerk to help in the fledgling business. Since their furniture and goods for a planned store didn't arrive for three months, Anna was forced to make do with "no bed to sleep in, no stove

to cook in, no table to eat off, no flour to bake bread." Still, Anna persevered, often running the dry-goods store on her own while raising six children and later operating her popular hotel with the assistance of a Chinese cook while her husband focused on the charcoal enterprise.[29] The only Jewish family in town, the couple was soon befriended by both their Mexican and Anglo neighbors, who showed Anna how to make due with limited amenities. As their businesses grew and circumstances improved, Anna and Isadore, who took a personal if paternalistic interest in his employees, appear to have been well liked by their workers. At the same time, Anna seems to have been regarded as a beneficent mother figure by her Mexican housemaids and loyal male Chinese cook.[30] Anna and Isadore Solomon became prominent figures in the small community, renamed Solomonville, which became the county seat, operating the Solomon Commercial Company, a hotel, ranch, and later the Gila Valley bank.

The Solomon family's interaction with a variety of other ethnic groups, including Native Americans, Mexicans, and Chinese, was not uncommon. Jewish women in the West were almost exclusively of white Euro-American background. We need to be mindful of the fact that in joining the westward expansionist movement, Jews as well as other Euro-Americans often displaced native peoples and utilized their labor, as well as the labor of marginalized immigrant groups such as Asians, to their economic, social, and political advantage. For example, Chinese servants were not uncommon in many Jewish San Francisco households, and Mary Ann Magnin trained Chinese women as seamstresses in her early exclusive women's clothing business. Yet, at the same time, many Jews in the West had favorable business and personal relationships with individual members of these groups, sometimes serving as popular traders, as Indian commissioners like Colorado's Otto Mears, who was fluent in the Ute language, or, in the highly unusual case of Solomon Bibo, as the governor of the Acoma Indians of New Mexico following his marriage to the chief's daughter. The Danoff brothers in New Mexico were successful merchants who traded with local Native Americans in their store in Gallup. Louis Danoff earned the Indian appellation "The Honest Man" for assisting them fairly with monetary transactions, and the three brothers and Louis's sister-in-law, Rose, who also worked in the store alongside the men, all spoke Zuni and Navajo fluently, along with some Spanish.[31]

In the American West, Jews encountered people of highly diverse

Blanche and Lillian Solomon, daughters of Anna Freudenthal Solomon, in a horse-drawn carriage, Solomonville, Arizona, 1905. (Courtesy of the Beck Archives, Penrose Library and CJS, University of Denver.)

backgrounds, including Native Americans, Spaniards, Mexicans, African Americans, Asians, Europeans, and Americans who juggled for power; a product of their era, Jewish women were not immune from exhibiting prejudice or forming stereotypes. However, they appear to have had a number of amiable relationships with some groups that had been marginalized in the West, most notably the Chinese and Mexicans. As noted earlier, however, these bonds were often those of an employer and servants or laborers. While many Jews displayed ambiguous attitudes toward other races, the long history of Jews as victims of discrimination may have predisposed them to be somewhat more sympathetic to the plight of other minority groups. According to family legend, Bavarian-born Denver merchant prince Leopold Guldman, proprietor of the Golden Eagle department store, sheltered a local Chinese man from a mob for three days, hiding him in a box of merchandise in his store.[32] Even though Jews, Protestants, and Catholics in the American West "coexisted with relative equanimity,"[33] largely because no single specific

religious faith ever acquired hegemony, in their closest associations Jewish women joined together with relatively small numbers of other Jews to fulfill Jewish communal functions and provide appropriate Jewish connections for their children. At the same time, within the multicultural nature of western settlement, they learned to live together with members of the larger community in social, cultural, and educational endeavors and business dealings. As Glenda Riley has recently pointed out, western "women of disparate groups did not exist totally separate from other types of women."[34]

A number of Jewish women first came in contact with non-Europeans as they entered the West. Just a year before Anna Solomon and her family headed west, Flora Langermann Spiegelberg traveled to Santa Fe, New Mexico, following the Santa Fe Trail. Flora was born in New York City in 1857 to an American-born mother and a father who hailed from Bavaria. She spent her early years in San Francisco before the family moved back to New York. Flora was later educated in Bavaria, and at the age of seventeen in 1874 married Willi Spiegelberg at the Nuremberg Reform Temple before embarking on an extended honeymoon in Europe. Willi Spiegelberg was a German-born immigrant who had built a prosperous business with his four brothers in New Mexico. The first of the clan had arrived in the area in 1844, and Willi had returned to Europe to find an acceptable wife.

Back in America, in 1875 Flora Spiegelberg and her husband traveled by train as far as Las Animas. They spent a harrowing night in a crowded "hotel" in Colorado packed with cowboys before continuing by stagecoach on a six-day trip with short stops for rudimentary meals with an unfamiliar southwestern flavor that included buffalo meat. During the journey Flora suffered a miscarriage. When she finally arrived at her destination she later recalled, "At that time I was the eighth American woman in Santa Fe. There were about fifty American men, officials and merchants, and a Mexican population of two thousand."[35] The Jewish community numbered less than one hundred, but she would become one of the growing town's most prominent citizens. A leader in local society, Flora would entertain elite New Mexicans of Spanish Catholic descent and visiting dignitaries, especially after Willi was elected mayor of Santa Fe in 1880. Flora Spiegelberg was also prominent in the small Jewish community, founding the first Jewish Sabbath School and hosting celebrations for the High Holidays and Passover in her home.[36]

Despite the differences in personalities and individual stories, the physical journeys to the American West of the Jewish women discussed above were not dissimilar from those of other Jewish women of the era. Secondary accounts from newspapers and family stories offer us confirmation of numerous westward bound Jewish women who shared parallel experiences. Americans before the turn of the nineteenth century were highly mobile, frequently pulling up roots in a successive search for often elusive success. Indeed, "high rates of geographic mobility" have long been and continue to be a characteristic of American life.[37] This theme has been graphically portrayed even in popular literature. Most of us are familiar with the famous "Little House" books by Laura Ingalls Wilder, fictionalized stories that chronicle the real lives of a gentile pioneer family that moved time and time again in search of fresh opportunities. Certainly all across America, Jewish women like Amelia Ullmann, who journeyed to St. Louis in 1852 from her native home in Coblenz in central Europe, stopping in Rotterdam, Liverpool, and New Orleans on the way, often felt they were traveling "to the end of the world."[38] But as Ava Kahn has noted, "the mobility of Jews in the American West is particularly striking."[39] The life of Rosa (Rosalia) Straus Goldsmith is emblematic of this phenomenon.

The story of Rosa Goldsmith is a graphic illustration of the extreme mobility and adaptability of early Jewish women in the West. Born in Durkheim, Bavaria, in 1840, Rosa immigrated to America in about 1857, and after arriving in New York soon married Abraham Goldsmith. It appears that Rosa's sister Clara married Abraham's brother, Henry. The details are sketchy, but it appears that Rosa and Abraham made their home in Leavenworth, Kansas, for a time, but migrated by covered wagon to Denver in 1859. Abraham is recognized as one of the original Jewish Colorado 1859ers, filing homestead claims for a ranch.[40]

In 1860, Rosa's sister gave birth in Denver to the first Jewish baby girl born in the new town. As was all too common during the era, the new mother died in the process, reflecting the high rate of maternal mortality. Rosa raised her sister's daughter, Clara, named after her mother, along with her own six children. Abraham served as one of the founders of Denver's Jewish cemetery association, necessitated by the death of his sister-in-law. When the Cherry Creek flooded its banks in 1864 and washed their home away, Rosa, her husband, and her brother-in-law moved to Pueblo, Colorado, with the children, farming on a homestead. Family lore relates that as a small child Clara was

kidnapped by local Ute Indians, but they do not appear to have been especially threatening because they returned her in exchange for food staples and a bolt of cloth. In 1880, the family moved yet again, this time to their final destination of Las Vegas, New Mexico, an important commercial center and the state's most populous town at the time. Here Abraham became a merchant. Rosa was a moving force in the founding of the town's Temple Montefiore and was described as "a real pioneer of the Rocky Mountain area." Rosa died in 1937 at the age of ninety-seven and was buried in the Montefiore Jewish cemetery.[41]

Just as the life of each pioneer Jewish woman in the West was different, as we have seen, so too was each of their early journeys west. However, several common themes appear that allow for some useful generalizations. As we have learned from Hanchen Hirschfelder's letters and Rosa Newmark's voyage, it may have been difficult but not impossible to mark Jewish holidays and observances. Jewish women were active participants in the westward movement, and their journeys were similar to women of other ethnic and religious groups.[42] Rare, indeed, was the case of the journey down the Santa Fe Trail provided by St. Louis gentile trader Samuel Magoffin for his wife Susan, who traveled in her own private carriage with a separate buggy for her maid and an extravagantly furnished tent. But even for the Magoffins, food soon became scarce, bad weather damaged their conveyance, and they lost a baby after premature labor.[43] Except for a privileged few—and even they were not immune to hardships—the physical journey for all those who made the trip to the West was harsh and demanding. This was true for both white women and women of color. African American women traveled overland by wagon or foot, however, as few were able to afford the cost of passenger ships,[44] the preferred method of transport for most Jews.

Shared hardships on the journey west allowed Jewish women the opportunity to meet and interact with a variety of people in close quarters, often providing them with new skills and opening new channels of communication as well as paths to acculturation. For example, on the wagon-train journey west, a supportive gentile woman taught Fanny Brooks how to bake bread, and later while the Brooks family resided in Portland, Fanny forged an affectionate relationship with Chinese neighbors, often receiving small gifts from them as tokens of their esteem.[45] The heterogeneous nature of the population on the journeys would often be amplified in the new communities in which they would settle.

When young Rebekah Bettelheim arrived in San Francisco in 1875, she found the city to be the most cosmopolitan city in America, observing, "One could see members of almost every nationality in the streets. It presented the curious anomaly of crudity and sophistication, of rough free-handedness and an attempt at culture. Amazement and delight were my first reactions to California."[46]

Although all Jewish women who immigrated to America in the mid-nineteenth century certainly shared the challenges of the transatlantic voyage and of early railway travel, few experienced the additional hardships of long wagon train and stage coach travel that was commonplace on the journey across the continental United States to the West. And compared to their gentile counterparts, Jewish women were distinguished by greater independence and influence within the family. An early study that examined the memoirs and diaries relating to well over one hundred and fifty non-Jewish families who traveled on the Overland Trail between 1843 and 1870 found that within the family setting the women deferred to men in almost all aspects of daily life, and the decision to migrate was made by the male. No pioneer wife in the group initiated the idea, and many were reluctant participants in the westward migration.[47] Of course, most single women who migrated west exhibited greater independence, but some, such as early pioneer female teachers, migrated not only to improve their personal circumstances but because of a commitment to a larger Evangelical Protestant mission.[48]

Many historians have described the Jewish family unit in nineteenth-century Europe, particularly in eastern Europe, as being intensely patriarchal.[49] Yet, it is interesting to note that although there were certainly prescribed gender roles, Jewish women appear to have exercised considerable influence in the family. Anna Freudenthal Solomon, for example, learned to read and write as a young girl in Poland, worked in her parents' stores at an early age, and, according to her memoirs, it was Anna who "encouraged" her pious father to migrate to America in an effort to improve the family's economic condition. As a young girl, she ran the dry-goods store with her mother in her father's absence. After her marriage to Isadore Elkan Solomon and their arrival in America, she was no silent partner. In recalling the move that ultimately brought them to Arizona, she stated: "*We* decided to do so"[50] (emphasis mine). Anna's granddaughter later observed that despite Anna's charming and gracious personality, "in family matters, she [Anna] was the dominant force."[51] Similarly, Fanny Brooks's husband often deferred to her on the

harsh journey west as well as in business dealings, and Fanny clearly "held the purse strings."[52] Flora Spiegelberg also appears to have taken a very forceful role beside her husband as a woman of unusual influence. All three shared a remarkable spirit of adventure. Admittedly, the sampling is small, but the phenomenon deserves further examination.

With the completion of the transcontinental railroad in 1869, linking the West with the East, the journey west would become significantly easier, shorter, safer, and more comfortable, bringing even more Jewish women to the region. Eveline Brooks Auerbach wrote that "the construction of the U [Union] and P [Pacific] across the continent was the greatest marvel of our age." As a child of ten, she witnessed the celebration that marked the meeting of the two railroad lines at Promontory Point in Utah. Starting out from Salt Lake City, it took the family two days and one night by wagon to reach Promontory, where she remembered "seeing the two engines arriving from different directions."[53] It is interesting to note that the Brooks family felt comfortable enough to undertake the trip with Mormon neighbors despite significant religious differences.

Affluent Jews made immediate and frequent use of the new railroads. Soon after the Brooks family traveled to Promontory Point, Julius Brooks announced to his family that "the railroad is finished. Why not go down to California for the winter?" Eveline Brooks Auerbach recalled that early trip as follows: "We took our bedding, our few duds, and a basket of food and left for California in November. The Pullman car was then not in existence, only a primitive first class car, which was very expensive. We took a tourist car with wooden benches. . . . The bridges were down, and many a time we were compelled to get out and walk a mile before we could catch the next train. It was hard work, as we had to carry our bedding and belongings. We had to sleep on the hard benches, but we soon got used to that."[54]

Others took an even longer railroad trip. Julia Frank Zeckendorf and her new husband, William, appear to have spent their honeymoon aboard the second transcontinental train trip of the Union Pacific to California before making their way to their new home in Tucson, Arizona, where they would become among the most prominent of the city's Jewish citizens.[55] Mrs. Salomon, wife of Edward Salomon, governor of the Washington Territory, also came west on the second train to join her husband. From Oakland she and friends proceeded north on the steamer *Idaho*.[56] In 1875, eleven-year-old Rebekah Bettelheim Kohut,

later a prominent New York City Jewish educator and activist, traveled by train with her family from Richmond, Virginia to San Francisco. It took the family ten days to cross the continent, carrying all their own food for meals and twice encountering hostile Indians along the way before joining Rebekah's father, the new rabbi at Congregation Ohabai Shalome.[57]

With the initial railroad route in place, a coach ticket from Omaha to Sacramento at first cost $75 and a first-class ticket $100. However, as new lines were added and time passed, prices became more reasonable, making it more affordable to travel west. At the turn of the century, many Jews of modest means took the train west in the hope of improving their health. East European immigrant Fanny Jaffe Sharlip, a victim of tuberculosis, recalled that her physician in Philadelphia advised her to "move to a warm climate, and since I was not going to give up without a fight, we decided to go to California." Fanny and her husband Ben gave up the family home and business "to pioneer" in Los Angeles, as she put it. Ben was also very enthusiastic about the move west, declaring "it is a new part of the country and we will grow with it." Within a short time the Sharlips and their infant daughter made the six-day trip on the "jerky" train, and upon entering California, Fanny "was overjoyed to see the green after all the snow and frost we had left behind." Fanny recovered her health and with her husband opened a grocery store and worked on behalf of other tuberculosis victims.[58]

Although the life of each individual Jewish female pioneer who journeyed west was unique, all shared a hope for opportunity, self-growth for themselves and their families, and the promise of settling in a new region that would allow them to live freely as Jews and Americans. Whether they came by ship, wagon, or train, the journey served as what Sandra Myres termed a "transitional link," a period in which to adapt from the old life to the new and acquire new skills that would be useful in their new homes. Moreover, the westward journey fostered adaptability and flexibility, traits that would prove extremely useful in their new surroundings.[59] For once they arrived in the American West, most Jewish women would find that their challenges had just begun as they developed new roles as community builders.

2

Building a Foundation

The remote mining community of Nevada City, located over 150 miles beyond San Francisco in the northern California goldfield district, may seem an unlikely site for an observant Jewish woman to have called home in the mid-nineteenth century. But Rosalie Wolfe Baruh and her husband, Aaron, resided there for over fifty years. When Aaron Baruh rode into the bustling mining camp in the early 1850s, the discovery of gold in the area in 1849 had swelled the local population to over six thousand. Many Jews had already arrived to take advantage of business opportunities in typical occupations as merchants and traders, primarily supplying clothing and dry goods and often opening branches of stores already established in San Francisco by their relatives. Jewish businessmen were found in unusually high numbers in the mining region, some settling in towns with their families while trading in surrounding camps and hamlets. Even in this transient environment, Jewish men and women were soon centrally involved in local civic and social life.

The Jewish population in Nevada City was small but active, numbering around thirty when Yom Kippur services were held in the local Masonic Hall as early as 1852. Jewish men were often prominent members of Masonic and Odd Fellows societies in the West, which operated as civic rather than religious organizations at the time, and it was not unusual to hold services in rented rooms in lodges before synagogue buildings were erected. The Baruhs moved into a home located on Main Street, raised seven children, and were able to celebrate the Sabbath and Jewish holidays and keep the Jewish kosher dietary laws with family and friends in the community. A *shochet* (butcher) made a regular yearly visit to slaughter kosher meat according to religious specifications. Matzah was ordered from San Francisco, and in the Baruh household, Rosalie presided over a kosher kitchen and also kept separate dishes for Passover use.[1] According to a contemporary traveler, by 1860 the Jewish population had grown to sixty and a Jewish cemetery was

managed by the Nevada Hebrew Society, a vibrant benevolent organiza-
tion founded in 1855.[2]

By the early 1860s, Hebrew ladies' benevolent societies had been
founded by Jewish women in several of the other leading California
mining towns, including Placerville, Mokelumne Hill, and Jackson.
When sixteen Jewish women in Jackson formed a Hebrew Ladies' Be-
nevolent Society in 1860, the total Jewish population in the town at the
time was only thirty-five.[3] It is possible that Rosalie Baruh participated
in their activities even though the towns were some distance apart. In
Oroville, another northern California goldfield town, a Hebrew Benev-
olent Society was founded even before the first Jewish cemetery was
deeded in 1859. The society was apparently disbanded and then re-
formed in the late 1870s because of concern about the lack of Jewish
education for the children of the town's Jewish families, some of whom
were attending a local Christian Sunday School. While all the officers of
the society were men, the wives and daughters of the local Jewish busi-
nessmen became the officers of the new Jewish Sabbath School, with
Julia Brooks serving as superintendent and other women teaching sub-
jects such as Hebrew, Jewish history, and music.[4] The stories of these
early pioneers demonstrates that once the journey west was completed,
whether over sea or over land, Jewish men and particularly women
turned to the task of community building and transplanting Jewish life.
As most historians have concluded, "once arrived and engaged in settle-
ment, women were culture carriers, community organizers, civilizers."[5]

The story of the Baruh family is far from unique. Jewish men and
women settled throughout the West in remote mining-supply towns like
Jacksonville, Oregon, and Walla Walla, Washington, as well as metrop-
olises such as San Francisco, Denver, Portland, and Seattle. The rapid
creation of new towns brought attendant needs. If Jewish men helped
stabilize the early western communities through commerce and govern-
ment and formed Jewish burial societies and early self-help associations,
Jewish women provided the foundation for the growth of Jewish com-
munal life and were often an integral part of the development of syna-
gogues, schools, and human service organizations such as orphanages
and homes for the aged. The first Jewish woman said to have arrived in
Oregon was a Mrs. Weinshank, the proprietor of a Portland boarding-
house for Jewish bachelors who worked in the area in 1853. A second
Jewish woman, Mollie Radelsheimer Blumauer, the Bavarian-born wife
of Simon Blumauer, one of Oregon's earliest Jewish residents, migrated

to Portland in 1853 after their wedding in New York City. Undoubtedly, Jewish single men in the town had gathered together for Sabbath and holidays services from the beginning, but in 1858, when the Jewish family population reached a critical mass, a formal Jewish congregation, Beth Israel, came into existence during the period when Oregon was still a territory. In little more than a decade, a second congregation, Ahavai Sholom, was formed, probably to satisfy the needs of a more traditionally observant group from Prussia and Poland.[6]

This trajectory was typical in most Jewish communities in the West, where the presence of women and children provided the impetus for establishing more formal Jewish institutions to meet expanded needs. As early as 1851, a San Francisco correspondent for the Anglo-Jewish journal the *Asmonean* reported "of late there has been quite an accession of ladies with their children. This will tend to improve and consolidate society, for when I first arrived, the community nearly destitute of the fair part of creation, you may be assured it was in a terribly disorganized state. . . . There are so many persons who have returned to the states and brought their families here, with the avowed determination of finally settling, that public feeling has decided on erecting a permanent building for a synagogue."[7]

In the Nevada Territory, site of the discovery of the rich Comstock Lode in 1859, Hebrew benevolent societies were established by 1862 in the mining-supply towns of Carson City and Virginia City, and as the latter community grew, plans for a Jewish congregation were announced in 1864.[8] The mining boom town of Eureka, Nevada, grew in the 1870s, with a peak population of about 9,000 in 1878 before its decline as nearby lead-silver mines were played out. Jewish services had been conducted as early as 1870, but the first formal Jewish organizations began in 1876. Jewish merchants were very prominent in the town, where the first store was owned by a Jewish businessman.[9] By 1875, according to a contemporary account, the Jewish population numbered one hundred, with the majority being families.[10] The organization of a Jewish congregation and religious school in 1876 was probably prompted by the growing number of females and children.

The pattern of the key involvement of women in building Jewish communities was replicated in most locations, although San Francisco and a few early California mining towns did establish congregations when there were only a small number of Jewish women in the population. Although Jewish men in Washington Territory were involved in

Congregation Ohabai Shalome of San Francisco (c. 1910), which began as a traditional synagogue in 1864. (Courtesy of the Western Jewish History Center, Judah L. Magnes Museum, Berkeley.)

commerce there by the early 1850s, the presence of families was a major ingredient in the development of the first Jewish organizations two decades later, and women tended to play significant roles. When the first Jewish synagogue was incorporated in Seattle in 1889, women received

full membership rights even though in contemporary congregations only men were normally counted as members. In 1892, a Ladies' Hebrew Benevolent Society was founded in Seattle with Esther Levy as its first president. Before its organization, Jewish women such as Babette Schwabacher Gatzert, wife of Bailey Gatzert, who was elected mayor of Seattle in 1875, worked alongside gentile women in aiding the poor.[11] In the smaller Washington State community of Tacoma, in 1890 pioneer Jewish women founded the Lady Judith Montefiore Society, which organized a religious Sunday School for children and holiday celebrations before a formal congregation came into existence.[12]

The story was similar in Boise, Idaho, where early single Jewish merchants were suppliers in the mining camps and met for regular holiday services in rented halls beginning in 1860, when notices about Jewish religious gatherings began to appear in local newspapers. By 1869, a Jewish cemetery was instituted, but it was not until 1895 that Congregation Beth Israel was founded. The organizational meeting for the congregation was held in the home of Moses and Helena Alexander, leading members of the small Jewish community. The couple had arrived in Boise only a few years earlier with their four young children and had been disappointed that no synagogue was present. As a highly successful proprietor of a string of men's clothing stores, Moses Alexander would go on to serve two terms as mayor of Boise before being elected as a two-term governor of Idaho in 1914, the first Jew to hold a governorship in the United States.[13] In Utah, the *Salt Lake Telegraph* reported that in 1864 "the celebration of the Atonement [*Yom Kippur*]"was held by Jews in Salt Lake City in the home of one of the local Jewish merchants. Some Jewish store owners closed their shops for the High Holidays, but not until 1881 did the small community found Congregation B'nai Israel, after more east European Jews arrived. Typically, the Hebrew Ladies' Benevolent Society contributed funds for a synagogue building.[14] The situation was analogous in Montana. As early as 1883, Jewish women were declared full members of Helena's United Hebrew Benevolent Society and within a few years pushed for the formation of a congregation and synagogue building. When a synagogue was erected in Butte, Montana, at the turn of the century, the Ladies Aid Society held a fair that raised over $4,000 to support the new B'nai Israel building.[15]

Lack of formal social welfare institutions in the early American West spurred a proliferation of female voluntary organizations, especially among Jewish women who often focused special attention on the needs

of widows and orphans. Before the state stepped in to take primary responsibility for welfare, religious groups often informally dispensed charity through benevolent societies, with women exercising leadership in an area that was considered an acceptable nurturing facet of the women's sphere. Jewish women gathered together in Portland in 1864 to organize the town's first Jewish Ladies' Benevolent Society, dedicated to aiding ill and impoverished female co-religionists and their children. However, the early executive board was composed entirely of men and not until the early 1880s did women exercise complete control in their own organization. Individual women like Cecile Friedlander, who became secretary of the society in 1879, and the forceful Emma Frohman Goldsmith, who took over as president in 1884, helped transform the society into an organization run exclusively by the women themselves. Bernard Goldsmith was a highly successful businessman who went on to serve as Portland's first Jewish mayor from 1869 to 1871. His wife, Emma, also a Bavarian immigrant, married Goldsmith in 1863, and even though the couple had seven children, Emma still found time for active community involvement.[16] William Toll has pointed out that Portland's German Jewish women exhibited far more independence than their counterparts in Germany and rural women in Oregon of that time. In Portland during the period between 1870 and 1930, "drastic changes in family structure and roles gave women new authority and encouraged their ability to provide leadership and to influence community values" in the American immigrant German and east European communities.[17] The shift in the control of the Portland organization from a mixture of men and women to exclusively woman is reflective of this trend.

As reflected by the Portland experience, expanding Jewish female roles appear to have been particularly well developed in the American West. The stories of the founding of multiple women's benevolent societies in early western towns and cities reinforce the primary role taken by women in social welfare issues. In focusing on the needs of women and children, the Portland group was typical of other early Jewish women in the West who faced the challenges of a developing region. These budding organizations not only provided needed assistance but served as a route for Jewish women to enter public life and reflected growing female influence. The "good works" carried on in their organized charities provided a community dimension to traditional female roles. In their own groups, Jewish women acquired valuable skills such

as money management, public speaking, diplomacy and negotiation while developing coalitions that would aid them in shaping public policy. In the governing bodies of the burgeoning American West, city building and growth took precedence over social services, especially in "instant" cities like San Francisco and Denver.[18] Because formal human services sponsored by government as we know them today were virtually nonexistent, at the time women looked to one another for support and assistance, particularly in times of crises or distress. An emphasis on voluntarism and the celebrated individualism that has come to be associated with the West placed the burden of caring for the needy squarely in the private arena.

The formation of voluntary associations appears to have been the preferred manner of attacking social ills of all types in the decades before and at the turn of the century before the state took over welfare issues. Historically, Americans have exhibited a long-standing proclivity to join voluntary associations in virtually every city, town, and village around the country. What may be surprising, however, are the findings of a recent important study based on census records and city directories that concludes that in the second half of the nineteenth century, associational life was most vibrant, visible, and existed in the greatest numbers in small cities and towns in the West, not in the East. In this context, the high involvement of western Jewish women in benevolent organizations mirrors the general trend in the region and provides us with a better understanding of their prominence.[19] Because of the prevalent domestic ideology, charitable public service was an area to which women were thought to be particularly well suited. Jewish women in the West shaped the domestic ideal to their advantage, justifying the opening of new public doors as a natural extension of their accepted roles as wives and mothers. American women, in general, who engaged in charitable pursuits at the time were tied by several common factors, including a special interest in assisting women and children, an inclination to concentrate on areas often ignored by government and male philanthropists, and a desire to exercise responsibility and power.[20]

In cities throughout the West, Jewish women were in the forefront in charitable organizations. In addition to fulfilling religious imperatives and genuine altruistic sentiments, charity work developed leadership skills and self-confidence and built women's group identity. It was also often a vehicle for upward mobility, which may have served to elevate the social positions of the women involved in the local community. This

aspect of charitable work became more important at the turn of the century when the earlier, more fluid social structure in the West became somewhat more hardened (although still distinctly more open than in other regions), and Jews in some cities like Los Angeles were sometimes excluded from elite gentile social clubs they had helped found.[21] This situation was similar to what occurred in Cincinnati, where Jews had arrived in the city in the early nineteenth century when the town was still considered a western frontier outpost. Even though pioneer Jews there enjoyed a high degree of community prominence and economic and political success, later they were not welcomed as members in a number of social clubs.[22]

Similarly in San Francisco in 1879, when the city's Jewish population was about 16,000, the Jewish representation in the elite ranks was extraordinarily high, and members of the Jewish community commanded great respect for both their many voluntary organizations and business achievements. However, at the same time, the city's first *Elite Directory* was divided into two sections, one specifically offering listings for Jews. Inexplicably, prominent pants manufacturer Levi Strauss, a leader in the Jewish community, was one of two Jews who appeared on the gentile list.[23] Still, if we look at the degree of acceptance in relative terms, in comparison to Jews who were not included at all in social registers in other American cities, particularly in the East as in the case of Boston and New York, for example, Jews in San Francisco still enjoyed substantial status.[24]

Involvement in benevolent institutions and endeavors afforded both Jewish and non-Jewish women in the West the opportunity to assume influential public roles. As early as 1855, a small group of pioneer Jewish women in San Francisco banded together to help "the sick and needy women of the Jewish faith." Less than a decade later, in 1862, German-speaking Jewish women in San Francisco established the Israelitischer Frauen Verein, later Anglicized in 1901 to the Jewish Ladies' Relief Society, for the purpose of "visiting the homes of the poor, aiding women and children in poverty and sickness, and attending to maternity cases."[25] Within a short time, Jewish women's aid organizations in San Francisco would multiply from these early efforts. Hannah Marks Solomons is a prime example of an early Jewish woman in San Francisco who acquired public influence through philanthropy. Arriving in San Francisco in 1853, she rejected an early suitor and supported herself by teaching first at Temple Emanu-El's religious school and then as

a public-school teacher before serving as the only female principal in San Francisco at the time. The West clearly offered women many new opportunities for increased visibility through civic activism. After her marriage in 1862 to Seixas Solomons, she became involved in numerous Jewish and secular women's groups. By 1868 she served as the president of the San Francisco Ladies Fair Association of Temple Emanu-El, a fund-raiser to benefit orphans, and took a primary role in the founding of the general community's Women's Educational and Industrial Union of San Francisco, which served as an advocate for working woman. Hannah Solomons was also a supporter of women's education and suffrage.[26]

With San Francisco's comparatively large Jewish population, in 1869 its Jewish women initiated yet another female assistance group, the Hebrew Ladies' Sewing Society, to benefit Jewish widows and orphans by supplying linens and clothing. By 1909, fifteen Jewish women's groups were functioning in San Francisco, most of them devoted to social service.[27] In New York City, with its significantly larger population, sixteen Jewish "sisterhoods of personal service" were operating at the same time. While these latter organizations were specifically tied to synagogues, they, too, often focused on benevolent work that aided women and children. Undoubtedly, other non-synagogue-based Jewish women's associations existed in New York City at the same time.[28]

The charity work performed by San Francisco's Jews, including women, was recognized by the larger community as well. In an 1895 issue of the *San Francisco Examiner*, later reprinted in the city's *Jewish Progress*, the newspaper noted that the generous Jewish response to victims of a major fire proved "that there is no class of people in this charitably inclined city that is so ready to offer aid when money is needed as the Hebrews. Known to be good to their poor, aged and unfortunate, they have shown themselves always ready and willing to advance money or other aid for gentiles in trouble." The article particularly lauded the general philanthropic work of affluent local Jewish women, observing that "many a Hebrew lady of wealth and position can be found day by day going through the poverty-stricken sections of the city aiding those who need instant help and giving others an opportunity to better their condition in life." Jewish charitable work in the city was also praised as being quiet, unostentatious, and systematic, alluding to the professionalism that was beginning to characterize philanthropic work during the era. A number of Jewish women were singled

out by name in the article, including, among others, Mrs. F. L. Castle, a founder of the Mount Zion Hospital; Mrs. Louis Sloss, a director of the Golden Gate Kindergarten Association; Mrs. P. N. Lilenthal, president of San Francisco's Emanu-El Sisterhood; and Mrs. Ignatz Steinhart, vice president of the Jewish Alliance and staunch supporter of the California Children's Hospital.[29] As the wives of local Jewish businessmen and community leaders, these elite or upper middle-class women had the leisure and means to make philanthropy a major focus of their lives, and their prominence in local charity work also brought them recognition and respect in both the gentile and Jewish communities.

The women of Los Angeles followed a pattern similar to those in San Francisco. According to Virginia Katz, the first secretary of the local Ladies' Hebrew Benevolent Society, Jewish women organized the city's very first female benevolent group in January 1870 when the Jewish population numbered less than 350. They were led by western Jewish female pioneer Rosa Levy Newmark, who arrived in Los Angeles with her family in 1854. Rosa Newmark later helped raise funds for Los Angeles's first formal institution of higher learning, St. Vincent's College, which in 1918 became Loyola College. Once again, the primary goals of the Los Angeles group included nursing the sick, aiding the poor, and preparing the dead for proper Jewish burial. Mrs. Katz provides a contemporary view of the primitive or nonexistent health services, remarking that at the time "it was almost impossible to obtain nurses in cases of sickness." She also noted that although the society was "devoted exclusively to the women and children of the Hebrew faith," that "there has never been a public calamity where assistance was asked that the society did not respond," demonstrating the willingness of the Jewish women to address critical general community needs as well as providing a public way of demonstrating that they were behaving as good citizens.[30] In most western communities, Jewish women were most closely associated with other Jews but operated successfully in the broader American secular environment as well, where they generally found acceptance as recognized contributors to the growth of social stability and welfare.

In the even more modest-sized California town of San Diego, although a few Jewish men gathered for High Holiday services as early as 1851, not until 1890 did Jewish women found the Ladies' Hebrew Aid Society. Typically, their goal was providing "relief to the sick and needy, to rehabilitate families and to aid the orphan and half-orphans." The

primary impetus behind the founding of the organization was Mrs. Simon Levi, who served as the treasurer for thirty years, one of numerous early western Jewish women who devoted themselves to Jewish philanthropic endeavors. Another of the group's members later observed that the society had served as the central focus of Mrs. Levi's life and that "all the energy and the care that she had were put into her work."[31]

San Bernardino's Ladies' Hebrew Benevolent Society, which became the Henrietta Hebrew Benevolent Society in 1891, was named after the Prussian-born Henrietta Ancker, the main impetus and "prime mover" behind the organization's founding in 1886. The wife of Louis Ancker, a successful California merchant, Henrietta developed a citywide reputation for her work with the needy of all ethnic and religious groups. From its inception, the society concentrated its work in the Jewish community to aid tuberculosis victims, widows and orphans, and the aged throughout California, but also offered considerable local aid to San Bernardino's residents regardless of religion, race, or class. When Mrs. Ancker died in 1890, the local newspaper eulogized her as "one of the most charitable women in San Bernardino," who in an effective but quiet manner assisted the "poor and needy regardless of creed or color."[32]

The large number of women's benevolent groups in so many western towns and cities also reflects the high rate of illness and infant and maternal mortality and the heightened vicissitudes that marked life in new-frontier settlements. Although Rudolf Glanz has claimed that infant mortality among German Jewish families in the West was lower than that of the general population, he does not provide quantitative statistics to support his claim, and the stories of the women in this study suggest otherwise.[33] In the tiny Colorado Gold Rush town of Tin Cup, the Jewish section of the cemetery holds only six graves, all for small children from only two families who died between the years of 1882 and 1888. The youngest passed away at the age of twelve days, and the oldest was only five at the time of his death.[34] Moreover, in Los Angeles between 1854 and 1873, of the twenty-eight Jewish burials, twenty-five were for people under the age of twenty-one.[35] In the Gold Rush mining communities of California, deaths resulting from illnesses such as smallpox and cholera as well as childhood diseases, childbirth, mining accidents, natural disasters, and fires necessitated the establishment of a number of local Jewish cemeteries. Nevada City's Jewish cemetery is a

sad reminder of infant mortality at the time, and one family alone buried eight children in the small town.[36] As traditional nurturers, Jewish women frequently stepped in at critical junctures to fill the void for their co-religionists and often the community at large, nursing and tending to the sick, comforting mourners, and, when necessary, preparing the dead for burial.

Another notable aspect of western settlement was that frontier women, including Jewish women, were often left "on their own" under two sets of circumstances. As Jewish men in the American West traveled over long distances in pursuit of professional or business opportunities or to acquire merchandise, their wives often took over in their absence, as in the case of Anna Solomon, honing their own management and leadership skills. This experience may have been a factor in the active role Jewish women played in business in the West. However, widows, permanently left on their own, particularly those at lower economic levels, faced the prospect of more severe challenges and dislocations in a region that was less developed than other parts of the country. While a stable support system and autonomy within the culture were already in place for many Native American women, including the Hopi and Navajo, Spanish Mexican women and poor widows of Anglo ethnic groups including Jews often had to rely on an inventive combination of strategies such as assistance that included relatives, other women, limited work opportunities, and charity.[37]

The geography of the western region of the country as well as the diversity of cultures found there likely had an impact on widowhood, with women in southwestern states coping differently than those in the East or the South. However, common to all groups was the influence of women's previous economic situation, and, unsurprisingly, middle- and upper-class women were better protected.[38] Women with business experience and those who had been raised to lead a conventional domestic life were both often thrust into business following the death of a husband. The story of Regina Moch, a longtime Jewish resident of Eureka, Nevada, is a good example of a woman in relatively comfortable circumstances who could draw on her own business experience to successfully support herself after widowhood. When her husband was killed in a fire in 1879 and their restaurant was burned to the ground, within a matter of weeks the resilient Mrs. Moch reopened, advertising "Mrs. Moch's New Restaurant" and offering reduced charges for board and meals to attract new customers.[39]

It is no coincidence that the development of Jewish communal and religious life in Arizona lagged behind that of other western states and that relatively few Jewish women resided in the state before the turn of the century. As we have seen in other areas, while men gathered for holiday services in the Arizona Territory in Prescott, Tucson, and Phoenix as early as the 1870s, not until Jewish women stepped in was the state's first synagogue erected in 1910. Although an early attempt by men to form a lasting early B'nai B'rith chapter failed, in 1884 a small group of Jewish women established their own organization, a Hebrew Ladies' Benevolent Society, to aid "the needy in times of distress." The society provided aid to both Jews and gentiles, raising funds through social functions well attended by the broader local community.[40]

Therese Marx Ferrin became president of the Hebrew Ladies' Benevolent Association of Tucson in 1890 and played an integral part in the establishment of the first congregation in the Arizona Territory. In early Tucson, Therese Ferrin seems to have served as a voluntary nurse and "healer" and was nicknamed "The Angel of Tucson" because of her involvement with numerous secular as well as Jewish charitable endeavors and personally caring for the sick. Born in Frankfurt, Germany, she immigrated to America and was employed as a milliner in San Francisco before relocating to Tucson after her marriage to Joseph Ferrin.[41] It was Therese Ferrin who hosted a meeting of community leaders with the goal of organizing a congregation, personally spearheading fund-raising for the project, and it was the Hebrew Ladies' Benevolent Society that actually acquired land for a synagogue as well as a cemetery.[42] Therese and the other women in the society were following a western as well as national pattern. As one historian put it, "Men's benevolent societies governed synagogues but women's benevolent societies financed and supported them: women's earliest efforts aimed to pay off building costs."[43]

Like San Francisco, Denver was the site of rapid urban growth, with the result that social services took a back seat. Colorado was still an untamed wilderness when the discovery of gold near Pike's Peak in 1858 brought the area to the nation's attention. By the spring of 1859, fortune seekers began to arrive in droves and used the rival infant camps of Denver and Auraria as jumping-off points. Jews also took part in the quest, and during the "big excitement," as the year of gold discovery was called, at least twelve Jews of central European descent migrated to Colorado to join the hunt for freedom, new opportunities, and wealth. Most established small businesses in new towns and mining camps

throughout Colorado. Although services were held in Denver in 1859 for Rosh Hashanah, the plan to form a Jewish congregation in the same year in anticipation of "brethren who intend coming here next summer with their families" did not seem to materialize.[44] It is interesting to note, however, that following the general trend in the West, it is the arrival of *families* that prompted the plan. Although the Hebrew Cemetery Association was formed in 1860, it was not until a dozen years later, in 1872, that the Denver Lodge of B'nai B'rith was organized and in 1874 that Denver's Congregation Emanuel was founded, when the population had increased sufficiently to turn to the building of an organized Jewish community. As early as 1870, in the silver boom town of Leadville, Colorado, the Hebrew Ladies' Benevolent Society was organized to benefit the needy and raised money for charity through fairs and ice cream socials. In 1889, thirty-four women banded together in the small town of Trinidad in southern Colorado to form the Hebrew Ladies' Aid Society, and members provided mutual support in illness and need as well as raising funds to help support Temple Aaron and pay off its mortgage.

By the early 1870s, the railroad had brought Denver from the edge of civilization to a trip of only several days from San Francisco or New York. Denver Jewish women added to the town's stability and were at the forefront in creating a structure for communal care that encompassed the community as a whole. A Hebrew Ladies' Benevolent Society was organized in 1872, and Delphine Cohen was a founder and first president, having the distinction of being the first Jewish woman in Denver to hold an office in any organization. Born in Alsace-Lorraine in 1834, she immigrated to America with her family, arriving in Denver in 1870. A talented businesswoman as well as a devoted charity worker, Delphine Cohen resigned as president in 1874 to work full time in addition to caring for her four children.[45] Delphine Cohen's resignation opened the door to philanthropic involvement to a woman who, as we have seen, would have a profound influence on the development of benevolent charity work in Denver within both the Jewish and larger general community—Frances Wisebart Jacobs.

Frances Wisebart Jacobs's unswerving commitment to the sick and indigent and her amazing ability to work with men and women from a variety of ethnic and religious groups earned her the nickname of Denver's "Mother of Charities" as well as a national reputation. One of the most publicly visible early Jewish women of the West in the area

of philanthropy, Mrs. Jacobs drew upon the traditional Jewish involvement of women in communal charity and fused it with the organizational structure of secular women's groups. Her initial work with the Hebrew Ladies' Benevolent Society focused exclusively on her co-religionists, but she soon widened her scope to include all of Denver's needy, internalizing both Jewish values of *tzedakah* and the Victorian ideal of true womanhood. Although she had no formal training, she was the prototype of the early social worker, frequently making personal visits to those who were ill and poor, freely dispensing advice, medication, and funds. In Denver in the early 1870s, Frances moved in a direction that was considered part of the proper area of "woman's sphere" at the time, caring for the ill and impoverished. An articulate, forceful, and energetic woman, and a superb organizer, she was typical of many middle-class women of her generation whose comfortable financial situation allowed them the time to channel their talents into what was regarded as a suitable and respectable role for a woman—that of nurturer and healer. At the same time, these activities afforded women more public roles than had traditionally been available to them.

In 1900, when sixteen portraits of pioneers were selected to be placed in the windows of the dome of the Colorado state capitol building, Frances Wisebart Jacobs was chosen as one of the elite group and the *only* woman. Her niece later recalled, "Aunt Frank was that rare combination of dreamer and doer. She not only dreamed of free kindergartens and orphanages, a home for the aged and a hospital, but with good business sense brought them to reality."[46] It was precisely these qualities of vision and practicality coupled with intelligence, good humor, effective female social networks, and what today we call political savvy that enabled Frances to be successful in a variety of philanthropic enterprises, both in the Jewish and general community.

As a founder of the nonsectarian Denver Ladies' Relief Society and the organization's first vice president, Frances Jacobs worked alongside Margaret Gray Evans, the territorial governor's wife, and Elizabeth Byers, wife of *Rocky Mountain News* founder and editor William Byers. Through this society, Jacobs and her female co-workers were able to provide coal, furniture, and food for many of Denver's poor, often through donations from Denver merchants like her husband, Abraham. As a middle-class Reform Jew, her social position was undoubtedly enhanced by her philanthropic work, and in 1881 she was the only Jewish woman who was involved in organizing a major charity ball sponsored

by the society, considered Denver's major social event of the season. Through her leadership in both the Hebrew Ladies' Benevolent Society and the Ladies' Relief Society, Frances Jacobs became active in an effort to bring Denver's charitable organizations under one umbrella in order to eliminate duplication and foster a "scientific," rational, centralized approach to relief services. At the same time, she cultivated allies and used her influence to move her philanthropic goals forward, involving Rabbi William Friedman of Congregation Emanuel and leaders of other religious groups such as social gospel advocate Reverend Myron Reed and Father William O'Ryan. One newspaper noted that Frances Jacobs was successful in this effort because "she was widely esteemed by Jew and non-Jew, having made many friends by her noble, altruistic service to humanity."[47] As one historian has observed, in the West, for the most part, the prevalent "concern for social order crossed denominational lines with relative ease."[48]

Through her attendance at the National Conference of Charities and Corrections annual meetings that were held in different parts of the country, Frances acquired a national reputation. A friend later recalled that "at all those gatherings she was a leader, her enthusiasm, her earnestness and her ability receiving prompt recognition." In a farewell address at one of the conferences, Frances reflected on local progress in social welfare and maintained: "In philanthropy and reform we (in Denver) have made a good beginning. We have genuine impulses and our faces are set in the right direction."[49] During the last years of her life she campaigned vigorously and vocally on behalf of tuberculosis victims, particularly in the Jewish community, which answered her call to action. Although she approached local newspaper editors, politicians, and prominent businessmen for support, in this instance she was turned down because they were unwilling to publicize the tuberculosis problem, which they felt might damage Denver's public image. Fortunately, however, Rabbi William Friedman and a number of trustees of Congregation Emanuel took on the challenge, and the National Jewish Hospital, which opened formally as a nonsectarian institution, was the eventual result.[50] A recent study of religion in the West has credited Friedman with a central role in both the creation of Denver's early federation of charities, which evolved into the national United Way, and in the founding of National Jewish Hospital, but it almost ignores the critical roles Frances Wisebart Jacobs played in both projects as a primary initiator and worker.[51]

What is particularly interesting about Frances Jacobs's philanthropic work in early Denver is the seemingly easy access she had to local leaders. The West appears to have been an especially hospitable environment for Jewish women who were located in many cities, towns, and villages in apparent close proximity to the centers of power. Often through their husbands, fathers, or brothers, or even on their own, Jewish women were part of social networks that included local movers and shakers. In other words, Jewish women in the West, like Emma Goldsmith in Portland and Frances Wisebart Jacobs in Denver, may often have operated as insiders to a greater extent than women in the East. The involvement of Jewish women in benevolent groups was pivotal because it was frequently the stepping-stone to expanded roles in communal and religious influence, and in the arenas of education, politics, the professions, and business.

By the early 1870s, Frances Wisebart Jacobs was also an articulate voice that was heard in public venues, and her name frequently appeared in local Denver newspapers. When discussing her social welfare concerns, she was quoted in the *Rocky Mountain News* as saying, "I know that whenever women lead in good work, men will follow,"[52] inverting the conventional view that men provided leadership. She was also an outspoken critic of insensitive treatment of female prisoners and exploitation of poor working women through long hours and low wages. She publicly urged working women to unite in protest, and several years before women's suffrage was adopted in Colorado, she maintained that "if we [women] had votes in the coming elections we would secure what we want."[53]

In her memoirs, New York City's well-known social activist and educator Rebekah Kohut maintained that in the 1890s it was highly unusual for Jewish women to achieve public recognition, speak publicly, or organize activities: "To have opinions and to voice them was not regarded as good form even in the home. . . . But to have opinions and to speak them out in public meeting!"[54] Yet twenty years earlier in Denver, Frances Jacobs was already visibly involved in all those activities and commanded respect among men and women alike, suggesting that the West was a fertile ground for women in finding their own voices.

Frances Wisebart Jacobs died in 1892 at the young age of forty-nine, after she contracted pneumonia when visiting an indigent family whose members were sick. Her funeral was attended by nearly two thousand people from diverse ethnic and religious groups, and among many nota-

bles she was eulogized by Denver's mayor, Colorado's former governor, and the president of the Denver and Rio Grande Railway. The day after her funeral, the *Rocky Mountain News* reported, "She knew no creed or denomination when a cry of distress was heard."[55] The outpouring of emotion after her passing was a testimony not only to her impact on the development of philanthropy in early Denver but to the acceptance of Jews, including women, in the early West. Her approach also often presaged that of Progressive reformists. A tribute by a local Protestant minister noted that she was able to "interest the top of society in the bottom," and a resolution adopted by the Charity Organization Society after her death praised her as being "abreast of the times in new and scientific methods of charity work."[56]

The story of Frances Wisebart Jacobs is an appropriate one with which to end the personal stories in this chapter. In many ways, she served as a bridge between one generation of western Jewish women volunteers and the next, reflecting the growth of female leadership and responsibility. The legacy she left reached well beyond the local community. The president of the National Conference of Charities and Corrections termed her death "a national loss."[57] When National Jewish Hospital was finally opened in 1899, some years after her death, the mayor of Denver observed, "The dedication of the National Jewish Hospital yesterday was an event of no ordinary significance. It consummates a work begun years ago by one of Denver's noble pioneer women, Frances Jacobs. . . . Out of her efforts has grown an institution national in scope and dedicated to the humane and charitable work in which during her lifetime she so earnestly engaged."[58]

Beginning with the first women's Jewish benevolent group founded in 1819 in Philadelphia by Rebecca Gratz, the dense web of early Jewish women's aid societies in America reflected both the strength of Jewish kinship networks and the strong Jewish tradition of mutual religious responsibility for the less fortunate, particularly the biblical injunction to care for the needy, especially helpless orphans and widows. Throughout the country, Jews founded social welfare organizations to care for their co-religionists, propelled by religious values that emphasized aid not merely as an altruistic impulse but as an imperative of justice. At the same time, they undoubtedly wished to demonstrate that Jews were not a burden on the host society, but took care of their "own." In New York City between 1848 and 1860, at least thirteen Jewish associations were set up to aid women and orphans and another twelve were set up

for the exclusive purpose of aiding women. Jews in New York set up significantly more welfare associations than any other contemporary immigrant ethnic group in the city, including Germans, Irish, Italians, and Scandinavians.[59] Southern Jewish women were also active in Hebrew ladies' benevolent societies, particularly in small towns where, as in the West, the groups helped maintain Jewish identity and sometimes were instrumental in raising funds for synagogues. However, with the exception of some notable women and possibly in the area of business, they do not appear to have been as publicly visible in positions of influence as Jewish women in the West.[60]

While men were expected to move within the public domain and women within the "sphere" of their homes in the period between 1850 and 1880, historians have come to realize that the demarcation lines between the spheres were often dynamic and increasingly blurred.[61] However, as we have seen, charitable public service was an area in which women were thought to be particularly well suited, and this view was often asserted by women themselves. For example, the 1896 Annual Report of the Seattle Ladies' Hebrew Benevolent Society proclaimed, "The field of benevolence and charity is properly and virtually woman's."[62] Within the Jewish community, in particular, while upholding the ideal of Jewish women of valor, men and women were negotiating and redefining the definition of "women's place" in relation to gender ideals and communal responsibility.[63]

Because of the many challenges of life on the raw frontier, including the prevalence of boom-and-bust economic cycles, and because as early settlers they had no access to established resources, Jewish women in the West quickly banded together to offer aid. Sometimes, as in Los Angeles, they founded the very first women's benevolent society in a town. While providing charitable assistance, these women also extended their public roles, sometimes working together with men in the Jewish and general community to accomplish their goals. As one historian has observed, "For nineteenth century women, the characteristic form of political activism was participation in a voluntary association."[64] Similarly, in studying white middle-class Protestant women in San Francisco during the formative years between 1850 and 1870, Mary Ann Irwin has found that "the very newness [of the city] offered space in which benevolent women could influence community politics through pioneering social welfare programs."[65]

Viewing the subject from a sociological perspective, Susan Chambré

has pointed out that the volunteer activities of Jewish women in nineteenth-century America paralleled those of women's groups in the broader society yet exhibited particular Jewish distinctions. Jewish tradition obligated both women and men to fulfill the concepts of *tsedakah*, which viewed charity as an act of righteousness and justice, and *gemilut chasidim*, acts of loving kindness. Jewish values stressed the giving of both time as well as money. In addition, Judaism, as evidenced in Proverbs, emphasized the central vital role of the *eshet chayil*, the "Woman of Valor," in the area of philanthropy.[66] Moreover, religious historian Janet Wilson James has noted that "compared with women of other faiths, Jewish women appear to have worked more closely with men in charitable undertakings,"[67] a phenomenon that was certainly evident in the American West.

Jewish religious imperatives concerning communal welfare and charity have animated Jewish communities for millennia. Jewish women in the West incorporated these underlying concepts into their philanthropic endeavors, building vital community institutions in the process. As William Toll has noted, "In the new cities of the West, Jewish women had been, from their arrival, part of public philanthropy within and occasionally beyond their religious community."[68] However, I would argue that more than "occasionally" did western Jewish women enlarge their public roles into the general community compared to Jewish women in other parts of the country. In nineteenth-century Philadelphia, Rebecca Gratz and other women from Mikveh Israel founded the first Female Hebrew Benevolent Society. They exhibited leadership within their own philanthropic organizations, but with the exception of Civil War aid to wounded soldiers, the Jewish women of the city continued to focus parochially only on their co-religionists. By the turn of the century, Philadelphia Jewish women had "lost their primacy in local charity," partly due to the increasing professionalization of philanthropy and the changing image and position of women in society.[69]

Yet, at the same time, as we will see in the next chapter, many western Jewish women were just hitting their stride. Although their main goal was initially mutual aid, as time passed a growing number of Jewish women used their philanthropic experience and the prevailing American concept that charity was woman's work to their advantage in accessing professional roles and developing a niche in what has been termed "maternalist politics."[70] Indeed, historian Sara Evans has maintained that between 1890 and 1920, American women moved forward

to perfect what she has termed "the politics of influence" to merge the "republican claim of female citizenship with the maternal commonwealth."[71] Although their numbers in terms of relative population were modest, the number and scope of the organizations that early western Jewish women created rivaled and sometimes exceeded those organized by Jewish women in the East and in other parts of the country. One central factor that gave rise to their prominence is that in the small, new Jewish communities in the American West, Jewish women and men "were highly integrated within the larger society socially than within any other contemporary locale."[72] In their voluntary associations, "women found a way to shape community life and to influence American concepts of community responsibility and social welfare."[73] So, too, the many voluntary but formally organized associations created by western Jewish women were key in developing the social culture of the Jewish community as well as the West in general and served as an avenue to expanded public opportunities for Jewish women as they helped create institutions that enhanced public life.

3

From Generation to Generation

"Let us put aside our differences and work together for that which is our common desire—the arousing of the Jewish conscious-ness and the developing of ideal Americanism."[1] When Seraphine Pisko penned these words as part of an essay for Denver's *Jewish Outlook* in January 1906, as a prominent member of Denver's influential, accul-turated Jewish German Reform middle class, she was perhaps uncon-sciously reflecting the intersection of a number of major developments in the contemporary American Jewish community. Jonathan Sarna has described these trends, which began in the late nineteenth century, as having comprised a Jewish "Great Awakening," "characterized by a re-turn to religion, a heightened sense of Jewish peoplehood and particu-larly new opportunities and responsibility for women, a renewed com-munity-wide emphasis on education and culture, a burst of organiza-tional energy."[2]

Seraphine Pisko's remarks also reflected the prominent role Jewish women were playing in sustaining and shaping American Judaism and Jewish life. They were prompted by the growing numbers of east Euro-pean Jews who had begun to augment both Colorado's Jewish commu-nity in the 1880s and the American West as a whole. After the turn of the century, most visibly in larger cities such as San Francisco, Los An-geles, Portland, Seattle, and Denver, Jewish women's work in philan-thropy in the West, as well as in other parts of America, was increas-ingly directed to assisting, and not incidentally Americanizing, their new immigrant co-religionists. The reference to "ideal Americanism" dem-onstrated the value acculturated American Jews at the time placed on forging an American identity for themselves and the newcomers in which they could be viewed as full participants, contributing to the best interests of the nation as both Jews and Americans.

By the turn of the century, the climate of western states such as Arizona, New Mexico, and especially California and Colorado had

attracted hundreds and later thousands of predominantly poor east European Jews who had joined other Americans to "chase the cure" for tuberculosis, the leading cause of death at the time. Their arrival often prompted tensions, making class and religious distinctions more apparent between the established, assimilated middle- and upper-class German Reform Jews and the more traditional east European immigrants who might threaten their social status as well as tax existing communal funds.[3] While the primary reasons most German Jews had moved west had been to seek greater economic prospects, enhanced freedom, and adventure, the most frequent reason given among east European Jews for migrating to Los Angeles was poor health, followed by family reunification and economic opportunity. In 1900 the Jewish population of Los Angeles was about 2,500; after an influx of east European immigration by 1907, it had increased to 14,000.[4]

Fanny Jaffe Sharlip is a prime example of this phenomenon. Born in Russia, she immigrated to Philadelphia in 1889 with her parents and siblings, attended the local public grammar school, and at a young age began working in a sweatshop, where she contracted tuberculosis. After her marriage, Fanny and her husband, Ben Sharlip, moved to Los Angeles at the turn of the century in the hope that the California climate would be beneficial. They opened a grocery store, and with her improved health, Fanny became highly committed to social welfare activities and was especially sensitive to the needs of poor tuberculosis victims. Fanny later asserted that she made saving lives the central goal of her religious observance, and with a group of other dedicated women and men, she was instrumental in the creation of the tuberculosis sanatorium in Duarte, the nonsectarian Jewish Consumptive Relief Association of Southern California, which later became knows as the "City of Hope." She recalled that, at the time, the trip to Duarte involved several hours on the street car or train and a walk of several miles as well as the emotional distress of working with people so ill, yet "the devotion to the cause was indescribable . . . we lived and breathed the sanatorium. Our women took turns visiting once a week."[5]

Colorado attracted even more tuberculosis victims than California. A 1916 report compiled by the National Council of Jewish Charities concluded "almost from the earliest days of the opening up of the western country a constant stream of health-seekers has been pouring over the arid lands of Colorado, Arizona, New Mexico, and California. Among Jews, the migration of consumptives is largely due to the cities of the

West and Southwest, the goal of most of them being Denver."[6] Closely involved with immigrants at the National Jewish Hospital for Consumptives and Denver's Jewish immigrant settlement house, Seraphine Pisko struggled with trying to honor their cultural and religious traditions and acculturating them to American norms at the same time. Many years later she would recall of her work at NJH, "We taught Americanization before it became a national by-word."[7]

Born in St. Joseph, Missouri, and educated in American public schools, Seraphine Pisko spent most of her adult life in the American West and was representative of the second generation of Jewish women who had succeeded the pioneers. In her own family, her mother Bertha Eppstein and sisters were also involved in Denver communal affairs, and Mrs. Eppstein had served as one of the first presidents of the Hebrew Ladies' Benevolent Society. In 1878 Seraphine married prominent Denver Jewish businessman Edward Pisko, who was eighteen years her senior and headed a thriving liquor business. An Austrian immigrant who had been elected to the Colorado state legislature in 1876 and had served as president of Denver's B'nai B'rith in 1877, Edward Pisko was a leader in Denver's growing community. The American West provided a supportive environment for professional growth when Seraphine was left a widow just a few years after the marriage, and she went on to become one of the best-known and influential western Jewish women of the era.[8]

Committed to her Jewish roots and imbued with the Progressive-era spirit, which emphasized the potential of education and social reform and the efficacy of applying business practices to social services, Seraphine Pisko entered enthusiastically into a variety of charitable activities, some of them national in nature. These included serving as president of the Hebrew Ladies' Benevolent Society, which was renamed the Jewish Relief Society in 1901, and also as president of the local chapter of the National Council of Jewish Women (NCJW), where she helped to organize the Denver Jewish Settlement House and a free kindergarten to benefit east European immigrants living on Denver's west side. She resigned her position as vice president of the Denver section of the NCJW in 1900, probably because her new duties as a paid fund-raiser for the National Jewish Hospital were so time consuming.[9]

As scholar Sheila Rothman has pointed out, from the 1880s through the 1920s, "women played a vigorous and significant role" in the politics of American reform, particularly in shaping social policy toward

women, children, and the family.[10] Like women across the nation at the time, Seraphine Pisko and her western peers believed that through their efforts women could effect changes that would move society in a positive direction. Reflecting both the era as well as the inclusive atmosphere of the American West, which continued generally to welcome Jews, Mrs. Pisko's philanthropic involvement extended well beyond the Jewish community. In 1899, for example, she attended the National Conference of Charities and Corrections in Cincinnati, where she represented the influential Woman's Club of Denver.[11] While Seraphine Pisko received increasing recognition locally and nationally for her social welfare work and organizational abilities as the years passed, apparently she felt that her role as the second vice president of the national NCJW board in the early 1920s was undervalued because she hailed from the West. When she retired from her position, she complained that eastern colleagues in positions of power within the NCJW often left her "hanging on the ragged edge" and saw her as "an outsider," reflecting conflicts within the organization. It professed to be a national entity but tended to concentrate its power base in New York City and other large eastern urban centers.[12]

Although a number of religioethnic sanatoriums were established in Colorado around the turn of the century, such as the Swedish National Sanatorium for Consumptives and the Evangelical Lutheran Sanitarium, National Jewish Hospital (NJH, 1899), and the Jewish Consumptives' Relief Society (JCRS, 1904) were the first of these types of institutions. Moreover, NJH and the JCRS were both formally nonsectarian, although the majority of patients at both institutions in the first decades were east European Jews, and they were the only sanatoria in the state that treated *all* patients free of charge. The founding of NJH, in particular, served a dual purpose: it not only provided relief and assistance to the ill and impoverished, but also demonstrated that the city's Jewish community took its larger communal civic duty seriously. As a consciously nonsectarian institution, it was no accident that the first patient admitted to NJH in 1899 was a young gentile Swedish woman from Minnesota.[13] In this context, the hiring of Seraphine Pisko was an excellent choice, given her reputation in both the general and Jewish community as an experienced worker on behalf of social welfare. By November 1901, the *Denver Times* was reporting that an early fund-raising trip by her to California had met with great success. The article also pointed out that "Mrs. Pisko is well known in Denver as one of the most bril-

Seraphine Pisko seated at her desk at the National Jewish Hospital, c. 1920s. (Courtesy of the Beck Archives, Penrose Library, and CJS, University of Denver.)

liant and active members of the Woman's Club and the Council of Jewish Women, and as one of the most earnest philanthropic workers in the city."[14]

Similarly, the story of Ray Morris David, who often worked cooperatively with Seraphine Pisko on charitable projects and moved in the same social circles, illustrates the ways in which a voluntary role served as a stepping-stone to a professional position. At the same time it demonstrates how the influx of east European Jews expanded the need for more professionalized social work and often led to wider public roles for Jewish women. Although Mrs. David was born in Mobile, Alabama in 1864, she was the daughter of German Jewish parents and spent part of her childhood in Germany. Longtime friends, Ray David and Seraphine Pisko had much in common. She, too, moved to Colorado with her family as a teenager and attended public schools, and in 1885 married David David, a pioneer Jewish Aspen businessman. Ray David was

also left a widow at a young age, but with five children to raise and support. Like Seraphine Pisko, she was also an active member of both the Reform Congregation Emanuel and the National Council of Jewish Women and involved herself in the wider Jewish community, especially in immigrant settlement work and aiding tuberculosis victims.[15] By 1914, Ray David had been elected president of the Denver Section of the NCJW.[16] Finally, the arrival of east European Jews "established [American-born] Jews as a functional aristocracy,"[17] and both Seraphine Pisko and Ray David were accorded great respect in both the Jewish and the larger community.

In 1915, the Denver Jewish Aid Society was reorganized on a more professional basis, and Ray David was hired as superintendent to supervise relief activities. Before holding this position, Mrs. David had been employed by National Jewish Hospital as a quasi-social worker to assist former patients in finding jobs and housing and, when necessary, offering financial assistance, which was known as "outside relief." In her position at NJH, Seraphine Pisko was Ray David's supervisor and appears to have highly valued Ray's efficiency and interpersonal skills.[18] Moving forward from earlier Protestant-inspired models of "personal service," both Seraphine Pisko and Ray David were representative of a new generation of educated Jewish women who felt they could bring a new professionalism to ameliorating social problems and charitable endeavors, similar to what men were accomplishing in the emerging business environment. By the time Denver's Jewish Aid Society was organized in 1915, Ray David was already a leading figure in Denver society, had been appointed to the State Board of Pardons, and was named a member of the Denver Board of Charities and Corrections. The letter of nomination for the latter position described Mrs. David as having "wide experience in philanthropic matters, having worked many years in conjunction with scientifically organized charities, combined with her warm heart and keen intelligence, render [sic] her an ideal person to serve upon such a board."[19]

After Ray David's appointment to the Jewish Relief Society, she became known as the "Little Mother to the Poor" in Denver, and one local newspaper reporter observed that in this capacity "she attends to the wants, the needs and the aspirations of the unfortunate, the sick and suffering Jews, who are sent to Denver from all parts of the country. Her constructive policy has made her a national authority in this work."[20] The imagery of "Little Mother" reflected the new Progressive-

era definition of proper womanhood, which emphasized the model of "educated mother,"[21] and in Denver, Ray David was looked upon as an ideal example. Her involvement with philanthropic work in the Jewish community also cemented her prominence in Denver society and shaped her as a social and political reform activist. She supported many progressive reforms, including women's suffrage, humane treatment of the insane, penal reform, and the elimination of child labor. Active in the Denver Woman's Club, she campaigned vocally for local clean government, and her name appeared in a local newspaper article highlighting prominent attendees at a gathering addressed by national suffrage leaders. She also served as an active member of the executive board of the Denver School League, as chairman of the Child Labor committee of the Woman's Club, and as a delegate to the Children's World Peace Movement. Like Frances Wisebart Jacobs and Seraphine Pisko, she was on a first-name basis with many Colorado officials, including Colorado's senators.[22] Involvement in peace efforts in the years leading up to World War I was common among activist American women during the era, and Jewish women like Ray David were often highly involved in relief activities because of their special concern for Jewish victims in Europe.[23] Second-generation women as well as men in the region often "inherited" the esteem accorded to the earlier Jewish pioneers. Both Seraphine Pisko and Ray David were clearly perceived as Jews, but this appears to have been no barrier in the American West to receiving very prominent local and national recognition in the late nineteenth and early twentieth centuries, in contrast to the situation in the eastern and southern parts of the country, where anti-Semitism was on the rise.

The involvement by Jewish women, first predominantly among German Reform Jews, in the national women's club movement, which fostered the organization of philanthropic, social, and cultural interests by gender, was not only a western phenomenon. The first president of the National Council of Jewish Women, Hannah Greenbaum Solomon, had been the first Jew to join the elite Chicago's Women's Club and she was also a prominent figure in that city's Jewish community.[24] Men's clubs of the era were becoming increasingly restrictive, but although the secularized women's clubs may have exhibited racial and economic biases, they welcomed middle- and upper-class Jewish women who shared progressive ideals. Indeed, one early observer noted that the movement was determined to avoid religious and political difference "which separate and antagonize common interest."[25] As the story of both Seraphine

Pisko and Ray David demonstrate, "For Jewish women, the club movement served as a stepping-stone from parochial Ladies' Benevolent Societies to city, state, and national organizations."[26] It is interesting to note, however, that western women such as Hannah Marks Solomons in San Francisco and Frances Wisebart Jacobs in Denver were attracting public notice well before the growth of the secular women's club movement, for the Federation of Women's Clubs was organized in 1890, just two years before Mrs. Jacobs died.

The creation of the National Council of Jewish Women in 1893, an outgrowth of the Congress of Jewish Women at the Chicago World's Columbian Exposition, was a watershed in the increasing influence of American Jewish women in public life, including those who lived in the American West. Although the Jewish Women's Congress was not revolutionary, it helped set the tone for significant enlargement of the public role of women in American Jewish communal life. Educator Anne Ruggles Gere observes that women's clubs were indeed part of public life, "but as intermediate institutions located between the family and state."[27] The NCJW had its parallels in similar women's clubs created by white middle class Protestants, but the council also exhibited a distinctly Jewish dimension. In addition to increasing Jewish knowledge among American Jewish women, in part to promote a reaffirmation of Jewish tradition, as well as philanthropy and social welfare reform, a primary goal of the council soon became the Americanization of east European immigrants. However, according to historian Seth Korelitz, the organization personified "pluralist" Americanization, which allowed for some acceptance of the immigrant heritage in combination with acculturation to the American environment. Moreover, he has maintained that the NCJW was unusual in comparison to similar gentile groups in that it emphasized civic involvement for the immigrant women as well.[28]

The NCJW's commitment to a greater degree of pluralism undoubtedly stemmed, in part, to the ambivalence many German Jews felt about their east European co-religionists. As we have seen in the case of Seraphine Pisko, soon a prominent leader in the Denver section, the desire to Americanize the newcomers and eradicate "Old World" customs was tempered by a degree of appreciation for the immigrants' religious and cultural traditions and commitment to Judaism. It allowed for sometimes contradictory viewpoints. For example, in a 1905 publicity pamphlet for NJH, Seraphine claimed that the books immigrant patients read at the hospital helped to "disenthrall them from the narrowness of

their Ghetto view of life," yet in a 1906 editorial she wrote that she hoped that American Jews would be "inspired with some of the spiritual passion which glows in the breasts of these ardent Jews."[29]

At the 1893 Congress in Chicago, Carrie Shevelson Benjamin of Denver represented the Jewish community of the Rocky Mountain West and delivered a flowery oration titled "Women's Place in Charity Work." She is another concrete example of how participation in women's clubs propelled Jewish women into local, state, and even national prominence. Born in Prenn, Russian Poland, in 1861, as a child she immigrated to the United States with her family, and she was in her early thirties at the time of the Women's Congress. In addition to attending public schools, she entered Syracuse University in 1877 at the age of fifteen and graduated with a B.A. in 1881, the first Jewish woman at the school to do so. She went on to earn a Master's degree in 1884 and taught languages on the high school level in Syracuse for a time. Because of the very literate tone of her speech, with many references to traditional Jewish texts as well as English classics, it is likely that she also received a strong Jewish education. It is known that her maternal grandfather was a rabbi back in Europe.[30]

In 1890 Carrie Shevelson married Maurice Benjamin, who appears to have worked as a manager or a clerk in local Denver businesses. The couple had three sons, all born after Carrie Benjamin delivered her address in Chicago. Like Seraphine Pisko and Ray David, Carrie was a member of the Woman's Club of Denver and served as the chair of the Philanthropic Department. A proponent of advanced education for women as well as an articulate spokesperson on behalf of the needy, she was appointed to the Colorado Board of Charities by the state's governor. She also authored several published articles, including two titled "The Colorado Woman" and "The Education of our Girls."[31]

Carrie Benjamin's conservative speech in Chicago reflected the evolutionary rather than revolutionary character of the Jewish Women's Congress.[32] Maintaining that "Woman's fitness for the work of charity is emphasized throughout the old Hebrew writings," she went on to say that woman is "divinely appointed, and innately fitted" for philanthropic work. Her remarks mirrored continuing contemporary views of the perfect fit between women's innate personality, religiosity, and charity work. While women's suffrage would soon be a fact in Colorado, Carrie Benjamin concluded, "If woman must be an organizer, with all the influence which that implies, let her emphasize the fact at

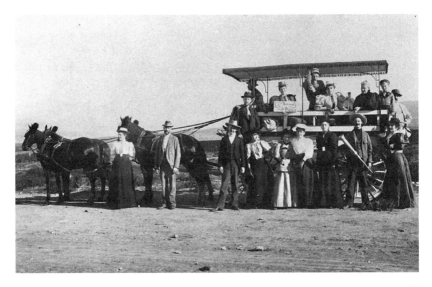

Denver Section, National Council of Jewish Women Kosher Picnic, c. 1895. (Courtesy of the Beck Archives, Penrose Library, and CJS, University of Denver.)

her meetings, clubs, and congresses, that woman's sphere may comprise, among other things suffrage, dress reform, and charity, but that the greatest of her duties is charity."[33]

Back in Denver, Carrie Benjamin helped organize the Denver chapter of the NCJW and became the organization's first president. Within a few years she also became the NCJW state vice-president for Colorado and chairman of philanthropy of the national organization. The membership of the Denver section at the time was the second highest in the country, exceeded only by that in Chicago.[34] In January 1897, a lengthy article by Benjamin titled "A Paper on Philanthropy" was published in the *American Jewess,* a periodical aimed at educated Jewish women, including many NCJW members. In her essay she stressed the principles of "scientific" charity and asserted that the aim of the NCJW was "ideal" charity, which included "personal service, and educational and industrial work." She also emphasized philanthropic work through venues such as "industrial schools, night schools, kindergartens, free baths, employments bureaus, lectures on sanitation, cleanliness, good citizenship," all of which were undertakings familiar to most NCJW women in chapters throughout the country.[35]

It was most unusual at the time for a Jewish woman of east European origin like Carrie Benjamin to take such a high-profile leadership position in the early NCJW. Faith Rogow, the author of the history of the national organization, has confirmed that the vast majority of the members of the group in the first decades after it was founded were elite wealthy women of German origin.[36] However, it is possible that because of smaller Jewish populations in the West and the more flexible social structure in the region, some east European–born women were accepted in prominent positions in the organization as well, particularly if they were well educated.

The national council initially emphasized Jewish renewal through Jewish self-education for women but later focused on social reform. While the NCJW officially shied away from approval of women's suffrage, many individual members were strong supporters. In her study, Rogow has maintained that the NCJW was innovative because until that time neither Jewish nor American culture had supported public speaking by women on important issues. As we have already seen in Colorado, however, a number of women held highly visible public positions locally, which in some cases became national in scope several years before the NCJW was founded.[37] It is possible that the early passage of women's suffrage in Colorado and in other western states fostered an environment that allowed Jewish women to assume influential public roles earlier than their counterparts around the country by raising political awareness. The national nature of the tuberculosis problem may also have helped to bring western Jewish women into national prominence through their discussions about health and philanthropy, while giving them contacts with leaders in other communities who sent local consumptives west to restore their health. While NCJW sections around the country shared many common goals, they also focused on a number of issues that related to their location and the size and specific needs of the local community.[38]

In Portland, Oregon, Jewish women involved in the NCJW were carrying out a parallel role as community activists. In an article published in 1905, prominent local NCJW member Blanche Blumauer claimed that the group "represented the best work of the Jewish women of Portland, and probably the best work of organized women in the State of Oregon. Organized in 1895 for self help and improvement, it has found its highest sphere in helping others." Blanche had served as an early NCJW president and was central to the establishment of Portland's

Neighborhood House, a variation of the popular settlement houses of the era, which offered educational classes in secular as well as Jewish religious subjects. Early NCJW members such as Mrs. Ben Selling, wife of one of Portland's leading Jewish philanthropists and businessmen, and Ida Loewenberg, a second-generation pioneer, also became critical in the development of the Jewish settlement. Here, too, issues concerning the relationship between the German and east European communities were of concern, and Mrs. Blumauer maintained that "through our monthly programs we have succeeded in bringing together the reform Jewess and her orthodox sister, giving to both a common interest in Jewish thought . . . and the Jewish woman's relation to the non-Jewish world."[39]

In Portland, the creation of an active section of the NCJW also opened a new door into the public arena. William Toll has stated that a major goal of the group was "to exercise public responsibility more equally with men," and that the city's NCJW was recognized "as the Jewish voice in civic issues." Moreover, as time passed, "The women simply eclipsed the men in their understanding and organization of welfare, and thereby gained a far larger civic role."[40] Toll has pointed out that Jewish settlement houses throughout the West were not founded by trained professionals but retained a Jewish character and were initiated by Jewish women who had longtime experience in benevolent societies. Those who emerged as "professionals" were part of the mainstream Jewish community.[41]

Such was the case of Portland's Ida Loewenberg, born to affluent and socially prominent Jewish immigrants from Posen and Bavaria, who played a role similar to that of Seraphine Pisko's in Denver at about the same time. In order to help support herself after family fortunes declined and her father died, Portland-born and educated Ida trained as a social worker in New York City. In 1912 she became the headworker—what we would today term the executive director—of Portland's Neighborhood House. Ida held this position for thirty-three years. Like Seraphine Pisko, she tried to respect the religious and cultural heritage of the east European immigrants while also acculturating them to America through English language and citizenship classes.[42]

The name "Neighborhood House" was suggested by Beth Israel's young rabbi, Stephen S. Wise, who later acquired a national reputation while in his pulpit at New York's Free Synagogue. The settlement began largely as a vocational training center but expanded to provide Ameri-

canization programs and social activities. One contemporary observer remarked that on entering the settlement, "One not only gains the spirit of democracy, but finds friendships and also an optimistic spirit. This democratic spirit is due to the hard and sincere work of the head worker [Ida Lowenberg]." Writing in an annual report issued nearly a decade after she was hired to head Neighborhood House, Ida maintained: "Thruout [*sic*] the years we have stressed the spirit of Jewishness, hospitality and kindness, and have now the joy of knowing that the House is indeed the cherished center for all neighborhood activities and organizations, the social and recreational oasis, not alone for the young people, but for the older men and women as well; in truth an institution promoting systematic Jewish and moral training, besides departments in art, science, English, civics, and athletics."[43]

Ida Lowenberg pointed with special pride to the success of Neighborhood House's English department and its "classes for foreigners," which provided "first aid" as a pathway to acculturation for "learning the new language he also learns to love his country." Ida also focused on the gratitude exhibited by the east European immigrant women who often encountered here their first opportunity to read and write in *any* language. In an attempt to sustain Jewish religious identity among the children of the immigrants, Hebrew, Sabbath, and Sunday Schools were operated cooperatively with the settlement. Ida viewed the religious schools as a bulwark against the materialism and preoccupation with business exhibited by many Jewish men and hoped that for the youth "here are sowed the seeds of religion which may be carried into their old age."[44]

In 1909, the Los Angeles section of the NCJW was founded by "fifteen women representing the 'best' families in the small, closely knit Jewish community," with the typical goal of "carrying on a planned program of philanthropy and self improvement." Moreover, the new group hoped to strengthen the relationships between local Jewish women and work on behalf of Judaism and social reform using the "best philanthropic thought." These women were inspired by the prevailing Progressive Era thought on scientific charity, and they reinvigorated a local Jewish settlement house by focusing on educating immigrant children both in their Jewish heritage as well as in American social mores. For example, the early NCJW yearbook proudly pointed both to lessons in cleanliness and to the story of Passover for its young charges. Within a short time, NCJW leaders hoped to encourage "every Jewish woman's

interest in public welfare."[45] In their Americanization efforts, their tone often appeared moralistic. They described the homes of many Jewish immigrants as places "where chaos reigns supreme," and they hoped to lay the foundation for proper "moral training" in an up-to-date nursery school for the children of working mothers.[46]

As time passed, the Los Angeles section of the NCJW carried out acculturation programs through the formal Immigrant Aid and Americanization Department. Beginning in 1919, Jewish female field workers, most of them university educated, were directed by social worker Jeanette Wrottenberg. The Los Angeles chapter was composed primarily of middle-class assimilated Reform Jewish women, and their social and religious values undoubtedly influenced their interactions with the east European immigrant women and at times could appear condescending. Writing in a local Jewish newspaper, one NCJW member maintained that through "sympathy and understanding . . . our American customs are translated and interpreted to the bewildered ones."[47]

Although east European Jews settled in many Washington Territory and State cities such as Spokane, Olympia, and Tacoma between 1880 and 1910, most of them called Seattle home. Once again, Babette Gatzert, wife of Seattle's first Jewish mayor, was involved in organizing voluntary associations, this time in the founding of the city's section of the NCJW in 1900, primarily composed of Reform Jewish women who had the leisure time available to engage in "friendly visits" to the sick and bereaved. Links among Jewish women in the West were not uncommon, and Seattle's Settlement House was organized at the prompting of Portland's Blanche Blumauer. Opened in 1906, the Settlement was envisioned as an instrument of social reform to aid poor immigrants in becoming productive American citizens. The role of Jewish women in the development of the Settlement was well recognized locally, and when a new building was erected in 1916 at a cost of $30,000—containing six classrooms, a library, kitchen, club rooms, and a large meeting hall—a local newspaper praised it as "a monument to women's energy."[48]

A historical survey of the Seattle Settlement House, written many years later, claimed that "the new immigrants were always very eager to learn the American way of doing things. They did not want to hold on to the old ways."[49] But was this the authentic view of the immigrants themselves or the reformers who were intent on acculturation as they worked to transform the newcomers from foreign "others" to "white" ethnic Americans?[50] Recent scholarship has suggested that across the

nation, the overriding intent of professional settlement workers was Americanization and that immigrant culture was celebrated only as a temporary means to accomplish that goal. This was the case in Philadelphia's Jewish settlement house, where the first headworker had a long association with the College Settlement and the National Association of Settlements, which had been inspired by Protestant social gospel models. She and her successors tried to move the focus from a "Jewish" settlement to a multiethnic one. According to historian Elizabeth Rose, in Philadelphia along with English classes came "the implicit message that, in order to prosper in America, the immigrants had to remake themselves from the inside out, using as a model the German-Jewish Americans who had preceded them."[51] However, this phenomenon appears to have been muted somewhat in the American West, where early Jewish settlement heads were largely drawn from a group of Jewish women who had long experience in benevolent work but were not heavily steeped in the culture of the settlement movement and its distinct Protestant roots.

Like settlement houses in Denver, San Francisco, Los Angeles, and Portland, Seattle's version provided classes in English, sewing, religious and citizenship instruction, and visiting nurses.[52] It is interesting to note that in contrast to these western cities, in Philadelphia the local NCJW concentrated on education and "contributed little to local philanthropy."[53] As was the case in Philadelphia, the NCJW section organized in Buffalo, New York, in 1895 focused on self-improvement and political activism, but by this time Buffalo Jewish women already had a highly developed charitable network and had organized Zion Settlement, one of the earliest American settlement houses, in 1891. Enormous immigrant population increases in Buffalo between 1880 and 1890 had made social welfare issues especially critical in the city and were probably a main factor in the unusually early involvement of these northern Jewish women.[54]

Regarded by some as the "greatest cultural leader that California Jewry produced in the early twentieth century," largely for her visible role in San Francisco society as a patron of art and literature and a founder of the opera and symphony associations, Hattie Hecht Sloss was also a leader in San Francisco's Jewish community through the local section of the NCJW and the Emanu-El sisterhood. Born and educated in Boston, she arrived in San Francisco in 1899 as the new bride of attorney Marcus Sloss, later a California Supreme Court Justice.

Marcus's father, Bavarian-born Louis Sloss, had arrived in California in 1849 and was an early partner in the successful Alaska Commercial Company.[55]

Hattie Sloss was one of a number of prominent female members of San Francisco's "first Jewish families," sometimes referred to as "The Gilded Circle." Composed predominantly of affluent German Jewish Reform Jews, which included Hannah Gerstle, Delia Fleishhacker, Corrinne Koshland, Sophie Lilienthal, and Rosalie Stern, among others, many of the women were highly visible in social and communal affairs, and marriages among the group often cemented business as well as social connections. For example, Rosalie Meyer, born into a pioneer Jewish California family, married Sigmund Stern, the nephew and heir of Levi Strauss, head of the famous and successful jeans company.[56] Rosalie became a prominent member of San Francisco civic life as an active member of the Red Cross in World War I, president of the San Francisco Playground Commission, and as the benefactor of Stern Hall, a women's residence building at the University of California at Berkeley and the donor of San Francisco's Sigmund Stern Grove outdoor theater.[57]

Hattie Sloss appears to have been more involved in Jewish causes than Rosalie Stern. For example, Hattie attended the organizing meeting of San Francisco's section of the NCJW, which was prompted by a visit from the council's national co-founder Sadie American, and Hattie was elected the founding president.[58] During its earlier years, the section stressed Jewish education as well as philanthropy and civic responsibility. Like so many upper-class Jewish women across America, Hattie Sloss was also prominently visible in the general community in work with the American Red Cross, the Community Chest, the Bay City Associated Charities, and the California State Board of Charities and Corrections. Even in the increasingly class conscious upper-level society of San Francisco at the turn of the century, her clear visibility as a Jew was no bar to her acceptance in prestigious secular organizations. For pioneer Jews and their descendants, religious discrimination in the West was minimal until the short-lived era of the Ku Klux Klan in the 1920s. This phenomenon of acceptance was commented upon in an 1896 article in New York's *The American Jewess,* which observed of San Francisco's Jewish women: "She keeps pace with the world's advancement equally with her sisters of other creeds. Of course in the charities of their own people, they are . . . deeply interested. . . . But it is not only for their own people alone they labor, but with broad-minded liberality,

they are active in the most important societies that bring relief to the needy of all classes."[59]

Not surprisingly, much of Hattie Sloss's work in the NCJW centered on aiding new east European Jewish immigrants, and she chaired the local council's immigrant aid department for fifteen years. Hattie Sloss also became the founding president of San Francisco's Hadassah chapter in 1917 (but later became a leading member of the city's anti-Zionist American Council of Judaism) and acquired a national reputation as a social worker, largely because of her experience with settling immigrants. In this capacity she was asked to serve as a member of the board of directors of New York City's training center for Jewish social workers.[60]

East European Jews in the West were not only recipients of women's philanthropy, however. They soon became the dispensers as well, sometimes forming their own organizations. In Denver, two east European immigrants soon rivaled their German Jewish counterparts in visibility and influence, perhaps reflecting the more flexible paths still open to immigrants in the West. Both Anna Hillkowitz and Fannie Eller Lorber emigrated from Russia to America as children. Although both were acculturated and became Americanized, they had a special affinity for their east European co-religionists and both spoke Yiddish fluently. Because of the significant migration to Colorado of Jewish tuberculosis patients at the turn of the century, the dynamic of philanthropy was changed in the Denver Jewish community. At first it put a strain on the resources of the small established German Jewish community of less than two thousand that already existed. Within a short time, as the stories of Anna Hillkowitz, Carrie Benjamin, and Fannie Lorber demonstrate, some of the east European Jews challenged the leadership positions of German Jews as they became more financially secure and upwardly mobile.

Anna Hillkowitz was born about 1880, the daughter of Rabbi Elias (Elya) and Rebecca (Hindel) Hillkowitz. The family moved to Denver in 1890 because the climate was thought to be beneficial for Rabbi Hillkowitz's asthma condition. After Anna graduated from East Denver High School in 1897, she entered library school and later found a job as a librarian with the Denver Public Library, probably the first Jewish woman of the era in Denver to enter that profession.[61] Education and community involvement were highly valued in the Hillkowitz household, and Anna was considered an intellectual bluestocking. She was

Founders of the Denver Jewish Sheltering Home, c. 1910: Sadie Francis appears at far right, with Fannie Lorber to her immediate left, and Bessie Willens is third from left. (Courtesy of the Beck Archives, Penrose Library, and CJS, University of Denver.)

also an active member of the Young Women's Jewish Alliance as well as the Denver section of the NCJW. Although the council is thought to have been a stronghold of the German Reform elite, in the more open West it appears these boundaries were more fluid, as the prominence of Anna Hillkowitz and later Fannie Lorber demonstrate. By 1909 Anna Hillkowitz was on the lecture roster for the organization, and was also a member of the program committee at the time that Seraphine Pisko and Ray David served on the executive board.[62]

Anna Hillkowitz first volunteered and then went to work for NJH's rival institution, the Jewish Consumptives' Relief Society (JCRS), founded and supported generally by east European immigrants of modest means. Leaders at the JCRS included Anna's brother Dr. Philip Hillkowitz, who served as the organization's president from 1904 to 1948, and Dr. Charles Spivak, another Russian immigrant who was well known in Colorado's medical community. Spivak's wife, Jennie Charsky Spivak, was formally listed as one of the three legal incorporators of the JCRS, along with Rabbi Hillkowitz and Abraham Kobey, also an east

European immigrant. Jennie often traveled around the United States speaking on behalf of the institution, and when she died at the age of ninety-six in 1965, her obituary noted that "she and her husband had made [the hospital] famous throughout the world."[63] Anna Hillkowitz's brother, Dr. Hillkowitz, often served as the spokesman for the fledgling sanatorium and maintained that NJH lacked not only a kosher kitchen but a "Jewish heart," emphasizing the JCRS's more traditional Jewish environment and the rejection of scientific charity. He also referred to the "breezy, Western species" of democracy that he said pervaded his institution in contrast to the NJH's more authoritarian management style.[64]

Dr. Hillkowitz's remarks reflected the national tensions between German and east European Jews. In Denver specifically, east European Jews often criticized the German Jews for lacking Jewish compassion and being overly concerned with bureaucratic rules and regimentation. This focus turned charity into a "business" and contributed to the lack of observance of traditional Jewish rituals. German Jews, on the other hand, viewed their east European brethren as old fashioned in their religious observance and as inviting disaster by indiscriminately allowing even critically ill patients in the last stages of tuberculosis from across the country to enter the JCRS. For example, in the Denver *Jewish Outlook* of April 1904, Rabbi William Friedman of Congregation Emanuel, a leading supporter of NJH, criticized the rival sanatorium's policies. "The appeal of the JCRS," he wrote, "extends an open invitation to the Jewish communities of the United States to send their penniless consumptives to Colorado. . . . The society cannot possibly benefit the incurable consumptives and is a dangerous menace to Colorado."[65]

Even before the JCRS formally opened, Anna Hillkowitz was closely involved with the organization as a volunteer, helping to collect furnishings for the early patient tent-cottages and serving in the first year on the JCRS Instruction and Recreation Committee. In 1906, she took a leave of absence from her position on the staff of the Denver Public Library to become a traveling "field secretary" or fund-raiser for the JCRS, before resuming her library job sometime in 1907. Anna's position at the JCRS was similar to Seraphine Pisko's early work at the NJH. As a paid employee she earned as much if not more than her male counterparts, for at the time her salary was about $200 per month, whereas another fieldworker, a Mr. Dolitsky, was earning only $150.[66] During her first six months on the job she visited over forty cities to

solicit contributions for the JCRS, speaking before women's groups, fraternal orders, and at federations and local synagogues. In early 1906 she wrote her supervisor, Dr. Spivak: "In the cities I visited I found that the German Jews and the Russian Jews do not and will not unite for any cause not even for the sake of charity. . . . It is deplorable that there is such a gulf and especially that it won't be bridged even for the cause of charity."[67]

Anna Hillkowitz's analysis of the interaction between German Reform and east European Orthodox Jews in the area of philanthropy reflects the complexity and ambivalence we have seen that characterized the relationship between the two groups. As an acculturated and Americanized east European immigrant, she was uniquely positioned to comment and obviously found mutual cooperation often lacking. Yet, as we have seen in Portland, Blanche Blumauer maintained that benevolent work was an opportunity to unite the two groups. In finding the glass half empty or half full, opinions were undoubtedly colored by religious affiliations, class, and ethnic backgrounds. For German Jews like Blanche, philanthropy through settlement work could be viewed as a positive, uplifting experience for immigrants and a vehicle for "bringing together the reform Jewish and her orthodox sister,"[68] while for east European Jews like Anna, Reform Jews could appear as uncooperative and insensitive.

On the advice of Dr. Spivak, who was influenced by socialist ideology, Anna concentrated on collecting numerous small donations rather than approaching the wealthy individuals who had been the key to Mrs. Pisko's fund-raising success for NJH. The JCRS was one of the first successful examples of a national institution organized and funded primarily by east European Jews for their fellow co-religionists. Anna Hillkowitz was particularly adept at approaching this group. She was often called on to speak, as in St. Joseph, Missouri, where she "spoke in Yiddish in *shool* (synagogue) [*sic*]."[69] While Anna was admired as an educated American woman, the ability to speak to the east European Jews in their own language undoubtedly generated a feeling of kinship with the people in her audience and encouraged their financial support.

The JCRS provided a professional employment opportunity for a woman from California as well. In 1909, Anna Jacobson Myers, who had been born in Vienna in 1866 into a traditionally observant family, became a fund-raiser for the organization in eleven western states. Anna met her future husband, Rabbi Isidore Myers, in Australia, where both

of their fathers served as pulpit rabbis. Anna and Isidore, who was born in Poland, married in 1897, and the couple lived first in San Francisco and then moved to Los Angeles, where in 1906 Isidore became the founding rabbi of a new, modern, conservative synagogue. Meanwhile, Anna became actively involved in the Jewish community among the more elite group of predominantly Jewish Reform women as the founding vice-president of the Jewish Women's Relief Association, which provided assistance both to Jews who were being persecuted in Russia and to new east European Jewish immigrants, primarily children, arriving in Los Angeles.[70]

The impact of the White Plague, as tuberculosis was commonly referred to, was felt in several western states, including California, and Anna Myers also became involved in both the Hebrew Consumptive Relief Society, which had the support of many powerful Jewish women in Los Angeles, and the Jewish Orphan's Home of Southern California, which housed a number of the children whose parents had succumbed to the disease. Los Angeles also supported two other local institutions for victims of tuberculosis, including the Kaspare Cohn Hospital (later a general hospital known as Cedars of Lebanon), and the Southern California Jewish Consumptive Relief Association, which established a sanatorium at Duarte, the "City of Hope." In addition, Anna Myers devoted time to the Hebrew Ladies' Benevolent Society and the Willing Hands of Sinai Congregation as well as secular charitable groups like the Associated Charities, the Humane Society, and the Mother's Circle.[71] Anna's voluntary positions had provided her with valuable experience in organizing, fund-raising, writing articles, speaking in public, and working with both assimilated upper-class Reform Jews and east European traditional immigrants. All these skills undoubtedly helped her to fulfill her new job description, for when she was hired in 1909 by the JCRS, she was described as an "exquisite blend of piety and purity of the old generation and the culture and refinement of a modern member of the Jewish Women's Council."[72]

For a period of about five years, Anna Myers traveled throughout the West, appearing largely before Jewish groups. Here she addressed potential supporters of the JCRS at synagogues in cities such as Las Vegas, New Mexico, Trinidad and Pueblo, Colorado, Helena, Montana, and Portland, Oregon, all apparently with great success. In Pueblo she was reported to have addressed the Reform congregation in English on Friday night and the Orthodox congregation in Yiddish during the

Sabbath day.[73] After retiring from the JCRS, she worked for several years as a social worker for the Los Angeles Federation of Jewish Charities and was elected president of the Los Angeles National Council of Jewish Women in 1913, which attested to her wide acceptance among the social elite. In 1911, the leaders at the JCRS had already noted her social connections and commented, "Our Mrs. Anna Myers is our great recruiting agent in the Northwest. Only a few days ago she won the hearts of the Jewish community in San Francisco where, under the patronage of the most prominent ladies a benefit performance was given for the J.C.R.S. . . . from which about $1,500 was realized."[74]

Though German and east European Jews in Denver sometimes clashed over the work of the two Jewish tuberculosis sanatoriums, they were apparently able to unite when the cause was dependent children. Fannie Lorber, in her work with the Denver Sheltering Home for Jewish Children, frequently served as a bridge between the groups. Using imagery that was popular among contemporary female social reformists, she often pointed out that "The cause of the child is the cause of humanity. In the tradition of Israel, the cause of the underprivileged child has been placed at the head of every charity and philanthropy."[75] Fannie Eller Lorber was born in Geishen, Russia, a small shtetl near Odessa, in 1881, and her family immigrated to America in the early 1890s, spending a short time in Portland and St. Louis before settling in Denver in 1896. Like the Hillkowitz family, the Ellers first settled in the east European enclave in the West Colfax area of Denver. There, Fannie Eller was exposed regularly to the plight of tuberculosis victims who were awaiting admission to one of the two Jewish tuberculosis hospitals, and their children, for whom they were often unable to care. In 1902, Fannie married Jacob Lorber, a Hungarian immigrant who operated a successful shoe business in downtown Denver. "Jake" Lorber later served in the state legislature, and the couple raised two sons.[76]

In 1907, Fannie Lorber and her close friend, fellow immigrant Bessie Willens, along with a small group of women in the West Colfax area, founded the Denver Sheltering Home for Jewish Children. It opened in a rented house the following year, with eight children and a matron. Around the turn of the century, a host of privately founded orphanages dotted the Denver landscape, several directed by Catholic nuns or Protestant middle- and upper-class women to benefit and "uplift" working-class children. Primary goals of the Sheltering Home included providing a Jewish environment for Jewish children and removing them from the

Fannie Lorber at the groundbreaking of the Lorber Building at the Denver Sheltering Home, 1937. (Courtesy of Beck Archives, Penrose Library, and CJS, University of Denver.)

proselytizing influence of Protestant and Catholic institutions, as well as demonstrating that Jews "cared for their own."[77] Most of the neglected children who entered the "Home" were not orphans in the strict sense of the word, but were placed there because one or both consumptive parents were temporarily unable to provide necessary care. The Sheltering Home served only kosher food and operated along Orthodox lines in the early years in regard to Jewish holidays and religious observances. Mrs. Lorber, who became a cultured and articulate woman, was the popular choice as president, an office she would hold for over fifty years until her death. Because of her favorable financial circumstances, she chose to stay involved on a voluntary basis.[78]

In a study of Jewish orphanages in the East and Midwest that focused on Philadelphia, New York, and Cleveland, historian Reena Sigman Friedman stressed that Jewish female founders and leaders in these cities were drawn largely from the more affluent "uptown" German Jewish community and were soon displaced by men.[79] However, while influential men were included as board members, women at Seattle's Shelter Home and Denver's Sheltering Home for Jewish Children were clearly in control. Moreover, Fannie Lorber was herself an east European immigrant and was far from a mere figurehead over her fifty years as president of the growing organization. Even as a volunteer, Fannie Lorber

commanded a prestigious presence both locally and nationally. In 1909, Fannie Lorber's name appeared for the first time as a member of the Denver Section of the NCJW, and in 1911 both Fannie Lorber and Seraphine Pisko were listed as members of the council's philanthropy committee.[80] Despite her immigrant origins, as an astute fund-raiser Mrs. Lorber certainly realized the potential for monetary donations from the more affluent Jewish women of the German community and the advantages of tapping expanded female philanthropic networks. In this, she was closer to Seraphine Pisko's model of raising funds than that of Anna Hillkowitz. As the years passed, the Sheltering Home provided not only food and shelter, but educational resources and religious and moral guidance to insure that the children would become "model" citizens and productive members of society as well as good Jews. This approach reflected the philosophy of most child welfare reformers in the early years of the twentieth century who often exhibited an interest in social control combined with more altruistic intentions.[81]

Mrs. Lorber had absorbed Progressive Era values as well as Jewish traditions, which contributed to her national reputation. At first, funds to sustain the Sheltering Home were raised only locally, but by 1920 it was decided that the institution needed to become "national" in scope as most of the children came from cities throughout the United States. Mrs. Lorber was soon dispatched to New York, where in short order she opened a local office, hired fund-raisers, and began establishing ladies auxiliaries in major cities around the country. Her business and organizational talent became legendary, and before her death the network of women's auxiliaries she had help create boasted over 100,000 members nationally. An administrator who later worked with Mrs. Lorber recalled, "Whatever Fannie wanted, Fannie got. . . . She was a very dynamic person, even though she spoke with a heavy accent."[82] Despite the Yiddish accent, she continued to speak effectively before large audiences for half a century. The Sheltering Home eventually evolved into the renowned Children's Asthma Research Institute and Hospital (CARIH) before ultimately merging with National Jewish Hospital. Fannie Lorber's pivotal role in Denver philanthropy not only provided aid to those in need, but gained her a public role of national prominence and elevated her social standing at home.

While some of the east European Jews did become active members of the NCJW, many were drawn to Hadassah, the second-oldest national Jewish women's organization. Founded in New York in 1912 by activist

and educator Henrietta Szold, the Zionist organization combined the Jewish emphasis on social welfare with the ideology of Zionism. In chapters throughout America, Jewish women, largely drawn from the middle class and practicing a more traditional form of Judaism, gathered to support medical services and educational activities in Palestine. In Denver, for example, Jewish women organized a local chapter in 1915. By 1918 the membership reached two hundred, and by 1948 it had grown to eighteen hundred. Belle Kauvar, wife of Vilna-born Rabbi Charles Kauvar, also an ardent Zionist and spiritual leader of the traditional Beth Medrosh Hagodol Synagogue, was an early leader in the Denver group. San Francisco's chapter was spearheaded by Rose Rinder in 1917. It supported the Jewish relief effort during World War I by supplying clothing for soldiers through its Sewing Circle and raising funds to provide medicine to settlements in Palestine. In Portland, Paula Lauterstein, wife of a Russian immigrant, served as Hadassah's first president in that city in the 1920s, and in 1927 the group raised $5,000 to endow a bed at the Hadassah Hospital in Jerusalem.[83]

As we have seen, many of the early Jewish women who had been involved in philanthropy were drawn from a prosperous middle class, mostly of German Reform background. The arrival of a significant number of east European immigrants, however, changed the dynamics of the Jewish community, both in America and specifically in the West. The focus of charitable work shifted from mutual aid to emphasize assisting the new immigrants. But ironically, as some of the earlier reformists had hoped, public school education often became the great leveler, thrusting both American-born and foreign-born but American-educated younger women such as Anna Hillkowitz and Carrie Benjamin and their families into professional and business success and into the mainstream of leadership. The second generation of Jewish women built upon the foundations laid by the pioneer generation and expanded and updated the benevolent work of their mothers. As William Toll has noted, "In Western cities where Jewish women had had public prominence during the pioneer generation, sisterhood and council work provided an opportunity to modernize rather than create the Jewish woman's public role."[84]

A study of turn-of-the-century Jewish clubwomen in Atlanta, Georgia, concluded that southern Jewish women "established organizations with non-Jewish women at surprisingly early stages in their club development, a move rarely paralleled in the North," yet others have

observed that in New York City sisterhoods at about the same time moved women's benevolent work into the public sphere.[85] Similar to the conclusions drawn in the study on Atlanta's Jewish women, historian Karla Goldman has theorized that "it may have been in the South, where numerous communities first organized themselves and built synagogues in the decades after the Civil War, that Jewish women were able to have the greatest communal impact."[86]

However, an examination of Savannah's Jewish women during the same period found that, partly because of the small Jewish population of the city, they were "heavily influenced by southern cultural patterns," which emphasized female docility and dependence. Although Savannah's Jewish women helped to foster Jewish identity in the home, there were "few public opportunities" for them, although the foundation of the local section of the NCJW in 1895 brought moderate gains.[87] Similarly, a recent study of South Carolina clubwomen at the turn of the century, which examined both white Protestant middle-class and elite white women as well as black clubwomen, found that women's clubs in the South generally lagged behind their peer groups in the North by decades. Furthermore, even though the clubs offered white southern women a window of opportunity, their efforts to exert public influence and effect social reform were often constrained by traditional southern notions of ideal womanhood and the need to recast the Confederate past in a more positive light. Additionally, African American women had to contend with stereotypes about black womanhood as well as race oppression. In other words, as historian Joan Marie Johnson points out, location had a profound influence on the lives of southern women. These women did expand their public roles slowly, but "at the turn of the century, changes in women's roles threatened the long established social order in the South, based on a hierarchy of race and sex." Even elite white clubwomen in South Carolina bent on educational reform received little support from conservative male politicians who resisted their attempts to exert political influence.[88]

Although Jewish women in the West also utilized benevolent organizations and, later, club work as a base for extending their public influence,[89] western Jewish women appear to have interacted in voluntary associations with their non-Jewish counterparts earlier, more rapidly, and more extensively than their southern and northern sisters. Even before they could vote, western women played a critical role in politics through their informal lobbying efforts. In part, this was a result of

the very newness of the early West, which translated at least initially into a more flexible social order. Because Jewish men and women were among the earliest settlers in many western communities, and because of the relative absence of overt anti-Semitism, from the beginning Jewish women in the American West were often welcomed as public partners in the quest for regional growth and stability and were among the nation's most active female community builders.

However, while early western Jewish women focused largely on mutual aid, their daughters and granddaughters expanded the transition into public life to include larger social welfare issues, often on a more professional basis as part of citywide efforts for reform and philanthropy. In part, this trend was sparked by the great migrations of the late nineteenth and early twentieth centuries from Europe and, to a lesser degree, from Asia, which impacted social welfare in urban centers throughout the United States. The arrival of east European Jews in particular changed the character of the American Jewish community, most visibly in heavily populated eastern and midwestern large cities such as New York and Chicago, and also notably in the West, a region that was highly urban.

Growing numbers of immigrants with attendant needs for housing, jobs, education, and health care, as well as the national reputation of many western states as health centers, necessitated the creation of new, more formal social welfare programs. By 1900, the term "philanthropy" as a reflection of the new "scientific" distribution of aid was increasingly being substituted for the old term "charity."[90] The second generation of western Jewish women expanded the strong communal involvement of the pioneers as charity workers to take an increasingly active public role in both the Jewish and general communities. Moreover, within the general American trend toward increased rationalization by the turn of the new century, a number of western Jewish women were part of a transition from benevolent voluntary charity workers to paid professionals as new opportunities for education and work evolved.

4

Religious Lives of Jewish Women in the West

When Mary Goldsmith Prag arrived in San Francisco from Poland as a child with her family in July 1852, two Jewish congregations already functioned in the infant town. Both of them followed traditional practices, but one adhered to Polish customs and the other to German ones. Just two months after their arrival, the Goldsmith family joined with other Jews to celebrate the High Holidays at Sherith Israel, the Polish congregation. Mary Prag later recalled: "The first *Rosh Hashanah* after our arrival, Mother not being able to go, Father took sister and me with him to the evening service of Sherith Israel. The men occupied the main floor, while the women were seated in the gallery. All synagogues at that time had a similar arrangement." Not many years later, she had the occasion to attend services at Temple Emanu-El, the synagogue largely supported by Jews from German-speaking lands in central Europe, as on "the eve of *Yom Kippur,* one of our neighbor's children was suddenly taken ill and it was decided to send for the mother who had gone to Schule. . . . I tagged along. The place appealed to us most brilliantly illuminated. . . . The house was crowded, floor and galleries, the latter solely with women garbed, most of them in white or light dainty lawns, white crepe shawls draping many a form."[1]

Mary Prag's memories of her "early days" in San Francisco, including her enthusiastic attendance as a young girl at the newly established Sabbath School, provides us with valuable insights into the religious lives of Jewish women in the early West. Not only was religion and synagogue worship an important facet of their lives, but many of the early frontier Jewish immigrants practiced a traditional form of Judaism. In response to new socioeconomic conditions, others gradually adopted what they perceived as pragmatic adaptations and modifications to Orthodoxy in a piecemeal fashion as they found themselves in a highly

diverse and pluralistic American society. Generally, however, Reform with a capital R as a philosophical ideology did not inform most Jewish congregations in the West until some decades later, when graduates trained at the Reform Hebrew Union College in Cincinnati arrived to assume pulpits.[2]

One notable exception, however, was the speedy transformation of San Francisco's Congregation Emanu-El, where in 1860 the famous European traveler Israel Joseph Benjamin found that the new "preacher," Dr. Elkan Cohn, a Prussian-born, University of Berlin–trained immigrant, had introduced German-based "Reform," including the introduction of mixed seating in family pews, a choir, and an organ. Benjamin, himself a staunch traditional Jew, appears to have been much more pleased to report that at the time Sherith Israel continued to follow "strictly Orthodox" rites, and that a third congregation, Shomrai Shaboth, had been formed and followed "in the good old way of their forefathers." The rapid growth and widespread acceptance of San Francisco's Jewish community, estimated by him to be five thousand at the time, within the larger society was highly impressive to Benjamin, who noted that "out of a Sahara of the desert they had come into a Canaan. That which in Europe has been barely possible in a long period of time was accomplished within eight years in America."[3]

Benjamin also recorded the existence of active Jewish religious communities in many of California's mining camps and in the mining-supply town of Sacramento. Here five hundred Jews now lived, and early residents had organized Congregation B'nai Israel in 1852, followed by a second German-based congregation soon after. At the same time, Benjamin lamented the decline in Jewish religious observances, which for many had devolved to merely marking the High Holidays. He was encouraged that in San Francisco, at least, "there are a great many who observe the dietary laws," and that a number of *shochtim,* or ritual slaughterers, were visible in the West. According to Benjamin, however, when one rabbi attempted to chasten a congregant about laxity in keeping the Jewish dietary laws of *kashruth,* particularly those related to abstaining from leavened bread during Passover, he was rebuffed, being told that "we live in the enlightened nineteenth century!"[4] The latter remark reflected the tensions exhibited by some Jews, both in the West and in America in general, in their quest to construct an authentic Jewish identity within a modern American context. Some abandoned Jewish practices such as *kashruth* because they wished to assimilate fully,

feeling that such public religious observances set them apart from the larger American society.[5]

However, as we have seen, others, most but not all of east European origin, remained committed observers. Among them were Rosalie Baruh in Nevada City and later Miriam (Mary) Kobey and her family in the 1880s mining town of Central City, Colorado. The Kobeys became temporary vegetarians until they moved to Denver because kosher meat shipped from the larger town often arrived spoiled. Miriam's granddaughter, Hannah Shwayder Berry, later recalled Sabbath visits to the Kobey household, where her grandparents Miriam and Abraham would be "dressed in their Sabbath clothes in the sitting room, both engrossed in reading from the Torah. Grandma would be reading what was called the *Teitch Hummish,* a Yiddish version of the Bible, and Grandpa the *Siddur* [prayer book] or the Hebrew Bible."[6] Miriam's granddaughter also recalled Passover at her own parents' table in Denver, where to usher in the holiday, "Mama, her face all flushed from the heat of the kitchen, lighted the candles, covered her eyes with her hands, and chanted the ancient blessing." In preparation for the family *seder,* Mrs. Shwayder brought out her Passover dishes and pots and spent days preparing traditional foods, such as gefilte fish, matzah balls, and hand-grated horseradish.[7]

The Helena, Montana, Jewish community had only a small group of traditional Jews in the 1870s, including the Polish-born family of Martha and Wolf Sabolsky, the latter a freight agent who transported merchandise over the 135-mile distance between Fort Benton and Helena. Their fellow townsman, Morris Silverman, a merchant who sold mining supplies, also acted as the informal lay rabbi, performing weddings, circumcisions, and serving as the longtime president of the local Hebrew Benevolent Society. Morris also took on the occasional job of *shochet* on behalf of the more observant Jews in town, who, "like Mrs. Sabolsky, would eat only Kosher chicken."[8] A Cheyenne, Wyoming, resident recalled that her family, originally from Poland, arrived in Cheyenne during World War I and that "my grandmother and grandfather Pasternack were so kosher that they had a separate table where they ate their dairy foods and a separate table for meat. . . . Very, very observant, very Orthodox."[9]

Ida Cook had been a contemporary of Miriam Kobey in Denver's west side east European immigrant community. Arriving at Ellis Island from Russia in 1892 with four children to meet her husband Harry, Ida

Miriam Rachofsky Kobey and grandchildren Silas, Rebecca, Philip, and Leon, Aspen, Colorado, c. 1905. (Courtesy of the Beck Archives, Penrose Library, and CJS, University of Denver.)

and the family soon headed west to Denver to join others from their native hometown in Europe. Not long after their arrival, Ida became the *mikvah* (ritual bath) attendant at a local shul, and before the turn of the century the couple opened their own popular steam-bath spa known as Cook's Russian Baths. It also contained a mikvah, primarily used by married Jewish women at the end of their menstrual cycle. At night the mikvah was open only to the Jewish women of the city, mostly the more traditional east European immigrants who observed the Jewish ritual, and for years Ida served as the faithful community mikvah attendant.[10] At about the same time that Ida was presiding over the local mikvah,

in 1910 Russian-born Devera Ginberg moved with her husband and daughter from New York City to Colorado, where she created handmade *sheitels* (wigs) for Jewish women in Denver who covered their hair in accordance with Jewish tradition. Although even many east European female immigrants had discarded the traditional sheitel in America as a concession to modernity, apparently enough women in Denver retained the custom to support a thriving business for Devera and her sister, Molly.[11]

Of the three central special traditional Jewish religious commandments for women—the lighting of the Sabbath candles; challah, setting aside and burning a portion of the special bread baked to sanctify the Sabbath with a blessing; and ritual mikvah observance—the lighting of candles seems to have been most commonly observed by both German and east European Jewish women throughout America. In contrast, use of the mikvah by Jewish women, particularly the German Reform Jews who often viewed it as an outmoded practice, declined in the nineteenth and twentieth centuries. As time passed, Americanized and acculturated German Jewish women became increasingly less observant of Jewish religious rituals than their east European sisters. They committed themselves more to community needs, which they felt reflected broader Jewish ethical principles, but also observed celebrations such as Passover, with its emphasis on freedom, which seemed more compatible with Protestant ideals.

Yet we do know that as early as 1857, the small Orthodox congregation of Hebrah Shimra Shabboth in North Beach, California, featured a mikvah.[12] Earlier that year, Rabbi Julius Eckman, the publisher of the new San Francisco Jewish periodical *The Weekly Gleaner,* had devoted an editorial in the first issue to "The Duties of Women." Here he emphasized the elevating and symbolic value of the three special commandments for women, including mikvah, to encourage their observance.[13] Rabbi Eckman, who had already served a year as Emanu-El's first rabbi beginning in 1854 and was later replaced by the more reform-minded Rabbi Elkan Cohn, was largely traditional in his religious outlook. While there is no way to determine precise levels of mikvah usage in the West, the building of mikvahs in many western towns and cities from Seattle to Denver, Los Angeles to Portland, and San Francisco to Spokane show that it was still important to a number of women.

There are examples throughout the West of women who remained

faithful to Jewish observances. As we shall see in the next chapter, though Bavarian-born Nanette Conrad Blochman was an industrious businesswoman in early San Francisco, she never let her work take precedence over her religious commitment. Her son, Lazar, recalled in his memoirs that "mother was a strict adherent to the Jewish faith and so kept her [millinery] business closed every Saturday as well as Jewish holidays. Her Jewish customers knew this, but she lost much of the transient trade because of that day."[14] Although Nanette Blochman was often the main support of the family, her husband, Emanuel, an Orthodox Jewish scholar born in France, instituted a Torah school for children in San Francisco in 1864, and had at various times tried his hand at dairy farming, wine making, and matzah baking.[15] In the early 1880s, western journalist I. N. Choynski called Mrs. Blochman "a noble example of a pious woman who conscientiously observed the tenets of old Israel regarding the dietary laws" and concluded that "such women are certainly rare in this age and country."[16]

In her memoir, *920 O'Farrell Street,* Harriet Lane Levy not only recounted the social gulf between San Francisco's turn-of-the-century German and Polish Jews but she shed light on religious life in the area through the practices of her own parents. She recalled that her Prussian Polish–born father, Benjamin Levy, rushed the last customers out of his shop on Friday afternoons so that he "might attend the service in the synagogue and hasten home to usher in the Sabbath with prayer and thanksgiving." While he acquiesced to a family pew at Temple Emanu-El, rather than maintaining the traditional separation between men and women, according to his daughter he exhibited a "passionate obedience to religious observance," including celebrating two traditional Passover seders instead of following the reform custom of only one seder.[17] As for Harriet's mother, Henrietta Michelson Levy, "The kitchen was the temple in which mother was the priest." The kosher dietary laws were strictly observed in the Levy household, with separate dishes and utensils for meat and milk and Passover dishes stored away and "undisturbed for three hundred and fifty days of the year." When Harriet's mother attended holiday synagogue services, she faithfully and knowingly recited her prayers in traditional Hebrew. Harriet, presumably having received her Jewish education at Temple Emanu-El's religious school, confessed that she understood little of the Hebrew prayers.[18] Like so many of the children of San Francisco's middle-class Jewish community who were inclined toward acculturation, Harriet was an

excellent student in her secular studies at the local girls' high school but took her Jewish studies far less seriously.

Keeping kosher and maintaining traditional Jewish life was also a priority for an east European mother in the early years of the twentieth century in Vernal, Utah. Claire Steres Bernstein was born in 1907 in the small town, which included only two other Jewish families, and she later recalled the central role played by her mother in maintaining Jewish observances for her family: "We kept a very, very Orthodox home . . . my mother . . . ate no meat at all until my father, like a *shochet,* learned how to ritually kill a chicken. When my mother prepared the house for Passover, we very carefully ate no leavening after we went to school. We had a strong cultural background in Judaism even though by that time we were the only Jews living in Vernal."[19]

The reality was that the Jewish population of the American West before the turn of the century, despite its newness and distance from more established Jewish centers, was composed of both traditionalists and reformers who cared enough about their Jewish roots to join together to establish the institutions so necessary for the preservation of Jewish life. As Mary Prag observed of the congregants who gathered at the Rosh Hashanah service in San Francisco in 1852, "Away from home and friends, they clung more closely together and were more devoted to the faith of their fathers."[20] In fact, as early as 1849 a group of about fifty Jews, including one woman, attended Yom Kippur services in a framed tent in the city, and the following year Rosh Hashanah was celebrated in a local Masonic Hall with three women in attendance; a short-lived congregation was initiated here as well. In 1851, a letter printed in the London *Jewish Chronicle* revealed that the modest number of Jews in San Francisco celebrated Passover with ritually baked matzah, and the young writer proclaimed, "I do not think the Jews in any part of the world could have kept the Passover more strictly than we did."[21] In the small town of Marysville, California, in 1853, the tiny Jewish community of sixteen families and a few single men managed to operate a daily Hebrew school attended by twenty-five girls and boys between the ages of seven and twelve.[22]

In her memoirs, New Mexico Jewish pioneer Flora Spiegelberg recalled that when she traveled the Santa Fe Trail in 1877, a stagecoach station master related a recent dramatic encounter with a pious German Jew. The stagecoach had stopped so that the four passengers, three Americans and one "German," could enjoy a meal. As was his habit,

the driver stood watch for hostile Indians. When he spotted a group of Native Americans approaching, he hurried the passengers into the coach but was unable to find his Jewish passenger. He finally found him "praying softly in Hebrew, a black skull cap on his head, a prayer shawl about his neck, and a prayer book in his hand." Even though the excited driver urged him to hurry, the Jewish man carefully wrapped up his religious items before boarding the stagecoach and remarked calmly to his fellow passengers, "Good friends, put your trust in God and He will bring you safely to your journey's end."[23]

Although we know nothing more of this observant Jew, it is likely that he and perhaps his wife and children went on to support one of the numerous synagogues that were founded in the American West by Jews who transported Judaism to a frontier setting. Before Jews arrived to settle the westernmost areas of America, their co-religionists had already gradually pushed westward across the continent to establish new Jewish communities across the nation, establishing a pattern for others to follow. But it was not only in the American West where Jewish women often provided the impetus for Jewish congregations and institutions. In early Chicago, for example, Dilah Kohn's traditional ritual needs, including kosher meat, prompted her sons to join with other Jews in the new settlement in 1847 to establish a Jewish congregation and hire a combination rabbi and shochet.[24]

The founding of multiple synagogues before the turn of the century, even in small towns as well as in medium and larger western cities like Sacramento, Denver, and San Francisco, reflected the congregational autonomy that marked both Jewish and Protestant religious bodies in America, in contrast to the monolithic pattern that had been common in Europe before immigration.[25] I. J. Benjamin noted this phenomenon of the American penchant for forming new Jewish congregations after internal disagreements and dissension among congregants and remarked, "This happens quite often in America."[26] In her memoirs, Rebekah Bettelheim Kohut, whose father, Albert Bettelheim, became rabbi of San Francisco's Ohabai Shalome in 1875, complained that the city "had too many congregations" and that there was an "unhealthy rivalry" among them.[27] With the arrival of a number of Russian immigrants who were part of the larger "tidal wave" of Jewish immigrants from eastern Europe to the United States, the proliferation of congregations continued, as they often wished to follow their own traditional Jewish customs.

While I. J. Benjamin's accounts of religious life in the American West

focused largely on male worship in synagogues, he did decry the lack of proper Jewish education for women. Historian Ellen Umansky has reminded us that it is a distortion to view the reality of Jewish women's religious lives merely through the prism of the men's sphere, such as through the study of Jewish texts or participation in public worship. According to Jewish tradition, women could neither lead public prayer services nor be counted toward the required ten needed for a minyan (communal worship), but Umansky maintains that Jewish women in America still exhibited a high degree of Jewish spirituality. Women in Reform congregations as well as those who retained the traditional aspects of the faith often felt religiously fulfilled by attending synagogue services or praying at home, lighting Sabbath candles and preparing holiday meals, attending to family needs, and most visibly in the public sphere through their charitable work. As daily pressures of work influenced many men to abandon Jewish learning and observances, "women's traditional religious domain . . . became more central than it had been in Europe" in "transmitting Jewish identification to children." As a result, many women became the primary communicators of Jewish identity, ethnicity, community, and spirituality.[28] Yet, despite the new conditions in America, Jewish tradition had always contained elements of the centrality of women in transmitting Judaism. In Proverbs 6:20–21, for example, children were exhorted not to forget "the teachings of your mother."

In the American West, the wives and mothers in frontier families were often expected to foster religious identity within the family by celebrating Jewish home-centered rituals and engaging in charitable work outside the home as well, enhancing Jewish life and community stability at the same time. In this they combined both Jewish traditional values and later the American Victorian bourgeois ideal for the upwardly mobile woman. Throughout America in the decades before the turn of the century, middle-class American German Jewish women in particular emulated their Protestant counterparts by serving both as pillars within the home and in houses of worship, in this case in synagogues.[29] For example, this was evident in the small southern town of Anniston, Alabama, where German Jewish women raised most of the funds to build the local Reform synagogue in the late 1880s.[30] Catholic nuns performed a similar task for their co-religionists, and Protestant women worked with local ministers to sustain missionary churches. Their philanthropy, however, focused more often on narrow social reforms that

eliminated the perceived evils of prostitution and on activism within temperance societies that sought to eliminate excessive drinking in saloons. While Jewish women were certainly not opposed to those goals, these were rarely the central focus of their social welfare work in the West.

A number of historians have speculated about the differing underlying attitudes on the nature of poverty and charity among Jews, Catholics, and Protestants that were played out in their social welfare institutions. One scholar summarized the topic as follows: "Protestant charity emphasized the danger of indolence and wastefulness; Catholic charity focused on 'good works' that earned a specific amount of 'grace' for the charitable soul; but Jewish charity valued the cheerful discreet donor who respected the dignity of the poor."[31] Another historian has maintained that Protestantism historically displayed great concern about respectability and worthiness, while Jewish and Catholic traditions operated on the basic assumption that poverty was a permanent condition; therefore little distinction was made over whether poverty was caused by sin, improvidence, or simple misfortune as Jews and Catholics forged ahead to found social welfare institutions.[32]

Rooted in their religious notions of proper behavior, Protestant missionary women in the West established a number of "rescue" homes for women of many other races, classes, and cultures in an attempt to uplift them with middle-class female moral ideals, even when the recipients did not share those same values.[33] The also founded orphanages and schools for children, which were ostensibly "nonsectarian" but in reality personified the vision of mainstream Protestantism. In her study of Protestant women and the emergence of the American welfare state, Maureen Fitzgerald traces the influence of Protestant religious thought, particularly the ethos of perfectionism on "secular" Progressive-era social work at the turn of the century.[34] In the light of these Protestant underpinnings, it is not surprising that even in the American West, where Protestantism as a whole was considerably less influential than in other regions of the country, many Jewish social welfare organizations, orphanages, and settlement houses specifically were founded in part so that Jewish children and family members would not have to be confronted with the proselytizing influence of their Protestant counterparts. As we have seen, for example, this was certainly the case in the organization of Denver's Sheltering Home for Jewish Children.

Contemporary observers as well as modern historians have also

noted the "feminization" of the American synagogue in the nineteenth century, at least in Reform congregations, part of a larger religious phenomenon that affected Protestant churches as well. In the Jewish community, while men were devoting most of their energies to entrepreneurial business activities, it was women who were most visible in attending Sabbath and holiday religious services. It is not surprising, therefore, that they took an increasingly active role in synagogue life, formerly the almost exclusive domain of men, through synagogue-based voluntary organizations such as benevolent societies and sisterhoods, and in fund-raising and Jewish educational endeavors. Indeed, the American Jewish community of the nineteenth and a good part of the twentieth century came to view the Jewish woman and religiosity as synonymous.[35] Certainly San Francisco's Rabbi Julius Eckman, publisher of *The Weekly Gleaner*, expressed this point of view when he declared, "Religion is everything to women."[36]

This perspective was also noted by Isaac Mayer Wise, leader of America's Reform movement, on a trip to the West in 1877. After visiting the Jewish communities of several western states, he stopped in Sacramento, California. There he found that although the service at the Jewish congregation of fifty-five members was "Orthodox, *Minhag* Polen" (according to Polish custom), there was barely a minyan of the required ten men, and only on the High Holidays did most congregants attend the synagogue. He went on to observe that this was common in all of California, and "the ladies uphold Judaism and I can add that the same is the case in Nevada and Utah."[37] Moreover, Paula Hyman has noted that "women seem to have persisted in ritual observances even after their husbands had abandoned their practices,"[38] although paradoxically some contemporary critics in the early years viewed Jewish women as a negative influence toward modernization and away from religious observance. Historian Marian Kaplan has found that a similar pattern characterized Jewish women in Germany between 1870 and 1913. Kaplan argues that German women during the era of rapid industrialization and modernization in their country adhered to family religious customs much longer than their husbands and children, and that they "remained the guardians of Jewish traditions."[39]

In the American West before synagogues were built, Jews worshipped in small groups, and many pioneers, both men and women, celebrated Jewish rituals as a means of maintaining Judaism. The story of the Jacobs family, who arrived in San Diego in 1851 via London and then had

a ten-year residence in Baltimore, provides an interesting case study, demonstrating that even in remote areas many Jews took Jewish practices seriously. When Hannah Solomon Jacobs, her husband Marks Israel Jacobs, and their children arrived in San Diego, there were not enough Jewish males to comprise a minyan, yet Marks Jacobs and two other men marked the High Holidays by praying together in a private house. Hannah presided over a kosher home, ushered in the weekly Sabbath by reciting the Hebrew blessing over the traditional candles, and educated her daughters in Jewish customs. The *San Diego Herald* recorded the Jewish High Holidays, commenting that "the Israelites of San Diego, faithful to the religion of their forefathers, observed their New Years days and day of atonement with due solemnity. . . . We are glad to record such an act of faith under circumstances the most unfavorable."[40] At the time, San Diego's population numbered less than one thousand and was comprised largely of Native Americans and Mexicans. They were joined by Spaniards, Americans, and Europeans to take advantage of opportunities spawned by the Gold Rush. An 1856 diary kept by the Jacobs's daughter Victoria, born in England in 1838, provides an intimate glimpse into the household of an observant Jewish family. Victoria Jacobs Franklin began recording her daily life when her fiancé, Maurice Franklin, presented her with a diary as a gift.

Victoria Jacobs's diary is filled with references to the Jewish Sabbath and holidays. On June 14, 1856, Victoria wrote, "It being Sabbath, me and Fanny were invited by my dear Maurice to dine with him and take a little walk." On several occasions, she records preparation for the "Day of Rest," as on Friday, June 20, 1856, when she wrote, "Busy cleaning for Sabbath."[41] Similarly, on October 9 of that year, she noted that "today is Yom Kippur. We all fasted well." And on October 14: "Today is Succoth, we are all busy doing nothing as there is no synagogue here."[42] The first congregation in San Diego, Adath Yeshuran, did not come into existence until five years later in 1861. It dissolved later but served as the origin of what later became Beth Israel. The first synagogue building was erected by Congregation Beth Israel in 1889. Victoria and Maurice Franklin were married on March 31, 1857, in a ceremony performed by her father "according to Jewish rites," as recorded in the *San Diego Herald*.[43] It is interesting to note that Maurice Franklin was the brother of Lewis Franklin, one of the other original Jews involved in the town's religious life.[44] The couple became parents of two children before Victoria Jacobs Franklin died in childbirth at the

age of twenty-three in 1861.[45] In 1857, her parents, Marks and Hannah Jacobs, moved to San Bernardino, California, where together they operated a store and hotel before moving yet again in 1869, this time to San Francisco. Here Marks became vice-president of the orthodox synagogue Ohabai Shalome in 1873.[46]

Jewish worship in San Diego appears to have followed traditional forms until the late 1880s. As the town boomed, the increase in the number of Jewish families spurred the formal founding of the Reform Congregation Beth Israel. A Jewish religious school connected with the congregation was instituted by 1887 largely through the efforts of Mrs. Abraham Blochman. Delita Mannasse and Celia Schiller, the unmarried daughters of two of San Diego's pioneer families, were the teachers. Three of Mrs. Blochman's own daughters also organized a social group for young Jews, and after daughter Miriam Blochman Brust married, she became active as a teacher in the religious school her mother had started.[47]

In typical fashion, by 1889 the women of Congregation Beth Israel held a popular Jewish Ladies' Fair to raise money for the erection of a synagogue building, bringing in the substantial sum of $1,500. Within a few years, in about 1892, the women of Beth Israel organized a Mother's Club, a precursor to the later sisterhood, which contributed funds to support the religious school and choir and later stepped in to aid the congregation on a general level when economic times were difficult. With an infusion of more traditional east European Jews at the turn of the century, by 1905 the Jewish population of San Diego was large enough to organize a separate Orthodox congregation, Tifereth Israel, which created its own Ladies' Auxiliary.[48]

In nearby Los Angeles, formal religious life was prompted by the arrival of Rosa and Joseph Newmark, who moved to the rough, undeveloped town in 1854. The pious Joseph, a successful merchant, also served as a lay rabbi until the establishment of the B'nai B'rith congregation in 1862, leading religious services and officiating at seven marriages before the arrival of a rabbi. The devout couple was integral to the life of the synagogue. Their home served as the site of the founding in 1854 of Los Angeles's first Hebrew Benevolent Society, and Rosa was the prime impetus behind the founding of the Ladies' Hebrew Benevolent Society in 1870, which dispensed charity as well as comfort to mourners and prepared the female dead for burial according to Jewish rites. For twenty years, Rabbi Abraham Edelman served as the con-

gregation's first rabbi, shochet, and teacher at the afternoon religious school established in the late 1860s. It is interesting to note that Rabbi Edelman's school accepted girls as well as boys. This was a departure from the European tradition, where Jewish women usually received their knowledge about Jewish rituals, the Bible, and prayers in the home from parents, usually mothers, and rarely received a formal Jewish education in school. With the feminization of the American synagogue and the breakdown of traditional norms came a new emphasis on female religious instruction. Although the congregation instituted some reforms, it remained formally Orthodox until the death of Joseph Newmark and the resignation of Rabbi Edelman, which soon followed.[49] Indeed, the transition to Reform was a major point of contention not only at Congregation B'nai B'rith but in synagogues throughout America during the era.

Subsequent rabbis at Congregation B'nai B'rith, which later became known as the Wilshire Boulevard Temple, continued the march toward Reform at the synagogue. One of the more popular projects was the introduction of a new Ladies' Aid Society that focused on raising funds and supervising the Sunday School and social activities. Eventually it became a formal sisterhood. Here, too, the "feminization" of the American synagogue was evident, and by the late 1880s "activity in Congregation B'nai B'rith became largely a feminine affair."[50]

In 1875, at the age of seventeen, Jennie Migel married Samuel Drachman in California and promptly left for her new home in Tucson, Arizona. As Joseph Newmark had done in Los Angeles, Samuel Drachman served as a lay rabbi in early Tucson, performing Jewish wedding ceremonies and holding religious services in the family cigar store. Jennie Migel Drachman became active in the Hebrew Ladies' Benevolent Society, and Sam served as the first president of Temple Emanu-El. Jewish observance was not easy in early Arizona, but apparently it was vital enough to the Drachmans to make the long trip to the West Coast to mark a central Jewish rite. A local diarist recorded that on March 16, 1877, "Sam Drachman and wife left with their child by stage for California to have the boy circumcised."[51] Later in Tucson, Therese Marx Ferrin was the major force behind the building of the city's first synagogue. Her grandson later recalled that before the creation of the synagogue, Therese hosted services at her home and kept watch over a Torah scroll that was kept there. With the assistance of her daughter Clara Ferrin Bloom, she personally collected money to erect Temple

Emanu-El.[52] Similarly, the home of Emanuel and Pauline Myer Linoberg in Sonora, California, became the site of Jewish religious gatherings and weddings.[53]

In the American West, Nevada stood out as the state with the highest percentage of foreign-born residents in the country. Though Jews in Nevada may have "adapted more readily, more completely, and more successfully" to the state than any other single ethnic group, many still expressed interest in bonding with their co-religionists and celebrating their Jewish heritage.[54] A rather remarkable photograph from the Nevada Historical Society collection depicts the Goodman family of Virginia City in 1869 in their well-furnished parlor. In that booming yet remote outpost, Mr. Goodman, with white beard and a conspicuous black Jewish skullcap, appears to be studying a traditional Jewish text while his wife looks on with approval.[55]

With a Jewish population of one hundred and fifty, Jews in Austin had founded a Hebrew Benevolent Society by 1863, and in the Comstock mining supply town of Virginia City, two Jewish benevolent associations and two B'nai B'rith lodges existed by 1865. High Holiday services were observed in both places. However, the Jews in Eureka were probably the most active, often importing rabbis from San Francisco at great expense for Rosh Hashanah and Yom Kippur, and establishing the first permanent Hebrew congregation in Nevada in 1876. Lena and Morris Badt, merchants and ranchers as well as committed Jews, moved to the northern Nevada agricultural and cattle center of Elko in 1868, and later to nearby Wells. Dedicated to Jewish rituals, the couple sent their sons all the way to San Francisco for bar mitzvah lessons and eventually maintained homes in both cities so their children could receive a proper education.[56]

In Salt Lake City, Jewish merchants and their families gathered together in 1865 for High Holiday services in Utah, in a hall donated by Mormon leader Brigham Young. Here they organized a temporary congregation. While only seven Jewish families lived in the city, "the ladies took much content in making and decorating ornaments for the Tora [sic] and Ark"[57] to show their interest in religious matters. Congregation B'nai Israel, established in 1873 and formally incorporated in 1881, eventually evolved into a reformed congregation though it was organized "under the old strict Orthodox form."[58] Members erected a three-room Hebrew School building in 1883, first holding religious services there in March 1883, led by local Jewish merchants Ichel Watters

and Moses Phillips. When a new synagogue building was erected in 1891, the Salt Lake City *Tribune* noted that the ladies "had raised the money for the stained glass windows . . . had fashioned and arranged the decorations . . . and had embroidered the curtains in Hebrew design." A local Jewish woman was also thanked for donating the "perpetually burning lamp" or "eternal light."[59]

Although the Jews of Boise, Idaho, did not organize a formal congregation until the mid-1880s, in September 1876 the local newspaper reported that on Yom Kippur "the stores of those of the Hebrew faith were closed last evening at sunset and will not reopen until after sunset this evening. Strict observers on this day abstain from food and drink of all kinds."[60] The Jewish population of the city numbered less than fifty out of a total population of two thousand when the first Jewish congregation, Beth Israel, was established in 1895. The modest group included its first president, Nathan Falk, who had brought his Munich-born young wife, Rosa, to the town in 1878. Nathan and his brothers, David and Sigmund, were partners in a local successful family business enterprise and were leaders in both the Jewish and secular Boise community. In a letter written to the editor of the *American Israelite* in 1895, the author reported that the decision to establish a congregation had been prompted by the death of a local Jewish woman, who "was a daughter of Israel in every sense of the word, beloved by all." Members of the local Jewish community came together to arrange for a proper burial but, realizing the need for a more formal structure, "all coreligionists present agreed that a shule (synagogue) and Sabbath-school was needed here, and that at no distant day we should take steps to organize for that purpose."[61]

Soon local Jewish women founded the Judith Montefiore Association, a temple sisterhood named after the well-known British leader of many Jewish charitable endeavors in London. The Boise Jewish women's group raised money for the maintenance of the reform synagogue, oversaw the religious education of the congregation's children, and arranged for the "proper observance of the Sabbath." For many years, Helen Falk held the only Jewish education classes in her home.[62] In establishing a temple sisterhood, the women of Beth Israel were following a pattern and joining with other middle-class Jewish women around the country who banded together to work together with a synagogue and to support Jewish life through their congregation, a more updated version of earlier benevolent societies.[63] Although similar in scope and purpose

to sisterhoods in other regions, as was the case in many small towns with small Jewish populations in the West, the Boise group took on extra significance as a key factor in Jewish life. For over a decade the congregation was led by president Moses Alexander, whose daughter was married under a *chuppah* (marriage canopy) at Beth Israel in 1901. While president of Beth Israel, Alexander served simultaneously as the mayor of Boise and later as two-term governor of Idaho. He maintained that the subject of his Jewishness never came up during the elections.[64] Most of the families who made up the congregation at Beth Israel were members of a prosperous merchant middle class, from central Europe and generally followed modified reform practices. However, with the arrival of east European Jews after the turn of the century, an Orthodox synagogue was founded as well in 1912. From 1912 to 1924, Reverend Moses Isaacs served as a combination rabbi, educator, and shochet, enabling a number of traditional Jewish women to maintain the kosher homes that were so important to them.[65]

As time passed, synagogue-based women's organizations often became a means of combining philanthropy, Jewish education, and religious identity in an effort to revitalize American Judaism through a new emphasis on the transmission of Jewish values, including the traditional concern for the needy. As historian Jonathan Sarna has pointed out, Jewish women across the country in the late nineteenth century were in the forefront of a movement to educate Jews about Judaism in order to keep them engaged and connected to Jewish life rather than continuing the Reform effort to "change" Judaism.[66] While one historian has shown that New York's Jewish congregations took the lead in founding these "charitably inclined Sisterhoods of Personal Service," ironically often inspired by Protestant social gospel models,[67] they were prominent in the American West as well. According to historian Felicia Herman, the Sisterhoods of Personal Service were also a way for Americanized Jewish women to accommodate Jewish traditions to prevailing ideas of American gender norms as a "vehicle for women's religious expression through charitable endeavors."[68] In San Francisco in 1893, Rabbi Voorsanger of Temple Emanu-El encouraged affluent women to follow the New York synagogues and form their own sisterhood to assist impoverished immigrant Jews in an effort to aid them as well as remove them from embarrassing public view. As early as 1894 the Sisterhood had established its first settlement house, geared to Americanizing the newcomers.[69] In typical fashion, it offered educational classes,

social clubs, child-care facilities, and employment counseling. Later it provided housing for single young Jewish women, supervised by a resident social worker in a showcase facility built in the early 1920s. In the *First Annual Report of the Emanu-El Sisterhood for Personal Service,* president Bella Seligman Lilienthal, a leading member of San Francisco's elite Jewish society, reported that although the organization was "not altogether sectarian in our charity . . . primarily, our object is to help our own people, because we feel that they need our help most and their interests are ours."[70]

In Denver, the Ladies of Congregation Emanuel helped support the synagogue through fund-raising events such as a fair organized in 1888 to help pay off the mortgage on the temple. In conjunction with the fair, the women published *The Fair Cookbook,* which turned out to be the earliest-known Jewish fund-raising cookbook in America. What makes this cookbook especially relevant for historians is its inclusion of traditional Jewish dishes such as matzah balls and Passover treats as well as recipes for oysters, strictly forbidden by Jewish dietary laws. Through the cookbook, these Denver women were exhibiting "a characteristic expression of German Reform Jews in America in this period," affirming philanthropy with a distinctive Jewish flavor, but not adhering scrupulously to kosher laws.[71]

Not only did sisterhoods such as the Ladies of Temple Emanuel carve out a public sphere for their members, but in the small Denver Jewish community, which numbered only about five hundred, the women played a role in sustaining the only Jewish congregation at the time. Some historians have viewed the sisterhoods of women, particularly in American Reform synagogues through the mid-1920s, as vehicles for expanded Jewish women's public religious roles. By instituting innovations such as introducing babysitting services, women at services now had the opportunity to join in public prayer. They have also suggested that in some areas of the country the sisterhoods actually replaced the early Hebrew ladies benevolent societies,[72] which seems to have been the case in the West as well, but at a slower pace.

As we have seen, the arrival in America of the east European Jews in the decades before the turn of the century coincided with a trend toward Jewish revivalism, which embraced Jewish values and education with renewed zeal. While Reform Judaism had grown in influence throughout America after the Civil War, in the last decades of the nineteenth century many Jewish women immigrants and some already

acculturated Jews found the modernizing reforms introduced by Reform Judaism problematic. They were meant to reflect an emphasis on individual spirituality over traditional observance, but some women felt the reforms devalued the personal religious observance of women, offering them "not a means of becoming more fully Jewish but rather a means of becoming less so."[73] As we have seen previously, even a staunch Reform Jew such as Denver's Seraphine Pisko expressed admiration for the visible Jewish sentiment and enthusiasm for Judaism expressed by the east European Jews with whom she came in contact through her hospital and settlement work. In 1902, the city's National Council of Jewish Women (NCJW) section, comprised predominantly of German Jewish women, sponsored a discussion at one of its educational programs devoted to the subject "Has Orthodoxy a Greater Tendency to Preserve Judaism than Reform?"[74]

For many Jewish traditionalists, tinkering with or eliminating observances such as kosher dietary and family purity laws, and Sabbath and holiday customs, appeared to insure the destruction of Judaism in a vain effort to conform to gentile society.[75] Though Orthodox western Jewish women later formed their own synagogue sisterhoods and auxiliaries and joined women's groups like the Zionist organization Hadassah, many remained loyal to Jewish *halacha* and remained active in older versions of the benevolent societies, including the Chevra Kadisha, a society to prepare the dead for proper Jewish burial. In Seattle at the turn of the century, for example, east European Jews unhappy with some nontraditional practices at the Ohaveth Sholum synagogue, which had been established in 1889, founded a number of traditional synagogues of their own and clustered in the Yesler Way–Cherry Street neighborhood. Soon the Jewish enclave was dotted with kosher butcher shops, grocery stores, and bakeries, and "on Friday evenings and Saturday mornings, hundreds of pious men, women, and children walked the neighborhood streets going to and from Sabbath services."[76] Similarly, during that time, numerous small shuls filled east European Jewish neighborhoods in many western cities such as Boyle Heights in Los Angeles and the Colfax section of Denver, while a major architecturally impressive Reform synagogue would anchor the more affluent Jewish areas.

One western Jewish woman in particular seems to have embodied the sometimes contradictory strains of religiosity among American Jews in the last decades before the turn of the century. Born in San Francisco

around 1861, Ray (Rachel) Frank Litman has perhaps attracted more interest than any other individual Jewish female westerner. References to the charismatic, controversial "latter-day Deborah" abounded at the time. The flexible, individualistic, and fluid nature of the American West provided a perfect backdrop for Ray Frank to construct a major public role in the region's religious development, offering her a national platform in the process. She later referred to the region as an area where "prejudices of a theological kind were unheard." A product of her times, Ray Frank also reflected the general revivalism and specifically Jewish American late-nineteenth-century awakening, with its emphasis on "saving Judaism" from assimilationist forces and making it relevant in modern American society. In often contradictory ways, she mirrored both "an unexpected move back to tradition among American Jews" and changing women's roles, as well as the prevalent competing strategies between reformers and traditionalist in their quest to insure the survival of American Judaism.[77]

Ray Frank was born to traditional Orthodox parents—Bernard, a peddler, and Leah, both Polish immigrants. She graduated from California's Sacramento High School in 1879 and later attended classes in philosophy at the University of California at Berkeley. Following a typical path for young Jewish women, she began as a teacher in a six-year stint in Ruby Hill, Nevada, working both with children of local miners and offering night classes for adults. Eureka, located only about two and a half miles from Ruby Hill, had a small but active Jewish population, but Ruby Hill had even fewer. Ray Frank probably chose the area because her ailing sister and family lived in Eureka, making it easy for Ray to visit and lend a helping hand.[78] From Ruby Hill she moved to Oakland, California, in the mid-1880s. Here she earned a living by giving private lessons, contributing to magazines and newspapers as a correspondent, and teaching Sabbath School in the city's first Jewish congregation. In the latter position, she had her first popular experience "preaching" when, as the new superintendent of the Jewish school, she lectured to both children and adults on Jewish history and Bible and received an enthusiastic reception.[79]

As her interest in Jewish issues increased and she became more knowledgeable about them, Ray Frank used her writing and oratory talents to reawaken her American contemporaries to practicing Judaism. In a famous letter to the editor of the New York *Jewish Messenger,* which had invited its readers to state what they would do if they were a rabbi,

Ray Frank responded vigorously. She criticized contemporary Jewish leaders for ignoring the spiritual underpinnings of Judaism and not promoting unity among all Jews. In 1890, she traveled to Spokane, Washington, as a correspondent for a California newspaper. Arriving shortly before Yom Kippur, she was shocked to find that not only did the town not have a synagogue, but that no arrangement had been made for holiday services of any kind. She agreed to deliver a sermon if services were held, and speaking on "The Obligation of Jews as a Jew and a Citizen," she emphasized Jewish unity and decried social and class distinctions, a theme she would repeat many times in the future. Ray Frank's sermon in Spokane launched a somewhat short-lived but much publicized career as an often mesmerizing traveling revivalist, speaking before appreciative audiences largely on the West Coast to groups in both Reform and Orthodox synagogues, men's lodges, and women's societies and clubs.[80]

Although Ray Frank was sometimes referred to in the popular press as the "girl rabbi," and modern feminists have often claimed her as a predecessor of contemporary female rabbis,[81] she insisted she never aspired to become a rabbi and was a staunch supporter of traditional roles for women as wives and mothers. At the same time, she emphasized the crucial role women had always played and continued to play in the maintenance of Judaism. Still, by emphasizing the Jewish role of "daughters of Israel," she was able to open the door to an enlarged space both for herself and other women in American Jewish religious life.

Ray Frank was a natural choice to play a pivotal role in the 1893 Jewish Women's Congress in Chicago. While the other representative from the West, Carrie Benjamin, was a relative unknown, by 1893 Ray Frank was nationally known as a rising star. Receiving triple billing at the critical event, she delivered the opening prayer to the female audience, and gave a major speech on "Women in the Synagogue," as well as the closing benediction. In her lecture, Ray Frank reflected the often ambiguous and contradictory threads of her philosophy. She praised women as "stronger spiritually," highlighted the influence of biblical women such as Miriam, Hannah, and Esther. She also singled out early medieval women such as Ima Shalom, daughter of the head of the Sanhedrin; Rachel Sabua, wife of Rabbi Akiba; and Beruria, wife of Rabbi Meir. At the same time, she emphasized the central role of Jewish women as wives, mothers, and religious teachers. While Frank proclaimed on the one hand that "Jewish woman had earned the right to

the pulpit," she maintained that the Jewish woman would be better advised to "make her home a temple," and that "her noblest work will be at home, her highest ideal, a home . . . as mothers in Israel."[82] These same divergent elements enabled Ray Frank to insist on the one hand that if she were a *rebbitzin* (rabbi's wife), "Friday night should be made so beautiful in my home that all should wish to imitate the celebration of our Sabbath in the true orthodox style," and on the other hand that Jewish ceremonies "must be altered by men to suit the times."[83]

Probably suffering from nervous exhaustion, in 1898 Ray Frank left America for an extended stay in Europe. In Germany, she met her future husband, economist Simon Litman, many years her junior, who later recalled that Ray appeared "as if she had been recovering from a breakdown." The couple married in 1901 and then moved to the United States, where her husband became a professor first at the University of California and then at the University of Illinois.[84] Following her own advice that women should not combine marriage and work, writing that "married women cannot do both things—attend to their home and follow a profession,"[85] Ray Frank Litman retired from the public scene while remaining active in her synagogue sisterhood, the NCJW, Hadassah, and the early Hillel organization at the university. To the end, she espoused a mixed message, reflecting both conservative and liberal elements. It is unlikely that she could have launched her career as a Jewish female "preacher" in the more established society of the East, but the fluid West, which promoted risk taking, was more open to experimentation in the changing roles of Jewish and American women.

As William Toll has observed, even in remote areas of the American West before the turn of the century, "Jewish women led religiously satisfying lives by creating a secure niche for their families."[86] Many also extended their religious lives beyond the home with a public presence to help ensure Jewish survival in the West. They did so through instituting religious education and working in synagogues as well as reaching out to those in need through benevolent organizations that were directed first toward their fellow Jews and then to the wider community. However, Toll minimizes the role that ritual participation played in the lives of many western Jewish women, maintaining that it was "sporadic" and that few actually kept a kosher home or followed traditional practices beyond a few symbolic forms of Judaism such as lighting Sabbath candles or preparing food for a Passover seder.[87]

Toll is correct, though, in maintaining that, particularly among German Jewish immigrants, many of whom were in the process of becoming assimilated in their quest to enter the mainstream American middle class, a number of western Jewish women and their families adopted a form of "civil" Judaism where secular as well as broad Protestant universalistic influences often prevailed.[88] For example, when Reform Rabbi William Friedman eulogized Denver's "Mother of Charities," Frances Wisebart Jacobs, in 1892, he proclaimed that "she carried into daily practice the principles of Judaism" while "she felt that a religion without creed or dogma, resting on the rock-rooted foundation of morality and humanity, was broad enough for her."[89]

Yet, as we have seen in previous pages, although many women adapted ritual through reform, a significant number maintained their religious traditions, often under challenging circumstances. Toll argues that "if we consider benevolence rather than ritual participation as the focus of married women's Judaism, then the religious life of Jewish women in the West grew with the needs of their communities."[90] However, without minimizing their critical and highly visible charity work, as we have learned for some Jewish women in the American West, observance and benevolent work went hand and hand. Even for those who were not particularly observant, involvement in philanthropy served as a natural extension of Jewish life in the home and the synagogue. It was another way in which to express a meaningful Jewish religious identity and at the same time served as a means for the preservation of Jewish tradition. In other words, as historians Jonathan Sarna and Pamela Nadell have expressed it, "Service to the Jewish community became itself an expression of religion, a means of affirming loyalty to God, Judaism, and the Jewish people."[91]

A number of historians have pointed to the high degree of religious diversity in the American West and the related weakness of mainstream Protestant denominations there that held sway in the East. This situation resulted in the phenomenon that "no one group dominated the other," resulting in a greater degree of mutual toleration in the West. In contrast to New England, for example, until the great western migrations, "no cultural-religious hegemony had laid a social foundation."[92] One of the more recent studies of religion in the American West has argued that in the period from about 1890 to 1920, "In most areas, the three historic faiths—Protestantism, Catholicism, Judaism—coexisted with relative equanimity as they tried to serve their congregations, ele-

vate the moral tone of their communities, and (they hoped) shape their regions for the foreseeable future." According to Ferenc Morton Szasz, the primary reason the relative mutual tolerance had prevailed was because the region never produced any single religious mainstream, and for the most part the "celebrated individualism of western life has remained preeminent."[93] Against this backdrop, in the dynamic open and developing region of the American West, where individual freedom was perhaps most glorified, Jewish women and men were free to choose how "Jewish" they wanted be. It is rather remarkable to note that many retained their active allegiance to Judaism and carved out a Jewish life.

5

From "Women's Work" to Working Women

To mark the beginning of the Jewish New Year in September 1912, "the last year [having] been an exciting year for us," Anna Freudenthal Solomon composed a handwritten fragment of her memoirs on a sheet of stationery bearing the letterhead of the Solomon Hotel in Arizona, an establishment she oversaw for over twenty-five years. The sheet bore the inscription "Cuisine and Service Unsurpassed. Prices Reasonable, Special Attention to Commercial Men" and "Board by the Day, Week, or Month." Indeed, the rates were very reasonable, as one dollar could buy three meals for a day.[1] In charge of the day-to-day operations at the hotel, Anna kept the books, paid bills, and oversaw a retinue of servants comprising a Chinese cook and Mexican gardeners and housemaids. As we learned earlier, she also became a respected member of the community and made the hotel, located next to the family store, famous as the center of "social life" not only in the small county seat of Solomonville, whose population numbered around one thousand at its height, but throughout the territory and then the state of Arizona. According to author Harriet Rochlin, Anna Solomon personally supervised the baking of fancy pastries, and fresh meat, fruit, and vegetables were supplied from the Solomon Ranch and Anna's own orchard and gardens.[2]

Before opening the hotel, Anna Solomon had already juggled a dual career familiar to many modern women today as both a working mother and shopkeeper, and as one historian has noted, "For women entrepreneurs, public and private life have always been inextricably linked."[3] After the family arrived in the primitive village called Pueblo Viejo in the late 1870s, Anna's husband Isadore Elkan ("I.E.") devoted himself to the "outdoor" work of their growing charcoal supply business and later their ranch. Anna raised the couple's six children, all of whom

later married Jews, and "attended the store and the housework."[4] The Solomon family later operated the small Gila Valley bank within their Solomon Commercial Company's new brick building and enlarged the enterprise to become a major significant banking business. Isadore was appointed the first postmaster in Solomonville in 1880 and was later chosen by Governor John C. Fremont to serve as the Graham County treasurer, a position he held for four years.[5] While Jewish boarding-houses run by women were not uncommon around the country before the turn of the century, a thriving hotel was much more unusual. Anna's work reflects the active economic role of Jewish women in the American West as proprietors of businesses in a region where risk-taking was often the norm and the newness of the area provided unprecedented possibilities for many women.

Throughout the United States, American women, among them Jewish women like Anna Solomon, often used the traditional "female spheres" of home and fashion as opportunities for business endeavors. For example, in the mid-1870s in Boston, more than four-fifths of women who advertised in the *Boston Directory* provided food, clothing, or lodging.[6] Enterprising American women of all ethnic and religious groups, including Jews, were to be found throughout the country, but it appears the American West afforded them an extra measure of opportunity. Moreover, as we have seen, the frontier character of early western society allowed a more liberal definition of gender roles than in other parts of the country.

The prominence of a number of western Jewish women in business is not altogether surprising in the light of tradition and the burgeoning regional economy. Historian Andrew Heinze has maintained that Jewish women in general have exhibited more involvement in commerce than women of most other ethnic groups.[7] Moreover, historian Eric Goldstein has argued that the greater involvement of Jewish women in family businesses and as contributors to family income than non-Jewish women of the same class fostered an exceptional "level of access to the world of commerce."[8] But many western women, Jews as well as non-Jews, still made a living from occupations that grew out of expanded versions of their traditional female roles as mothers and housekeepers, such as producing and selling clothing and running boardinghouses, groceries, restaurants, or, in rarer cases, hotels. For example, San Franciscan Mary Ellen Pleasant, one of the most prosperous African American women in the country when she died in 1904, is an interesting

example of a melding of roles: she made her fortune in areas that were considered men's province—quicksilver mines and real estate—as well as in a string of exclusive boardinghouses. As with many of her female contemporaries, her success was due largely to the opportunities provided by the rapid growth of the western economy in the second half of the nineteenth century, in this instance in San Francisco and California as a whole.[9]

Like Anna Freudenthal Solomon, who had run her father's store in Posen during his absence, some of the early western women had already developed business skills in Europe that would prove valuable in their new homes. As already noted, in Europe harsh economic conditions and traditional Jewish family life had often necessitated the breadwinning labor of women. Similarly, in colonial America and in the early national period, women's and men's cooperative and interdependent labor was often required in order to simply survive. However, in America by the mid-nineteenth century, particularly after the Civil War, industrial capitalism resulted in a greater separation between home and work. Involvement in business pursuits increasingly became part of "men's sphere," and societal norms often bestowed a badge of approval on the rising status of families where wives did not have to "help out" because of a husband's financial success.[10] While many western Jewish women also aspired to this social domestic ideal of American womanhood, in the American West some Jewish women like Anna Solomon *chose* to work outside the home either because of financial incentives or because they enjoyed the challenge, economic independence, and public influence it often brought.

We have already learned that the first Jewish woman in Oregon, a Mrs. Weinshank, opened a boardinghouse in Portland for Jewish bachelors in 1854.[11] In 1859, Mrs. Emily Stodole advertised in San Francisco's *The Weekly Gleaner*, offering *Pesach* (Passover) accommodations for boarders.[12] Western women like Mrs. Weinshank and Mrs. Stodole found that such enterprises not only provided them with a means of making a living but also supplied a needed service for early Jewish settlers, mostly unmarried males, who longed for an environment that would bring them into contact with their co-religionists or in some cases provide them with kosher meals. This appears to have been the case in a kosher Jewish boardinghouse run by Mrs. Willie Kierstle in Seattle in the late 1880s.[13] Of course, boardinghouses run by Jewish women were not only a western phenomenon. As early as 1750 Hannah

Moses was running a small jewelry store and taking in boarders in Philadelphia, and by 1790 Charity Cohen was running a Jewish boardinghouse in New York City.[14] In the 1820s Esther Hart operated a boardinghouse in Philadelphia that enabled the widow to provide for her ten children after the death of her husband.[15]

While boardinghouses appear to have been ubiquitous, the freewheeling and rough, undeveloped nature of the early American West multiplied the need for temporary housing for an often transient population that followed gold strikes and attendant business opportunities.[16] Ernestine Greenbaum arrived in Los Angeles in the early 1850s, one of the first Jewish women and possibly the mother of the first Anglo child born in the infant settlement. On the way west, the Greenbaums had enjoyed the hospitality of a California ranchero, which inspired Ernestine to open her own establishment. During the early 1870s, she opened a successful boarding hotel where she was considered "a motherly friend to many a young and homeless Jewish boy seeking his fortune in the West." Inspired by her early success, in 1875 Ernestine and her husband Ephraim opened the popular White House Hotel and were joined by a Mrs. Goldstein. The latter had started in business as the proprietor of a private boardinghouse, which also hosted and catered events for groups, and went on to open a fruit, candy, and cigar stand before combining forces with the Greenbaums.

Other early Jewish businesswomen in Los Angeles included Flora Cohen, who was listed as a "sole trader" independent of her husband, and a Mrs. H. Cohen, who operated as a seamstress, milliner, and supplier of "fancy goods."[17] In 1867, Rosa Newmark of Los Angeles wrote to one of her daughters who lived in New York at the time, describing the elaborate wedding of her youngest daughter, sixteen-year-old Harriet Newmark Meyer. In the letter, she praised the work of Mrs. Cohen, who had created her daughter's "tastily" and "beautifully" fitted bridal gown.[18] Caroline Gerson, who had six children between the ages of four and fourteen, was listed in the 1870 census as being in the "grocery and dry goods" business. Her husband, Charles, was probably out of town acquiring merchandise for their store at the time the census was taken or was inadvertently left off, but the couple probably operated the enterprise together.[19]

In Utah, Fanny Brooks, whom we met in an earlier chapter, was not only an early pioneer traveler to the West, but ran several successful business enterprises as well. In the 1860s and 1870s, the boom-town

environment of Salt Lake City allowed Fanny to help her husband, Julius, take advantage of real estate and other investment opportunities and also enabled her to develop her own separate and influential economic role. She took in boarders, prepared meals and sold them to large groups of travelers who used the city as a rest stop on their journey west, and operated her own successful millinery business.[20] In 1853 Fanny Brooks was listed as owning a millinery store worth $2,200 on the tax assessor's list, and was noted as having paid her full tax of $5.50. Known as a woman with sound business sense, by 1884 she appeared on a list of proprietors of prosperous Salt Lake City businesses as "Mrs. Brooks, Millinery Store and Bakery."[21] Although we might wonder at the unusual combination of food and clothing, across America and the West millinery was a very popular women's enterprise, and it was not uncommon for milliners in more remote areas to diversify their products to improve their sales.[22] As early as the 1860s Mrs. S. Kline of Vancouver advertised as a "practical milliner and dressmaker." Similarly, in 1873 in Kaluma, in the Washington territory, Mrs. Silverman ran her own millinery department with the "latest styles of HATS, CAPS & BONNETS" as a separate division of her husband's clothing store for men.[23] In Helena, Montana, Mary Aaron, wife of a local Jewish businessman, operated her own branch of her husband's millinery business in the early 1880s, and an R. G. Dun agent estimated the worth of her business to be between $5,000 and $7,000.[24]

A number of Jewish businesswomen had been involved in mercantile ventures since colonial days, most often as small shopkeepers, or they managed larger estates and businesses after the deaths of their husbands. However, by 1840 the prevailing social norm in urban centers, particularly on the East Coast, for the middle and upper classes generally confined women's place to the home. Working-class women, usually not considered businesswomen, labored out of necessity and occupied low status and low-paying jobs.[25] According to historian Irene Neu, with the arrival of large number of Jews from central Europe after the 1850s, at first the wives of many early Jewish merchants joined their husbands in the shops, but as family fortunes improved these predominantly German Jewish women mirrored their gentile neighbors in conforming to the contemporary female ideal by retiring from business to keep house and raise children. As we have learned, east European Jewish women who immigrated to America after 1880 had already developed respected and often necessary roles as breadwinners and were

much more likely to accept employment in America. However, although Neu noted the surge in employment among Jewish immigrant women of east European background during that era, she reported that they were found most often in the larger urban centers of the East in the needle trades of the garment industry, generally earning meager wages to help support the family. Neu stressed that neither German nor east European women generally understood ambitious business ventures, though she listed a few "exceptional" women like Jennie Grossinger of hotel fame and beauty consultant Helena Rubenstein. Neu concluded her study on Jewish businesswomen by noting their "scarcity" in American history, which she maintained was attributable in large part to women expending their energies on club and social work, cultural pursuits, and teaching.[26]

However, in the American West between 1850 and 1930, many Jewish women did take a leading role in family businesses, often working beside husbands and fathers, some venturing out on their own, with a number becoming independent entrepreneurs. They certainly were not "scarce." Although the women's names are frequently absent from census records or city directories, photographs in archives throughout the West bear testimony to countless females who worked behind the counter of grocery and dry-goods stores. It is interesting to note that one of the primary examples of the few prominent American businesswomen that Neu noted was Tillie Ehrlich Lewis, a Jewish New York City garment worker who went to work in 1913 at the age of twelve, later moved west, and in the 1930s opened a tomato cannery in California that earned her a fortune as the owner of Tillie Lewis Foods, Inc.[27]

By introducing the Italian pomodoro tomato to Stockton, California, Tillie Lewis initially established the successful Flotill Products Company with an Italian partner, later developed Tillie Lewis Foods with the help of Meyer Lewis, her manager and eventual husband, and in 1951 was named the Business Woman of the Year by the Associated Press Newspaperwomen. When Tillie sold her company to Ogden Foods in the 1960s, she received almost $9 million from the sale and was elected the larger company's first woman director. In addition to being successful in business, Tillie Lewis was a strong supporter of Jewish and secular philanthropic causes. In her will she left sizable bequests to Stockton's Temple Israel, the University of the Pacific, and the Hebrew Free Loan Association of San Francisco.[28]

Before the middle of the nineteenth century, the property rights of

American women generally followed the English common law of coverture, which practically speaking merged a married woman's legal identity with that of her husband. Single and widowed women enjoyed relative economic freedom in this area. Beginning in 1839 with a limited Mississippi law primarily related to slaveholdings, state legislatures across America only gradually passed laws enlarging the economic rights of women. In 1860, New York passed one of the more comprehensive Married Women's Property Acts. However, influenced by Spanish and Mexican civil law, California, Colorado, and other western states were among the earliest to recognize women as separate traders. In eastern states, married women were battling for the right of contract until the 1880s, and not until 1895 could married women in all states hold property in their own names. Before the passage of married women's property acts, only a small number of women operated independently as "feme sole traders," albeit with the permission of their husbands. Western women were prominent among them.[29]

One of the earliest Jewish woman who operated her own business as a sole trader was Caroline Tannenwald, who ran the Round Tent Store in the mining supply town of Placerville, California. She had purchased the enterprise for $8,000. The 1849 California constitution had made provisions for married women to own property in their own names, and an 1852 California statute, unlike the law in many eastern states at the time, allowed married women also to own businesses in their own names. In March 1856, Caroline filed her "intention to carry on in my own name and on my own account the business of buying and selling and trading in Clothings, dry goods and gold dust." Between 1852 and 1870, eleven wives of Jewish merchants in the California mining district of Tuolumne County filed documents recording sole ownership.[30]

At about the same time, Bavarian born Nanette Conrad Blochman, whom we met in the previous chapter, was presiding over Mrs. E. Blochman Millinery in San Francisco while her husband experimented with a variety of business ventures, including dairy farming. In his 1870 memoirs, her son Lazar Blochman recalled his mother's ability to make "a fair living for us," and asserted that "I certainly admire my mother's incessant work in business, as well as raising a family of 5 children." Despite financial pressures, as an observant family the Blochmans kept the shop closed on the Sabbath and on Jewish holidays, but assisted by "her trained milliners, established a reputation as a fancy milliner and had a wide scope of customers."[31] Like so many of her Jewish contem-

poraries in the West, Nanette Blochman melded a private role as mother and wife with a public role as businesswoman, at times the primary support of her entire family. Being the proprietor of her own business allowed her and many other married, widowed, or divorced women in the American West the more "flexible" opportunity to tend to children and household duties while earning an income.[32]

Just a few years after Caroline Tannenwald had filed her intention to open a business in Placerville, Amelia Dannenberg of San Francisco became a highly successful and independent manufacturer of children's clothing and later of ladies' suits and cloaks. Amelia was born in 1829, and she and her husband Joseph had immigrated to the American West from the Rhineland. At first importing fine embroidered infant items from Europe, by 1860 she had opened her own profitable factory. She was soon recognized as an award-winning manufacturer of baby clothing, and her husband was involved in the sales side of the business.[33] Dannenberg's story demonstrates that the contemporary market economy in America could transform even "feminine" occupations connected to "women's work" into "wealth accumulation."[34] Moreover, while some women participated in businesses that were considered men's sphere, many women created enterprises, either on their own or with their husbands, that were geared particularly toward women's needs, such as Fanny Brooks's millinery store or Amelia Dannenberg's infants' and ladies' wear factory.[35]

Although her clothing business was operated on a much more modest scale than that of Amelia Dannenberg, in 1882 Helen Levinson Newmark convinced her husband, Joseph Solomon Newmark, an often unsuccessful businessman who operated a tobacco store in Sacramento, to relocate to San Francisco. She persuaded him to "open a business there, of children's ware, etc. I would participate and we could, I hoped, support ourselves. . . . Our business was very good; a child from babyhood up to twelve years could find clothes here." Mrs. Newmark apparently possessed not only sound business sense but was an efficient supervisor and hard worker as well. She employed several seamstresses and recalled in her memoirs that when one of her Jewish neighbors returned home from work at the end of the day and passed the Newmark establishment, he would often remark, "Stop working, Mrs. Newmark, it is already nine o'clock. But I had to finish my work." Unfortunately, Joseph Newmark's decision to sell the business while Mrs. Newmark was out of town with a sick child plunged the family back onto

shaky financial ground. Back in Sacramento, the resourceful Mrs. Newmark took in boarders to pay off the mortgage on their new house.[36]

London-born Sarah Nathan Goldwater, grandmother of Senator Barry Goldwater, who ran unsuccessfully for president in 1964, operated her own dressmaking business in Sonora, California, before settling in San Francisco, clearly independent from her husband Mike (Michel) Goldwater. "Big Mike" Goldwater, born in Poland, had followed the Gold Rush to California in 1851 with his brother Joseph, but one bankruptcy followed another until he finally founded the successful Goldwater Department Store chain in Arizona. In 1885 Michel Goldwater was elected mayor of Prescott, Arizona. Sarah Goldwater remained in San Francisco raising their eight children, with regular visits from her husband until he moved there permanently when he retired. In 1877, for example, the local Arizona newspaper reported that Goldwater "arrived in San Francisco today, where he intends to remain four or five weeks, and be present during the Jewish New Year and participate in the festivities attendant thereto."[37] While Jewish men in the West were often away from home for extended periods of time as they traveled on business, the Goldwater arrangement stands out as being highly unusual.

By 1870 the mining supply town of Eureka, Nevada, was the home of at least a half dozen Jewish businesswomen, all of whom operated their enterprises separate from their husbands. As was the custom of the era, however, in city business directories and in newspaper advertisements, the first names of married women were often not listed. Thus, Mrs. S. Leventhal, Mrs. Solomon Ashim, and Mrs. M. A. Ashim all ran local grocery stores, the latter selling dishes as well as fish and poultry, and Mrs. David Lesser's shop specialized in fruit. Sarah Loryea sold millinery, and she and restaurant and boardinghouse operator Regina Moch were probably the most successful entrepreneurs of the group.[38] Since the total Jewish population at the time was only around one hundred, the number of independent Jewish businesswomen in Eureka is striking. In addition, there were probably other Jewish women who assisted their husbands, fathers, or brothers in a family business. It appears that not only did the West provide significant commercial opportunities for women, but that the frontier environment sometimes required their participation, as we have seen in the case of Anna Solomon.

In 1877, during his travels through the West, Isaac Mayer Wise visited the mining camp of Eureka, with its one main street of stores,

hotels, and saloons. Although Wise was condescending about the some-
what primitive town, which he described as "this hole in the moun-
tain," he was most impressed by the boardinghouse and Parker House
restaurant run by Mrs. Moch. Praising his hostess he observed, "We
went to the restaurant of Mrs. Moch, and to our surprise, there was
served a breakfast than which one could not find better at Delmonico's
in New York. . . . The table set by Mrs. Moch was far superior to any-
thing we have seen outside the largest cities."[39] As we have seen, when
Mrs. Moch's husband, John, was killed in 1879 in a savage fire in Eu-
reka, which destroyed many buildings including their restaurant, with-
in a month the resilient woman was back at work, advertising "Mrs.
Moch's New Restaurant."[40] In the 1880 state census, Regina Moch's
age was given as forty-five, and her profession was listed as "restauran-
teur."[41] Similarly, Annie Stargarth Mitchell took over the running of the
family hotel near Visalia, California, when her husband passed away.
After Annie's marriage to Levi Mitchell in Stockton in 1866, the couple
traveled by stage to the mining village of Tailholt, and she joined him in
his business, the White River House hotel, while raising four children.
Annie became the primary cook, supervising Chinese servants, and con-
tinued the business on her own when Levi died in 1885.[42]

At least one of Eureka's Jewish businesswomen, Sarah Loryea, had
first made a successful living in Virginia City, Nevada, in one of the
thriving but transient mining towns on the Comstock, for a time em-
ploying two female assistants. Her story demonstrates both the popular-
ity of fashionable clothing in the frontier West, where apparently Vic-
torian clothing dictates were still influential, and the extreme mobility
of the region's Jewish women and their families as they moved from
place to place, often following economic opportunity in boom towns
only to move again in "bust" cycles. Fashion often reflects broader so-
cial history, and it is likely that the popularity of feminine accouter-
ments such as intricately decorated bonnets and gowns demonstrated
for many women that even within rough mining communities they
could incorporate what they considered "civilized" touches. Moreover,
as one historian has observed, the custom fashion trade created a "fe-
male economy," in which women were the principal actors as propri-
etors, workers, and consumers.[43] Jewish pioneer Mrs. Loryea was the
first milliner to advertise in the Comstock region. As early as 1861 she
offered the latest styles in bonnets as well as French flowers and fine
merino cloth, while her husband pursued separate business interests as a

partner in a saloon. In Virginia City, Sarah Loryea also diversified her stock to include "Ladies Fine Cloaks, Dry Goods, Fancy Goods, Perfumery, Stationery, Fine Crockery, Glassware." Mrs. Loryea seems to have been an ambitious businesswoman, also operating a dressmaking and millinery shop in Carson City, Nevada, where she made "ball Dresses of every description."[44]

More unusual in the field of millinery was the husband and wife team of Louise and E. Jackson, Jewish immigrants from Russia and Prussia, respectively. In an area that was known for rapid population turnover and transience, their prestigious bonnet, hat, and fancy-trimmings business flourished for over ten years on Nevada's Comstock in Virginia City. Louise passed on her millinery skills and training to her daughters, a common way for women to insure that their offspring could make a living if necessary.[45]

As we have seen, millinery was a popular business throughout the West, and the purchase of luxury goods in boom towns apparently found a ready market. Although historian Wendy Gamber has focused on the millinery and dressmaking trades in the Northeast and Midwest, she has observed that before the turn of the nineteenth century "dressmakers and milliners were everywhere," and while "fashion" may have been oppressive to some women, it created significant opportunities for others to become businesswomen as proprietors of their own shops.[46] In the early 1880s, a Mrs. Gotthelf operated an exclusive establishment in Tombstone, Arizona, in the local mining region. In September 1882 the local newspaper reported that "Mrs. Gotthelf arrived home on Thursday and her many old customers will be pleased to know that while absent, she purchased one of the finest assortments of hats and millinery goods ever brought to the territory. Evidently she has great faith in the future prospects of our camp judging from the expensive stock of millinery goods she has purchased."[47] Another early Arizona woman also demonstrated business acumen. Dora Loon Capin and her husband Hyman together expanded his tailoring shop into a retail clothing business, and eventually the family operated a major hotel chain that earned them a fortune.

Women in the Midwest followed a pattern similar to those in the West, and while both groups "ignored some of the northeastern dictates of true womanhood," they operated simultaneously as "women on the edges of their sphere, with one foot in the male world of profit-seeking, but the other firmly planted in a world of tradition and female cul-

ture."[48] In the South, prevailing cultural patterns generally mitigated against active early female involvement in business. A recent study of Jewish women in Savannah found that Jewish "husbands and fathers dominated the business world" and that "few women in Savannah's Jewish community were able to participate in such pursuits," although some took in boarders, often with the assistance of live-in servants.[49]

Jewish women in the American West also often balanced their economic and family roles. However, one of the West's most unusual and more radical early Jewish female entrepreneurs, Anna Rich Marks, who arrived in the Utah Territory in the early 1870s, cast her business net far beyond an occupation that drew on traditional "woman's work." Born in Russian Poland in 1847, Anna immigrated as a teenager, first to London, where she married Wolff Marks at the age of fifteen, and then to America. In Utah, Anna took advantage of opportunities unheard of for women in the East. After establishing a successful dry-goods business in Salt Lake "with the assistance of her husband,"[50] Anna and her spouse moved to Utah's Tintic mining district and settled in Eureka City in 1880, with Anna "in the lead in a buggy followed by many wagons loaded with everything necessary to open a store."[51]

"In the lead" was an apt description of Anna Marks's style of business and of her relationship with her unassuming husband. Reputedly not averse to carrying a gun and using it to get her point across, Anna Marks was a tough negotiator. Before her death in 1912 she owned the controlling interest in two mines in her own name, the Anna Rich and the White Cloud, made a fortune in real estate in Salt Lake City and Eureka, and held profitable independent investments in diamonds.[52] At about the same time that Anna Marks was building an empire in Utah, Rose Reznick Danoff worked beside her husband and brothers-in-law in the family store as an Indian trader in Gallup, New Mexico. Her nephew later recalled that Rose, who spoke Zuni and Navajo fluently in addition to some Spanish, was a "terrific Indian trader, "and in the store Native Americans were paid "top price for their goods because we anticipated making a fair profit on what we sold them."[53]

The careers of sisters Hattie and Minnie Mooser combined elements of traditional "women's sphere" domestic roles with new business opportunities. Both women were born in Nevada, Hattie in 1878 and Minnie in 1881, but grew up in Sacramento and lived in Los Angeles before ultimately moving to San Francisco. The Mooser family had always taken a keen interest in the theater, and Mrs. Mooser often took

her teenaged daughters to San Francisco to attend the opera or theater. As an adult, Hattie also became especially interested in child welfare and served as a volunteer with the local juvenile court. She also worked with the Red Cross during the famous 1918 flu epidemic to help organize food centers for victims of the disease. Later she recalled soliciting ninety gallons of soup each day from local restaurants and city clubs to provide needed food. Hattie also went on to found San Francisco's first children's theater in 1918.[54]

In 1921, Hattie and Minnie Mooser opened the Aladdin Studio Tiffin Room in Chinatown, which evolved into San Francisco's first restaurant supper club and catered to a theater and art clientele. The business prospered because of the warm and gracious personalities of the two sisters. They began the enterprise by serving a highly popular fifty-cent luncheon and leaving evenings open for fund-raising events for charitable groups. Their tearoom was one of the first to give jobs to young Chinese women and men as waitresses and busboys. A few years later, the Mooser sisters started the Aladdin nightclub during Prohibition, but the business failed because their refusal to sell liquor put them at a severe disadvantage alongside bootlegging clubs. After they closed their business, they managed a restaurant near San Francisco's famous Golden Gate Park.[55]

Another western woman who ventured beyond more traditional female commercial roles was Jennie Harris of Oakland, California. Born in Vilna, Lithuania, in 1893, Jennie's family immigrated to America when she was a child of eight, and she arrived in Oakland in 1903. While still in her early twenties, in 1915 Jennie Harris established her own business, a long-distance hauling and storage business called the No-D-Lay Transfer, Express and Storage Company and later also went into the used furniture business.[56] Just out of school, Jennie Harris went to work for a moving and storage company as a clerk to help support her mother and sister, earning a very modest salary of ten dollars per week. Having learned quite a bit about the actual moving operations through her office position, she soon decided she could do better on her own. In 1915 she used her total savings of five dollars to hire two men and a horse and wagon and launched a successful business that ten years later included a fleet of trucks, and her net worth was estimated at $35,000.[57]

Her unusual career sparked interest from many diverse contemporary magazines, ranging from *Sunset* magazine to *The Motor Truck*. An arti-

cle in a 1928 issue of *How* magazine noted that part of the secret of her success was that female clients liked the idea of putting their furniture and household items in the capable and caring hands of another female who understood how they felt about their prized possessions. The article also pointed out that Jennie Harris was one of only three women in the entire country who were operating similar enterprises. When Jennie was asked if she had any trouble getting men to work for her, she replied, "I ask a man at the outset if he is willing to work for, and to take orders from, a woman, if he is not, we never begin. But most men don't care, so long as they get union wages and are treated squarely." She emphasized that although she was a fair and generous employer, she maintained strict standards and each new employee was given a typed set of rules and regulations.[58]

While the extraordinary success of Mary Ann Magnin in San Francisco and Jeanette Meier in Portland was not the norm for most women, they demonstrate the possibilities available for western Jewish women, and it is more appropriate to view them, as more recent historians of exceptional businesswomen in America have, as "representing points on a wide spectrum of women's business activities and contributions."[59] Born in Holland in 1848 and married at the age of sixteen in London to Isaac Magnin, Mary Ann Cohen Magnin is an example of a forceful woman in the American West who used her creative talent and management skills to create a fashion empire. In 1875 she journeyed to San Francisco by steamer in steerage with her husband and seven of their eventual eight children. In the thriving metropolis, Isaac found limited work as a fine gilder and Mary Ann utilized her talent as a skilled artisan in the detailed embroidery of baby clothing, bridal wear, and lingerie to augment the family's income. In 1877, Mary Ann expanded her small shop and established I. Magnin in San Francisco. While the business bore the name of her husband, it was Mary Ann, with her eye for innovation and shrewd business sense, who was the real power in the enterprise, and she personally supervised the purchase of all merchandise. As her grandson later recalled, "[It was] really her store." For a time after the infamous 1906 San Francisco earthquake destroyed the I. Magnin building, she directed the transfer of merchandise to her home, and the business continued operations virtually uninterrupted. The fashionable fancy clothing trade was a lucrative undertaking in a city where an elite upper class society had developed, and by the time Mary Ann Cohen Magnin handed over the business to her sons

when she formally "retired" in 1900 (although she still made a daily appearance at the store), the luxury women's clothing empire had developed a national reputation.[60]

In Portland, Oregon, Jeanette Meier played a similar role as the power behind Meier & Frank. Aaron Meier had already operated a small general store in the modest-sized town of some thirteen hundred residents when he traveled back to his birthplace of Bavaria in 1863. He soon returned with his new bride, Jeanette Hirsh, to find that his business had collapsed in his absence and that he needed to start over once again. Although Jeanette raised the four children born to the couple (one daughter died in infancy), it was not long before she set her hand to expanding the business, and several of her relatives were brought in to assist, as was a new partner, Emil Frank.

Like many of the West's Jewish businesswomen, Jeanette Meier was also involved in Jewish communal affairs. When a group of Jewish women in Portland initiated plans for a sheltering home for Jewish children whose parents were too ill to care for them, to insure that a "Jewish child should be reared in a Jewish institution," they turned to Jeanette for financial support and leadership. According to one report, "through her aid and influence all obstacles were removed." A nineroom home was purchased on Corbett Street along with an "isolation house" for ill children donated by Mrs. Meier, and in July 1919 the first group of children was admitted.[61] On the occasion of her eighty-first birthday, Jeanette Meier personally paid off the mortgage along with all accrued interest on Portland's Jewish Shelter Home for children. To honor her generosity, the board of the home elected Jeanette as an honorary president.[62]

By the time Aaron died in 1889, Jeanette Meier was the often autocratic matriarch of Meier & Frank, the largest department store in the Pacific Northwest. One of her great-nephews later recalled regular Sunday evening family meetings where "my great-aunt, Jeanette Hirsch Meier, got up at the head table and told each of these men exactly what they were going to do and how they were going to do it."[63] To cap the family's economic and social success, the Meiers' youngest child, Julius, was elected governor of Oregon in 1930.

Jewish women who "helped out" in the family business in the West were certainly not unusual, but few businesses achieved the financial success of the one owned by the Zellerbach family. When Jennie Baruh, the daughter of Rosalie and Aaron Baruh of Nevada City, California,

married Isadore Zellerbach of San Francisco in the 1880s, she probably never dreamed that at her death in 1965 at the age of ninety-three she would leave a personal fortune of over $10 million dollars, more than half of which she donated to charity. Isadore's father had operated a growing paper company in San Francisco in the 1870s, and after Isadore became president, the younger Zellerbach negotiated a merger that resulted in the Crown Zellerbach Corporation, one of the largest paper companies in the world. In the early days, Rosalie kept the books for the growing enterprise while juggling her responsibilities as a wife and mother.[64]

East European immigrant Hannah Robison and her daughters as well as sons all worked in the family dry-goods establishment, a "mini-department" store, presided over by her husband Lazarus Robison in the first decades of twentieth-century Portland, Oregon. Like so many Jewish immigrants, by utilizing the labor of family members instead of hiring outside help, the Robisons managed to build a successful business. When a new building was later erected for Portland's Jewish old age home, major funding was donated by Hannah's sons, prompting the renaming of the facility to the Robison Home for the Aged in honor of Hannah and Lazarus.[65]

In the late 1920s, Portland's Russian-born Rosie Schnitzer and Jennie Wolf were formally and legally listed as co-partners with their husbands in their profitable joint endeavors, the Alaska Junk Company and Schnitzer-Wolf Machinery Company "in consideration of the love and affection" of their spouses. While the "active management and control" of the enterprises was vested with the men, Rosie and Jennie each received a quarter interest in the businesses and were "entitled to share in the profits and losses equally."[66] The proceedings of a later court case involving the two families and the Internal Revenue Service reveal fascinating details about just how influential Rosie and Jennie were in the businesses. The court ruled that the two women should be considered as partners for tax purposes because "negotiations on important transactions and decisions about new ventures were not made at the office but at the partners' homes, with full participation of the wives." Furthermore, not only had Rosie and Jennie brought capital to the early business, but "Jennie Wolf, in particular, and her better education and business acumen, appears to have exerted decisive influence over business discussions, not only at the humble beginning when her husband was very dependent upon her, but increasingly over the years."[67]

In the small railroad town of Pocatello in southeastern Idaho at the turn of the century, Harry and Ida Jacobs together operated the Jacobs Department Store, which at first carried men's and women's ready-to-wear clothing and later became an exclusive ladies-wear shop. Although the Jewish population in Pocatello was tiny, the Jewish High Holidays were celebrated in private homes, and in 1901 services were hosted by Harry and Ida. In 1915 the family moved briefly to New York City because of the ill health of one of the children, but before long Harry returned to Idaho and opened branches of the Fashion Shop in Twin Falls and Burley. Before joining her husband in Idaho, for a time Ida served as the buyer for the business in New York City.[68]

As previously noted, with the arrival of larger numbers of east European Jews in the American West after 1880 came a concurrent rise in Jewish women involved in business. Although, as we have seen, the West was home to a number of notable women in pioneer settlements in the region, the majority of the predominantly middle- and upper-class women of the era did not work outside the home. It bears repeating, however, that the Jewish business pattern, particularly in eastern Europe, had included the central role of women in the marketplace, and they were highly visible in America as well. The presence of Jewish women in Washington Territory, for example, by the end of the 1880s included Flora Goldberg, who sold liquor there, and the affluent women of the successful Schwabacher merchandising clan. Most notable among them was Babette Schwabacher Gatzert, Bavarian-born wife of Seattle's mayor, who co-owned many of the family's real estate properties and also took an active role in the business after her husband's death. Seattle's Caroline Kline Gallard also owned property in her own name and played a similar role when she assumed managerial responsibility for the family business when her husband passed away. She was also highly active in philanthropic projects in the Jewish community. When she died, most of her large fortune was left for the establishment of a home for the aged and poor.[69]

Most common at and after the turn of the century throughout America were situations in which east European Jewish women and their daughters ran their own small stores or worked in increasingly acceptable positions as sales clerks and office assistants in the numerous department stores that were springing up to meet the demands of increasing consumerism. In the central Appalachian coal fields in parts of Virginia, West Virginia, and Kentucky, east European Jewish women

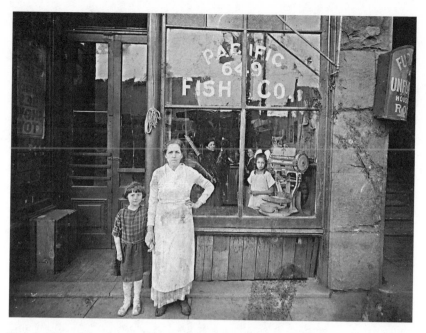

Dora Levine and daughter Esther in front of her fish market, Portland, c. 1910. (Courtesy of the Oregon Jewish Museum Archives.)

worked alongside husbands and fathers in small stores and businesses, sometimes operating their own grocery and dry-goods stores, and were often crucial to the financial stability of their families in an unstable local economy.[70] Of course, Jewish women, while highly prominent, were not the only immigrants to engage in business. For example, Italian women occupied similar roles around the country. In a study of the Italian community of Milwaukee, Wisconsin, at the turn of the century, the predominant ethnic groups engaged in business were found to be Italians and Russian Jews. Italian women operated as grocers, restaurateurs, saloon keepers, and dry-goods owners. Like many Jewish women, they combined their business work with domestic roles as wives and mothers. In Milwaukee, the majority of married Italian women operated their businesses independently of their husbands.[71]

Dora Levine of Portland, Oregon, is a particularly colorful example of a western woman of east European origin who ran her own small but thriving business. Arriving in the city in 1910, Dora soon purchased a fish market for one hundred dollars and operated Levine's Fish Market

for nearly three decades in the immigrant Jewish neighborhood. Her children helped, while her husband Ephraim served the community as a shochet. Dora's day began at 5 A.M., when local women began to knock on her door to purchase fresh carp, salmon, and whitefish; at night she was often still personally delivering orders. Thursdays and Fridays were her busiest days as the store was crowded with shoppers who were preparing for the Sabbath, when her store was closed. Still, she made time for her children and was involved in the Jewish community as an active member of her synagogue and Hadassah. Dora later recalled, "Twenty-eight years I worked night and day, day and night for twenty-eight years."[72] Portland was also the home to Sara Neusihin, sister of the longtime spiritual leader of the Orthodox Congregation Shaarie Torah, Rabbi Joseph Fain. Like Dora Levine, Sara used her domestic-based talent to launch her business enterprise, assisted by family members. Her company, the popular and famous Mrs. Neusihin's Pickles, grew out of early efforts in her basement in South Portland's immigrant neighborhood.[73]

In Denver, one of the most popular enterprises for east European Jews was the creation of small corner grocery stores, often "mom and pop" operations, with the emphasis on the women. In 1907, Annie Orlinsky Miller ran a successful neighborhood grocery to support her small children and a disabled husband who had moved to Colorado to "chase the cure" for tuberculosis. From 1915 to 1945, Rose Cohen oversaw the day-to-day operations at the family grocery located in Denver's West Colfax east European enclave and encouraged her son, who became an attorney and later a judge, to stay in school. One woman recalled that in the 1920s her grandmother, Becky Levin, operated a small grocery store in the front room of the family's home while her husband operated a barber shop a block away. According to her granddaughter, Mrs. Levin wore a white apron all day and cooked and cleaned for her family in the back of the house, hurrying to the front room to "serve the trade" when the bell rang to signal the entrance of a customer.[74]

As we learned previously, Fanny Jaffe Sharlip arrived in the United States from Russia in 1889 as a young girl and began her working life in a factory in Philadelphia at the age of twelve. For several years she toiled making vests in a sweatshop, where she soon contracted incipient tuberculosis, the disease that had killed her father. After her marriage to Ben Sharlip, the couple moved to Los Angeles at the turn of the cen-

tury in search of better health. Fanny Sharlip was apparently the businessperson in the family. As a child in a Philadelphia public grammar school, she had excelled in arithmetic, and her talent for mathematics stood her in good stead in later life. While her husband tried to "find himself" in Los Angeles, Fanny took matters into her own hands: "I could see that there was gold to be made here, but we didn't understand how. I found a store that had just been completed. . . . It seemed like a respectable middle-class neighborhood where a grocery store would do well." Fannie made a good impression on the landlord, and with her toddler daughter in tow, canvassed the housewives in the area to see if they would patronize her store.[75] Although her husband contemplated going into a different business with a new acquaintance, Fannie informed him, "No, you're going into business with me." Eventually the enterprise flourished, and Fannie and Ben's business expanded to a dry-goods and hardware store, and soon they were able to purchase the property. The friendly and engaging couple turned their store into a neighborhood hub, which "served as an advisory bureau, information center, a real estate office, a post-office and a bank."[76]

Sometimes the "businesses" undertaken by Jewish women could be quite modest indeed but were still necessary for family income. In the hamlet of Vernal, Utah, in the first decades of the twentieth century, Claire Steres Bernstein recalled that her father barely eked out a living trading in furs and hides. To supplement the family's income, her mother "took care of the garden, raised vegetables and helped support us by baking bread," getting up in the middle of the night to set the bread and then baking several times during the day.[77]

The evidence suggests that women in the West, Jewish women among them, who were engaged in commercial enterprises were predominantly married women and sometimes widows who worked to augment the family income, to experience a degree of autonomy, and to utilize their creative and business talents. For example, in the small urban mining frontier town of Helena, Montana, while most wives and mothers were formally listed by census takers as involved in "keeping house," by 1880 more than 27 percent were taking in boarders, 40 percent owned property of their own, and by the late 1890s well over a hundred, including Jewish milliner Mary Aaron, operated independent businesses.[78]

Similarly, over a decade later the Cheyenne, Wyoming, *City Directory* for 1913–14 listed Mrs. Sara Garlezky as the proprietor of the Philadelphia Bargain Store, while one son was listed separately as a

clerk in another business. She and her husband, Louis, had arrived in Cheyenne in 1905, and when Louis passed away in 1909, she continued successfully to operate the men's clothing store until her death in 1916. Sara was one of the original supporters and members of the Orthodox Mt. Sinai congregation, which built Wyoming's first synagogue in 1915. Her son, Dave Garlett, later recalled, "Our home was a haven for any in need. Our mother always had food, clothing, a room, and some money plus a cheerful word to all those in need."[79] Also in Cheyenne, Mrs. Esther Veta operated a dry-goods store listed independently of her husband's junk business, and another relative, Mrs. Rose Veta, was described as a grocer and the proprietor of the Western Junk and Bottle Yard. Bertha Myers, wife of William Myers, the successful owner and president of Cheyenne's Myers Dry Goods, was listed as the treasurer of the company, although it may have been an honorary title.[80]

Like Fanny Brooks, Babette Gatzert, and Caroline Gallard, other Jewish women on the frontier were property owners in the region. As early as the mid-1850s, Hannah Jacobs of San Diego, whom we met in the last chapter, owned real estate in Old Town in her own name as well as stock in the San Diego and Gila South Pacific and Atlantic Railroad Company.[81] After Rachel Cohen married Isadore Strassburger in 1867 in a civil ceremony followed by traditional Jewish rites in Virginia City, Montana, the couple became leading citizens in the gold-mining town. The wedding guests included the governor of Montana and other local leaders. Some years later, Rachel Strassburger purchased in her own name a lot from Virginia City's mayor and later donated land to the local Catholic Church so they could build a hospital.[82]

The purchase of property as a vehicle to increased economic prosperity appealed to many western Jewish women. The Veta family, for example, arrived in Cheyenne in 1906 from the Russian Ukraine, and Johnny Veta recalled that his grandfather and father began as laborers for the local Union Pacific Railroad. However, it was his grandmother Ada who "managed the finances of the family. She'd saved my father's check, and they lived on my grandfather's check. When she accumulated enough for a down payment, she bought a piece of property," and later additional savings launched the family into their own businesses.[83] Born in Russia in 1887, Nancy Goodman Rafish immigrated to America as a young woman to join two older siblings in Livingston, Montana, where her older brother was a fur and hide dealer. In 1919, Nancy married Harris Rafish, an older widower, who worked as a tailor in Butte,

Montana. Rafish had four grown daughters from his first marriage, and Nancy and Harris later became parents of a son and daughter. In Butte, Nancy supplemented the family income by taking in a few boarders. When her husband died during the Great Depression, she used the family's modest savings to purchase a boardinghouse, where she fed and housed miners for fifty cents a day. Before long, Nancy Rafish, who never learned to read or write English, owned twenty-eight separate pieces of property in Butte.[84]

Despite the apparent predominance of married Jewish businesswomen, Hannah Levy is an unusual example of an unmarried Jewish woman in the American West who built a business empire from a small store. Although she remained single her entire life, she operated within the backdrop of a supportive family structure. Born in 1905 in southern Germany, Hannah and two brothers immigrated to America in the 1920s because of the extremely depressed economic conditions at home. After a few years of working as a shop girl first in New York City and then in Denver, where the entire family was reunited by the late 1920s, Hannah Levy and her brother Jack opened a small hosiery store, with Hannah as the chief buyer for the business. The modest enterprise eventually evolved into the Fashion Bar corporation, and by the 1980s the Levys employed over seventeen hundred people in eighty stores spread across the West. One of the divisions was named Hannah after Fashion Bar's co-founder and co-chair of the board, who was by then a leading Denver philanthropist in the Jewish and general community. She continued to take a leading and active role in the business until her death in 1994. As the matriarch of the large Levy clan, Hannah Levy loved children but never married, and her brother Jack commented that instead "she gave birth to Fashion Bar." In an interview at the age of seventy-nine, she looked back over her long career and observed, "In this business you really have to live it and put your whole heart into it."[85]

Later, another Coloradan, Ruth Mosko Handler, born in 1916 to east European immigrant parents and raised in Denver, co-founded the enormously successful Mattel Toys, where Ruth introduced the Barbie Doll. Her father, Jacob Mosko, a blacksmith, had arrived in Denver in 1905 and within a few years sent for his wife and the six children who had been born in Europe. As the youngest of the eventual ten children, Ruth developed a taste for business in her older sister's drugstore. After her sophomore year at the University of Denver she dropped out to marry Denverite Izzy Elliot Handler, and the couple moved to Los

Hannah and Jack Levy in front of the Fashion Bar Store in Denver, c. 1950s. (Courtesy of the Beck Archives, Penrose Library, and CJS, University of Denver.)

Angeles, where they partnered with Harold Matson to start the business enterprise that evolved into the toy empire.[86]

As an aside, it is interesting to note that unlike Jewish women in the East and Midwest, few western women were employed in the clothing industry as factory workers, largely because such work was rare in the region, with the exception of Los Angeles, which had several thousand small clothing factories. However, while these women were engaged in the marketplace, by no means could they be considered "business" women. From 1920 through the early 1930s, many Jewish female east European immigrants in Los Angeles were employed alongside Italian,

Mexican, and American women and men as garment workers, mostly in men's clothing production, and Jewish women were prominent in the local trade union movement. However, younger Jewish women, armed with an American education, were encouraged by their parents and the Jewish middle- and upper-class community to forsake factory work for white-collar employment in the sales and clerical fields.[87] Indeed, between 1890 and 1930, women's work in America in general underwent significant changes, one of the most important being the emerging white-collar clerical occupations that were tied to the increasing levels of higher education for females.[88]

The preponderance of western Jewish women in clothing- and food-related enterprises suggests that they may have entered these "feminine" areas partly as a strategy that allowed them to be seen as nonthreatening in a male-dominated business world. Once they had their foot in the door, Jewish women in the American West broadened traditional roles as wives and mothers, and, using household skills such as cooking and sewing, many became at least moderately successful boardinghouse operators or milliners and seamstresses, among other related enterprises. These were considered respectable occupations for women, but it is clear that they could also be profitable. A small but significant number of women, such as Anna Freudenthal Solomon, Jeanette Hirsch Meier, and Mary Ann Cohen Magnin, parlayed their domestic roles into highly successful commercial enterprises, while others like Anna Rich Marks and Jennie Harris insisted on entering businesses that had traditionally been reserved for men.

As we have seen, the involvement of Jewish women in business has long been a tradition, one they continued in the early American West. Some western Jewish women worked in traditional roles as homemakers, some worked alongside their husbands and other family members in family businesses, and those who were bold or enterprising enough to operate commercial enterprises of their own had ample opportunity to prosper economically. In the early American West, Jewish women were able to take advantage of the sometimes uncertain but diverse and burgeoning economy to carve out an economic niche for themselves, largely in businesses that primarily served women, children, and families in a growing region that offered a welcoming environment. Women's wages were generally higher in the early West than in the East because women were a distinct minority in the region and therefore domestic skills could command higher pay, and economic partnerships

between husbands and wives were also more common. As one historian has observed, the increasingly urbanized and thriving western frontier offered women more opportunities to make money than in similar areas in the East, and "provided women with the opportunity to distinguish themselves as capable individuals."[89] Jewish women in early towns and cities throughout the American West often proved themselves to be among the most innovative, hardworking, and self-reliant, demonstrating a remarkable degree of entrepreneurial acumen.

6

Scaling the Ivy Walls and into the Professions

"This is woman's golden era." These are the words with which seventeen-year-old western Jewish female journalist Alice G. Friedlander concluded her speech on women's rights before the Portland Press Club in Oregon in 1893. Asked to speak at the group's banquet, the young woman not only maintained that "in the newspaper office woman finds a clear field," but that "the time is near when women will vote and hold office," and "the law, medicine, education—every walk in life requiring intellectual rather than manual force is wide open to the women of America."[1] While many women in the country may have found Alice's words overly optimistic and perhaps naive, by the 1890s the women's sphere was undoubtedly enlarging, and in the American West some women were already given the right to vote. Others were taking advantage of higher education and entering professions that had previously been the exclusive province of men. For example, in Washington State as early as 1882, Julia Heyman Bauer became a professor of languages at Whitman College. Less than two decades later, in 1901, Bella Weretnikow Rosenbaum graduated from the University of Washington's law school and was admitted to the bar the same year, the fourth female and first Jewish woman to practice as an attorney in the state. In 1905 Sarah Vasen Frank was a physician and superintendent at the Kaspare Cohn Hospital in Los Angeles.

Young Jewish women in the early American West benefited from the region's generally progressive attitude toward female education. In a 1924 newspaper interview, Harriet Ashim Choynski, who had arrived in San Francisco as a child in 1850, recalled that in the early 1860s, "The big fuss then was whether or not a girl was going to be ruined by going to high school. I am proud to say that San Francisco decided against that nationwide prejudice and pioneered in girls' education."

Harriet graduated with the first class of thirteen students from the General High School of San Francisco in 1861, taught Jewish religious school for a time, and married journalist Isador N. Choynski in 1862.[2] Between 1870 and the turn of the century, increasing numbers of women began attending secondary school in America, primarily in public high schools, and by 1900 female high school graduates outnumbered their male counterparts.[3] It is noteworthy that over the decades high school enrollment for western females remained consistently high, and in 1900, according to the U.S. Commissioner of Education, the percentage of females enrolled in high schools was the highest in the West, slightly higher than in the Northeast and significantly higher than in the South.[4]

The West was also progressive at the college level. At the University of California, for example, in 1870, according to its Board of Regents, women were admitted "on equal terms in all respects with young men." By 1900, women made up about 46 percent of the student body, although their presence was not always greeted with enthusiasm by male professors, administrators, and students who feared the feminization of the university. The University of California was one of the earliest and largest of the coeducational institutions of higher learning in the West and had benefited from funds from the Morrill Land Grant Act, which enabled it to merge the former College of California (1855) and the Mechanical Arts College (1866) into a single new entity.[5] Jewish women in California were quick to take advantage of this opportunity for higher education made available to them in their own state.

Several all-women's colleges opened in the Northeast after the Civil War, including Vassar and Wellesley, but not until the 1880s did Columbia University launch Barnard for female students and Harvard University founded its annex for women, later named Radcliffe College. In the Midwest, the University of Chicago opened in 1892. Initially it offered an unusual opportunity for women to pursue higher education in greater numbers, but by the turn of the century it followed a pattern similar to that of most coeducational colleges. Because of a fear that women were overrunning the institution, in 1902 the university opened a separate junior college for freshmen and sophomore women. In the South, women had very limited access to higher education until at least the 1880s and 1890s.[6] Historian Amy Thompson McCandless has demonstrated that although opportunities for higher education expanded in the South between 1890 and 1920, southern culture mitigated against

widespread acceptance or high standards for women's schooling. Instead, it still emphasized putting "the lady on a pedestal" and a dual southern and American identity, and suffered from a backward economy. The majority of southern women in the late nineteenth century, especially black women, found it difficult to receive even an elementary-school education. The modest number of privileged white women in the South who were able to pursue higher education generally attended schools that were "colleges" in name only.[7]

Yet the 1862 Morrill Act allowed a number of western and midwestern states to establish state-supported land grant colleges that offered access to women. This widening door for women in higher education had an economic as well as ideological basis. The admittance of women boosted formerly small enrollments in states with only modest populations, and western government-supported schools were also responsive to taxpayers who often wanted their daughters as well as their sons to attend college.[8] Although women's suffrage has often been seen as the central factor in the advancement of American women, higher education was probably as important, if not more so. As one astute observer has noted, "It was, in general, access to the universities in the late nineteenth century that provided the key to the woman's cause, more than access to the vote."[9] In 1900, 15.2 percent of western women were professionals while only 8.1 percent of women held professional occupations nationally,[10] presumably reflecting wider opportunities for women in the American West during the era as well as the rapid economic development in the region.

The growing number of educated Jewish women professionals in the West reflected both the general trend in the region as well as Jewish cultural norms. In America, Judaism's traditional emphasis on men's sacred religious learning and the attendant need for literacy was soon transformed into general secular education as a highly valued central goal for girls as well as boys. Formal education for males often still took precedence, however, particularly when finances were limited and female work was necessary to help sustain a household. But the children of immigrant Jewish parents at the turn of the century exhibited unusually high levels of school attendance, even when the parents themselves lacked formal education and were impoverished.[11] From the beginning, most western educational institutions from grammar school to college were generally coeducational, reflecting both economic and population realities as well as an egalitarian spirit. In addition, as western Jewish

pioneer immigrant families became more financially secure, education appealed to many parents as a path to American acculturation and success for both daughters and sons.

Moreover, young Jewish students also benefited from the generally prevalent mutual tolerance in the West. In San Francisco, for example, as early as 1856 public school authorities discontinued prayer and Bible reading in deference to Catholics and Jews.[12] Jewish girls in the region usually attended public primary and high schools, but in some of the more elite social circles in cities such as San Francisco, private school attendance was not uncommon. There, for example, many middle- and upper-class girls attended Madame Ziska's and Miss Murison's schools, the former initially more of a finishing school and the latter an academically demanding institution, where young women were prepared for college through courses such as English, rhetoric, Latin, and science. As Melissa Klapper has pointed out, the kinds of schools young Jewish women attended during the last decades of the nineteenth century depended largely on class and location.[13]

Even in the American West, some middle- and upper-class young women were educated at home by governesses or in finishing schools at the direction of parents who felt "too much" higher education was unnecessary for women or a potential barrier to marriage. But attitudes gradually changed. In a 1982 interview, Belle Fligelman Winestine of Helena, Montana, who was by then an elderly woman of ninety-one, recalled that although her parents wanted her and her sister Frieda to attend finishing school so they could become socially accomplished, "Frieda was the one who said that instead of going to finishing school, we were going to college. . . . When our parents saw how terribly she wanted to go, they were willing to send her. And, of course, when she went, I would be the one to go too."[14] Many western Jewish daughters were able to convince their parents of the advantages of higher education.

Belle Fligelman Winestine graduated in 1913 with a degree in philosophy from the University of Wisconsin. She also studied journalism, became active in student government as the president of women students, and was a talented and popular orator. She was chosen as the first female commencement speaker. Just a year later, back in Montana, she became the first female news reporter for the *Helena Independent* and soon a prolific writer, a lobbyist for women's suffrage, and later an assistant to newly elected congresswoman Jeannette Rankin. Frieda,

whom Belle had called "the bright one of the family," became a linguist and poet. She studied for her doctorate but never received it.[15]

Within generally widening opportunities, for many Jewish women in the West and throughout America teaching was the earliest and most prominent path to the professions. Indeed, teaching earned the appellation of woman's "true" profession. Across the United States, teaching was initially considered the province of men, and when it devolved to women it became an often underpaid and unappreciated job. Still, teaching held the distinction of being the first middle-class profession for women. In the early 1800s, only 10 percent of teachers were women, but by the 1920s, 86 percent of American public school teachers were female. While it is true that the nineteenth-century domestic ideal was often used to justify teaching as the natural extension of homemaking and motherhood, at the same time it also allowed women to earn a living, a level of status and autonomy, the opportunity for higher education, and an entry into the public sphere.[16] Because American women were barred completely from or had limited access to other professions, and because they were influenced by Victorian notions of women as naturally suited for the instruction of children, teaching became an increasingly feminized profession by the turn of the century.[17]

In the last decades of the nineteenth century, the combined forces of industrialization, urbanization, and immigration brought an increased emphasis on the need for public education to prepare children for modern life, multiplying the need for more teachers just as women were more prominently entering the market economy.[18] Moreover, advanced education for women paved the way for entry into new jobs and professions that required higher-level skills.[19] Social historian Daniel Walkowitz has noted that at the turn of the century women were beginning to exhibit new expectations about work as a paid career, yet many went on to assume positions in the workplace that incorporated traditional female caretaking roles in such professions as teaching, nursing, and social work.[20] As another historian put it, even armed with college degrees, many Victorian-era women "cultivated domestic virtues" in their choice of professions, and only a small percentage chose or were able to enter areas considered at the time more suited to men, such as law, medicine, and architecture.[21]

Jewish women were members of an ethnic group that was highly attracted to new white-collar jobs and to the growing female profession of teaching in unprecedented numbers. As one historian has noted,

Jewish women as teachers became the "pinnacle of immigrant parents' aspirations for their Americanized offspring." By 1920, for example, Jewish women were disproportionately making up 26 percent of New York City's new teachers.[22] Already by the 1880s, "normal schools," generally one- or two-year college-type programs for the training of teachers, were springing up throughout the country, including the West, and by 1890 a little over one hundred existed in America.[23] Most of these educational institutions concentrated on instruction in education, teaching techniques, and classroom management, and many potential teachers honed their professional skills in model or "practice" schools associated with their institutions. Although limited in scope, the existence of normal schools, which welcomed attendance of intelligent women who had completed a high school course, provided higher education for women in an era during which university opportunities for females were still limited and created "an environment where women could blossom."[24] Many of the normal schools eventually evolved into four-year colleges and universities.

In the American West, the demand for female teachers, who often could be hired for lower pay than men, increased dramatically, in part because schools added an air of respectability to new towns and helped attract new settlers. For example, in 1859 the San Francisco Jewish paper, *The Weekly Gleaner,* reported that salaries for grammar school teachers in Sacramento schools were posted at $140 per month for men but only $120 per month for women.[25] Not only could teaching earn a woman a living and be appreciated as an acceptable and respected female profession, but in some cases it could also thrust her into public prominence. Indeed, teaching was often an intermediate step on the way to a more distinguished career. Such was the case with Mary Goldsmith Prag, who as we have already seen arrived in San Francisco as a young girl, and later with her daughter, Congresswoman Florence Prag Kahn. Mary graduated from the city's Girls' High School as well as the State Normal School. She married, and later became a grammar school teacher, head of the department of history and vice-principal in the Girls' High School from which she had graduated, and a teacher in the religious schools of Sherith Israel and Congregation Emanu-El. A committed activist, Mary Prag spoke out publicly for the right of married teachers to work and initiated the state's pension plan, earning her the title of "Mother of the Pension Movement in California." In her later years she became the first Jewish woman in the state to hold office by

serving on San Francisco's Board of Education. Florence Prag Kahn, who started out as a teacher, became the first Jewish congresswoman in the United States. Florence Prag graduated in 1887 as one of seven women in a coed class of forty students at the University of California.[26]

Another San Franciscan, Hannah Marks Solomons, enjoyed similar prominence. Independent and self-reliant, before her marriage in 1862 to Seixas Solomons she had taught in both the city's public and Jewish religious schools and for a time was the only female and youngest school principal in San Francisco. She was also an active member of a number of Jewish and secular clubs, and in this capacity worked for women's suffrage and on behalf of working women. When her marriage failed, teaching helped support Hannah and her children.[27] Teaching also launched the career of another prominent Jewish Californian we have already met, Ray Frank, who graduated from Sacramento High School in 1879 and moved to the mining town of Ruby Hill, Nevada. There she taught the children of miners in public school for six years in addition to running night classes for adults. The *Daily Elko Independent* published the first of many of her future articles as a newspaper correspondent and journalist, this first one on the topic of education. Upon her return to California, she gave private lessons to support herself and took classes in philosophy at the University of California.[28]

The support of parents, particularly mothers, often influenced young women to seek higher education.[29] When Florence Prag Kahn had decided to attend college she was encouraged by her mother, Mary Goldsmith Prag. Evelyn Jacobs, the daughter of Frances Wisebart Jacobs, Denver's "Mother of Charities," was trained as a teacher, and for many years taught in Denver public schools before becoming principal of a local primary school around 1910.[30] Activist and educator Rebekah Bettelheim Kohut, raised in San Francisco, graduated from a normal school in California with a teacher's certificate before marrying Rabbi Alexander Kohut in 1887 and moving to New York. Rebekah's father, San Francisco's Rabbi Albert Bettelheim, had encouraged his children to read widely from his extensive personal library and actively supported his daughter in becoming one of the first female students at the University of California, where she studied history and literature for a time. Rebekah Kohut later established the Kohut College Preparatory School for Girls in New York City.[31]

Harriet Lane Levy's immigrant pioneer businessman father was inordinately proud of his daughter's scholastic achievement as valedictorian

of her class at San Francisco's Girls' High School. In her previously cited memoir, *920 O'Farrell Street,* the story of her life growing up in a largely Jewish middle-class neighborhood wedged in between the city's rich and poor, Harriet recalled, "He was happy in giving me the education, which, to him, was as incantation, commanding the powers of light and darkness. My scholarship dazzled him."[32] When Harriet expressed interest in college, her father thought it over and, despite being advised that higher education might "spoil the chances" of a girl for marriage, he assented and decided "he wanted a university education for me." Harriet Lane Levy entered the University of California at Berkeley to pursue a bachelor's degree in philosophy and, encouraged by the president of the college, graduated in 1885.[33] Harriet's experience as the daughter of a successful immigrant businessman appears to be representative of many middle-class families. Although the daughters of the Jewish elite were often groomed for a social life, middle- and lower-class families increasingly came to see higher education for their children, females as well as males, as a vehicle to increased status and upward mobility.

Immigrant Jewish parents appear to have been especially appreciative of the benefits of higher education. Born in Posen, the widowed Helen Newmark eventually moved to Berkeley so that her youngest children, son Milton and daughter Millie (Amelia), could attend the university. Because the family income was very modest, both of the young people helped work their way through college, Milton taking odd jobs during vacations and Millie giving German lessons. Mrs. Newmark proudly reported "Milton studies industriously and eagerly. . . . Millie was also very eager to go to the university," and both "have done excellently in all their subjects." Milton graduated in 1899 and Millie in 1901, and both of them initially became teachers. Milton eventually practiced law in San Francisco and was admitted to the California bar in 1905. Millie Newmark had earlier completed a two-year course, probably at a normal school, to prepare her for teaching. For a few years she had run a popular private kindergarten, but because of the long hours and very modest income, she decided to seek a higher degree in order to secure a better teaching position.[34]

In 1884, sisters Mina and Esther Norton graduated from the State Normal School in Los Angeles, two of several local young Jewish women who had attended the institution, and Mina became the first teacher at the Santa Monica Canyon School before moving on to another Los

Angeles school nearer her family's home. Although a high percentage of female normal school graduates around the country did not marry (estimates vary between 35 and 60 percent),[35] in middle-class Jewish families teaching was often seen as an acceptable interim career on the way to marriage. This was the case for Mina Norton, who stopped teaching when she married traveling clothing salesman Isidor Cohn in 1904.[36] In December 1884, Emma Fleishman and Jeannette Lazard graduated as the valedictorian and salutatorian, respectively, of their class of fifteen at the Branch State Normal School in Los Angeles. The daughter of Jewish Los Angeles pioneers, Jeannette soon began teaching in a one-room schoolhouse in what was then an agricultural area of the city, where she boarded with a farming family during the week. The following year she left teaching to marry Louis Lewin, and the couple became the parents of two sons.[37] San Francisco novelist Emma Wolf and her seven sisters all trained as teachers, and, with the exception of Emma, all taught school.[38] Another San Franciscan, Josephine Cohn, began her public school teaching career in the 1890s and also taught Hebrew School at Temple Emanu-El. She later served as the principal of several elementary schools in the city.[39]

Throughout the West, young Jewish women joined the growing number of female teachers. Despite lower pay for females, more women than men became schoolteachers in the early West compared to the East. At the turn of the century, most women teachers who married did not remain in the profession, so new teachers were almost always in great demand to replace the pool of educators. Examples abound of early Jewish western women who pursued a teaching career before marriage. Delia Fried of Portland taught grade school in Aurora, Oregon, before marrying merchant Julius Durkheimer in 1889. The couple settled in the hamlet of Burns, Oregon, "a wild underdeveloped assembly of newly constructed wooden shacks, right in the middle of sagebrush land," but by 1895 the settlement became a small town and Julius was elected mayor. The couple later moved to Portland so they could be part of a larger Jewish and general community.[40]

The son of Elsie Myers Spaulding recalled that his mother, born in 1874 to affluent Jewish parents of central European descent, was the "first Jewish child born in Cheyenne if not Wyoming." Elsie's father, William Myers, owned a thriving early dry-goods and ladies' clothing store in Cheyenne, and both her parents were leading members of the local general and Jewish community. Like her mother, Bertha Frank

Myers, who had arrived in Cheyenne from New York as a bride in 1873, Elsie taught at the local Jewish religious school, which for a time was held in the Spaulding home.[41]

In 1890, Elsie Myers graduated as the valedictorian of her high school class. The same year, the Wyoming Territory became a state and women there again received the right to vote, but this time as residents of a state. As the daughter of prominent local citizens, she participated in many of the state celebration festivities on July 10, attending a party at the Governor's Mansion and a ball in the rotunda of the State Capitol as well as several parades and a fireworks display. Elsie entered Vassar College in 1891, graduating in 1895. On her return to Cheyenne, she secured a Wyoming teaching certificate and taught high school English and German in her hometown for eight years before her marriage in 1903 to Arthur Spalding. Her son later reported that the wealthy Myers family made sure that their daughter was transported to her job in style, and "when she was teaching school, she used to come to school with a driver and horses." The couple became the parents of two sons, and although Elsie's husband was not Jewish, she remained very active in Cheyenne's Jewish community as a longtime member of a charitable group and the Temple Emanuel Jewish Sewing Circle, as well as serving twice as president of the local B'nai B'rith women's chapter and as a member of the Mt. Sinai Synagogue Sisterhood. A talented musician, she took a leading role in a number of local music societies as well as the Cheyenne Symphony, and was also a prominent member of the American Association of University Women, which established a scholarship in her honor in the late 1950s.[42]

Both daughters of Arizona Jewish pioneer Therese Ferrin also became involved in the teaching profession. Hattie Ferrin, in 1879 the first Jewish girl born in Tucson, graduated from the University of Arizona in 1898, one of two women in a class of four seniors. It is interesting to note that she received a bachelor of science degree from the university's School of Mines, the only degree available at the time. In 1905 she married banker Charles Solomon, the son of Isadore and Anna Freudenthal Solomon.[43] The couple first began married life in Solomonville but moved to Tucson after Charles became president of the Arizona National Bank. They held a prominent role in the city's educational, religious, and civic life.[44] Also in Tucson, Clara Ferrin Bloom became a student at the University of Arizona in 1893 and graduated in 1901. She

taught elementary school for eleven years before her marriage to merchant David Bloom. An active member of the National Council of Jewish Women and Temple Emanu-El, she also remained a lifelong member of the Alumni Association at the University of Arizona. In 1973 a newly built elementary school in Tucson was named in her honor.[45] As one of the key founders of Tucson's early synagogue, which was built in 1910, Therese Ferrin also inspired both of her daughters to teach at Temple Emanu-El's Sunday School.[46]

While teaching at the university level was much more uncommon for women, several Jewish women in the West were pioneers in the profession. After Julia Heyman of Portland wed Jacques Bauer in 1864, the couple moved to her husband's home in Walla Walla, Washington. Born in Alsace-Lorraine and educated in Paris, Julia Bauer was fluent in at least five languages and received an honorary Ph.D. in recognition of her work on a new linguistic dictionary. In Walla Walla, she ran a school for women, children, and officers from the nearby military fort, but gave up the project when she became a professor of languages at Whitman College in 1882.[47]

Born in New Jersey, Josephine Israel, the daughter of Prussian immigrants, moved with her family to Helena, Montana, as a teenager in 1882. She graduated from Helena High School and went on to teach drama and elocution at Montana Wesleyan University. After her marriage to local Jewish attorney H. Sol Hepner, she became an officer of the Montana Children's Hospital, a founder of the Shodair Hospital for handicapped children, and the first woman appointed to Helena's Public Library Board.[48]

At the University of Denver in 1903, Jennie Charsky Spivak, wife of leading Colorado physician and co-founder of the Jewish Consumptives' Relief Society (JCRS) Dr. Charles Spivak, was listed on the faculty as an instructor of Russian language, a position she held until 1913.[49] Jennie was born in Russia in 1871, and her family first settled in a Jewish agricultural colony in New Jersey before she moved to Philadelphia. At the age of eighteen she enrolled in a local normal school but in 1891 entered the University of Pennsylvania as a biology student. The college proved a very unwelcoming environment for a woman, and she left Penn after her first year and briefly studied law at Cornell.[50]

In 1893 Jennie Charsky married Dr. Charles Spivak, and because of her poor health, probably incipient tuberculosis, the Spivaks moved to

the "Queen City" in 1886. She completed her college degree at the University of Denver, after having abandoned her law studies. She recovered her health in the western city. When the JCRS opened in 1904, Jennie was listed as one of the three formal incorporators and the only woman among them.[51] An intellectual woman, Jennie was a prominent member of Denver's elite Why Club women's discussion group while also teaching and raising a family. She was later honored for her work in education as a "Representative Woman of Colorado."[52]

By the end of the nineteenth century, only 228 women in the entire United States had received doctorates.[53] Among them was San Franciscan Jessica Blanche Peixotto, who received a Ph.D. in social economics from the University of California in 1900, the second doctorate awarded to a woman there. Born in 1864 to prosperous Sephardic Jewish parents, the family moved to San Francisco when Jessica was a young child. She graduated from high school in 1880 and received private lessons for a time in an effort to continue her education. Her wealthy merchant father had offered to hire the finest teachers for his brilliant daughter but saw no reason for her to attend college. Despite her family's initial opposition to her pursuit of formal higher education, Jessica persevered and she entered the University of California at Berkeley in 1891. In the mid-1890s she formally became a Ph.D. candidate at Berkeley and spent a year at the Sorbonne to complete her thesis, which focused on the French Revolution and modern French socialism. Within a few years of receiving her doctorate, Jessica Peixotto became Berkeley's first woman faculty member in 1904, first as a lecturer in sociology and then in social economics. In 1907 she was appointed assistant professor. She went on to be named the first female full professor at the school in 1918, authoring two books in her field of economics.[54] While enrolled in college, Jessica already exhibited a concern for social welfare issues and volunteered her skills to help poor working women at the Women's Educational and Industrial Union of San Francisco improve their English.[55]

Although even coed universities around the country could be challenging for women students and teachers, who were often resented by male colleagues, Jessica Peixotto was recognized as an accomplished and brilliant professor. One of her books, *Getting and Spending at the Professional Standard of Living,* published in 1927, focused on the subject of academic salaries for professors. In her study, she noted the long-time commitment of America as a nation to university education "as

time has gone on, particularly in the West."[56] Many of her students admired her style and considered her a favorite teacher. Her interest in social work and young people led to her appointment to the State Board of Charities and Corrections. In this capacity she had for many years major oversight of California's juvenile penal system.[57] Jessica Peixotto's academic accomplishments are particularly impressive because at that time most women in coeducational institutions who received faculty rank rarely achieved full professorships, usually left as adjuncts or at similar lower status.[58]

Journalism and writing also attracted many educated western women. These skills opened a path to professional careers for a group of intelligent and ambitious Jewish women who were anxious to have their opinions heard in the public arena. For some of them, writing may have been an avenue by which to present Jews to their fellow citizens in a positive light, while others may have used their prose to work out personal issues involving their Jewish identity. The only child of Gussie and Sam Friedlander, a theater and concert agent, Alice Friedlander Lauer, who was quoted at the beginning of this chapter, was born in Louisville, Kentucky, in 1875. Her mother, Gussie Fox Friedlander, had died giving birth to her only child. Before the turn of the century, Sam Friedlander's business interests influenced him to make Portland, Oregon, the family home. Alice thrived as a newspaper reporter, and in 1896 *The American Jewess* reported that the "bright young writer" had been elected secretary of the Pacific Coast Women's Press Association.[59] As she had maintained in her speech before the press club, a profession did not have to bar a woman from marriage and a family. In her early twenties, Alice Friedlander married Emanuel Lauer, a Portland wholesale druggist, and the couple became parents of two daughters. In 1908, the Lauers moved to Los Angeles, and in the 1920s Alice served as the president of the Los Angeles section of the National Council of Jewish Women.[60]

Hattie Schayer Friedenthal pursued a similar path in Denver. She graduated from East Denver High School in 1884 and attended Denver Medical College, but turned to journalism instead. In addition to authoring articles in such popular magazines of the day as *Harper's Bazaar*, in 1917 Hattie became editor of the *Denver Jewish News*. Active in a variety of local Jewish organizations, she served as vice-president of the Denver Jewish Sheltering Home and as a president of the local section of the National Council of Jewish Women, where she frequently lectured on Jewish and educational subjects. In an obituary

Hattie Schayer Friedenthal was remembered as a "leader whose inspiring persuasive powers have been felt in Jewish communal life for nearly half a century."[61]

San Francisco appears to have been an especially fertile ground for female Jewish writers, who became prominent members of the city's literary and artistic set. It produced the successful popular novelist Emma Wolf, author of five books as well as shorter pieces of fiction, whose best known novel, *Other Things Being Equal* (1892), dealt with the subject of intermarriage. A victim of polio, Emma often retreated into an interior world of writing and used her own experiences as a member of San Francisco's Pacific Heights Jewish upper middle class as background for her work. Emma, her father, a successful California pioneer originally from Alsace, and the rest of her family were members of the Reform congregation Emanu-El. Although Ruth Levice, the strong, sensitive, intellectual, and family-oriented heroine of *Other Things Being Equal,* marries a non-Jewish physician, she does so only after much soul searching and struggles to respect her Jewish identity. Despite the apparently happy marriage of two soulmates, the book ends with hints of future unresolved social and religious issues, and appears to have reflected Emma's own conflicted views.[62] Emma Wolf's high school classmate Rebekah Bettelheim Kohut later recalled that Emma, one of a family of eleven children, was a "fine influence" on her friends, and although Emma "was handicapped from birth by a useless arm . . . her memory was the most remarkable I have ever encountered."[63] Even as a teenager, Emma's future success as a writer was recognized by her contemporaries. Later, her novels received good reviews, especially in the Jewish community. In 1897, a book review in the national periodical the *American Jewess* maintained that "Emma Wolf is not only the best Jewish fiction writer of America, but the peer of the best novelists."[64]

San Francisco was also home to journalist, drama critic, and memoirist Harriet Lane Levy, author of *920 O'Farrell Street,* and to the famous avant-garde modernist writer and later expatriate, Gertrude Stein. All three women had attended institutions of higher learning: Emma Wolf was a product of a California normal school, Gertrude Stein matriculated at Radcliffe, and Harriet Levy was a graduate of the University of California. According to an article in *The American Jewess* in 1896, Harriet had "brilliant intellectual qualities," and at one time she had been drama critic for the *Wave* magazine. The article also men-

tioned Emma Wolf's sister, Alice Wolf, as the author of a number of "excellent short stories" and a book titled *A House of Cards*.[65]

Born in the mining town of Calaveras, California, to Polish immigrant parents, Miriam Michelson attended schools in San Francisco and became a successful journalist, short-story writer, and novelist. Of her five published novels, one, *In the Bishop's Carriage*, became a bestseller, and another, *A Yellow Journalist*, featured an influential Jewish character.[66]

Carolyn Anspacher was born in San Francisco in 1907, the descendant of two pioneer Jewish families. At the University of California she majored in drama, graduated from Berkeley in 1930, and began a long and respected career in journalism beginning with work for the *San Francisco Chronicle* in 1932.[67] In an interview conducted in 1979, Carolyn Anspacher revealed that she began her career without formal training. In need of a job during the height of the Depression, she simply talked her way into a position on the staff of the city's leading newspaper. An acquaintance of Carolyn's mother introduced her to the *Chronicle's* publisher, and when he asked Carolyn what she could do, she boldly replied, "Everything." The twenty-three-year-old was immediately assigned to cover a story about a prominent art collector, a subject she knew nothing about, and she spent hours in the library to prepare for the interview. To her amazement and gratification, and with no prior experience, her first story was printed with a by-line the following day. Carolyn Anspacher developed into a fine journalist, and she broke new ground as a female reporter covering stories from crime to politics and exposés that included acclaimed stories about mistreated mental health patients.[68]

Law was also a profession that attracted a number of pioneer Jewish women around the turn of the century, yet as late as 1910 women made up only one percent of lawyers nationally.[69] In pursuing a legal career, western Jewish female attorneys undoubtedly drew on Jewish traditions of justice, law, and scholarship as well as a respect for American civic virtues to establish practices in a region that appears to have been relatively hospitable to women in the profession. Of the modest numbers of early American female defense lawyers, for example, most practiced in the West, where more elastic social conventions made it more acceptable for women to appear and argue before all-male juries.[70] The precocious Felice Cohn, granddaughter of a Polish-born rabbi, was born in

Carson City, Nevada, sometime between 1878 and 1884 and attended public schools there, earning her high school diploma in 1894 at a young age and the first of three teaching certificates the following year. Felice went on to attend the University of Nevada and Stanford, by then a prominent western educational institution, and received a degree from the Washington Law School in St. Louis before passing the Nevada bar in 1902, one of the youngest people in the history of the state to do so. In 1883 the Nevada legislature had voted to allow females to practice. The fifth female, the first native-born Nevadan female, as well as the first Jewish woman to practice in the state, mining law was her specialty. In a newspaper interview she declared, "I have a great liking for the law and I find it entirely within a woman's power."[71]

Felice Cohn later became Nevada's first female assistant U.S. attorney in 1906 and an ardent advocate for the women's vote. She authored Nevada's suffrage amendment. It first passed in 1911, was later affirmed by popular vote in the election of 1913, and was made part of Nevada's constitution in 1914. Another milestone was achieved when Felice was admitted to practice in the U.S. Supreme Court in 1916, one of the first women in the nation to be accorded this distinction. In the 1920s, she authored a short article on women and politics in Nevada and alluded to the possibility that the western state offered a more open door for females, observing that the lives of Nevada women "appear much like the lives of our sisters in other states—broadened and sweetened, mayhap, by the splendid liberty that is ours."[72] The American West had certainly allowed a talented woman like Felice Cohn a place to grow to her full potential. A vocal proponent of legislative protection for women and children, including child labor and adoption laws, she never married but was active in many organizations, including Nevada's B'nai B'rith women's auxiliary as president, the Nevada and California bar associations, and the board of the National Association of Women Lawyers. She died in 1961.[73]

The University of Washington Law School in Seattle was the backdrop for another western Jewish woman of unusual ability. Born in a small town on the Russian-Polish border in 1880, Bella Weretnikow and her parents immigrated to North America in 1882, settling first in Winnipeg, Canada. In Winnipeg, she attended public schools and an afternoon Hebrew School. After her parents divorced, Bella and her mother moved to Seattle, where Bella continued her high school studies. Both of her parents remarried, and Bella lived with her mother, Eliza

Marks, and her new family behind her mother's secondhand store located on the Seattle waterfront, which catered to sailors and transient workers. In her memoirs, Bella recalled her mother's lifelong struggle with poverty and her strong desire to provide her daughter with the best possible education: "She was determined that I should receive all the learning, all the knowledge and all the advantages that she so sorely missed." Encouraged by her doting but illiterate mother, and anxious to make something of herself, Bella's diary, composed during her school years, indicate that she was a successful and serious student. Even as a child in a poor immigrant family, Bella had hoarded five-cent coins until she had saved enough to make "a trip to the secondhand store" to purchase books to nurture her love of reading.[74] While most female college students at the turn of the century came from the homes of the rising middle class,[75] Bella Weretnikow clearly emerged from a working-class milieu.

At the age of sixteen, Bella skipped her last year of high school to begin college early at the University of Washington. She later recalled the examination process and noted that "perhaps no one was more surprised than I when I found I had successfully passed them all, and became a full-fledged college student."[76] From almost her first day at college she felt "at home" in the academic environment, where "one is so entirely independent," and at once "decided that law shall be my profession."[77] As a senior college student, on her way to bachelor's degrees in political and social science in 1900, she also simultaneously enrolled as a student in the first class of the University of Washington's School of Law. During these years Bella also kept the books and served as the buyer in her mother's shop. On May 29, 1901, Bella graduated from the new law school and less than a week later, on June 6, 1901, she was also admitted to the Washington State bar, the first Jewish female attorney in the state, and only the fourth woman from any ethnic or religious group. In the first law class of thirty students, three were women, and Bella later recalled "The fact that I was Jewish did not seem to have any significance at the time."[78]

Attracted by a notice about the Seattle Jewish community in the *American Israelite,* a young Tennessee attorney in Nashville, Lewis Newman Rosenbaum, wrote to congratulate Bella. The newspaper had reported that "among the graduates of the University Law School is Miss Bella Weretnikow. Miss Weretnikow received her bachelor's degree only last year."[79] Bella began working in a local law office and soon

Bella Weretnikow Rosenbaum (right) with classmates at the University of
Washington, c. 1899. (Courtesy Dr. Judith W. Rosenthal.)

argued her first successful case in the King County Superior Court. Be-
fore long, Rosenbaum moved to Seattle, started a romance with Bella,
and the couple married in 1905, later moving to New York. Lewis and
Bella Weretnikow Rosenbaum raised five children, and although Bella
gave up the practice of law after her marriage, she and her husband,
who became a successful real estate investor, remained active in local
synagogue and civic affairs in both Seattle and New York City.[80]

The accomplishments of Felice Cohn and Bella Weretnikow are espe-
cially impressive considering that, when they began practicing law, some
states still did not allow a woman to be admitted to the bar. It was even
more difficult to open a practice. In her study of women lawyers in
America, historian Virginia Drachman has maintained that "more than
any other profession women sought to enter in the nineteenth century,

law was the most engendered and closed to women." Even by 1920, female lawyers were still rare. Nationally at that time, women made up only 1.4 percent of all lawyers, 4.7 percent of all scientists, and 5 percent of all doctors. In the more conventionally "feminine" professions, women made up 86 percent of all teachers and 66 percent of all social workers.[81] However, a small group of Jewish female attorneys thrived in the more open environment of the West, where a number of early important victories for women's legal education occurred.[82]

The field of medicine was also popular with a small but prominent group of western female Jewish physicians, although the road for women in general in the medical profession was long and often filled with frustrations. The traditional Jewish emphasis on health and healing as well as social justice probably influenced their choice of career. Dr. Emma Sutro Merritt, one of the region's earliest women doctors, was the daughter of the famous millionaire and philanthropist Adolph Sutro, which undoubtedly eased the process for her. The Prussian-born Sutro had arrived in California in 1850, made a fortune in Nevada's Comstock Lode, and was elected mayor of San Francisco in 1895. Sutro married Leah Harris in a Jewish ceremony in about 1855, and Emma Laura, the eldest of their children, was born in San Francisco in November of 1856. Emma apparently studied medicine in both San Francisco and Paris. After she graduated from the University of California's medical department in 1881, she was probably the first Jewish female physician in the West. The occasion of her graduation was noted in San Francisco's *Jewish Progress*, which reported that her father held an elegant dinner in her honor to mark the event. Emma was considered an able physician as well as businesswoman, and was appointed her father's guardian in his later years when his mind failed.[83]

In October 1896 an article titled "The Jewess in San Francisco" appeared in the New York–based periodical *The American Jewess*, which proudly proclaimed, "There are three Jewish doctresses in the city." Most notable was Dr. Adele Solomons Jaffa, later a respected child psychiatrist, a rare field for a woman at the time. Adele was one of Hannah Marks Solomons's five accomplished children (two other children had died at an early age). She received her medical degree from the Hahnemann Medical College of the Pacific in 1893, and received her license to practice medicine in California in 1894. Back in San Francisco, Adele practiced medicine that was often geared toward young children. Following in her mother's footsteps, she was also an active community

volunteer, presenting lectures to girls on women's health issues. In 1895 she married Meyer Jaffa, a professor of nutrition at the University of California, who later became the first director of the California Bureau of Food and Drugs, and gave up her practice of medicine for a time while her children were young. Beginning in 1925, while she was in her late fifties, she spent two years at the University of California studying psychology and child development, and when she returned to the practice of medicine she devoted herself to psychiatric care of children. Known as the "play doctor," she focused on child development and developed several popular intelligence tests for preschoolers.[84]

The magazine article also noted the presence in San Francisco of a new physician and former teacher, Natalie Selling, as well as Amelia Levinson, who had been "practicing for some time with marked success."[85] For a time, both Amelia and Natalie rented rooms in the home of Amelia's aunt, Mrs. Helen Newmark. In her memoirs, Mrs. Newmark recalled that when her son was stricken with diphtheria in San Francisco in the 1890s, she consulted her "dear niece, Amelia," who was studying medicine at the time and was advised to call in a local doctor at once.[86]

Los Angeles was the home for many years of Dr. Sarah Vasen, born in Quincy, Illinois, in 1870, the only daughter in a family of nine children. After receiving her medical degree in the 1890s at what later became the University of Iowa Medical School, she began her career as an obstetrician at a local Quincy hospital, and in 1898 became a physician and superintendent of Philadelphia's Jewish Maternity Home. In 1904 she moved to California to join a brother who had already located there, and in 1905 took on an expanded position as superintendent at the Kaspare Cohn Hospital, where she was recognized for her "efficiency . . . and good service." After retiring from her position at the hospital around 1910, Sarah opened a successful private maternity practice and for many years also volunteered her services to the Jewish poor. In Los Angeles, Sarah was an active member of Congregation B'nai B'rith, and when she married businessman Saul Frank in 1912 at the age of forty-two, the ceremony took place at the synagogue. Sarah Vasen Frank retired from practice after her marriage, and the couple moved to Glendale, California, in 1915, where Sarah became involved in local Jewish communal affairs and was a key figure in the formation of a Jewish religious school for children.[87]

Concentrating on the needs of women and children was common for female physicians at the time. While these Jewish women doctors were pursuing a career that was still largely the domain of men, many still focused on aspects of medicine that fell within the traditional women's sphere of the care of women and children. Even those who did not work specifically with women and children tended to incorporate traditional Jewish emphasis on caregiving and responsibility for the poor and disadvantaged in their practices. Arriving in Los Angeles in 1906 from Chicago, Dr. Kate Levy followed Dr. Sarah Vasen as the second Jewish female physician in Los Angeles. She was closely associated with the work of the Southern California Jewish Consumptives Relief Society located in Duarte, which was organized in 1912. In 1914 Dr. Levy authored an appeal in the B'nai B'rith *Messenger* in which she asked for "the cooperation of the whole Jewish public regardless of case or creed" for the support of the tuberculosis sanatorium.[88] Russian immigrant Dr. Anna Reznikow received her degree from the Still College of Osteopathy in Missouri in 1913 and soon headed to Globe, Arizona, to practice medicine. As one of the few women doctors in the state, for nearly a decade Anna devoted most of her practice to delivering babies before she moved to Minnesota in the early 1920s.[89]

Esther Rosencrantz, one of the most accomplished of the early western Jewish female physicians, was born in San Francisco in 1876. After graduating from Stanford in 1899, she entered the prestigious Johns Hopkins University, studied under leading Canadian-born American physician William Osler, and received her medical degree in 1904. In an era when even few Jewish males were admitted to Johns Hopkins, Esther's entry into the school is especially impressive. While a medical student at Johns Hopkins, Esther and the other three female medical students became involved in Dr. Osler's tuberculosis specialty and served as informal social service workers, undertaking home visits to patients who attended his hospital clinic. Osler was considered one of the greatest doctors in the world during his lifetime, and it is clear Esther idolized him and consciously set out to follow in his medical path.[90]

After her graduation from medical school, Esther Rosencrantz focused on tuberculosis research and treatment in New York City and Europe for nearly a decade. In 1913 she returned to California and was appointed an assistant and later associate clinical professor of medicine at the University of California. Esther also served overseas during World

War I, including two years with the Red Cross Tuberculosis Commission in Italy, and was decorated by both the American and Italian governments for her contributions. Back in San Francisco, Esther continued her tuberculosis work, personally assisting poor patients with food and medicine and supervising the San Francisco Hospital Tuberculosis Clinic as the attending physician under the auspices of the University of California until 1937. According to a fellow physician, her "leadership was felt in every movement against the white plague." She also authored a number of medical studies on tuberculosis, but as the threat of tuberculosis lessened, Esther's career waned and she retired in 1943. While she does not appear to have had much active connection to the Jewish community, a leading local rabbi conducted her memorial service, and her death received prominent coverage in the San Francisco Jewish newspaper. Esther Rosencrantz was later remembered as "one of the most dynamic, energetic, vital, and enthusiastic of women . . . who enlightened and stimulated her students."[91]

Although she did not formally study medicine, Elizabeth Fleischmann-Aschheim was an early female professional pioneer in the related area of radiology. Born in California in 1867 to Austrian Jewish immigrant parents, Elizabeth dropped out of high school for financial reasons and soon found work as a bookkeeper and office manager in San Francisco. Her brother-in-law, a doctor, encouraged her interest in the new field of radiology, and in 1896, she opened the first X-ray lab in the West. In 1900, Elizabeth married Israel J. Aschheim, the executive director of the Pacific Coast B'nai B'rith, but she maintained her office and continued her work. Although she was self-taught, she soon acquired an international reputation, and her expertise was utilized and praised by the Surgeon General of the U.S. Army as she helped diagnose bullet wounds in soldiers returning from the Spanish-American War. Elizabeth Fleischmann-Aschheim died in 1905 as a result of radiation poisoning. Her obituary in the *San Francisco Chronicle* characterized her as "one of the most admirable women of science" and noted that "she acquired the reputation [of] the most expert radiographer of the world."[92]

While informal and volunteer nursing was not uncommon among western Jewish women in the early years, trained nurses who chose the profession as a career were less visible, and indeed modern nursing in America did not develop until the mid to late nineteenth century. As we have seen in an earlier chapter, Therese Ferrin worked for many years as a volunteer nurse and "healer" in Arizona, and in Los Angeles

the women's benevolent group founded in 1870 by Jewish pioneer Rosa Newmark focused on nursing the sick and impoverished. At the turn of the century, many cities around the country developed visiting nursing programs, including one in Portland spearheaded by Louise Waterman Wise, the wife of Rabbi Stephen S. Wise, the spiritual leader of the city's Beth Israel congregation.[93]

One of the more notable western Jewish nurses was Esther Silverstein Blanc, who was born in Wyoming in 1913 to Romanian immigrant parents who had moved west to join a Jewish agricultural community and homesteaded in Chugwater. Esther's parents enthusiastically supported her decision to become a nurse. Influenced by a liberal social conscience, she attended the School of Nursing at the University of California, graduating in 1934. She volunteered as a nurse in Spain during the Spanish Civil War and served in the U.S. Army Nurse Corps during World War II. After her marriage, the Blanc family moved to San Francisco, where Esther earned a Ph.D. in medical history. She later taught at the University of California's School of Medicine for over a decade.[94]

Before obstetrics became a specialized medical profession, many Jewish women had been skilled midwives, perhaps harkening back to the biblical tradition of Shifra and Puah, who had delivered so many babies in Egypt. By the turn of the century, they were being elbowed out of the profession by trained physicians, often males, who frequently looked upon midwives as unprofessional and backward amateurs. However, in Denver at the turn of the century, Miriam (Mary) Rachofsky Kobey, an observant east European immigrant who had migrated with her family first to Central City and then to Denver in 1880, earned the gratitude of many women in the West Colfax area and the admiration in the medical community for her work as a midwife. Miriam's husband, Abraham Kobey, served as a rabbi and scribe, and Miriam supplemented the family's modest income with an occasional gold piece from wealthier clients. For the poor, she performed her services free of charge, often soliciting funds from local merchants to purchase a layette. According to her granddaughter, Dr. Buchtel, one of Denver's leading obstetricians at the turn of the century, brought Mrs. Kobey to a national meeting of gynecologists held in Denver and presented her as "the most famous midwife in Denver. She never uses instruments, but rarely loses a baby or mother." Herself the mother of eight children, Miriam Kobey delivered hundreds of babies in her Denver career and was formally registered as a midwife in the city's medical records.[95]

More unusual was the occupation of Dorothy Wormser Coblentz, the first Jewish female architect in the American West. Born in New Mexico in 1894, she was raised in San Francisco. In 1912 Dorothy graduated from the Girls' High School at the same time that Mary Prag was serving as vice-principal, and later enrolled in the University of California as an architecture major.[96] By 1918, she was employed by famed architect Julia Morgan, who was the first woman to enroll in the College of Engineering at the University of California in the 1890s and the first licensed female architect in the state. Julia was well known as the architect of the Hearst castle in San Simeon, California.[97] At Julia's direction, Dorothy assisted with some cataloging work at the Hearst Castle, and after receiving her state architect's certificate she worked as an associate architect on San Francisco's Emanu-El Sisterhood Residence Club for Jewish working girls.[98]

Similarly, another Californian, Alma Lavenson Wahrhaftig, acquired a national reputation as an innovative photographer. Born in San Francisco in 1897 to pioneer Jewish parents, Alma's family moved to Oakland in 1906 following the famous San Francisco earthquake, and she attended the University of California at Berkeley, where she first became interested in photography. By the 1920s she was a highly regarded professional who successfully competed against preeminent American photographer Amsel Adams in a local competition. Alma married attorney Matt Wahrhaftig in 1933, and the couple became the parents of two sons. Beginning in the 1920s her work was exhibited in local museums and later appeared in New York's Metropolitan Museum and the Museum of Modern Art, and in 1979 she received the prestigious Dorothy Lange Award for photography. When she died at the age of ninety-two, she was still a member of Oakland's Temple Sinai, a board member of the Oakland Symphony, and active in the Oakland Museum.[99]

Librarianship and social work, more common occupations for young Jewish women, were often considered "semiprofessions" in the early years. During the first decades of the twentieth century they were often denigrated as being less demanding and an appropriate modernized version of traditional female domestic fields. For example, at a national meeting of the National Conference of Charities and Corrections, one leading expert titled his presentation "Is Social Work a Profession?" and concluded that it was a poorly paid field that did not require specialized professional skills, but rather relied primarily on intuition.[100] Although for many years teaching still remained a more popular and lucrative

profession for women,[101] as we have seen in previous chapters a number of Jewish women, such as Ida Loewenberg in Portland, Seraphine Pisko and Ray David in Denver, and Anna Myers in Los Angeles, drew upon their long experience in women's benevolent organizations to carve out a successful career for themselves in the area of social work and administration. For the most part, these women reflected an informal "induction" into social work by "apprenticeship," serving as a bridge to a later generation of more professionally trained social workers who received a Master of Social Work degree.[102] Historian William Toll has noted this particular tendency for informal training through experience among early western Jewish female social workers.[103] However, as time passed the call for formal training became more insistent. For example, in 1912, leaders of Denver's Jewish immigrant neighborhood settlement house reported, "We have learned the lesson that at least one efficient trained worker must lead the staff of volunteers and must be a resident of the house."[104]

Beginning in 1912, after studying for a time at the New York School of Social Work, Ida Loewenberg served as the "headworker," or what we would term today the executive director, at Portland's Neighborhood House. For thirty-three years she oversaw settlement work with new east European immigrants. Ida had attended private school and spent a year studying music in Germany, but a decline in family finances after the death of their father encouraged both Ida and her sister Zerlina to pursue professional studies to help support themselves. After high school, Zerlina enrolled in Portland's library school. Born to affluent parents of central European origin who were active in Portland society life, neither of the two sisters married, and both devoted most of their adult lives to community service. Ida, Zerlina, and a younger brother continued to live with their mother in a family home after the youngest daughter, Rose, eventually married. As a public librarian, Zerlina also focused on work with east European Jews in the South Portland immigrant district, and she apparently had a close and favorable relationship with the newcomers, helping to ease their transition and acculturation by supplying them with both Yiddish and English newspapers and literature.[105] Similarly, Anna Hillkowitz proceeded to librarianship school after high school and supported herself for many years as a Denver librarian before her marriage to a New York dentist. In 1923, a survey was conducted by the National Council of Jewish Women relating to the contemporary careers of American women. Although

New York City and Chicago were excluded from the study, its author found teaching still to be the most popular career, but cited sixty-nine American female lawyers, forty female doctors, and twenty-four college and university professors—professional areas in which western Jewish women had achieved early prominence—within the United States.[106]

Informal social work training was certainly evident in the case of May Goldsmith, daughter of Emma and Bernard Goldsmith, Portland's early Jewish mayor. The unmarried May lived in Portland with her parents, but after her mother passed away and her father died in 1901, she moved to Seattle to join a brother. May had undoubtedly worked beside her mother in Portland's charity organizations and utilized this experience to launch a career as the first executive secretary of Seattle's Jewish Welfare Society, originally called the Seattle Hebrew Benevolent Society, in 1927.[107] Even as a professional administrator of a philanthropic agency engaged in social work, she exhibited a sense of noblesse oblige. In an annual report written during the Depression, May Goldsmith wrote: "We, as Jewish Citizens of Seattle must give to the people who are looking to us to help them. . . . We, who are more fortunate and have never suffered from want must keep them."[108] Later she was engaged to process applicants at the Kline Gallard Home for the Aged. Her longtime volunteer experience at first enabled her to successfully administer the Benevolent society's programs to assist local indigent families, but in the mid-1940s she was edged out of her position to make room for a professionally trained social worker, part of a larger American trend in both the general and Jewish communities.[109]

The move from volunteer philanthropy to professional service was not altogether uncommon. The daughter of a prominent Jewish San Francisco family, Amy Steinhart Braden attended Sabbath and Sunday School at Temple Emanu-El as well as private school at Madame Ziska's before entering the University of California at Berkeley, from which she graduated in 1900 at the age of twenty-one. The philanthropic endeavors of Amy's parents served as an example for their daughter, and she later recalled that from an early age, "I always felt that some day I was going to devote myself to the so-called charities. . . . I volunteered my services for a number years." Although Amy stated that at first "it never entered my head that I would be anything but a successful social butterfly," as time passed she focused on a career. Amy became particularly involved in child welfare, first through the juvenile court, but "gradually I realized I wanted to carry on on a full-

time basis." Amy became a professional, paid social worker, traveling the state to supervise dependant children and their families. After her marriage to Robert Braden in 1924, she went on to serve as the executive secretary of California's Department of Public Welfare between 1925 and 1930.[110]

Undoubtedly influenced by traditional Jewish emphasis on marriage and children, most women in this study were married, and mostly to professional men. But a number of the new professionals remained single. William Toll has noted a significant tendency at the turn of the century in which Jewish women, generally from middle-class or well-to-do families, either married at a later age and had fewer children than their mothers' generation or remained unmarried their entire lives. This reflected an American trend, and Toll suggests that new options for supporting themselves, a reduction in the stigma previously attached to spinsterhood, and even specific personal circumstances where the "right" man simply did not appear accounts for this phenomenon.[111] Certainly employment and professional life in western cities allowed for a greater degree of autonomy among Jewish women. It is also interesting to note that although there are some exceptions, Ida and Zerlina Loewenberg being prime examples, it appears that married Jewish professional women were more likely to retain a high profile in the Jewish community. For example, while Jessica Peixotto was proud of her Jewish origins, she devoted herself almost exclusively to her teaching and scholarship, and Esther Rosencrantz seemed wedded to her medical career and patients.

While historian Lynn Gordon has maintained that between 1870 and 1920 most American college women were predominantly from "white, Protestant, middle-class homes" and that the small number of Jewish women in higher education did not increase appreciably until the 1920s, she admits that the evidence upon which this claim rests is sketchy.[112] However, while the women in this study may be a highly selected group of talented women, it appears that from anecdotal as well as some statistical evidence, Jewish women in the West pursued the chance for higher education in significant numbers. At the turn of the nineteenth century and in the previous decades, "pioneering professionals were among the first generations of college-educated women,"[113] and western Jewish women were prominent among them.

In 1920, the *American Jewish Yearbook* published a study conducted by the Bureau of Jewish Social Research, which recorded the number of

Jewish college students in 106 "of the most prominent educational institutions" in the nation for 1918–1919. The study concluded that Jewish enrollment in higher education was three times the proportion of the country's Jewish population. The statistics were broken down by both female and male enrollment. Predictably, the five schools with the highest Jewish female enrollments in actual numbers were in New York City, Chicago, and the Boston area: in descending order, at Hunter College (502); New York University (419); Columbia (249); the University of Chicago (190); and Smith (99). However, the University of California (93) ranked sixth in the number of Jewish women students, a very impressive standing considering the relatively modest Jewish population in the West at the time. In addition another twenty-five Jewish women attended college in Colorado, divided between the University of Colorado and the University of Denver, and a smaller number were enrolled at the University of Southern California, the University of New Mexico, and Reed College in Oregon.[114] In 1920, the entire Jewish population in the West is estimated to have been about 300,000, while the number of Jews in New York City alone was well over 1.5 million. Moreover, both Hunter and Smith were women's colleges while the University of California was coed.

Just as western Jewish women took advantage of an unusual degree of civic, philanthropic, and business opportunity, as we have seen in earlier chapters, they also demonstrated cutting-edge involvement in levels of education and professions that had formerly been the exclusive domain of men. This is not merely historical hindsight, but a phenomenon often observed by the women themselves at the time. For example, Harriet Ashim Choynski realized that the West was providing her with new chances for advanced study when she graduated from high school in 1861, educational possibilities that were not always the norm for women in other areas of the country. The entry of western Jewish women into higher education was also facilitated by the relative absence of anti-Semitism in the region. While Amy Steinhart Braden felt that as a college student at the University of California at the turn of the century she was not rushed for any sororities because of genteel latent social anti-Semitism, nothing prohibited her from actually attending and graduating from college in Berkeley or from socializing with many gentile as well as Jewish friends on campus.[115] Moreover, as a 1916 article titled "The Jewish College Girl" observed of sororities around the country, gentile girls also frequently ran up against discrimination in

"bids" due to the very nature of the secret societies.[116] Bella Weret-nikow was able to enter law school at the University of Washington at the turn of the century without challenges to either her gender or her Jewish origins. It is also interesting to note that, according to the previously mentioned Bureau of Jewish Social Research report of 1920, Jewish women at the time tended to enroll in the study of law at about the same proportion as Jewish men, and at a much higher rate than non-Jewish females,[117] and as we have seen many early female attorneys tended to practice in the more hospitable West.

Jewish settlers, including women, who migrated West before and at the turn of the century were clearly propelled in large part by the search for expanded opportunities. Whether these new prospects were indeed a reality or more of a psychological perception, given a pervasive "frontier mentality," it is not surprising that many searched for personal fulfillment and a way to make a living through education and careers. Although individual circumstances varied, a pattern emerges of independent and determined Jewish women in the early West who were intent on taking advantage of the possibilities of higher education and the professional positions available in the region, including a number who boldly stepped into such traditionally male-dominated professions as medicine and law.

7

Entering the Political World

"My mother was horrified" is the way Belle Fligelman Wine-
stine recalled her stepmother's reaction in 1914 on hearing that Belle
had delivered a political speech on behalf of women's suffrage in Mon-
tana on a busy Helena street. A recent graduate of the University of
Wisconsin, where she had received a degree in philosophy and studied
journalism, Belle Fligelman had returned to Helena after brief news-
paper stints in New York and Milwaukee to work as a reporter on the
Helena Independent. According to Belle, Ghetty Fligelman made her
displeasure over her stepdaughter's high-profile political involvement
very clear. "While it was all right for women to vote, she [Ghetty] said,
no respectable lady would speak on a street corner. She warned me that
if I made one more speech on the street, I needn't come home. That
night I slept at a hotel and charged it to my father."[1]

By 1900, the vote for women had been won only in the states of
Wyoming (1890), Colorado (1893), Utah (1896), and Idaho (1896), all
four of them located in the West. The feisty Belle Fligelman was the
daughter of the prosperous proprietor of Fligelman's New York Dry
Good's Company in Helena. She was one of a number of western Jew-
ish female pioneers, undoubtedly influenced in part by Jewish ideals of
social justice and responsibility, who helped secure women's suffrage
not only in the region but for women throughout the United States. In
doing so they wedged open a new door for political involvement for
Jewish women in the American West.

It is important to note that even in the West, support for women's
suffrage among Jewish women was not universal. For example, as we
learned in an earlier chapter, popular Jewish orator Ray Frank's views
reflected a complex synthesis of contemporary liberal and conservative
strains of thought. In her case, Ray looked to Jewish tradition to em-
phasize the centrality of home and family life. She opposed suffrage
because she felt women at the time were not well versed enough in poli-

tics to make sound judgments, and building the foundations of a solid home life should be their focus. In an 1899 interview, over a decade before women's suffrage had become a reality in California, she maintained, "I believe in all forms of intellectual progress . . . but I am not a suffragist. . . . Understand, I believe in the intellectual and educated woman, whatever her sphere of life is to be . . . [but] their intellectual powers must be made first to illumine their homes and afterwards the world beyond."[2] However, while at first glance Ray's comments appear to support narrow views on women's capabilities, her ideas on suffrage were closely connected with her broader conservative conviction that all voters, whether male or female, needed adequate education before they could exercise their voting rights properly. In an earlier newspaper interview in 1895 she stated, "I do not believe in universal suffrage for either men or women. The suffrage should be granted strictly according to the intelligence and capacity of the individual for government."[3]

Belle Fligelman Winestine stood on the opposite end of the spectrum on "the woman's question." Belle had delivered her maiden speech on suffrage and had her first taste of political life while still a student at the University of Wisconsin, where she had served as president of the Women's Student Government Association and editor of the student newspaper's women's page. At the invitation of the organizers of the state's women's suffrage movement, in 1913 she spoke before Wisconsin legislators on the right of women to vote. Although her views on the subject at the time were still admittedly fuzzy, she recalled, "I knew suffrage was right, but I didn't know you had to have *reasons* for being right. . . . I just knew that theoretically women ought to be able to vote." To her astonishment, Belle received resounding applause, and she arrived back in Helena the following year just as Montana's campaign for women's suffrage was heating up.[4]

As a reporter for the *Helena Independent,* Belle Fligelman was assigned to cover a speech in Lewistown by Jeannette Rankin, then chair of Montana's women's suffrage organization. Belle was highly impressed by Rankin's delivery, her grasp of effective political tactics, and her emphasis on women's issues and the special interests they represented. Belle, too, learned how to "sell suffrage" to the people of Montana through shrewd marketing. Both women reflected a growing number of nonradical yet savvy mainstream women who were at the forefront of a new "commercialized style of politics" that appropriated public space to benefit their cause.[5] Soon Belle was an ardent campaigner for the cause,

speaking not only on street corners and meeting halls, but in saloons as well. In one of her more unusual campaign adventures she traveled with a friend by horse and buggy to the nearby mining town of Marysville, where on the return trip in the dark of night, Belle "held a lighted kerosene lantern over the horses' tails so that she could see the road." On November 3, 1914, women's suffrage was approved by male vote in Montana, making it one of the last states in the West to allow women the right to vote, but still years ahead of the nation as a whole. When Belle's political mentor, pacifist Jeannette Rankin, ran for office and was elected to Congress in 1916, the first woman in the nation to hold that office, Belle was invited to come aboard, initially to help mobilize the campaign and then as Rankin's assistant as a writer and secretary.[6] Another western state, Wyoming, was also the first in the nation to produce a woman governor, Nellie Tayloe Ross, who in 1925 was elected to complete her late husband's term.

Although myriad reasons have been offered to explain the early acceptance of the vote for women in the West, including practical needs stemming from small populations, an especially noteworthy explanation is that the region "seemed to be a safe place to experiment with woman suffrage," an ideal testing ground for a new political concept.[7] Of all the states in this study, only New Mexico delayed its franchise for women until national women's suffrage became a reality in 1920. Indeed, the victory in key western states between 1890 and 1914 helped "reinvigorate" the national movement and provided support and inspiration for the federal amendment.[8] After the passage of the Nineteenth Amendment in 1920, western women continued to express interest in politics. In the early years after the passage of the national women's suffrage law, many women in the United States, particularly in the South, still chose not to vote. However, in the West, where American women had first been enfranchised, even in the early 1920s women were voting at rates almost equal to those of men, unlike their counterparts elsewhere.[9]

In 1917, while working for Congresswoman Rankin, Belle met her future husband, Norman Winestine. At the time, he was working in the Hoover wartime Food Administration office, and he later served on the staff of *The Nation* magazine in New York. The couple married in 1918 and over time became the parents of three children, two daughters and a son. During the next few years, which included some time in Europe, neither Belle nor Norman earned enough through their writing to support the family, so in 1921 they moved to Helena, where Norman

worked with Belle's father, Herman, to manage the family department store. After marriage, Belle Fligelman Winestine continued her interest in both writing and politics. She was a frequent contributor to several magazines, including the *Atlantic Monthly,* as well as authoring several short stories and a play. She was also highly active in the League of Women Voters and made an unsuccessful bid for the Montana state senate in 1932.[10] In 1999, the Montana *Missoulian* named Belle Fligelman Winestine one of the hundred most influential Montanans of the twentieth century.[11]

While the term "politics" has most often been narrowly associated with the actual electoral process, many women entered the realm of politics through other avenues, sometimes through voluntary organizations and at times through the back door as the wives or daughters of male politicians. It is important to note that, in all three of these paths, western Jewish women, whether liberal or conservative in their political philosophies, like their contemporaries elsewhere, often focused on what some historians have identified as "maternalist" politics,[12] which emphasized the social welfare needs of women, children, and families. Moreover, in the West the entry of Jewish women into the political arena was facilitated by both the relatively greater acceptance of Jews in general and the often more elastic notions of men's and women's spheres.

Over the last several decades, new practitioners of women's history have expanded the definition of politics to include the study of how women involved in organizations influenced the political life of their communities. For example, historian Paula Baker's wide definition of politics encompasses "any action, formal or informal, taken to affect the course or behavior of government or the community."[13] In an era when women were especially active in local and community affairs, from the mid-nineteenth to early twentieth century, organizational work provided a platform for political and social change. Women from a variety of ethnic, religious, and socioeconomic groups, Jewish women prominent among them, created associations to meet their particular needs and interests. Historian Hasia Diner has asserted that beginning in the late nineteenth century, American Jewish women were actually engaged in political activities that were played out through their roles in social welfare and philanthropy. She cites the creation of a Jewish old-age home in Chicago and the organization of Boston's Beth Israel Hospital in 1915 as prime examples of the work of Jewish women who "thought and acted politically in the name of social amelioration."[14]

Scholar Paula Hyman has found that Jewish women in Germany at the turn of the century followed a similar trajectory through the organization of the League of Jewish Women (1904) and by working on behalf of the needs of women and children in the area of social welfare.[15]

This particular aspect of political involvement was certainly manifested prominently in the American West. At times, the three different political paths—speaking and writing, volunteer work, or through association with male relatives—followed by western Jewish women overlapped. When Belle Winestine was just a child of five in 1896, Selina Solomons was already entering the realm of politics by campaigning for the right of women to vote in California. The eldest of Jewish pioneer educator and activist Hannah Marks Solomons's five highly accomplished children, Selina was born in San Francisco in 1862. As we have seen in previous chapters, the long-standing role of western Jewish women in philanthropy and benevolent organizations had provided an influential public role for many. Despite being excluded from formal politics, as one historian has noted, "Long before they were voters, American women were important political actors."[16] Moreover, many historians have demonstrated that not only did women play a public role even before the long road to suffrage, but "over time they managed to exert a good deal of influence on the course of events despite their disenfranchisement."[17]

Before the passage of nationwide suffrage through the Nineteenth Amendment, women frequently utilized voluntary organizations both to educate as well as to pressure public officials and other influential men,[18] and "women's associations were remarkable sources of popular power and public leverage in American democracy."[19] As political scientist Jo Freeman so aptly put it, "Women got suffrage *after* they proved themselves to be an important political force."[20] Through their philanthropic charity work, social welfare endeavors, and later involvement in women's clubs, Hannah Solomons and her contemporaries in western states, as Jewish middle-class women activists, had opened a door for a new generation of younger women political activists and social reformers.

Indeed, the first political stirrings and political involvement of nineteenth- and early-twentieth-century Jewish women were informed and inspired by their organizational activity. Given the popular American ideology of their day that viewed females as morally superior, women were able to justify their activity in reform efforts as an appropriately

feminine pursuit, which, in turn, soon led them down political roads. As we have seen, the separation of women's and men's spheres was often fluid and permeable, particularly in the West, and in reality there were probably multiple spheres in which women's organizations and clubs were prominent as influential groups within "competing publics."[21] As Kathryn Kish Sklar has observed, women's organizations facilitated the creation of a particularly female public and political culture,[22] although this certainly did not preclude their forging alliances with men to accomplish common goals. Furthermore, after the Civil War, at least to some degree, the political involvement of women in politics became increasingly acceptable while women also became more comfortable with their expanding role in the area.[23]

With the continued growth of an American middle class, in the last decades of the nineteenth century a number of women who had acquired a higher level of education as well as the leisure for political involvement were eager to enter the political world. It should, therefore, come as no surprise that many of the Jewish women we have encountered in the previous chapters that focused on education, the professions, and organizational life were also active in politics. Western women, in general, were prominent among politically minded female American citizens and exerted influence over political events. In Utah, for example, where women enjoyed full suffrage as citizens of the third state to give women the vote, in 1900 a Mrs. Jones, president of Salt Lake City's Woman's Republican Club, served as an alternate at the Republican National Convention. In the same year, Elizabeth Cohen served as an alternate delegate to the Democratic convention and held the distinction of being the first female voting delegate in either of the two major party conventions. When the regular delegate became ill, she was elected to fill the vacancy. Not only did Mrs. Cohen become the first woman delegate to a national Democratic convention, but she earned a moment of fame when she seconded the nomination of presidential candidate William Jennings Bryan. The western states of Colorado and Idaho also sent women to the Republican conventions in 1900 and 1904.[24]

Interestingly, Mormon women enjoyed a number of early political privileges at the same time that the Mormon Church allowed the practice of polygamy, the sanctioning of plural wives. The Utah territorial legislature had initially granted women the right to vote in 1870, partly as a strategy to obtain a better popular image in the nation. But because

of polygamy, Congress revoked their right to vote through the 1887 Edmunds-Tucker antipolygamy act. In 1890, polygamy was officially ended in the Utah territory, opening up the possibility of statehood. Women's suffrage in Utah was written into the new 1895 constitution, and through the efforts of local suffragists as well as the support of the Mormon Church, the vote was restored to local women as Utah became a state in 1896. In the same year, Dr. Martha Hughes Cannon, a Mormon, was elected the first female state senator in the United States.[25] All women in Utah, the small number of Jewish women among them, also benefited from the right to vote in the state.

The national pattern of increasing political involvement particularly among middle-class and elite women was highly visible in the West. As a case in point, most of California's early active suffragists, including a small group of Jewish women, were members of the middle and upper classes and had little need to support themselves through jobs. But by the turn of the century, socialist working-class women in the state began to expand the boundaries of the coalition for women's suffrage.[26] It is interesting to note that the two most prominent national Jewish women's organizations, the National Council of Jewish Women (NCJW) and Hadassah, whose leaders were located mainly in East Coast urban centers and were primarily drawn from the middle and upper classes, were reluctant to officially support a suffrage resolution as late as 1917. After years of debate about the conservative economic policy of middle-class suffrage leaders, women in the Workmen's Circle finally endorsed suffrage in the same year.[27] In contrast to the West, Jewish support in New York City in 1917 for a women's suffrage referendum to a significant degree came from the immigrant and working classes.[28]

Although Californian Selina Solomons came from a prominent family, after her parents' marriage dissolved, both Selina and her mother Hannah turned to teaching, writing, and related professions to augment the family income. As an ardent supporter of the enfranchisement of women, Selina utilized her writing talent to become an author of a popular play on the subject, *The Girl from Colorado*, which was billed as a romantic comedy about the "American Votes-For-Women" and featured a comic character named Aunty Suffridge.[29] By the first decade of the twentieth century, female supporters of suffrage were increasingly using imaginative marketing tools such as public performances to marshal broader support for enfranchisement and to demonstrate that suffragists were not radical harridans but could be "womanly" and domes-

tic at the same time.[30] Reading *The Girl from Colorado* from a contemporary viewpoint, one is stuck by the play's overt attempt to portray suffragists as modern and professional, yet likable, attractive, and feminine. In the end, the heroine gets her man, as well as the vote.

Selina Solomons also recorded the history of the California suffrage movement in her 1912 book, *How We Won the Vote in California*. Although the 1896 campaign for women's suffrage in the state failed, largely due to the power of liquor lobbyists who feared that if women were given the vote they might shut down the profitable saloons, on October 10, 1911, California joined the other western states of Wyoming, Colorado, Utah, Idaho, and Washington to become the sixth state in the nation to allow women to be enfranchised. Selina later characterized the event as "the greatest day of my life."[31] As recorded in her book, in the failed 1896 campaign Selina Solomons had "personally canvassed two San Francisco precincts"—one of her own, inhabited by an intelligent well-to-do-class, most Americans; the other in the "South of Market region of poor working people, largely of German and Irish extraction." Learning from their mistakes in the earlier campaign, by 1910 the women were better organized and cast a wider net for broader support, and Selina Solomons became highly visible as a moving force and president of the newly formed Votes-For-Women Club of San Francisco. Located at 315 Sutter Street, in the heart of San Francisco's commercial area, the mainstream organization incorporated some socialist influences by encouraging support for suffrage among working women, primarily clerks and shop girls who worked near the club in the retail shopping district, and by providing speakers, literature on the subject, and a five cent "tempting and nourishing luncheon."[32] Like many successful suffragists around the nation, Selina had become adept at drawing on the educational and advertising campaigning styles of the major political parties of the early twentieth century, including the use of door-to-door canvassing and attractive signage.[33] The benefits of "municipal housekeeping" by reform-minded females was a popular theme, and Selina Solomons later maintained, "The need of the ballot in the hands of the women of the community in bettering conditions . . . was amply proven by the Votes-For-Women Club in the course of its career."[34]

A consummate organizer, Selina Solomons coordinated local demonstrations on behalf of women's suffrage, participated in a number of "votes for women" parades, and worked with national women's suffrage luminaries such as Carrie Chapman Cott and Susan B. Anthony.

As a poll worker in the 1911 election, Selina rose at dawn. At the end of the day, before the final returns were counted, it appeared that the suffragists had lost once again. Returning home at a late hour, Selina remained firmly committed to the cause, and after encountering a group of antisuffrage men, she could not resist mounting a last defense, maintaining: "We do not desire to destroy the home. But we do desire and intend to have a voice in our own government." The next day Selina and her co-workers were encouraged to find that although the suffrage issue was defeated in San Francisco, enough other cities and hamlets around the state voted to ensure the passage of the new state constitutional amendment. Clearly, Selina Solomons had played a critical and central role in the enfranchisement of California women.[35]

At about the same time as Selina Solomons was campaigning in California, Carson City attorney Felice Cohn was using her considerable negotiating and diplomatic skills to push the same state amendment for women's suffrage in Nevada, which she had authored. Although it was initially passed by both the Nevada senate and assembly, in order to become part of the state constitution the resolution had to succeed in another legislative round, and it passed by popular male vote in the next election. In 1914, significantly due to the efforts of Felice, who "effectively managed the legislative lobby," women in Nevada were enfranchised, as it became the ninth state to pass a women's suffrage law.[36]

In the 1920s, while practicing law in Reno, Felice Cohn penned a short essay titled "Women of Nevada Interested in Politics." In her understated and sometimes humorous style, she maintained, "There is one clarion call that we [women] all respond to and one topic of conversation that never grows old or stale or loses interest, and that is Politics!" Felice attributed the keen political interest of Nevada's women in part to the state's relatively sparse population and the fact that "we know all, or nearly all of our politicians personally . . . and we are not afraid to speak our minds about them." Despite running for public office several times, including once as a candidate for the state assembly in 1924, she was never elected. Nevertheless, she remained a lifelong, effective proponent of policies concerning the health and welfare of women and children, besides having been a highly persuasive voice on behalf of women's suffrage in Nevada.[37]

Mother and daughter Mary Goldsmith Prag and Florence Prag Kahn were two of the earliest and most visible western Jewish women to open

the doors to female participation in the public sphere of politics. Arriving in San Francisco with her family in 1852, Mary Goldsmith Prag received a strong Jewish as well as secular education and soon became an early leader both in the general and in the Jewish community. As a longtime respected teacher and later vice-principal, in an 1892 address before the Association of California Teachers she pushed for a state pension plan for teachers, which was later adopted. Women's issues were also vitally important to Mary, and she had also been instrumental in changing the rules to allow married women to teach and in pushing for equal pay for female teachers. At about the age of seventy-five she was appointed to the San Francisco Board of Education, the first Jewish woman in California to hold public office.[38] Many Jewish women would become involved in public education and serve on school boards throughout the West. Later, when Florence Prag Kahn ran for reelection at the age of sixty-five, some detractors complained that she was too old to hold office. Florence merely laughed, remarking with her characteristic wit, "Wait until my mother hears that." At the time, eighty-nine-year-old Mary Prag was still serving as an active member on the Board of Education.[39]

The influence of Mary Prag and Hannah Solomons helped poise their capable daughters to assume positions of leadership. Florence Prag Kahn, the first Jewish woman in the United States to be elected to Congress, was born in Salt Lake City in 1866 but as a young child moved to San Francisco with her family. Like her mother before her, she also attended the Temple Emanu-El religious school and was active in the congregation. Encouraged by her mother, Florence entered the University of California and graduated in 1887. Before marriage to Julius Kahn in 1899 when she was in her early thirties, Florence again followed in her mother's footsteps by pursuing a successful career in teaching English and history on the high school level, a profession that seemingly prepared a number of women for public careers.

As we have seen, Jews in early San Francisco enjoyed significant social and political status, and Mary Prag's and Julius Kahn's inner circle connections were extended to Mary's daughter and Julius's wife, Florence. The Kahns had a watershed year in 1899 as Julius Kahn had recently been elected to serve in the House of Representatives from San Francisco's Fourth District, and the new couple soon moved to Washington, where Florence later gave birth to two sons. As the wife of a

popular Republican politician, Florence kept abreast of the issues of the day, faithfully attended congressional debates, and personally aided her husband as his secretary.[40]

The story of Florence Prag Kahn also illustrates another important point about the political role of Jewish women in America, particularly in the West before equal suffrage. Throughout American history, beginning with Abigail Adams, wives and daughters of politicians often worked behind the scenes to influence their spouses and fathers. For example, in an often quoted letter from Abigail Adams to her husband, future president John Adams, while he was attending the Continental Congress in Philadelphia in March 1776, she urged him to "Remember the Ladies" and afford them some measure of power in the construction of the new government.[41]

As we have learned, in the American West numerous male Jews were elected to public office as municipal officials, mayors, governors, and even senators. Their female relatives were often involved in attending mass meetings, parades, rallies, and campaigns and worked cooperatively with men in the field of partisan politics to effect social reform or eliminate corruption.[42] Certainly, Helena Kaestner Alexander, wife of Idaho's governor, Moses Alexander, and Ida Maas Bamberger, wife of Utah's governor, Simon Bamberger, supported their husbands in political life. For example, both the Bambergers were personally acquainted with and visited President Woodrow Wilson, and the couple traveled together to Washington, D.C., and other major cities on the East Coast for political meetings and celebrations. In an article that appeared in 1916 in the *Salt Lake Tribune,* the newspaper noted that despite Ida's primary concern with her home and family, "since her arrival in Utah as a bride Mrs. Bamberger has taken an active part in civic and philanthropic work."[43] So, too, Florence Kahn had acquired significant firsthand political experience through Julius's political office before her own election to Congress.

It is interesting to note that despite Julius Kahn's political prominence, the family income was apparently modest. During the years of 1919 and 1920, while Julius served in Congress, Florence Kahn also contributed a regular column to the *San Francisco Chronicle* for which she was paid and in which she demonstrated a sophisticated grasp of political issues. She had also assumed secretarial duties, in part to save money. But Florence was far more than a secretary, serving as both Julius's sounding board as well as a knowledgeable adviser. A humorous

story recounted by her husband indicated that not only was money an issue for the young couple, but that they operated together as a team. When the Kahns were invited to have dinner with President McKinley, Julius recalled they had walked to the executive mansion to save the one dollar cost of a carriage. He later reportedly commented, "In what [other] country could two poor Jews be on their way to dine with the head of state?"[44] When Julius died in 1924, Florence was elected in a close special race to take his place in the House and went on to be re-elected five more successive terms until her defeat in 1936 in the wake of the Democratic landslide under Franklin Roosevelt.

Florence Prag Kahn became the first Jewish woman and only the fifth woman overall up to the time of her election to serve in the United States Congress. Although her initial election was brought about by her husband's death, she proved to be an extremely able and forceful politician in her own right. Florence worked diligently on behalf of her constituency, shepherded successful legislation for the San Francisco–Oakland Bay Bridge and Marine Hospital, and exhibited a very public Jewish identity. She remained a lifelong member of San Francisco's Congregation Emanu-El as well as a member of Hadassah and the National Council of Jewish Women. While many western Jewish women involved in the political arena pursued a liberal social agenda, some like Florence Kahn drew on Jewish values that emphasized continuity and moderation. In 1929 she was appointed the first woman to serve on the House Armed Services Committee and the Appropriations Committee. As a Republican, she was in many ways a conservative politician, supported a strong military presence and the FBI, and was a personal friend of J. Edgar Hoover.[45] Indeed, after Florence lent her support for increased funding for his organization, Hoover affectionately nicknamed her the "mother of the FBI." It is interesting to note that when her support of the FBI was criticized as possibly opening the door for a repressive police state, Florence dismissed the accusation as nonsense and justified her position by offering a "maternalist" political argument, maintaining that she was responding to the concerns of the nation's mothers who wanted a safer environment for their children.[46] Her words demonstrate that political conservatives as well as liberals were involved in family issues and could employ maternalistic rhetoric to their advantage.

When Florence Prag Kahn died in 1948, she was also remembered, among her numerous accomplishments, for her "occasionally frightening talents for ramming through legislation." Known for her capability,

Florence Prag Kahn as Acting Speaker, United States House of Representatives, Washington, D.C., 1926. (Courtesy of the Western Jewish History Center, Judah L. Magnes Museum, Berkeley.)

outspokenness, and wit, one contemporary writer observed that with Florence, "You always knew how she was going to vote but only God has the slightest inkling of what she is going to say."[47] She also made frequent public references to her Jewish heritage. After a disagreement with her, New York's Fiorello La Guardia (then a congressman and later mayor) denounced Florence Kahn as a reactionary politician and follower of Senator George H. Moses of New Hampshire. Florence rose to her feet in Congress and acerbically shot back the rejoinder, "Why shouldn't I choose Moses as my leader? Haven't my people been following him for ages?" While Florence diffused the tense situation in her typically humorous style, she was in fact generally a staunch conservative, but at times could also be surprisingly liberal in her views, as in the case of women's rights or her vocal opposition to film censorship.[48]

Florence Prag Kahn was one of many western Jewish women who exhibited a high degree of social awareness and political activism, a

legacy of early Jewish female involvement in social welfare and reform while building new settlements. The former schoolteacher, who had once considered becoming a lawyer but was thwarted by limited family finances, became the personal friend of eight presidents and upon her death was eulogized as "one of the outstanding women of the twentieth century."[49] Perhaps President Roosevelt's outspoken relative Alice Roosevelt Longworth summed up Florence Kahn's Washington political career most astutely in a 1934 article for the *Ladies Home Journal:* "Mrs. Kahn, shrewd, resourceful, and witty, is an all-around first-rate legislator, the equal of any man in Congress, and the superior of most."[50]

In addition to supporting suffrage and running for political office, western Jewish women's political presence was felt through their quest for social improvement. Jewish women in the West were involved in these types of political/welfare activities early on, and the key role Frances Wisebart Jacobs played as a lobbyist and advocate for the founding of National Jewish Hospital in Denver in the 1880s is a prime example. As we have seen, throughout the country women who were active in local sections of the NCJW often participated in communal work that extended beyond the Jewish community and into what became the political arena, and NCJW chapters in the West figured prominently in this phenomenon. Perhaps because of the early western legacy of women's suffrage, Jewish women in the region were keenly aware of the responsibilities and rights of citizenship. For example, although most of the organization's meetings focused on self-education and welfare efforts on behalf of east European immigrants, in March 1899 the Denver section of the Council discussed the possible distribution to members of a booklet compiled by the State Federation of Women's Clubs concerning "Colorado State Laws Affecting the Rights and Property of Women." In May 1901 members considered an invitation from the Colorado Equal Suffrage Association to form a committee to work with women from other organizations around the state.[51] In 1907, Jewish women in Portland's NCJW section in Oregon successfully used political tactics to pressure local newspapers to stop "the uncalled for" and discriminatory labeling as Jews of suspected criminals who happened to be Jewish. The members were incensed about the practice because religious appellations were not attached to suspects from other religious denominations.[52]

As we have seen, the Jewish legacy of social welfare initiated and carried out by Frances Wisebart Jacobs in Colorado in both general and

Jewish women's groups expanded into a general advocacy of women's rights. An early prototype Progressive, Frances Jacobs stressed the role of education in bringing about reforms for the working class. Well before women's suffrage was passed in Colorado in 1893, she appealed to the men "who have the right to vote . . . to legislate away the shackles of industrial slavery." She lamented the fact that women had not yet attained the right to vote to secure their political goals and that we "have no voice in the laws," and advised working women to band together to "demand equal pay for equal labor."[53] Like many female activists, Frances Wisebart Jacobs supported women's suffrage as a concrete vehicle for addressing social injustice that was exacerbated by urbanization and industrialization rather than as a theoretical argument for equality. As historian Elisabeth Clemens has pointed out, many American women supported enfranchisement not as a philosophical natural right but because they wished to secure specific reforms such as protective legislation for working women and children.[54]

One of the more prominent Denver Jewish women influenced by Frances Wisebart Jacobs was Ray David, who, as already noted, was highly visible in social welfare work on behalf of Jewish immigrants at the turn of the century as the director of the Central Jewish Aid Society. Both Ray David and her Denver colleague in social work and philanthropy, Seraphine Pisko, were members of a distinct elite Jewish German Reform social group and leaders in the NCJW, but were highly integrated into general city life as well as having had close ties with the east European Jewish community. As ardent supporters of a variety of Progressive-era reforms, their philanthropic work was a path to political influence. Mrs. David was particularly vehement about reforms that involved children, including child labor laws to end their exploitation.

In 1913, Denver's Mayor James Perkins appointed Ray David to the City Board of Charities and Corrections. The following year, Colorado's governor Elias Ammons appointed her to the Colorado State Board of Pardons, and Governor John Vivian later appointed her to the Child Center Committee. As one historian has pointed out, at the turn of the century in issues relating to children, "powerful men listened to women and were willing to act on female advice."[55] Ray was also a strong proponent of women's suffrage, appearing frequently at early rallies. She worked actively for the women's vote across the nation through the Denver Woman's Club and later the Women's Voter League, where she

led sessions to educate women on how to exercise their political rights. In the first decade of the twentieth century, Ray was listed in a local newspaper as being one of the founding organizers of the Women's Voter League whose central agenda was to bring women together with the goal of "seeing women play a larger part in the political life of the city," part of a larger Progressive-era movement for clean government and municipal reform. In 1914, she was quoted as urging Colorado women to give up luxuries in an effort to support the efforts of suffragists in Nevada and Montana. And like many women across the nation, she was involved with the female peace movement, urging local women to protest the war in Europe. This political stance ultimately did not prove popular with the American people, and pacifist congresswoman Jeanette Rankin of Montana lost her reelection, largely due to her outspoken views against America's entry into World War I. Still, the Denver newspaper article approvingly described Ray David as "a suffragist whose head is forever on her shoulders."[56]

Government appointment or election to civic commissions and school and charitable boards was not unusual among Jewish women in western states. It was often a reward for Jewish political support and high-profile contributions to their communities. For example, in New Mexico, Flora Spiegelberg was a member for many years of Santa Fe's City Commission and was the force behind the building of the first children's playground there. Flora's husband, Willi Spiegelberg, served as Santa Fe's mayor from 1884 to1886. Because of the family's high political visibility, Flora entertained such contemporary notables as General William Tecumseh Sherman and President Rutherford B. Hayes on their visits to the West. She not only supported her husband's political life as a popular hostess, but played a central role in the development of the city's sanitary and waste planning program during a twenty-year period.[57] In Portland, Blanche Blumauer, a former president of the local section of the NCJW, ran unsuccessfully in 1916 as a candidate for the city's school board, in a bid supported by the council.[58]

Although she resided in Denver for less than two years during 1913 and 1914, Golda Mabovitch Meyerson, or Golda Meir, as she later became known, is an unusual example of the importance of tuberculosis to the growth of the Jewish community in a number of western states, and to women's political growth and awareness. Golda's sister, Shayna Mabovitch Korngold, was one of the many east European Jews who

flocked to Colorado to "chase the cure." Shayna was a patient at both the National Jewish Hospital (NJH) and later at the Jewish Consumptives' Relief Society (JCRS), and after recovering her health she married Sam Korngold and settled in a small duplex in the West Colfax immigrant neighborhood. Golda ran away from Milwaukee to her sister's home in Denver when her parents refused to let her attend high school in her hometown and instead encouraged her to marry a local Jewish man twice her age. While "arranged" matches and the importance of marriage over higher education for young Jewish women may not have been uncommon among immigrant Jewish parents, Golda's extreme reaction demonstrated her independent streak. In Denver, according to her report card, Golda left a record as an excellent student at North High School, receiving high grades in all but mechanical drawing. She also met her future husband, Morris Meyerson, who introduced her to the world of art and culture during the time she resided in the city.[59]

More importantly, it was in Denver that Golda Meir, who became one of the most important political leaders of the twentieth century, particular as prime minister of Israel, was exposed to the many Jewish intellectuals who came to the Korngold house for tea and heated discussions. Many had come to Colorado for health reasons, and Golda hovered in the background as they engaged in political debates over a variety of contemporary issues such as socialism and women's place in society, to which she "listened raptly." As Golda later recalled in her memoirs, "In Denver, life really opened up for me," and she found the "ideological discussions about politics much more interesting than my lessons."[60] In the absence of large factories, Denver never boasted a significant Jewish labor movement, but the JCRS and NJH served as transient bases for political discussions among the radical Jewish intelligentsia who were among the patients at the two hospitals.

If we broaden our definition of politics even further to include public policy and service in the area of social reform, then certainly women such as Dr. Jessica Peixotto, the first female full professor at the University of California at Berkeley, used their expertise for the welfare of American citizens, particularly children. As a professor in the emerging field of social economy, Peixotto's emphasis was on the discipline's connection with social welfare issues. Recognized as a leading social economist, she was called upon to serve as a member of the Berkeley Commission of Public Charities from 1910 to 1913, and in 1912 she was

appointed by Governor Hiram Johnson as a member of the State Board of Charities and Corrections, a position she held until 1924. This board supervised all of California's penal and charitable institutions, and as chair of the Committee on Children and the Committee on Research, Jessica Peixotto had ultimate responsibility for the care of over 12,000 children. During World War I her reputation for public service in California led to federal appointments as a member of the national committees on Women in Industry, Child Welfare, and most importantly, as the executive chairman of the Child Welfare Section of the Women's Committee of the Council of National Defense. In this capacity, her main goal was to insure that children were allowed the opportunity to attend school rather than being forced to take jobs in which they are exploited.[61]

Jessica Peixotto's emphasis on the role of economics in creating changes in social welfare reflected broader American reform ideology that called for alleviating the increasing social problems brought about by industrialization, urbanization, and mass immigration by focusing on the working classes primarily through assisting women and children. In her public work, she was in the vanguard of the campaign that by the 1940s led to the emergence of the American "welfare state."[62] In addition, Jessica was an important force in bringing professionalized social work to California. In 1917, she organized and directed a program to train local social workers. Her work evolved into a professional graduate program at the University of California at Berkeley within the Department of Economics. A colleague later described her as a pioneer in the field and "also a pioneer in her conviction that education and training were necessary for social workers." He particularly pointed to her "aim to make science serve humanity."[63]

By the turn of the century, women reformers throughout the country made prominent use of the social sciences. For example, in Chicago, Alice Hamilton, a physician at the city's famous Hull House settlement, utilized her research on occupational diseases to pressure politicians to pass workmen's compensation laws and child labor laws. Following a path similar to that taken by Jessica Peixotto, in 1919 Hamilton became the first woman appointed to the staff at the Harvard Medical School when she became an assistant professor of industrial medicine. However, the policy at Harvard toward female teachers was apparently less liberal than at the University of California, and Alice Hamilton's

position came with certain strings attached, including not being allowed to use the Faculty Club nor to march in graduation ceremonies. She was never promoted beyond the level of assistant professor.[64]

Most of the Jewish women in the West who became active in public policy, whether through grassroots reform movements, club work, women's suffrage, or in the formal political arena, often focused on issues relating to women and children, or "maternalist politics." This emphasis is what often distinguished them from their male counterparts.[65] Many specifically aimed their reform activism at the negative effects of urbanization and industrialization. Increased opportunities for higher education provided women with new skills and an expanded horizon in which to become "effective agents of social improvement." As we have observed, like their gentile counterparts, Jewish women became "capable speakers, good writers, and sharp-eyed social critics."[66] Centrally involved during the early stages of the American welfare state, many looked to municipal, state, and federal governments to improve living conditions for all classes.

As Jews, many of these predominantly middle-class women, whether liberal or conservative in their political outlook, drew on the traditional Jewish emphasis on social justice and responsibility. As westerners they sometimes also contended with overt strains of individualism and self-reliance. Yet, the complex challenges of settling a new land allowed early western Jewish women to blend these strands in the face of pressing needs for mutual aid and to grow new settlements. As time passed, they became increasingly politically and socially active as advocates for social improvement and political reform, and a number exercised considerable power between 1880 and 1930. As many scholars have noted, as the nexus for multiple and often competing groups, "the cities were focal points of social change,"[67] and as we have seen, western Jewish women were largely urban dwellers. Moreover, women's achievement of suffrage in the United States began on the western frontier.[68]

Florence Prag Kahn was only one of a small group of women around the nation elected to national public office in the first decades after the passage of the Nineteenth Amendment. Ironically, women voters did not form a voting block during those years, nor did they vote the significant number of women into office that many antisuffragists had feared.[69] While women's suffrage and election or appointment to public office offered the most visible affirmation of women's expanded public and political roles in the American West, their activist roles in voluntary

organizations, both Jewish and secular, were equally if not more important. Jewish women played a central part particularly in these latter and often undervalued activities. They may have felt their most enduring mark in these endeavors, which reflected not only contemporary power relations, but ultimately influenced the course of regional and national politics.

Conclusion
Opening New Doors

In 1912, the year after women's suffrage was passed in California, Selina Solomons arrived at a San Francisco polling location and announced, "Good-day, fellow citizens. I've come to vote."[1] Selina's bold declaration revealed her confidence that as a Jewish woman she was entitled to be treated as a respected member of the western community. Unsurprisingly, in the second half of the nineteenth and the early twentieth centuries, Jewish women across America were highly visible in the vanguard of social welfare and progressive reform endeavors, commerce, higher education and the professions, and in the maintenance of Jewish life. However, considering their relatively modest numbers, the level of involvement of Jewish female pioneers in the West is particularly striking. While the Jewish population in the American West had grown to about 300,000 by 1920, Jews in New York City alone at the same time numbered well above 1.5 million. As the stories of the diverse western Jewish women in this study have demonstrated, they were often strong minded and independent and played an integral role in settling America's western frontier and promoting Jewish continuity as they built new lives in a region that offered them a host of expanded possibilities.

The high profile of these early Jewish western women is the result of a number of complex and intertwined factors. First, it was partly the result of the distinctiveness of the West for women, in general. In her study of female homesteaders in Colorado, historian Katherine Harris criticized several early studies on western women that rejected outright the notion of increased female independence and opportunities as they moved West. She asserted, "The fact is, some women prospered in the West, and some did not. To understand the reasons for the differences, we need to learn about the smaller, more homogeneous populations of western women."[2]

Western Jewish women are one such important group. Ethnicity, class, education, gender, and religion all influenced the multiplicity of historical experiences in the American West. It has become commonplace to note that Jewish religious and cultural traditions have encouraged a respect for learning, community responsibility, and ambition. As a distinct group, the majority of Jewish women in the West, who were almost exclusively of white Euro-American background, were among those who *did* prosper, though sometimes they took advantage of the labor of less fortunate women of color who occupied less privileged positions on the mobility ladder. While these interactions were often cordial, as in the case of Anna Solomon and her Mexican and Indian employees, some undoubtedly were less so, and these encounters reflect the complexities of race relations in the region where Jews generally found acceptance as part of a white, middle-class elite despite the presence of relatively mild, social anti-Semitism.

In 1997, Glenda Riley, one of the preeminent historians of western women, acknowledged that historians studying women of the West still disagreed as to whether western women's experiences were significantly different from those of women in other parts of the country. Though she maintained that many more studies were needed to test hypotheses and assumptions before any definitive conclusions could be drawn to ascertain whether what she termed "essentialism"—whether western women were essentially the same as or different from American women in other regions—was indeed the case, she also revealed that her personal feeling was that "western women are, I suspect, indeed different."[3]

When I began my research, I, too, suspected Jewish women in the West had followed a somewhat different path from their sisters in other regions. In an effort to broaden contemporary portrayals of the American Jewish women's experience, I initiated an investigation into the ways in which western Jewish women both diverged from and resembled their counterparts in other areas of the country. I have concluded that the experience of western Jewish woman on the whole was indeed different in degree and scope from that of their contemporaries elsewhere. By examining the lives of early Jewish women in the region, we gain a deeper understanding of the diverse roles and experiences that informed both the lives of all western women as well as Jewish women throughout the United States. *Jewish Women Pioneering the Frontier Trail* was undertaken with precisely this goal in mind. As we have seen, the West offered new opportunities to women, Jewish women among

them, in a number of particular areas, including higher education, political and social influence, and expanded economic and professional roles. Against the backdrop of a rapidly developing and bustling economic region, which welcomed bold enterprise, women could and did find their niche.

It would be inaccurate to suggest that the frontier was devoid of prejudice, but the freewheeling, evolving nature of the early West also offered distinctive prospects to a host of diverse ethnic and religious groups. The location and definition of the term "frontier" has changed over time in American history, but one common theme is surely that it was an "unconstructed" region,[4] where the initial lack of organized systems often brought not only the unexpected but new expectations. The authors of a recent volume about religion in the West have pointed out that "each region [of the country] has its distinctive religious layout,"[5] and that cooperation between Jews, Protestants, and Catholics was observable in the West long before it appeared in other regions of the country.[6] In addition, as we have learned, no one religious denomination predominated in the West. This phenomenon takes on particular significance for women specifically in the light of historian Theda Skocpol's argument that in America generally, "Religious disestablishment and competition also facilitated the extraordinary civic empowerment of American women."[7] The elevated level of religious pluralism in the West, a result, in part, of the region's ethnic variety, frontier ethos, and inner divisions, benefited Jewish women to a significant degree by admitting them into the power structure. Simultaneously, for many "the frontier had shaped a new vision of what was necessary and possible for women,"[8] and Jewish women profited from this more general flexibility as well.

The physical open spaces within the geographical boundaries of the West also tended to foster at least a psychological perception of unlimited opportunity. For example, an early east European Jewish resident of Cheyenne, Wyoming, whose relatives arrived in the town around the turn of the century, maintained, "Almost everybody in the family thought that Cheyenne and Wyoming were the Garden of Eden."[9] A number of historians have also pointed to the transformative power of the urban mining frontier for westerners, "particularly its women," which "promoted increased economic opportunity and social equality for its oftentimes unwilling changelings."[10] Others have emphasized the region's lead in pioneering political equality for women through suf-

frage, part of the "broader opportunities the frontier offered for remaking American society."[11] Historian Mary McCune has recently asserted that before America's entry into World War I, few Jews were active participants in the suffrage movement.[12] But as we have seen, by that time Jewish women could vote in nearly all of the western states.

A number of key factors worked together to shape the American West as a particularly inviting setting in which Jewish women could flourish. First, their relative success is attributable partly to the general underlying Jewish religious and cultural influences that informed the lives of most American Jewish women, regardless of region, which emphasized the value of communal obligations, education, hard work, and concern for the needy. Second, and probably most crucial, was the question of timing and the pioneer status of early Jewish populations in the West. The fact that Jews settled early in the region helped legitimate their status. At the same time, the generally middle and sometimes elite economic and class status of most, though certainly not all, western Jewish women, against the backdrop of the developing social, political, and economic conditions of the region, also played a central role.

Furthermore, a relative absence of overt anti-Semitism and the need for capable leaders in the rapidly developing West provided an entré for many Jewish women into public work, business, and the professions. Partly a process as well as a place, within constraints the American West fostered a frontier mentality, which opened wider paths and provided greater social, economic, and political opportunities for Jewish women as well as men. As John Livingston noted, these types of opportunities for Jews were "markedly in advance of other regions of the country."[13]

The highly pluralistic, multiethnic, multireligious nature of early western towns often made it easier for pioneer Jewish immigrants to find acceptance than they had in the older established towns and cities in the South or East. Contrary to earlier popular stereotypes, the West was not the exclusive domain of adventurous white, Anglo-Saxon, Protestant males. From colonial times onward, Jews tended to prefer and achieve the greatest success in pluralistic communities. Because the West had no entrenched elite that sought to keep Jews out, Jewish women as well as men frequently moved into leadership positions with relative ease. At the same time, it is worth noting that the same qualities that pointed many pioneering Jews westward, including individualism, resourcefulness, self-reliance, and the desire to improve their own lives and the lives of their families, may in fact also have promoted leadership.

We certainly need to consider the possibility that these early women and men were a self-selected group. As active community builders in a variety of roles, both domestic and public, in nineteenth-century American western frontier settlements Jewish women were poised to take advantage of unprecedented possibilities in a new and dynamic region, with new rights, greater freedom, and opportunities that were not yet always available elsewhere in the country.

Being members of a double minority in the West, as women and Jews, may have also energized some women and encouraged them to venture into the public realm. Leadership positions provided them with an opportunity to prove their worth and make a name for themselves. Accomplished women such as Frances Jacobs, Florence Kahn, Belle Winestine, and Felice Cohn, among many others, must have been pleased with the prominent recognition they received. Particularly in early western boom towns, where growth was often rapid and chaotic and the number of females was small, mutual assistance was critical. Here western women enjoyed more equal status than women in other regions of the country. Domestic skills, for example, commanded top dollar and encouraged many women to become seamstresses and food purveyors or to pursue hotel and boardinghouse ventures, paths we have seen followed successfully by Jewish women like Mary Ann Magnin in California, Anna Solomon in Arizona, and Regina Moch in Nevada. As time passed, the innovative environment of the West offered Jewish women the possibility of greater access to higher education, professional positions, and entry into formal politics. If they did not often break boundaries, they certainly stretched them, with Jewish women's agency being evident throughout the West.

At the same time, we should not romanticize life in the West. It could bring harsh realities along with new opportunities. In a recent editorial, noted western historian Patricia Nelson Limerick observed that while the region's preeminent novelist Wallace Stegner once observed that the American West "is the native home of hope," it has also been a region in which tension, conflict, and dismay have played a role.[14] Not all of the Jewish pioneers and their daughters and sons found economic prosperity and social success; some continued to long for their former homes, and, as we have seen, infant, child, and maternal mortality, particularly in the early years, hovered tragically over many families as they fashioned a western existence and identity. And there were elements of commonality as well as diversity between the women's experience in the

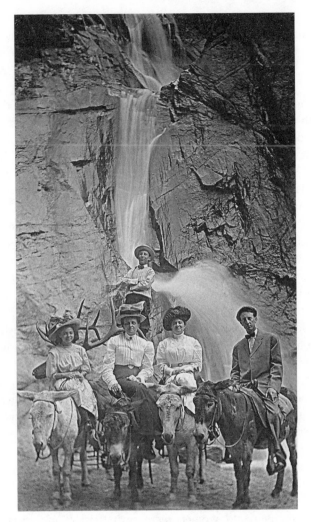

Bernstein family at Seven Falls, Colorado, 1910. (Courtesy of
the Beck Archives, Penrose Library, and CJS, University of
Denver.)

West and American women in other regions, as well as among women
of various ethnicities, religions, and classes within the region itself. The
vicissitudes of life, including the death of a spouse, illness, or financial
calamity, for example, could force women across the nation, regardless
of their origins, into seeking work outside the home.

Yet, as the author of a recent study of Jewish life in America's small towns reminds us, "sectional identity had an influence on the Jews of America," and the role of "place" is certainly important in the drama of American Jewish history.[15] While New York City (and by extension a number of East Coast and a few Midwest urban centers as well) has been the home for America's largest Jewish community from the beginning (with the exception of San Francisco in the 1870s), there has been ample evidence to demonstrate that "Jewish life in New York City is not and never was representative of the diverse experiences of Jews who have lived and continue to live in different towns, cities, and regions of the United States."[16]

We should not exaggerate the distinctiveness of the American West for Jewish women, but at the same time it is important to note that at the very least these women in a region that was frequently progressive opened new doors wide enough to facilitate entry into a variety of social, economic, professional, and political areas in the last geographical American frontier. Immigration to the West was a transformative event, one that enabled many Jewish women to shape new lives for themselves and their families. From the first step of migration itself, Jewish women appear to have enjoyed considerable decision-making prerogatives within the family structure, roles that often continued in their new surroundings, where many of them became significant agents of community formation. Historian William Toll has noted that in western cities, Jewish women clearly exhibited public prominence as early as the pioneer generation.[17]

Echoing John Higham's thesis about Jewish acceptance, Jonathan Sarna has rightfully pointed out, "Where Jews had 'pioneer' status they generally fared better than where they were seen as latecomers or interlopers."[18] The crucial point is that the American West was a region where Jewish men and women *were* early settlers in virtually every town and emerging hamlet, which helped to legitimize their status and often enabled them to occupy a prominent place in civic hierarchies as community leaders. This phenomenon influenced not only the pioneers themselves but their children and grandchildren as well, and was a critical factor in the opportunities available to western Jewish women. As one historian has observed, "The degree to which Jews were involved in the early growth of a city and had achieved a notable and respected place in public and private life . . . directly influenced how later generations of Jews were received."[19] Moreover, as noted previously, Jews

in the West were largely although not exclusively urban dwellers, and cities often provided wider social, economic, and educational opportunity for women as well as men. After 1890, the population in the West grew at a faster rate than in any other region of the country, and a number of towns grew into impressive metropolises. As some historians have suggested, cities were "intersections of various systems of power—based on *gender,* class, ethnicity, and region."[20] Western Jewish women were among the groups that were able to acquire a share of influence, in the process often developing strong identities that simultaneously blended gender, Jewish, and western elements.

Jewish Women Pioneering the Frontier Trail is not meant to be an all-inclusive book about every notable Jewish woman in the West. Rather, the stories of the women who appear in these pages were chosen as representative of not only the movers and shakers, but of "ordinary" women as well, in an attempt to form a composite portrait within a variegated historical backdrop. Jewish women in the West were not only impacted by their region, but as shaping agents they also influenced the development of the region in a variety of ways. First, a number of them played a pivotal role in sustaining and transmitting Judaism both in the home and in synagogues and philanthropic endeavors. Particularly in the early years, the presence of Jewish women in frontier settlements heralded the beginning of organized Jewish communal life. At a time when ritual observance often diminished among Jewish men preoccupied with commerce, many Jewish women retained at least some of their customs and traditions. A religious historian has recently written that Jews in the West appear to have been somewhat more observant than their co-religionists in other parts of the country where a larger Jewish presence was in evidence.[21] Second, western Jewish women increasingly played a central role not only in the home, but also in the public arena, where they fostered the development of both the general and Jewish community through social, religious, and welfare activities and in business, educational, and professional endeavors. Because of their central role within the home, perhaps these women, more than men, were able both to acculturate to western and American society and retain their religiosity because of the underlying interconnectivity of religion, family, and community within Judaism. A particular integral by-product of Jewish women's contributions to community social welfare systems was the increased political and economic stability of western towns and cities. Ironically, as towns grew into cities and large

metropolises and as new advances after World War I in communication and transportation worked together to minimize the importance of regionalism, western life also became more similar to the social order of the older established areas in the East, South, and Midwest. As time passed, distinctions between western women and their counterparts in other regions gradually faded.

As we have seen, most Jewish women in the West operated within the family structure, and religion and family were intricately intertwined in Jewish life. Over time, a number of married western Jewish women were able to successfully navigate traditional domestic roles and at the same time enter the public arena, whether through voluntary organizations, often working for social betterment as "municipal housekeepers," or in business and, in rarer cases, in higher education, the professions, and politics. Along the way they adapted to life in the West by redefining the contemporary concept of woman's sphere to include expanding public roles and concomitant independence. Even those who did not marry, such as pioneer attorney Felice Cohn in Nevada, educator Jessica Peixotto in California, and social worker Ida Loewenberg in Oregon, devoted much of their professional life to assisting families, particularly women and children, and were themselves encouraged by their own supportive family members. Felice Cohn was instrumental in the passage of women's suffrage in Nevada and child labor and adoption laws, Jessica Peixotto worked many years on behalf of juvenile offenders, and Ida Loewenberg helped immigrant Jewish families adjust to their new surroundings. The involvement of so many Jewish women in these issues is not surprising considering the traditional Jewish emphasis on family as well as the fact that Americans have long held the view that the family is the fundamental unit of society.[22]

The very newness of life in the western frontier environment provided opportunities and experiences that may have contributed to the fluid identities of these women as Jews, females, and westerners. Yet, despite ample opportunity to assimilate unnoticed into the larger society, nearly all the women in this study identified themselves publicly as Jews, and most, on various levels, were somehow involved in Jewish communal affairs while also enjoying a high degree of integration into general society. In other words, even as they were part of the larger western community, on the whole early western Jewish women retained their distinctive religious and ethnic ties. When noted educator and activist Mary Prag, who lived in Salt Lake City for several years in the late

1860s before returning to San Francisco, was questioned by Mormon leader Brigham Young about her ties to Judaism, she firmly and proudly informed him that she and her husband were Jews "by birth, race, faith, conviction."[23]

In a recent survey of American Jewish history published to coincide with the 350th anniversary of the Jewish community in America, historian Hasia Diner observed that since the first group of Jewish immigrants who arrived in New Amsterdam in 1654, "a constant process of negotiation shaped the history of Jews in America" as they fashioned an American Jewish identity.[24] So, too, many Jewish women in the American West constructed a distinct American Jewish identity by synthesizing the American and Jewish values and traditions they held dear through an internal and sometimes external process of negotiation, but one which also integrated a western component. And in all their endeavors, from charity, social welfare work, and religion, to politics, business, and the professions, these Jewish women exhibited a distinctly female or feminine, if not consciously feminist, perspective.

The rapid growth of frontier settlements in the West opened economic avenues for women as well as men, progressive western ideas about higher education for females fostered professional growth, and the region led the nation in the early adoption of women's suffrage. My examination of the lives of hundreds of western Jewish women for this study has persuaded me that going West or growing up in the West signaled promise for many Jewish women. Recalling her family's move to the West in 1875, Rebekah Kohut, who spent her formative years in the region, described the promise that had attracted so many Jewish settlers and recalled, "The West allured with the many tales of the land flowing with milk and honey. To be a pioneer, or almost a pioneer, was a pleasing thought."[25] Although Jewish women in the early West did not all share identical experiences, they did live in a geographical region that allowed for a great deal of flexibility. It was often populated with individualistic inhabitants, in an area that included the awe-inspiring natural beauty of mountains, prairies, deserts, and the grandeur of rugged, majestic, and vast expanses of landscape. It was also a place where Jewish women could hope to build new lives that expanded their horizons, one that frequently offered a sea of possibilities. Here they were able to help shape the contours and parameters of their region and of the American Jewish community as well.

Notes

NOTES TO THE INTRODUCTION

1. *Memoirs of Frances Jacobs* (Denver: Charity Organization Society, 1892); Frances Wisebart Jacobs File, Beck Archives of Rocky Mountain Jewish History, Penrose Library, University of Denver, hereafter referred to as the Beck Archives; Marjorie Hornbein, "Frances Jacobs: Denver's Mother of Charities," *Western States Jewish Historical Quarterly* 15 (January 1983), 133; and Ida Uchill, *Pioneers, Peddlers, and Tsadikim* (Denver: Sage Books, 1957), 18–19, 145.

2. *Memoir of Anna Freudenthal Solomon*, copy on deposit in the American Jewish Archives, Cincinnati.

3. See Mary Prag, " Early Days," Florence Prag Kahn and Julius Kahn Collection, 1975.009, Western Jewish History Center, Judah L. Magnes Museum, Berkeley.

4. Pisko File, Beck Archives; Jeanne Abrams, entry on "Seraphine Eppstein Pisko"; Paula E. Hyman and Deborah Dash Moore, *Jewish Women in America* (New York: Routledge, 1997), 1077; Uchill, *Pioneers, Peddlers, and Tsadikim*, 145.

5. This felicitous phrase was used by historian Glenda Riley in her book *A Place to Grow—Women in the American West* (Arlington Heights, Ill.: Harlan Davidson, 1992).

6. Interview with Arnold Sky, 1979, Tape 46, on deposit in the Beck Archives.

7. "Trail Blazers of the Trans-Mississippi West," *American Jewish Archives* (October 1956), 125, and Mark Elliot and Marie Still, *Lest We Forget: Remembrances of Cheyenne Jews* (Cheyenne, Wyo.: Aaron Mountain Publishing, 1990), 12–13.

8. Moses Rischin and John Livingston, *Jews of the American West* (Detroit: Wayne State University Press, 1991), 15–16.

9. Two especially fine examples are Ava F. Kahn, "To Journey West: Jewish Women and Their Pioneer Stories," in Ava F. Kahn, ed., *Jewish Life in the American West* (Los Angeles: Autry Museum of Western Heritage, 2002), 53–81, and William Toll, "From Domestic Judaism to Public Ritual, Women and

Religious Identity in the American West," in Pamela S. Nadell and Jonathan Sarna, eds., *Women and American Judaism: Historical Perspectives* (Hanover, N.H.: University Press of New England, 2001), 128–147.

10. James Nottage, "Foreword," in Kahn, *Jewish Life in the American West*.

11. New perspectives on early western women were spawned by a seminal 1980 essay by Joan M. Jensen and Darlis A. Miller, "The Gentle Tamers Revisited: New approaches to the History of Women in the American West," *Pacific Historical Review* 49 (May 1980), 173–213.

12. The Jewish population was between 7 percent and 8 percent of San Francisco's total population by 1870 (Rischin and Livingston, eds., *Jews of the American West*, 34), and in 1860 Jews made up an estimated 2 percent to 5 percent of New York City's population.

13. Bruce Phillips, "The Challenge of Family, Identity, and Affiliation," in Ava Kahn and Marc Dollinger, eds., *California Jews* (Hanover, N.H.: University Press of New England, 2003), 17.

14. *Eureka Reporter,* April 26, 1912.

15. Earl Pomeroy, "On Becoming a Westerner," in Rischin and Livingston, eds., *Jews of the American West,* 196–197.

16. For example, Francis Salvador was elected to South Carolina's First Provincial Congress in 1774, and Charleston Jews were influential merchants and political officials early in the nineteenth century. See Theodore and Dale Rosengarten, *A Portion of the People: Three Hundred Years of Southern Jewish Life* (Columbia: University of South Carolina Press, 2002). A number of Jewish mayors were elected between 1890 and 1915 in Alabama, Florida, Louisiana, Arkansas, and Texas. Since race played such a defining role in the South, it is probable that Jews enjoyed political prominence for a time because they were perceived as "white" rather than "other." See Raymond Arsenault, "Charles Jacobson of Arkansas: A Jewish Politician in the Land of the Razorbacks, 1891–1915," in Nathan Kagonoff and Melvin Urofsky, *Turn to the South— Essays on Southern Jewry* (Charlottesville: University of Virginia Press, 1979), 56–75. Although he has concentrated on east European Jews, Lee Shai Weissbach notes the involvement of early German Jewish merchants in small southern towns as well. See Lee Shai Weissbach, "East European Immigrants and the Image of Jews in the Small-Town South," *American Jewish History* 85 (1997), 231–262.

17. Interview with Arnold Sky, "Cowboys and Kneidelach," *Jerusalem Post Magazine,* September 8, 1978.

18. Robert Hine and John Faragher, *The American West: A New Interpretive History* (New Haven: Yale University Press, 2000), 238.

19. See Linda Mack Schloff, *And Prairie Dogs Weren't Kosher* (St. Paul: Minnesota Historical Society Press, 1996), 44–48. Between 1882 and 1910, homestead claims were filed by about one thousand Jews in North and South

Dakota alone, and other Jewish residents in the region tended to settle in small towns.

20. William Toll, *The Making of an Ethnic Middle Class: Portland Jewry over Four Generations* (Albany: State University Press of New York, 1982), 46.

21. Moses Rischin, "The Jewish Experience in America," in Rischin and Livingston, *Jews of the American West*, 32–33.

22. Susan Armitage, "Women and Men in Western History: A Stereoptical Vision," in Gordon Bakken and Brenda Farrington, eds., *The Gendered West* (New York: Garland Publishing, 2001), 385–387.

23. Claire Steres Bernstein interview, August 1, 1972: "Keeping Kosher in Vernal," in Eileen Hallet Stone, *A Homeland in the West: Utah Jews Remember* (Salt Lake City: University of Utah Press, 2001), 147–149.

24. Ewa Morawska, *Insecure Prosperity, Small-Town Jews in Industrial America* (Princeton, N.J.: Princeton University Press, 1996), 21.

25. Paula Hyman, "Gender and the Immigrant Experience in the United States," in Judith Baskin, ed., *Jewish Women in Historical Perspective* (Detroit: Wayne State University Press, 1998), 314.

26. Jonathan D. Sarna, ed. and trans., *People Walk on Their Heads: Moses Weinberger's Jews and Judaism in New York* (New York: Holmes and Meier, 1982), 43.

27. Naomi W. Cohen, *Encounter with Emancipation* (Philadelphia: Jewish Publication Society of America, 1984), xi.

28. Pomeroy, "On Becoming a Westerner," 202.

29. Eldon B. Ernst, "American Religious History from a Pacific Coast Perspective," in Carl Guaneri and David Alvarez, eds., *Religion and Society in the American West* (Lanham, Md.: University Press of America, 1987), 12.

30. See, for example, John Higham, *Send These to Me* (Baltimore: Johns Hopkins University Press, 1984), 142–144; Jonathan D. Sarna, "A Sort of Paradise for Hebrews: The Lofty Vision of Cincinnati Jews," in Jonathan D. Sarna and Nancy H. Klein, *The Jews of Cincinnati* (Cincinnati: Study for the American Jewish Experience, 1989), 9; Judith E. Endelman, *The Jewish Community of Indianapolis* (Bloomington: Indiana University Press, 1984), 3.

31. Moses Rischin, "Introduction, The Jews of the West: The Metropolitan Years," *American Jewish History* 68 (June 1979), 392, and Higham, *Send These to Me,* 142.

32. Glenda Riley, "Writing, Teaching, and Recreating Western History through Intersections and Viewpoints," in Gordon M. Bakken and Brenda Farrington, eds., *Where Is the West?* (New York: Garland, 2000), 109.

33. Glenda Riley, *Building and Breaking Families in the American West* (Albuquerque: University of New Mexico Press, 1996), 87.

34. See William Toll, "Intermarriage and the Urban West," in Rischin and Livingston, *Jews of the American West.*

35. Annegret S. Ogden, ed., *Frontier Reminiscences of Eveline Brooks Auerbach* (Berkeley: University of California Press, 1994), 33, 38.

36. Flora Spiegelberg, "Reminiscences of a Jewish Bride of the Santa Fe Trail," *Jewish Spectator,* September 1937, 24.

37. Elizabeth Herr, "Women, Marital Status, and Work Opportunities in 1880 Colorado," *Journal of Economic History* 55 (June 1995), 341.

38. *Helena Herald,* November 11, 1889.

39. *Helena Illustrated,* March 1, 1890.

40. Barbara Kirshenblatt-Gimblett, "The Moral Sublime: The Temple Emanuel Fair and Its Cookbook, Denver, 1888," *Rocky Mountain Jewish Historical Notes* 13 (Spring/Summer 1995), 4.

41. Jacob R. Marcus, "The American Colonial Jew: A Study in Acculturation," in Jonathan D. Sarna, ed., *The American Jewish Experience,* 2nd ed. (New York: Holmes and Meier, 1997), 6–10.

42. Michael A. Meyer, "The Reform Movement's Land of Promise," in Sarna, ed., *The American Jewish Experience,* 60–63.

43. Hasia Diner, "American West, New York Jewish," in *Jewish Life in the West,* 47. Using the term "German Jews" is a convenient way to identify Jews from different German states in central Europe, and "Russian" Jews includes Jews from eastern Europe. Diner asserts that many "German" Jews were actually from Posen, which was a Polish province, and this has been a subject of discussion among historians for years. She also objects to terming Jews from Austria-Hungary as "German." More importantly, Diner argues that American Jews have symbolically divided America into a paradigm that views the New York experience as more "Jewish" and the West as more "American," a schema with which many Jews of the West, who worked diligently to maintain their Jewish identity, religion, and institutions, would have undoubtedly taken umbrage. In her latest book, *The Jews of the United States, 1654 to 2000* (Berkeley: University of California Press, 2004), 79, Diner revisits the "German" versus "eastern European" categories and suggests that "these popular categorizations should not be dismissed as completely inaccurate, just overly simplistic."

44. Leon A. Jick, *The Americanization of the Synagogue, 1820–1870* (Hanover, N.H.: University Press of New England, 1992), 182.

45. Naomi W. Cohen, *Encounter with Emancipation: The German Jews in the United States, 1830–1914* (Philadelphia: Jewish Publication Society, 1984), 162–167.

46. Abraham J. Karp, *Golden Door to America: The Jewish Immigrant Experience* (New York: Viking Press, 1976), 13–15.

47. Strictly speaking, they were Jews from central Europe, as Germany did not become a unified nation-state until 1871.

48. Julia Niebuhr Eulenberg, "Jewish Enterprise in the American West: Washington, 1853–1909," Ph.D. diss., University of Washington, 1996, 33–34.

49. Minnie Landman DeNelsky, *An Autobiography* (Cincinnati: American Jewish Archives, n.d.), 70.

50. Kahn, *Jewish Life in the American West,* 16–18, 54.

51. Jenny Krajewski Shafran as quoted in Meta Buttnick and Julia Niebuhr Eulenberg, "Jewish Settlement in the Small Towns of Washington State: Republic," *Washington State Jewish Historical Society Newsletter* 3 (March 1984), 6–7.

52. Duane Smith, *Rocky Mountain West* (Albuquerque: University of New Mexico Press, 1992), 240, and Gary Ferguson, *The Great Divide* (New York: Norton, 2004), 212–213. In a 1970s study of women in the trans-Mississippi West, Julie Roy Jeffries maintained that the liberating environment of the West had been exaggerated. See her *Frontier Women: The Trans-Mississippi West, 1840–1880* (New York: Hill and Wang, 1979).

53. Sandra L. Myres, *Ho for California!* (San Marino, Calif.: Museum Reproductions, 1980), x.

54. See Rebecca J. Mead, *How the Vote Was Won* (New York: New York University Press, 2004).

55. *Papers of the Jewish Women's Congress* (Philadelphia: Jewish Publication Society of America, 1894), 6–7.

56. William Toll, "Gender, Ethnicity, and Jewish Settlement Work in the Urban West," in Jeffrey Gurock and Marc Raphael, *An Inventory of Promises* (New York: Carlton Publishing, 1995), 293–294.

57. Sandra L. Myres, *Westering Women and the Frontier Experience, 1800–1915,* (Albuquerque: University of New Mexico Press, 1981), 239.

NOTES TO CHAPTER 1

1. Hanchen Meyer Hirschfelder letter, 1856, Johanna Hirschfelder Collection, 2000.015, Western Jewish History Center, Judah L. Magnes Museum, Berkeley.

2. This information is based on calculations from the U.S. Census records for 1880 and 1900 by historian Elizabeth Jameson, "Towards a Multicultural History of Women in the United States," in Gordon Bakken and Brenda Farrington, eds., *The Gendered West* (New York: Garland, 2001), 204.

3. For an example of this phenomenon in microcosm, see Stefan Rohrbacher, "From Württemberg to America: A Nineteenth-Century German-Jewish Village on Its Way to the New World," in Sarna, ed., *The American Jewish Experience,* 2nd ed. (New York: Holmes and Meier, 1997), 44–58.

4. Abraham J. Karp, ed., *Golden Door to America: The Jewish Immigrant Experience* (New York: Viking Press, 1976), 15.

5. Deborah Dwork, "Immigrant Jews on the Lower East Side of New York: 1880–1914, in Sarna, *The American Jewish Experience,* 122.

6. Roger Daniels, *Coming to America* (New York: HarperPerennial, 1991), 225.

7. Annegret S. Ogden, ed., *Frontier Reminiscences of Eveline Brooks Auerbach* (Berkeley: University of California Press, 1994), 19–23.

8. Ibid., 23.

9. Ibid., 26, 28.

10. Ibid., 27–30.

11. Ibid., 39–54.

12. Hanchen Meyer Hirschfelder letter, 1856.

13. Ibid.

14. Robert Levinson, *The Jews in the California Gold Rush* (New York: Ktav, 1976), 66, 78.

15. Ibid., 68, 110.

16. Transcript of interview with Janet Levy, Seattle, 1972, no. 1824, the University of Washington Libraries, Special Collections.

17. Autobiographical Notes of Mrs. Joseph S. Newmark, Mrs. Joseph S. Newmark Papers, The Bancroft Library, University of California at Berkeley, 3–4.

18. Mary Prag, "Early Days," Florence Prag Kahn and Julius Kahn Collection, 1975.009, Western Jewish History Center, Judah L. Magnes Museum, 1, Berkeley.

19. Myer Newmark Diary, 1852–53, Entry for February 5, 1853, in Ava F. Kahn, *Jewish Voices in the California Gold Rush: A Documentary History, 1849–1880* (Detroit: Wayne State University Press, 2002), 123.

20. Max Vorspan and Lloyd P. Gartner, *History of the Jews of Los Angeles* (Philadelphia: Jewish Publication Society of America, 1970), 19, 63.

21. Irena Narell, *Our City: The Jews of San Francisco* (San Diego: Howell-North Books, 1981), 62.

22. *The Jewish Progress* (San Francisco), July 16, 2005.

23. *Crosswinds* (Albuquerque), June, 1997, and "Gathered Vestiges of a Covered-Wagon Diaspora," *New York Times,* February 4, 2001.

24. Floyd Fierman, "The Drachmans of Arizona," *American Jewish Archives* 16 (November 1964), 135–138.

25. Rosa K. Drachman, "From New York to Tucson in 1868," reprinted in *Western States Jewish History* 22 (October 1989), 18–19.

26. Ibid., 20–21.

27. *The Arizona Miner,* September 27, 1879.

28. "Memoirs of Anna Freudenthal Solomon," American Jewish Archives.

29. Ibid.

30. Elizabeth L. Ramenofsky, *From Charcoal to Banking: The I. E. Solomons of Arizona* (Tucson: Westernlore Press, 1984), 53, 118–119.

31. Interview with Hyman O. Danoff, "Indian Traders of the Southwest: The Danoffs of New Mexico," *Western States Jewish Historical Quarterly* 12 (July 1980), 298–299.

32. Dayle Friedman Rabinowitz, "The Saga of Leopold Henry Guldman— An American Jewish Success Story," *Rocky Mountain Jewish Historical Notes* 6 (Spring 1984), 7.

33. Ferenc Morton Szasz, *Religion in the Modern American West* (Tucson: University of Arizona Press, 2000), xiii, xvi.

34. Glenda Riley, "The Future of Western Women's History," *The Historian* 66 (Fall 2004), 542.

35. See Flora Spiegelberg, "Reminiscences of a Jewish Bride of the Santa Fe Trail," *Jewish Spectator*, August, 1937, and Michael Lawson, "Flora Langermann Spiegelberg," *Western States Jewish Historical Quarterly* 8 (July 1976), 291–308.

36. Lawson, "Flora Langermann Spiegelberg," 297, 302.

37. Robert Hine and John Faragher, *The American West: A New Interpretive History* (New Haven: Yale University Press, 2000), 12.

38. As quoted in Jacob R. Marcus, *The American Jewish Woman: A Documentary History* (New York: Ktav, 1981), 191.

39. Ava F. Kahn, "To Journey West: Jewish Women and Their Pioneer Stories," in Ava F. Kahn, ed., *Jewish Life in the American West* (Los Angeles: Autry Museum, 2002), 78.

40. *Las Vegas Daily Optic*, February 7, 1936; Ida Uchill, *Pioneers, Peddlers, and Tsadikim* (Denver: Sage Books, 1959), 19. There is a discrepancy between information in the news clippings and Uchill's information on the family origins.

41. Clippings File, Goldsmith Family, Beck Archives, University of Denver Special Collections.

42. For examples of general journeys west by women of other ethnic and religious groups, see John Faragher, *Women and Men on the Overland Trail* (New Haven: Yale University Press, 1979); Julie Roy Jeffries, *Frontier Women: The Trans-Mississippi West, 1840–1880* (New York: Hill and Wang, 1979); and Glenda Riley, *A Place to Grow—Women in the American West* (Arlington Heights, Ill.: Harlan Davidson, 1992), 61–92.

43. Virginia Scharff, *Twenty Thousand Roads: Women, Movement, and the West* (Berkeley: University of California Press, 2003), 41–46.

44. Shirley Ann Wilson Moore and Quintard Taylor, "The West of African American Women, 1600–2000," in Quintard Taylor and Shirley Ann Wilson Moore, eds., *African American Women Confront the West, 1600–2000* (Norman: University of Oklahoma Press, 2003), 7.

45. *Frontier Reminiscences of Eveline Brooks Auerbach,* 27–30, 44.

46. Rebekah Kohut, *My Portion (An Autobiography)* (New York: Thomas Seltzer, 1925), 40.

47. Faragher, *Women and Men on the Overland Trail,* 163.

48. Polly Welts Kaufman, *Women Teachers on the Frontier* (New Haven: Yale University Press, 1984), xvii–xxii.

49. In her recent book, *Princess or Prisoner: Jewish Women in Jerusalem, 1840–1914* (Waltham, Mass.: Brandeis University Press, 2005), 2, Margalit Shilo has claimed that Jewish men in Europe "initiated the bold step of immigration" to Israel during the period and that it was presented to their families as a "fait accompli." This does not appear to be the case with Jewish immigration to the American West, although undoubtedly many Jewish women in the region also experienced some distress over separation from family members in Europe or other parts of the country. My sampling indicates that many Jewish women joining the westward migration shared in a sense of excitement and promise of a better life for themselves and their families.

50. "Memoirs of Anna Freudenthal Solomon," American Jewish Archives.

51. Ramenofsky, *From Charcoal to Banking,* 22.

52. Kahn, "To Journey West: Jewish Women and Their Pioneer Stories," 61.

53. *Frontier Reminiscences of Eveline Brooks Auerbach,* 63.

54. Ibid., 65.

55. Zeckendorf File, Bloom Southwest Jewish Archives, University of Arizona Libraries.

56. Julia Niebuhr Eulenberg, "Jewish Enterprise in the American West: Washington, 1853–1909," Ph.D. diss., University of Washington, 1996, 228.

57. Kohut, *My Portion,* 38–39.

58. "Memoirs," Fannie Jaffe Sharlip Collection, 1978.013, 92–93, Western Jewish History Center, Judah L. Magnes Museum.

59. Sandra Myres, "Victoria's Daughters," in Lillian Schlissel, Vicki Ruiz, and Janice Monks, eds., *Western Women: Their Land, Their Lives* (Albuquerque: University of New Mexico Press, 1988), 269–270.

NOTES TO CHAPTER 2

1. Robert Levinson, *The Jews in the California Gold Rush* (New York: Ktav, 1978), 117, 184.

2. I. J. Benjamin, *Three Years in America, 1859–1862,* vol. 2 (Philadelphia: Jewish Publication Society of America, 1956), 36.

3. Rudolf Glanz, *The Jews of California* (New York: Waldon Press, 1960), 68.

4. Rosaline Levenson, "Oroville's Jewish Cemetery: Enduring Legacy of the Gold Rush," *Western States Jewish History* 23 (October 1990), 3–9.

5. Vera Norwood, "Women's Place: Continuity and Change in Response to Western Landscapes," in Lillian Schlissel, Vicki Ruiz, and Janice Monk, eds., *Western Women, Their Land, Their Lives* (Albuquerque: University of New Mexico Press, 1988), 155.

6. Steven Lowenstein, *The Jews of Oregon, 1850–1950* (Portland: Jewish Historical Society of Oregon, 1987), 7, 49–52.

7. *Asmonean,* March 31, 1851, as cited in Glanz, *The Jews of California,* 29.

8. John P. Marschall, "Jews in Nevada: 1850–1900," *Journal of the West* 23 (January 1984), 63.

9. Norton B. Stern, "The Jewish Community of a Nevada Mining Town," *Western States Jewish History,* 15 (October 1982), 48–50.

10. *The American Israelite,* September 3, 1875, 5.

11. Julia Niebuhr Eulenberg, "Jewish Enterprise in the American West: Washington, 1853–1909," Ph.D. diss., University of Washington, 1996, 4, 25, 270, 280. Early Jewish male settlers in the Washington Territory often waited over five years before sending for family members.

12. Molly Cone, Howard Droker, and Jacqueline Williams, *Family of Strangers: Building a Jewish Community in Washington State* (Seattle: Washington State Jewish Historical Society, 2003), 81.

13. David Crowder, "Biographical Sketch," in *The Moses Alexander Collection* (Boise: Idaho Historical Society, 2004), 1–2, and *The Idaho Statesman,* April 9, 2002, 3.

14. *Salt Lake Telegraph,* October 11, 1864.

15. Julie L. Coleman, *Golden Opportunities: A Biographical History of Montana's Jewish Communities* (Helena, Mont.: SkyHouse, 1994), 12, 45.

16. Lowenstein, *The Jews of Oregon,* 17–21, 57.

17. William Toll, *The Making of an Ethnic Middle Class* (Albany: State University of New York Press, 1982), 42–43.

18. In *Instant Cities: Urbanization and the Rise of San Francisco and Denver* (New York: Oxford University Press, 1975), historian Gunther Barth characterizes both as "instant" cities that compressed in a short time what it took other urban centers several generations to accomplish.

19. Gerald Gamm and Robert D. Putnam, "The Growth of Voluntary Associations in America, 1840–1940," *Journal of Interdisciplinary History* 29 (March 1999), 511–515.

20. Kathleen D. McCarthy, ed., *Lady Bountiful Revisited* (New Brunswick, N.J.: Rutgers University Press, 1990), x.

21. Max Vorspan and Lloyd P. Gartner, *History of the Jews of Los Angeles* (Philadelphia: Jewish Publication Society of America, 1970), 65, 181. The first was the Los Angeles Social Club, which was organized in 1870, with Jewish men predominant among the officers. When the California Club was founded in

1887 it included a number of affluent Jewish men, but eventually they were no longer welcomed.

22. Jonathan D. Sarna, "A Sort of Paradise for Hebrews, the Lofty Vision of Cincinnati Jews," in Jonathan D. Sarna and Nancy H. Klein, *The Jews of Cincinnati* (Cincinnati: Center for Study of the American Jewish Experience, 1989), 9.

23. Peter R. Decker, "Jewish Merchants in San Francisco: Social Mobility on the Urban Frontier," *American Jewish History* 68 (June 1979), 405–407.

24. See John Higham, "The Rise of Social Discrimination," in John Higham, *Send These to Me* (Baltimore: Johns Hopkins University Press, 1984), 117–152. Higham points to the famous 1877 incident in Saratoga, New York, where banker Joseph Seligman was denied entrance to the Grand Union Hotel as well as exclusion of Jewish men from social clubs and that of Jewish girls from some eastern private schools.

25. Josephine Cohn, "Communal Life of San Francisco Jewish Women in 1908," *Emanu-El* (San Francisco), April 17, 1908.

26. Ava F. Kahn and Glenna Matthews, "120 Years of Women's Activism," in Ava F. Kahn and Marc Dollinger, eds., *California Jews* (Hanover, N.H.: University Press of New England, 2003), 143.

27. Cohn, "Communal Life of San Francisco Jewish Women in 1908."

28. Jenna Weissman Joselit, "The Special Sphere of the Middle Class Jewish Woman: The Synagogue Sisterhood, 1890–1949," in Jack Wertheimer, ed., *The American Synagogue* (New York: Cambridge University Press, 1987), 209.

29. *The Jewish Progress* (San Francisco), July 12, 1895.

30. Virginia Katz, "The Ladies' Hebrew Benevolent Society of Los Angeles," in Mrs. M. Burton Williamson, ed., *Ladies' Clubs and Societies in Los Angeles in 1892* (Los Angeles: Historical Society of Southern California, 1892), 16–17.

31. Mrs. Lucien A. Blochman, "Ladies' Aid Society," *San Diego Jewish News*, September 22, 1922.

32. Norton B. Stern, "The Charitable Jewish Ladies of San Bernardino and Their Woman of Valor, Henrietta Ancker," *Western States Jewish Historical Quarterly* 13 (July 1981), 369–375.

33. Rudolf Glanz, *The Jewish Woman in America: Two Female Immigrant Generations*, vol. 2 (New York: Ktav, 1976), 23.

34. Eleanor P. Harrington, "Tincup: The Cemetery of Four Knolls," *Colorado Central Magazine* 32 (October 1996), 8.

35. Vorspan and Gartner, *History of the Jews of Los Angeles*, 20.

36. Susan Morris, *A Traveler's Guide to Pioneer Jewish Cemeteries of the California Gold Rush* (Berkeley: Magnes Museum, 1996), 3, 50.

37. For a highly informative study of the effects of widowhood on women living in Arizona, Colorado, New Mexico, and Utah, see Arlene Scadron, ed., *On Their Own, Widows and Widowhood in the American Southwest, 1848–1939* (Chicago: University of Illinois Press, 1988).

38. Scadron, *On Their Own,* 301–310.

39. *Eureka Daily Sentinel,* May 26, 1879.

40. Blaine Lamb, "Jewish Pioneers in Arizona, 1850–1920," Ph.D. diss., Arizona State University, 1992, 302–203, 307, 312.

41. Interview with Theodore Bloom, March 22, 1999, as cited in Maggie Jones, "Jewish Women's Roles in Religious Institutions," unpublished term paper, Women's Studies 200, University of Arizona.

42. Lamb, "Jewish Pioneers in Arizona," 309–310.

43. Donna Gabaccia, *From the Other Side: Women, Gender and Immigrant Life in the U.S.* (Bloomington: Indiana University Press, 1994), 82.

44. *American Israelite,* January 20, 1860.

45. Delphine Cohen File, Beck Archives of Rocky Mountain Jewish History, Penrose Library, University of Denver.

46. *Denver Republican,* July 14, 1900, and *Denver Post,* November 30, 1958, Empire Section, Frances Wisebart Jacobs File, Beck Archives.

47. Marjorie Hornbein, "Frances Jacobs: Denver's Mother of Charities," *Western States Jewish Historical Quarterly* 15 (January 1983), 133, and Ida Uchill, *Pioneers, Peddlers, and Tsadikim* (Denver: Sage Books, 1957), 118–19, 145.

48. Ferenc Morton Szasz, *Religion in the Modern American West* (Tucson: University of Arizona Press, 2000), 6.

49. "Mr. Appel's Address," in "Memoirs of Frances Jacobs," Denver, Charity Organization Society, 1892, 10–13, Jacobs File, Beck Archives, University of Denver.

50. Various clippings in the Jacobs File, Beck Archives, University of Denver, and Marjorie Hornbein, "Frances Jacobs: Denver's Mother of Charities," 137–40.

51. Szasz, *Religion in the Modern American West,* 57.

52. *Rocky Mountain News,* August 27, 1888.

53. *Daily News* (Denver), August 27, 1888, 2.

54. As cited in June Sochen, "Some Observations on the Role of American Jewish Women as Communal Volunteers," *American Jewish History* 70 (September 1980), 27.

55. *Rocky Mountain News,* November 5, 1892.

56. "Memoirs of Frances Jacobs," 9, 15.

57. Ibid., 22.

58. As quoted in an unidentified clipping, "NJH History: Birth of a Hospital," National Jewish Hospital Collection, Box 9, Beck Archives.

59. Nathan Kagonoff, "Jewish Welfare in New York (1848–1860)," *American Jewish Historical Quarterly* 56 (September 1966), 30–33.

60. Mark Bauman, "Southern Jewish Women and Their Social Service Organizations," *Journal of American Ethnic History* 22 (Spring 2003), 34–78. In

this very complex, lengthy, and often murky essay, Bauman appears to say that the role of Jewish women in the South gradually expanded. He suggests that southern distinctiveness played a role but that the factor of Jewish affiliation was more important than region. Since he only contrasts the role of southern Jewish women with those in the Northeast, it is difficult to ascertain how they developed compared to western Jewish women. A study by Deborah Weiner, "Jewish Women in the Central Appalachian Coal Fields, 1890–1960: From Breadwinners to Community Builders," *American Jewish Archives Journal* 50 (2000), 10–33, demonstrates that Jewish women in a number of small coal towns in the South played both an important economic and communal role in helping sustain Jewish identity. However, all the women in the study were of east European origin, and the period under study was mainly the first decades of the twentieth century. In Sherry Blanton, "Lives of Quiet Affirmation: The Jewish Women of Early Anniston, Alabama," *Southern Jewish History* 2 (1998), 25–53, the author discusses the active roles Jewish women played in the small southern town in the creation and maintenance of Temple Beth-El.

61. For a thorough discussion of the concept of the women's sphere and the historiography surrounding the subject, see Linda Kerber, "Separate Spheres, Female Worlds, Woman's Place: The Rhetoric of Women's History," in Kerber, *Toward an Intellectual History of Women* (Chapel Hill: University of North Carolina Press, 1997), 159–199. Helena M. Wall, "Notes on Life since A Little Commonwealth: Family and Gender History since 1970," *William and Mary Quarterly* (October 2000), 822–823, examines evolving perspectives on the concept of "women's sphere."

62. As quoted in Eulenberg, *Jewish Enterprise in the American West*, 281.

63. Beth S. Wenger, "Jewish Women and Voluntarism: Beyond the Myth of Enablers," *American Jewish History* 79 (Autumn 1989), 16–36.

64. Suzanne Lebsock, "Women and American Politics, 1880–1920," in Louise A. Tilly and Patricia Gurin, eds., *Women, Politics, and Change* (New York: Russell Sage, 1990), 37.

65. Mary Ann Irwin, " 'Going About and Doing Good': The Politics of Benevolence, Welfare, and Gender in San Francisco, 1850–1880," in Mary Ann Irwin and James F. Brooks, eds., *Women and Gender in the American West* (Albuquerque: University of New Mexico Press, 2004), 237.

66. Susan M. Chambré, "Parallel Power Structures, Invisible Careers, and the Changing Nature of American Jewish Women's Philanthropy," *Journal of Jewish Communal Service* 76 (Spring 2000), 206, 208.

67. Janet Wilson James, "An Overview," in *Women in American Religious History* (Philadelphia: University of Pennsylvania Press, 1980), 17.

68. William Toll, "From Domestic Judaism to Public Ritual: Women and Religious Identity in the American West," in Pamela S. Nadell and Jonathan D.

Sarna, eds., *Women and American Judaism: Historical Perspectives* (Hanover, N.H.: University Press of New England, 2001),129.

69. Evelyn Bodek, "Making Do: Jewish Women and Philanthropy," in Murray Friedman, ed., *Jewish Life in Philadelphia, 1830–1940* (Philadelphia: ISHI Publications, 1983), 147–152, 162.

70. Irwin, "Going About and Doing Good," 258.

71. Sara M. Evans, *Born for Liberty: A History of Women in America* (New York: Free Press, 1989), 143.

72. Paula E. Hyman, *Gender and Assimilation in Modern Jewish History* (Seattle: University of Washington Press, 1998), 30.

73. Ann Firor Scott, *Natural Allies: Women's Associations in American History* (Chicago: University of Illinois Press, 1991), 178.

NOTES TO CHAPTER 3

1. *Jewish Outlook* (Denver), January 5, 1906.

2. Jonathan Sarna, *American Judaism* (New Haven: Yale University Press, 2004), 137.

3. For a detailed look at the impact of tuberculosis on the Colorado Jewish community, see Jeanne Abrams, *Blazing the Tuberculosis Trail* (Denver: Colorado Historical Society, 1990).

4. Norma Fain Pratt, "Immigrant Jewish Women in Los Angeles: Occupation, Family and Culture," in Jacob Marcus, ed., *Studies in the American Experience* (Cincinnati: American Jewish Archives, 1981), 79.

5. Memoirs, Fanny Jaffe Sharlip Collection, 1968.012, 122–126, Western Jewish History Center, Judah L. Magnes Museum, Berkeley.

6. Jacob Chester Teller, *Report on the Problem of Combined Poverty and Tuberculosis in Denver, Colorado* (New York: National Conference of Jewish Charities, 1916), 20.

7. Seraphine Pisko as quoted in an unidentified, undated NJH press release clipping, c. 1923, National Jewish Hospital Collection, Box 33 Pisko/Dauby/Grabfelder Correspondence, Beck Archives, University of Denver Special Collections.

8. Jeanne Abrams, "Entry of Seraphine Pisko," in *Jewish Women in America* (New York: Routledge, 1997), 1077, and Ida Uchill, *Pioneers, Peddlers, and Tsadikim* (Denver: Sage Books, 1957), 145.

9. William Toll, "Gender and the Origins of Philanthropic Professionalism: Seraphine Pisko at the National Jewish Hospital," *Rocky Mountain Jewish Historical Notes* 11 (Winter/Spring 1991), 3.

10. Sheila M. Rothman, *Women's Proper Place* (New York: Basic Books, 1978), 4.

11. Denver Council of Jewish Women Membership Directories, 1890–99, 1903–4, and 1909–1910, NCJW Collection, Beck Archives, University of Denver.

12. As cited in Mary McCune, *"The Whole Wide World, Without Limits": International Relief, Gender Politics, and American Jewish Women, 1890–1930* (Detroit: Wayne State University Press, 2005), 116.

13. For an in-depth study of Colorado's early tuberculosis institutions, see Abrams, *Blazing the Tuberculosis Trail.*

14. *Denver Times*, November 12, 1901.

15. *Intermountain Jewish News*, January 22, 1982, Section B, 2.

16. Denver NCJW Membership Directory, 1909–1914, NCJW Collection, Beck Archives, University of Denver.

17. Linda Gordon Kuzmack, *Woman's Cause: The Jewish Woman's Movement in England and the United States, 1881–1933* (Columbus: Ohio State University Press, 1990), 29.

18. Seraphine Pisko to Samuel Grabfelder, July 18, 1913, NJH Collection, Box 2, Beck Archives, University of Denver.

19. Governor Elias Emmons to Ray David, March 23, 1914, and Mary Bradford to Mayor J. M. Perkins, September 9, 1914, copy of Ray David Scrapbooks, Beck Archives, University of Denver.

20. Unidentified newspaper clipping, Ray David Scrapbook.

21. Rothman, *Women's Proper Place*, 5.

22. Clippings, Ray David Scrapbook, Beck Archives, University of Denver.

23. For a detailed account of the relief work conducted by Jewish women through the NCJW, Hadassah, and the Workmen's Circle, see McCune, *"The Whole Wide World, Without Limits."*

24. Faith Rogow, "Gone to Another Meeting: The National Council of Jewish Women, 1893–1993," in Pamela S. Nadell, ed., *American Jewish Women's History: A Reader* (New York: New York University Press, 2003), 64.

25. Jennie Croly, *History of the Women's Club Movement* (New York: H. C. Allen, 1898), 16.

26. Deborah Grand Golomb, "The 1893 Congress of Jewish Women: Evolution or Revolution in American Jewish Women's History?" *American Jewish History* 70 (1980), 52–67.

27. Anne Ruggles Gere, *Intimate Practices: Literary and Cultural Work in U.S. Women's Clubs, 1880–1920* (Urbana: University of Illinois Press, 1997), 13.

28. Seth Korelitz, " 'A Magnificent Piece of Work': The Americanization Work of the National Council of Jewish Women," *American Jewish History* 83 (June 1995), 184–187, 203.

29. "Throwing Out the Lifelines," October 1905, 10, Box 22, National Jewish Hospital Collection, Beck Archives, University of Denver; *Jewish Outlook* (Denver), January 5, 1906, 3.

30. "Carrie Ida Shevelson (Benjamin)," in *Alumni Record and General Catalogue of Syracuse University, 1872–1910, 675*, Syracuse University Archives, Special Collections; Rogow, *Gone to Another Meeting, 226.*

31. "Carrie Ida Shevelson (Benjamin)"; and John Livingston, "Editor's Note," *Rocky Mountain Jewish Historical Notes* 10 (Winter/ Spring 1990), 2.

32. Golomb, "The 1893 Congress of Jewish Women," has concluded that the Jewish participants viewed themselves first as Jews and not as women, suggesting they were far from radical feminists.

33. Carrie Shevelson Benjamin. "Woman's Place in Charitable Work—What It Is and What It Should Be," in *Papers of the Jewish Women's Congress* (Philadelphia: Jewish Publication Society, 1894), 145–156.

34. *American Jewess* 1 (April 1895), 30.

35. *American Jewess* 4 (January 1897), 179–181.

36. Rogow, *Gone to Another Meeting*, 27, 203–205.

37. Ibid., 66.

38. William Toll, "A Quiet Revolution: Jewish Women's Clubs and the Widening Female Sphere, 1870–1920," *American Jewish Archives* 61 (1999), 17.

39. Blanche Blumauer, "Council of Jewish Women in Portland—1905," reprinted in *Western States Jewish History* 9 (October 1976), 19.

40. William Toll, *The Making of an Ethnic Middle Class* (Albany: State University of New York Press, 1982), 56–57.

41. William Toll, "Gender, Ethnicity, and Jewish Settlement Work in the Urban West," in Jeffrey Gurock and Marc Raphael, *An Inventory of Promises* (New York: Carlton Books, 1995), 293–294.

42. Steven Lowenstein, *The Jews of Oregon, 1850–1950* (Portland: Jewish Historical Society of Oregon, 1987), 82–83, 140–141.

43. Roza R. Willer, "The History of Jewish Social Work in Portland," unpublished paper, June 1923, 13–16, Oregon Jewish Museum Archive.

44. Ibid., 16, 20.

45. "A Half Century: National Council of Jewish Women, Los Angeles Section, 1909–1959," reprinted in *Western States Jewish History* 37 (Winter 2004), 149–151.

46. Ibid., 152.

47. "Los Angeles Section, Council of Jewish Women," *California Jewish Review*, November 9, 1923.

48. *The Jewish Voice* (Seattle), November 3, 1916, 1.

49. Jean Porter Devine, *From Settlement House to Neighborhood House: 1906–1976* (Seattle: Neighborhood House, 1976), 8.

50. Val Marie Johnson attributes this as a central goal for Jewish and gentile reformers in her article, "Protection, Virtue and the 'Power to Detain': The Moral Citizenship of Jewish Women in New York City, 1890–1920," *Journal of Urban History* 31 (July 2005), 655–684.

51. Elizabeth Rose, "From Sponge Cake to Hamentashen: Jewish Identity in a Jewish Settlement House, 1885–1952," *Journal of American Ethnic History,* Spring 1994, 3–8.

52. Molly Cone, Howard Droker, and Jacqueline Williams, *Family of Strangers: Building a Jewish Community in Washington State* (Seattle: Washington State Jewish Historical Society, 2003), 93–94. It is interesting to note that San Francisco's Jewish settlement house was established as early as 1894 by the Emanu-El Sisterhood of Personal Service rather than the NCJW.

53. Evelyn Bodek, "Making Do: Jewish Women and Philanthropy," in Murray Friedman, ed., *Jewish Life in Philadelphia* (Philadelphia: ISHI Publications, 1983), 159.

54. See Marta Albert, "Not Quite 'A Quiet Revolution': Jewish Women Reformers in Buffalo, New York, 1890–1914," *Shofar* 9 (Summer 1991), 62–77.

55. For an excellent overview of the multiple activities of Sloss, see William N. Kramer and Norton B. Stern, "Hattie Hecht Sloss: Cultural Leader/Jewish Activist of San Francisco," *Western States Jewish History* 35 (Spring/Summer 2003).

56. For a lively look at the lives of the Gilded Circle, see Harriet and Fred Rochlin, *Pioneer Jews: A New Life in the Far West* (Boston: Houghton Mifflin, 1984), 132–139.

57. Rosalie Meyer Stern Collection, 1971.003, Western Jewish History Center, Judah L. Magnes Museum, Berkeley.

58. *Jewish Messenger* (New York), September 7, 1900, and May 17, 1901, 10, 10–11, respectively.

59. *American Jewess* (New York), October 1896.

60. *Who's Who in American Jewry* (1926), 579. For Sloss's involvement in the American Council on Judaism, see Fred Rosenbaum, "Zionism versus Anti-Zionism," in Moses Rischin and John Livingston, *Jews of the American West* (Detroit: Wayne State University Press, 1991), 119–135.

61. Information Sheet on the Hillkowitz family, Biographical Files, Beck Archives, University of Denver; S. Friedenthal, "The Story of the Jews of Denver," *Reform Advocate* (Chicago), October 31, 1908.

62. CJW Membership Directory, 1909–10, Beck Archives, University of Denver.

63. Obituary, *Rocky Mountain News,* November 26, 1965, 73.

64. *First Annual Report of the JCRS,* 1905, 1,14, JCRS Collection, Beck Archives, Box 170, University of Denver.

65. *Jewish Outlook* (Denver), April 15, 1904, 7, 8.

66. Charles Spivak to Anna Hillkowitz, May 23, 1906, JCRS Collection, Box 223, Fieldworker's Correspondence, Beck Archives, University of Denver.

67. *First Annual Report of the JCRS,* 3–4, 30, JCRS Collection, Box 170,

Beck Archives, University of Denver; and Anna Hillkowitz to Charles Spivak, February 7, 1906.

68. Blumauer, "Council of Jewish Women in Portland—1905," 19.

69. Anna Hillkowitz to Charles Spivak, March 19, 1906.

70. William N. Kramer and Norton B. Stern, "Anna Meyers: Modern Fundraising Pioneer in the West," *Western States Jewish History* 19 (October 1987), 335–345.

71. *B'nai B'rith Jewish Messenger,* October 29, 1909, 15–16.

72. *The Sanatorium, Fifth Annual Report of the JCRS* 3, January 1909, 51, JCRS Collection, Box 170, Beck Archives, University of Denver.

73. Kramer and Stern, "Anna Meyers," 339–341.

74. *The Sanatorium* 5 (September–December 1911), 51, JCRS Collection, Box 170, Beck Archives, University of Denver.

75. Fannie Lorber, "The Story of the National Home for Jewish Children at Denver," unpublished essay, National Asthma Center Collection (NAC), Box 11, Beck Archives, University of Denver.

76. Fannie Lorber Biographical File, Beck Archives, University of Denver.

77. For a more detailed look at orphanages in Denver at the turn of the century, see Jeanne Abrams, "Children without Homes: The Plight of Denver's Orphans, 1880–1920," *Colorado History,* 2001, 55–93.

78. Lorber File; Friedenthal, "The Jews of Denver."

79. Reena Sigman Friedman, "Founders, Teachers, Mothers and Wards: Women's Roles in American Jewish Orphanages, 1850–1925," *Shofar* 15 (Winter 1997), 23–25.

80. CJW Membership Directory, 1909–10 and 1911–12.

81. Fannie Lorber, "President's Annual Report, 1927," NAC Collection, Box 5, Beck Archives, University of Denver. For a discussion of the element of social control, see David Rothman, *The Discovery of the Asylum* (Boston: Little, Brown, 1990), and William Trattner, ed., *Social Welfare or Social Control?* (Knoxville: University of Tennessee Press, 1983).

82. Interview with Jack Gershtenson, 1987, NAC Collection, Box 12, Beck Archives, University of Denver.

83. *Denver Jewish News* (April 25, 1925), 20; Hadassah, San Francisco Chapter Records, Western Jewish History Center, Judah L. Magnes Museum, Berkeley; Lowenstein, *The Jews of Oregon,* 153.

84. William Toll, "From Domestic Judaism to Public Ritual: Women and Religious Identity in the American West," in Pamela S. Nadell and Jonathan D. Sarna, eds., *Women and American Judaism: Historical Perspectives* (Hanover, N.H.: University Press of New England, 2001), 139.

85. Beth Wenger, "Jewish Women of the Club: The Changing Public Role of Atlanta's Jewish Women," *American Jewish History* 76 (March 1987), 312;

also see Felicia Herman, "From Priestess to Hostess: Sisterhoods of Personal Service in New York City, 1887–1936," in Nadell and Sarna, *Women and American Judaism*, 148–181.

86. Karla Goldman, *Beyond the Synagogue Gallery—Finding a Place for Women in American Judaism* (Cambridge, Mass.: Harvard University Press, 2000), 144.

87. Mark I. Greenberg, "Savannah's Jewish Women and the Shaping of Ethnic and Gender Identity, 1830–1900," *Georgia Historical Quarterly* 82 (Winter 1998), 755, 760–761, 768–774.

88. Joan Marie Johnson, *Southern Ladies, New Women: Race, Region, and Clubwoman in South Carolina, 1890–1930* (Gainesville: University Press of Florida, 2004), 1–5, 17.

89. Beth Wenger, "Jewish Women of the Club: The Changing Public Role of Atlanta's Jewish Women," 332–333.

90. Daniel J. Walkowitz, *Working with Class* (Chapel Hill: University of North Carolina Press, 1999), 27.

NOTES TO CHAPTER 4

1. Mary Goldsmith Prag, "Early Days," 5, 6, Florence Prag Kahn and Julius Kahn Collection, 1975.009, Western Jewish History Center, Judah L. Magnes Museum, Berkeley.

2. Hynda Rudd, "The Mountain West as a Jewish Frontier," *Western States Jewish Historical Quarterly* 13 (April 1981), 249.

3. I. J. Benjamin, *Three Years in America, 1859–1862*, vol. 1 (New York: Arno Press, 1975), 199, 200, 204, 210.

4. Ibid., 235, 236.

5. Charles H. Lippy, *Being Religious, American Style* (Westport, Conn.: Greenwood Press, 1994), 122–123.

6. Hannah Shwayder Berry, *The Tale of a Little Trunk and Other Stories* (Denver: 1977), 24; Ida Uchill, *Pioneers, Peddlers, and Tsadikim* (Denver: Sage Press, 1959), 168.

7. Berry, *The Tale of a Little Trunk and Other Stories*, 36.

8. Julie L. Coleman, "Some Jews of Early Helena, Montana," *Rocky Mountain Jewish Historical Notes* 2 (March 1979), 2.

9. Interview with Margaret Veta in Mark Elliott and Marie Still, *Lest We Forget: Remembrances of Cheyenne's Jews* (Cheyenne, Wyo.: Aaron Mountain Publishing, 1990), 173.

10. Michael Zelinger, *West Side Story Relived* (Denver: Wandel Press, 1987), 37; author's interview with Charlene Cook Sachter, May 23, 2005.

11. Interview with Peryle Hayutin Beck, February 1989, Beck Archives, University of Denver.

12. *Weekly Gleaner,* April 17, 1857, 8.

13. *Weekly Gleaner,* January 16, 1857, 4–5.

14. L. E. Blochman biographical memoirs, c. 1870, in Ava F. Kahn, *Jewish Voices of the Gold Rush: A Documentary History* (Detroit: Wayne State University Press, 2002), 300.

15. Ibid., 267–269.

16. *American Israelite,* July 29, 1881.

17. Harriet Lane Levy, *920 O'Farrell Street,* reprint (New York: Arno Press, 1975), 85–89.

18. Ibid., 191, 242.

19. Claire Steres Bernstein interview, August 1, 1972: "Keeping Kosher in Vernal," in Eileen Hallet Stone, *A Homeland in the West: Utah Jews Remember* (Salt Lake City: University of Utah Press, 2001), 147–149.

20. Mary Prag, "Early Days," 5, Florence Prag Kahn Collection, Western Jewish History Center, Judah L. Magnes Museum, Berkeley.

21. Samuel H. Cohen, *Jewish Chronicle* (London), July 18, 1851, in Kahn, *Jewish Voices of the California Gold Rush,* 70–72; 147.

22. *American Israelite,* April 21, 1872, 6.

23. Flora Spiegelberg, "Reminiscences of a Jewish Bride of the Santa Fe Trail," *Jewish Spectator,* August 1937, 21.

24. Hasia R. Diner and Beryl Lieff Benderly, *Her Works Praise Her* (New York: Basic Books, 2002), 103–105.

25. Jonathan D. Sarna, "The Revolution in the American Synagogue," in Karen Mittlemen, ed., *Creating American Jews: Historical Conversations about Identity* (Philadelphia: National Museum of American Jewish History, 1998), 21.

26. Benjamin, *Three Years in America,* vol. 2, 9.

27. Rebekah Kohut, *My Portion* (New York: Thomas Seltzer, 1925), 47.

28. Ellen M. Umansky, "Spiritual Expressions: Jewish Women's Religious Lives in the United States in the Nineteenth and Twentieth Centuries," in Judith Baskin, ed., *Jewish Women in Historical Perspective* (Detroit: Wayne State University Press, 1998), 337–345.

29. See Selma Berrol, "Class or Ethnicity: The Americanized German Jewish Woman and Her Middle Class Sisters in 1895," *Jewish Social Studies* 47 (Winter 1985).

30. Sherry Blanton, "Lives of Quiet Affirmation: The Jewish Women of Early Anniston, Alabama," *Southern Jewish History* 2 (1999), 35–39.

31. Peter Holloran, *Boston's Wayward Children: Social Services for the Homeless* (Cranbury, N.J.: Associated University Press, 1989), 63.

32. N. Sue Weiler, "Religion, Ethnicity, and the Development of Private Homes for the Aged," *American Ethnic History* 12 (Fall 1992), 65.

33. Peggy Pascoe, *Relations of Rescue* (New York: Oxford University Press, 1990), xxi.

34. See Maureen Fitzgerald, "Losing Their Religion: Women, the State, and the Ascension of Secular Discourse, 1890–1930," in Margaret Lamberts Bendroth and Virginia Lieson Brereton, eds., *Women and Twentieth-Century Protestantism* (Chicago: University of Illinois Press, 2002).

35. See introduction in Karla Goldman, *Beyond the Synagogue Gallery* (Cambridge, Mass.: Harvard University Press, 2000); Jenna Weissman Joselit, "The Special Sphere of the Middle-Class American Jewish Woman: The Synagogue Sisterhood, 1890, 1940," in Jack Wertheimer, ed., *The American Synagogue* (New York: Cambridge University Press, 1987), 206.

36. *Weekly Gleaner*, September 23, 1859, 8.

37. William Kramer, ed., *The Western Journal of Isaac Mayer Wise, 1877* (Berkeley: Western Jewish History Center, 1974), 44–45.

38. Paula Hyman, *Gender and Assimilation in Modern Jewish History: The Roles and Representation of Women* (Seattle: University of Washington Press, 1995), 22.

39. Marian A. Kaplan, "Priestess and Hausfrau: Women and Tradition in the German-Jewish Family," in Steven M. Cohen and Paula E. Hyman, eds., *The Jewish Family: Myths and Reality* (New York: Holmes and Meier, 1986), 62–64.

40. *San Diego Herald*, October 9, 1851.

41. Sylvia Arden, ed., *Diary of a San Diego Girl, 1851–1856* (Santa Monica, Calif.: Norton B. Stern, 1970), 18, 22.

42. Ibid., 54–57.

43. *San Diego Herald*, April 4, 1857.

44. Ronald D. Gerson, "Jewish Life in San Diego, California, 1851–1918," M.A. thesis, Hebrew Union College, Cincinnati, 1974, 8–12.

45. Arden, *Diary of a San Diego Girl*, 11.

46. Richard L. Golden, "The Marks I. Jacobs Family," in William M. Kramer, ed., *Old Town, New Town: An Enjoyment of San Diego Jewish History* (Los Angeles: Western States Jewish History Association, 1994), 62.

47. Ronald D. Gerson, "Jewish Religious Life in San Diego, California, 1851–1918," 38–39, 44–48, 77–78.

48. Ibid., 54, 64, 83.

49. Max Vorspan and Lloyd P. Gartner, *History of the Jews of Los Angeles* (Philadelphia: Jewish Publication Society of America, 1970), 19, 63.

50. Ibid., 88.

51. Jennie Migel-Drachman File, and unidentified clipping, "George Hand's Diary," Bloom Southwest Jewish Archives, University of Arizona Libraries.

52. Interview with Theodore Bloom, March 22, 1999, as cited in Maggie Jones, "The Roles of Jewish Women in Synagogues," unpublished term paper, Women's Studies 200, University of Arizona, Tucson, 1999.

53. Susan Morris, *A Traveler's Guide to Pioneer Jewish Cemeteries of the California Gold Rush* (Berkeley: Magnes Museum, 1996), 14.

54. Russell R. Elliot, *History of Nevada* (Lincoln: University of Nebraska, 1973), 382–383; Wibur S. Shepperson, *Restless Strangers: Nevada's Immigrants and Their Interpreters* (Reno: University of Nevada Press, 1970), 75.

55. A copy of the photograph appears in Ronald M. James and C. Elizabeth Raymond, *Comstock Women: The Making of a Mining Community* (Reno: University of Nevada Press, 1998), 69.

56. John P. Marschall, "Jews in Nevada: 1850–1900," *Journal of the West* 23 (January 1984), 63–65.

57. *The Hebrew* (San Francisco), October 27, 1865.

58. *Salt Lake Herald* (Salt Lake City), September 13, 1885.

59. Juanita Brooks, *History of the Jews in Utah and Idaho* (Salt Lake City: Western Epics, 1973), 82, 100.

60. *Idaho Territorial Statesman* (Boise), September 28, 1876.

61. *American Israelite,* February 7, 1895.

62. Elizabeth Edrich, "The Creation of a Jewish Community: Boise's Jewish Congregations," M.A. thesis, California State University, Sacramento, 2002, 5–6.

63. Joselit, "The Special Sphere of the Middle-Class American Jewish Women," 207–209.

64. Jody Tee, *Rivers in the Desert: A Video Presentation on Ahavath Beth Israel* (Boise, Idaho: Jody Tee Creative Services, 2004).

65. Edrich, "The Creation of a Jewish Community," 10, 15–16.

66. Jonathan Sarna, *American Judaism* (New Haven: Yale University Press, 2004), 138.

67. Joselit, "The Special Sphere of Middle-Class American Jewish Women," 209.

68. Felicia Herman, "From Priestess to Hostess: Sisterhoods of Personal Charity in New York City, 1887–1936," in Pamela S. Nadell and Jonathan D. Sarna, eds., *Women and American Judaism* (Hanover, N.H.: University Press of New England, 2001), 148.

69. William Toll, "Pioneering: Jewish Men and Women of the American West," in Karen S. Mittleman, ed., *Creating American Jews: Historical Conversations about Identity* (Philadelphia: National Museum of American Jewish History, 1998), 35.

70. *First Annual Report of the Emanu-El Sisterhood for Personal Service,* 1895, 5–6, San Francisco Emanu-El Sisterhood Collection, 1970.011, Western Jewish History Center, Judah L. Magnes Museum, Berkeley.

71. *The Fair Cookbook* (Denver: Ladies of Congregation Emanuel, 1888), copy on deposit at the Beck Archives of Rocky Mountain Jewish History, Penrose Library, University of Denver; Barbara Kirshenblatt-Gimblett, "The Moral Sublime: The Temple Emanuel Fair and Its Cookbook, Denver, 1888," *Rocky Mountain Jewish Historical Notes* 13 (Spring/Summer, 1995), 2–5.

72. Pamela S. Nadell and Rita J. Simon, "Ladies of the Sisterhood: Women in the American Reform Synagogue, 1900–1930," in Lucinda Joy Peach, *Women and World Religions* (Upper Saddle River, N.J.: Prentice Hall, 2002), 177–181.

73. Umansky, "Jewish Women's Religious Lives in the United States in the Nineteenth and Twentieth Centuries," 339.

74. "Denver Section, Council of Jewish Women Directory, 1902–1903," NCJW Collection, Box 4, Beck Archives, University of Denver.

75. Umansky, "Jewish Women's Religious Lives in the United States in the Nineteenth and Twentieth Centuries," 339.

76. Howard Droker, "A Coat of Many Colors: The History of Seattle's Jewish Community," *Portage*, Spring 1983, 8–9.

77. Sarna, *American Judaism*, 140–147.

78. Reva Clar and William M. Kramer, "Ray Frank: The Girl Rabbi of the Golden West," *Western States Jewish History* 18 (1986).

79. Simon Litman, *Ray Frank Litman: A Memoir* (New York: American Jewish Historical Society, 1957), 4–6.

80. Ibid., 6–13.

81. See, for example, Pamela S. Nadell, *Women Who Would Be Rabbis* (Boston: Beacon Press, 1998). In a more recent article, Nadell has emphasized the spiritual aspects of the religious life of Ray Frank. See Pamela S. Nadell, "Opening the Blue Heaven to Us": Reading Anew the Pioneers of Women's Ordination," *Nashim* 9 (June 2005), 90–91.

82. Ray Frank, "Woman in the Synagogue," in *Papers of the Jewish Women's Congress* (Philadelphia: Jewish Publication Society of America, 1894), 52–65

83. Litman, *Ray Frank Litman: A Memoir*, 14–15.

84. Ibid., 144–145.

85. Ray Frank, "Jewesses of Today," Ray Litman Papers, American Jewish Historical Society, New York, Box 1.

86. William Toll, "From Domestic Judaism to Public Ritual," in Nadell and Sarna, eds., *Women and American Judaism*, 128.

87. Ibid., 132.

88. For a thoughtful essay on this phenomenon, see Ewa Morawska, "Assimilation of Nineteenth-Century Women," in Paula E. Hyman and Deborah Dash Moore, eds., *Jewish Women in America: An Historical Encyclopedia* (New York: Routledge, 1997), 82–90.

89. "Rabbi Friedman's Eulogy," in "Memoirs of Frances Jacobs" (Denver: Charity Organization Society, 1892), 7, Jacobs File, Beck Archives, Special Collections, University of Denver.

90. Toll, "From Domestic Judaism to Public Ritual," 132.

91. Nadell and Sarna, eds., *Women and American Judaism*.

92. Eldon G. Ernst, "American Religious History from a Pacific Coast Per-

spective," in Carl Guarneri and David Alvarez, eds., *Religion and Society in the American West* (Lanham, Md.: University Press of America, 1987), 12. See also Douglas Firth Anderson, " 'We Have Here a Different Civilization': Protestant Identity in the San Francisco Bay Area, 1906–1909," *Western Historical Quarterly* 23 (May 1992), 199–221.

93. Ferenc Morton Szasz, *Religion in the Modern American West* (Tucson: University of Arizona Press, 2000), xiii, xvi.

NOTES TO CHAPTER 5

1. Memoirs of Anna Freudenthal Solomon, handwritten fragment, September 17, 1912, Freudenthal Family Papers, Box 1, Folder 3, University of New Mexico Special Collections, Albuquerque.

2. Harriet and Fred Rochlin, *Pioneer Jews: A New Life in the Far West* (Boston: Houghton Mifflin, 1984), 96.

3. Virginia G. Drachman, *Enterprising Women: 250 Years of American Business* (Chapel Hill: University of North Carolina Press, 2002), 3.

4. Memoirs of Anna Freudenthal Solomon, copy on deposit in the American Jewish Archives, Cincinnati.

5. "Autobiography of Isidor Elkan Solomon," Southwest Jewish Archives, University of Arizona Libraries, Tucson.

6. Wendy Gamber, *The Female Economy: The Millinery and Dressmaking Trades, 1860–1930* (Urbana: University of Illinois Press, 1997), 27.

7. Andrew R. Heinze, "Advertising and Consumer Culture," in Paula E. Hyman and Deborah Dash Moore, eds., *Jewish Women in America: An Historical Encyclopedia* (New York: Routledge, 1997), 24.

8. Eric L. Goldstein, "Between Race and Religions: Jewish Women and Self-Definition in Late Nineteenth Century America," in Pamela S. Nadell and Jonathan D. Sarna, eds., *Women and American Judaism: Historical Perspectives* (Hanover, N.H.: University Press of New England, 2001), 186.

9. Lynn M. Hudson, *The Making of "Mammy Pleasant": A Black Entrepreneur in Nineteenth-Century San Francisco* (Urbana: University of Illinois Press, 2002), 1–3, 8. By 1870, Pleasant's assets totaled $30,000, according to the U.S. Census, equivalent to about $1 million today.

10. Robert E. Wright, "Women and Finance in the Early National U.S.," *Essays in History* 42 (2000), 5.

11. Steven Lowenstein, *The Jews of Oregon* (Portland: Jewish Historical Society of Oregon, 1987), 7.

12. *Weekly Gleaner,* April 15, 1859, 5.

13. Julie Niebuhr Eulenberg, "Jewish Enterprise in the American West: Washington, 1853–1909," Ph.D. diss., University of Washington, Seattle, 1996, 258.

14. Irene D. Neu, "The Jewish Businesswoman in America," *American Jewish Historical Quarterly* 66 (June 1976 to June 1977), 138–139.

15. Hasia R. Diner and Beryl Lieff Benderly, *Her Works Praise Her* (New York: Basic Books, 2002), 93.

16. See Julie Nicoletta, "Redefining Domesticity, Women and Lodging Houses on the Comstock," in Ronald M. James and C. Elizabeth Raymond, eds., *Comstock Women: The Making of a Mining Community* (Reno: University of Nevada Press, 1998), 44–67, for a detailed account of lodging and boardinghouses in the bustling mining town of Virginia City, Nevada, from 1860 to 1910.

17. Max Vorspan and Lloyd P. Gartner, *History of the Jews of California* (Philadelphia: Jewish Publication Society of America, 1970), 10, 35, 303.

18. "A Letter from Mother to Daughter," reprinted in *Western States Jewish History* 4 (July 1973), 277.

19. Norton B. Stern, "Jews in the 1870 Census of Los Angeles," in Norton B. Stern, ed., *The Jews of Los Angeles: Urban Pioneers* (Los Angeles: Southern California Jewish Historical Society, 1981), 130, 137.

20. Annagret S. Ogden, ed., *Frontier Reminiscences of Eveline Brooks Auerbach* (Berkeley: University of California Press, 1994), 86–91.

21. Juanita Brooks, *History of the Jews in Utah and Idaho* (Salt Lake City: Western Epic, 1973), 15–17.

22. Wright, "Women and Finance in the Early National U.S.," 9. In a study of women in business in seven midwestern states in 1870, of approximately 30,000 women who were surveyed, over 19,000 were listed as milliners, dressmakers, and mantua makers. Lucy Eldersveld Murphy, "Business Ladies: Midwestern Women and Enterprise, 1850–1880," *Journal of Women's History* 3 (Spring 1991), 66.

23. Eulenberg, "Jewish Enterprise in the American West," 56.

24. Paula Petrik, *Women and Family in the Rocky Mountain Mining Frontier, Helena, Montana, 1865–1900* (Helena: Montana Historical Society, 1987), 60.

25. For a more extensive discussion on the subject, see Gerda Lerner, "The Lady and the Mill Girl: Changes in the Status of Women in the Age of Jackson," *Midcontinent American Studies Journal* 10 (Spring 1969), 5–15.

26. Neu, "The Jewish Businesswoman," 145–153.

27. Ibid., 151.

28. Reva Clar, "Tillie Lewis: California's Agricultural Industrialist," *Western States Jewish History* 16 (January 1984), 140–153.

29. Drachman, *Enterprising Women,* 32; "Married Women's Property Acts in *The Reader's Companion to American History* (Boston: Houghton Mifflin, 2005). For a lucid account of the legal statutes affecting women economically, see Edith Sparks, "Married Women and Economic Choice: Explaining Why

Women Started Businesses in San Francisco between 1890 and 1930," *Business and Economic History* 28 (Winter 1999), 293–295.

30. Ava F. Kahn, ed., *Jewish Voices of the California Gold Rush: A Documentary History, 1849–1880* (Detroit: Wayne State University Press, 2002), 258.

31. L. E. Blochman, biographical memoirs, c. 1870, in Kahn, *Jewish Voices of the California Gold Rush*, 300, 301.

32. A particularly useful case study is Sparks, "Married Women and Economic Choice," 288–293, which found that married, widowed, and divorced women made up the vast majority of San Francisco businesswomen in 1890.

33. Norton B. Stern, "Six Pioneer Jewish Women of San Francisco," *Western States Jewish History* 30 (1998), 163–165.

34. Wright, "Women and Finance in the Early National U.S.," 4.

35. Drachman, *Enterprising Women*, 4.

36. "Autobiographical Notes of Mrs. Joseph S. Newmark," Mrs. Joseph Newmark Papers, Bancroft Library, University of California, Berkeley, 7–8, 11.

37. *Weekly Arizona Miner*, September 7, 1877.

38. Norton B. Stern, "The Jewish Community of a Nevada Mining Town," *Western States Jewish Historical Quarterly* 15 (October 1982), 65.

39. William M. Kramer, ed., *The Western Journal of Isaac Mayer Wise, 1877* (Berkeley: Western Jewish History Center, 1974), 22.

40. *Eureka Daily Sentinel*, May 26, 1879.

41. Nevada Census for Eureka, 1880, Nevada State Preservation Office.

42. Annie R. Mitchell, "Pioneer Merchants of Tulare County, California," *Western States Jewish Historical Quarterly* 2 (April 1970), 124–125.

43. Gamber, *The Female Economy*, 2.

44. As cited in Janet I. Loverin and Robert A. Nylen, "Creating a Fashionable Society: Comstock Needleworkers from 1860 to 1880," in James and Raymond, *Comstock Women*, 117, 122–123.

45. Ibid., 123, 126, 344.

46. Gamber, *The Female Economy*, 1–3, 7.

47. *Tombstone Epitaph*, September 16, 1882. Millinery and dressmaking were early and popular women's enterprises throughout the nation. In a study of early businesswomen in Utica, New York, Mary P. Ryan, *Cradle of the Middle Class: The Family in Oneida County, New York, 1790–1865* (Cambridge, U.K.: Cambridge University Press, 1981), 205, found that "Dressmaking and millinery were the chief avenues of entrepreneurship open to women."

48. Lucy Eldersveld Murphy, "Business Ladies: Midwestern Women and Enterprise—1850–1880," *Journal of Women's History* 3 (Spring 1991), 65.

49. Mark I. Greenberg, "Savannah's Jewish Women and the Shaping of Ethnic and Gender Identity, 1830–1900," *Georgia Historical Quarterly* 82 (Winter 1998), 756–758.

50. Obituary, *Eureka Reporter,* April 26, 1912.

51. *Eureka Reporter,* October 25, 1963.

52. Obituary, *Eureka Reporter,* April 26, 1912.

53. Hyman O. Danoff, "Indian Traders of the Southwest: The Danoffs of New Mexico," *Western States Jewish Historical Quarterly* 12 (July 1980), 296, 299.

54. "Aladdin Sisters—Hat & Min," and "Social Service," Hattie and Minnie Mooser Collection, 1968.012, Western Jewish History Center, Judah L. Magnes Museum, Berkeley.

55. Ibid.

56. Jennie Harris Collection, 1983.013, Western Jewish History Center, Judah L. Magnes Museum, Berkeley.

57. H. H. Dunn, "Woman Operates Own Truck Fleet," *Motor Truck,* February 1927; H. H. Dunn, "Jennie Harris," *How Magazine,* June 1928.

58. H. H. Dunn, "Jennie Harris"; Maybel Sherman, "Jennie, the Expressman," *Sunset Magazine,* January 1925.

59. Susan Ingalls Lewis, "Women in the Marketplace: Female Entrepreneurship, Business Patterns, and Working Families in Mid-Nineteenth-Century Albany, New York, 1830–1885," Ph.D. diss., Binghamton University, New York, 2002, 15.

60. Interview with Cyril Magnin, October 1976, Oral History Collection, Western Jewish History Center, Judah L. Magnes Museum, Berkeley; Obituary, *San Francisco Chronicle,* December 16, 1943.

61. Roza R. Willer, "The History of Jewish Social Work in Portland," unpublished paper, June, 1923, 69–70, Oregon Jewish Museum Archives, Portland.

62. Minutes, Jewish Shelter Home, February 13, 1924, Oregon Jewish Museum Archives, Portland.

63. As cited in Steven Lowenstein, *The Jews of Oregon, 1850–1950* (Portland: Jewish Historical Society of Oregon, 1987), 22–25.

64. Irena Narell, *Our City: The Jews of San Francisco* (San Diego: Howell-North Books, 1981), 61.

65. Robison File, Oregon Jewish Museum Archives, Portland.

66. Articles of Co-Partnership Agreement, January 1928, Oregon Jewish Museum Archives, Portland.

67. Sam Schnitzer, Petitioner, et al., v. Commissioner of Internal Revenue, Respondent, July 14, 1949, 13 *Tax Court of the United States Reports,* on deposit in the Oregon Jewish Museum Archives, Portland.

68. Nancy Schoenburg, "The Jews of Southeastern Idaho," *Western States Jewish History* 18 (July 1986), 294–296, 305.

69. Eulenberg, "Jewish Enterprise in the American West," 57–60; Molly Cone, Howard Droker, and Jacquline Williams, *Family of Strangers: Building a*

Jewish Community in Washington State (Seattle: Washington State Historical Society, 2003), 201–203.

70. Deborah Weiner, "Jewish Women in the Central Appalachian Coal Fields, 1890–1960: From Breadwinners to Community Builders," *American Jewish Archives Journal* 50 (2000), 12–18.

71. Diane Vecchio, "Gender, Domestic Values, and Italian Working Women in Milwaukee: Immigrant Midwives and Businesswomen," in Donna R. Gabaccia and Franca Iacovetta, eds., *Women, Gender, and Transnational Lives: Italian Workers of the World* (Toronto: University of Toronto Press, 2002), 160–167.

72. Interview with Dora Levine, 1977, Oregon Jewish Museum Archives.

73. Lowenstein, *The Jews of Oregon*, 129.

74. Jeanne Abrams, *A Grocery Store on Every Corner*, video script (Denver: Rocky Mountain Jewish Historical Society, 2002), and interview with Linda Levin, January 2002, on deposit in the Beck Archives of Rocky Mountain Jewish History, Penrose Library, University of Denver.

75. "Memoirs," Fanny Jaffe Sharlip Collection, 1978.013, 41, 98, Western Jewish History Center, Judah L. Magnes Museum, Berkeley.

76. Ibid., 98, 99, 121.

77. Interview with Claire Steres Bernstein, August 1, 1972: "Keeping Kosher in Vernal," in Eileen Hallet Stone, *A Homeland in the West* (Salt Lake City: University of Utah Press, 2001), 149.

78. Petrik, *No Step Backward*, 60–62.

79. *Cheyenne City Directory, 1913–14* (Cheyenne, Wyo.: R. L. Polk); Dave Garlett, "Garlett Family," in "Biographical Sketches of Jewish Citizens of Cheyenne, Wyoming," May 1968, on deposit in the Beck Archives, University of Denver.

80. *Cheyenne City Directory, 1913–14*.

81. Jacobs Family File, San Diego Historical Society, San Diego, California.

82. Bernard Kelson, "The Jews of Montana," Chapter 1, *Western States Jewish Historical Quarterly* 3 (April 1971), 172.

83. Interview with Johnny Veta in Mark Elliott and Marie Still, *Lest We Forget: Remembrances of Cheyenne's Jews* (Cheyenne, Wyo.: Aaron Mountain Publishing, 1990), 167.

84. Author's interview with Mel Rafish, July 6, 2005.

85. Fashion Bar/Levy Collection, Box 2, on deposit in the Beck Archives, University of Denver, and *Denver Post*, "Contemporary," May 26, 1984.

86. Michael Zelinger, *West Side Story Relived* (Denver: Wandel Press, 1987), 51; Jeanne Abrams, *A Colorado Jewish Family Album, 1859–1992* (Denver: Rocky Mountain Jewish Historical Society, 1992), 60.

87. Norma Fain Pratt, "Immigrant Jewish Women in Los Angeles: Occupation, Family and Culture," *Studies in the American Jewish Experience* (Cincinnati: American Jewish Archives, 1981), 80–82.

88. John R. Rury, *Education and Women's Work* (Albany: State University of New York Press, 1991), 106.

89. Julie Nicoletta, "Redefining Domesticity," in James and Raymond, eds., *Comstock Women, 66.*

NOTES TO CHAPTER 6

1. Alice G. Friedlander, "A Portland Girl on Women's Rights," *Sunday Oregonian* (Portland), October 8, 1893, 11.

2. *The Bulletin* (San Francisco), January 12, 1924, 1.

3. John L. Rury, *Education and Women's Work* (Albany: State University of New York Press, 1991), 4, 16.

4. Ibid., 63.

5. As quoted in Lynn D. Gordon, *Gender and Higher Education in the Progressive Era* (New Haven: Yale University Press, 1990), 52, 70.

6. Ibid., 19, 85, 120.

7. Amy Thompson McCandless, *The Past in the Present: Women's Higher Education in the Twentieth-Century American South* (Tuscaloosa: University of Alabama Press, 1999), 12–13, 19, 33.

8. Barbara J. Harris, *Beyond Her Sphere: Women and the Professions in American History* (Westport, Conn.: Greenwood Press, 1978), 98.

9. Peter Gay, *The Bourgeois Experience: Victoria to Freud* (New York: Oxford University Press, 1984), 182.

10. As cited in Rebecca J. Mead, *How the Vote Was Won: Woman Suffrage in the Western United States, 1868–1914* (New York: New York University Press, 2004), 18.

11. John L. Rury, *Education and Social Change* (Mahwah, N.J.: Lawrence Erlbaum Associates, 2002), 7.

12. Catherine Ann Curry, "Public and Private Education in San Francisco: The Early Years, 1851–1876," in Carl Guarneri and David Alvarez, *Religion and Society in the American West* (Lanham, Md.: University Press of America, 1987).

13. Melissa R. Klapper, *Jewish Girls Coming of Age in America, 1860–1920* (New York: New York University Press, 2005), 69, 75–77, 97.

14. Susan Leaphart, ed., "Frieda and Belle Fligelman: A Frontier-City Girlhood in the 1890s," *Montana: The Magazine of Western History,* Summer 1982, 90–92.

15. Ibid. and "Interview with Belle Winestine," in Thomas N. Bethell, Deborah E. Tuck, and Michael S. Clark, *The Native Home of Hope* (Salt Lake City: Howe Brothers, 1986), 22–25.

16. Nancy Hoffman, *Woman's "True" Profession: Voices from the History of Teaching,* 2nd ed. (Cambridge, Mass.: Harvard University Press, 2003), 2–5.

17. Rury, *Education and Women's Work*, 21.

18. Ibid., 31–32.

19. Rury, *Education and Social Change*, 18.

20. Daniel J. Walkowitz, *Working with Class* (Chapel Hill: University of North Carolina Press, 1999), 8, 13.

21. Burton J. Bledstein, *The Culture of Professionalism* (New York: Norton, 1976), 119–120.

22. Ruth Jacknow Markowitz, *My Daughter, the Teacher: Jewish Teachers in the New York City Schools* (New Brunswick, N.J.: Rutgers University Press, 1993), 1, 2, 11.

23. Hoffman, *Woman's "True" Profession*, 39.

24. Christine A. Ogren, "A Large Measure of Self-Control and Personal Power: Women Students at State Normal Schools during the Late-Nineteenth and Early-Twentieth Century," *Women's Studies Quarterly* 18 (Fall/Winter, 2000), 212–213, 216–217.

25. *Weekly Gleaner*, June 11, 1859, 5.

26. See Scrapbook in the Florence Prag Kahn Collection, Western Jewish History Center, Judah L. Magnes Museum, Berkeley, and Ava F. Kahn and Glenna Matthews, "120 Years of Women's Activism," in Ava F. Kahn and Marc Dollinger, eds., *California Jews* (Hanover, N.H.: University Press of New England, 2003), 144–145, 148.

27. Kahn and Matthews, "120 Years of Women's Activism," 145.

28. Simon Litman, *Ray Frank Litman: A Memoir* (New York: American Jewish Historical Society, 1957), 4, 5.

29. Barbara Miller Solomon, *In the Company of Educated Women* (New Haven: Yale University Press, 1985), 67–68.

30. *The Trail* 5 (May 1913), 28; Ida Uchill, *Pioneers, Peddlers, and Tsadikim* (Denver: Sage Books, 1957), 119.

31. Rebekah Kohut, *My Portion* (New York: Thomas Seltzer, 1925), 49–50.

32. Harriet Lane Levy, *920 O'Farrell Street*, reprint (New York: Arno Press, 975), 95.

33. Ibid., 124.

34. Autobiographical Notes of Mrs. Joseph S. Newmark, Mrs. Joseph S. Newmark Papers, The Bancroft Library, University of California at Berkeley, 14–16.

35. Ogren, "A Large Measure of Self-Control and Personal Power," 223–224.

36. "Mina Norton: First Teacher at Santa Monica Canyon School," *Western States Jewish Historical Quarterly* 14 (October 1981), 76–79.

37. "Jeanette Lazard and Her Los Angeles School," *Western States Jewish Historical Quarterly* 4 (October 1971), iii.

38. Emma Wolf, *Other Things Being Equal,* edited with an Introduction by Barbara Cantalupo (Detroit: Wayne University Press, 2002), 9–10.

39. "The Cohn Sisters, San Francisco," *Western States Jewish History* 20 (January 1988), 173.

40. Interview with Sylvan Durkheimer, 1975, Oregon Jewish Museum Archives, Portland.

41. Interview with Lyman Spalding in Mark Elliott and Marie Still, *Lest We Forget: Remembrances of Cheyenne's Jews* (Cheyenne, Wyo.: Aaron Mountain Publishing, 1990), 136–138; Obituary, *Cheyenne-Wyoming State Tribune,* April 1, 1975.

42. Ibid.

43. "The First Jewish Girl Born, Educated and Married in Tucson," *Western States Jewish Historical Quarterly* 12 (January 1980), 165–166.

44. Elizabeth L. Ramenofsky, *From Charcoal to Banking: The I. E. Solomons of Arizona* (Tucson: Westernlore Press, 1984), 197.

45. Clara Ferrin File, Bloom Southwest Jewish Archives, University of Arizona Libraries.

46. Maggie Jones, "The Roles of Jewish Women in Synagogues," unpublished term paper, Women's Studies 200, University of Arizona, Tucson, 1999.

47. Julia Niebuhr Eulenberg, "Jewish Enterprise in the American West: Washington: 1853–1909," Ph.D. diss., University of Washington, 1996, 230.

48. Patricia L. Dean, "The Jewish Community of Helena, Montana, 1866–1900," Honor's Thesis, Carroll College, 1977, 59; copy on deposit at the American Jewish Archives, Cincinnati, Ohio, SC-4871.

49. University of Denver Bulletins, 1903–1913, Penrose Library Special Collections, University of Denver.

50. Harry D. Boonin, *The Jewish Quarter of Philadelphia* (Philadelphia: Jewish Walking Tours of Philadelphia, 1999), 64.

51. Letter from Dr. Charles Spivak, February 1896, Spivak Biographical File, Box 5A, and JCRS *Sanatorium,* Box 170, JCRS Collection, Beck Archives, University of Denver.

52. Uchill, *Pioneers, Peddlers, and Tsadikim,* 58.

53. Solomon, *In the Company of Educated Women,* 134.

54. Henry Rand Hatfield, "Jessica Blanche Peixotto," in *Essays in Social Economics in Honor of Jessica Blanche Peixotto* (Freeport, New York: Books for Libraries Press, 1935, reprint 1963), 5–9.

55. Kahn and Matthews, "120 Years of Women's Activism," 145.

56. Jessica B. Peixotto, *Getting and Spending at the Professional Standard of Living* (New York: Macmillan, 1927), 2.

57. Gordon, *Gender and Higher Education in the Progressive Era,* 62–66; Solomon, *In the Company of Educated Women,* 88.

58. Penina Migdal Glazer and Miriam Slater, *Unequal Colleagues: The En-*

trance of Women into the Professions, 1890–1940 (New Brunswick, N.J.: Rutgers University Press, 1987), 26.

59. *The American Jewess* 4 (October 1896), 44.

60. Biographical Introduction, "A Portland Girl on Women's Rights—1893," *Western States Jewish Historical Quarterly* 10 (January 1978), 146.

61. Obituary, *Denver Jewish News,* March 29, 1922.

62. Emma Wolf, *Other Things Being Equal,* 9, 15–18.

63. Kohut, *My Portion,* 60–61.

64. "Book Brieflets," *American Jewess* (Chicago), February 1897, 236.

65. Rebecca Gradwohl, "The Jewess in San Francisco—1896," *American Jewess* (Chicago), October 1896, 11–12.

66. Pamela Matz, "Entry on Miriam Michelson," in Paula E. Hyman and Deborah Dash Moore, *Jewish Women in America: An Historical Encyclopedia* (New York: Routledge, 1997), 923–924.

67. Norton B. Stern, "Six Pioneer Jewish Women of San Francisco," *Western States Jewish History* 30 (1998), 165.

68. Interview with Carolyn Anspacher, May 13, 1979, Western Jewish History Center, Judah L. Magnes Museum, Berkeley.

69. Solomon, *In the Company of Educated Women,* 127.

70. Barbara Allen Babcock, "Women Defenders in the West," *Nevada Law Journal* 1 (Spring 2001), 1.

71. Biographical information and quote from John Marschall, unpublished essay "Felice Cohn." Felice Cohn's birth date is in dispute. Professor Marschall has recently reported that Felice Cohn's correct date of birth was May 14, 1878, and not 1884, as previously believed, maintaining, "It was an artifice kept alive by her and her family." The birth date of 1884 had originally given Cohn the distinction of being the youngest person in the state to pass the bar. E-mail from John Marschall to Jeanne Abrams, July 18, 2005.

72. Felice Cohn, "Women of Nevada Interested in Politics," in Max Bernheim, *Women of the West* (Los Angeles: Publisher's Press, 1928).

73. Guy Rocha, "Stepping Up to the Bar: Female Attorneys in Nevada," *Sierra Sage,* January 2002; John Marschall, unpublished manuscript, "Felice Cohn"; and Jean Ford "Biographical Sketch of Felice Cohn," www.unr.edu/wrc/nwhp/biograph/cohn.htm.

74. "My Life," Memoirs of Bella Weretnikow Rosenbaum (1957), 18, 19, Bella W. Rosenbaum Papers, American Jewish Archives, Cincinnati.

75. Solomon, *In the Company of Educated Women,* 64.

76. "My Life," 32.

77. Diary of Bella Weretnikow, September 2, 1896, Bella W. Rosenbaum Papers, American Jewish Archives, Cincinnati.

78. "My Life," 46.

79. *American Israelite,* June 6, 1901.

80. For a very informative article about Bella's life, see Judith W. Rosenthal, "Bella Weretnikow, Seattle's First Jewish Female Attorney," *Columbia Magazine* 18 (Spring 2004). Judith W. Rosenthal is Bella's granddaughter.

81. Virginia G. Drachman, *Sisters in Law: Women Lawyers in Modern American History* (Cambridge, Mass.: Harvard University Press, 1998), 2.

82. Ibid., 47.

83. Robert E. Stewart, Jr., and Mary Frances Stewart, *Adolph Sutro: A Biography* (Berkeley: Howell-North, 1962), 32–33, 141, 210; *Jewish Progress* (San Francisco), November 11, 1881, 4.

84. Rebecca J. Gradwohl, "The Jewess in San Francisco—1896," 11, and the Adele Solomons Jaffa and Meyer E. Jaffa Papers, Western Jewish History Center, Judah L. Magnes Museum, Berkeley.

85. Gradwohl, "The Jewess in San Francisco—1896," 11.

86. Autobiographical Notes by Mrs. Joseph S. Newmark, 13.

87. Reva Clar, "First Jewish Woman Physician of Los Angeles," *Western States Jewish Historical Quarterly* 14 (October 1981), 66–75; Julie Beardsley, "Dr. Sarah Vasen: First Jewish Woman Doctor in Los Angeles, First Superintendent of Cedars-Sinai Hospital," *Roots-Key* 23 (Los Angeles) (Summer/Fall 2003).

88. "Beginnings of the Jewish Consumptive Relief Society (City of Hope)," *Western States Jewish History* 20 (January 1998), 122–123.

89. "Early Arizona Lady Physician," *Western States Jewish Historical Quarterly* 5 (October 1972), 24.

90. "In Memoriam—Esther Rosencrantz, Medicine: San Francisco"; "Biography," the Esther Rosencrantz Papers, Special Collections/University Archives, University of California at San Francisco; Michael Bliss, *William Osler: A Life in Medicine* (New York: Oxford University Press, 1999), 282, 492–493.

91. "In Memoriam—Esther Rosencrantz," "Biography," and Obituary, *Jewish Community Bulletin* (December 22, 1950), 6.

92. Peter E. Palmquist, compiler, "Elizabeth Fleischmann-Aschheim, Pioneer X-Ray Photographer," *Western States Jewish History* 23 (October 1990), 25–36, 44–45.

93. Evelyn Rose Benson, *As We See Ourselves: Jewish Women in Nursing* (Indianapolis: Center Nursing Publishing, 2001), 43.

94. Ibid., 62–64.

95. Hannah Shwayder Berry, *The Tale of a Little Trunk and Other Stories* (Denver: 1977), 3, 21–26.

96. "First Jewish Lady Architect of the West," *Western States Jewish History* 17 (October 1984), 19–22.

97. Virginia G. Drachman, *Enterprising Women: 250 Years of American Business* (Chapel Hill: University of North Carolina Press, 2002), 116–119.

98. "First Jewish Lady Architect of the West," 23–24.

99. Alma Lavenson Wahrhaftig Collection, 1979.004, Western Jewish History Center, Judah L. Magnes Museum, Berkeley.

100. Daniel J. Walkowitz, "The Making of Feminine Professional Identity: Social Workers in the 1920s," *American Historical Review* 95 (October 1990), 1053–1054.

101. Solomon, *In the Company of Educated Women*, 126–127.

102. Esther Lucille Brown, *Social Work as a Profession* (New York: Russell Sage, 1938), 21.

103. See William Toll, "Gender, Ethnicity, and Jewish Settlement Work in the Urban West," in Jeffrey Gurock and Marc Raphael, *An Inventory of Promises* (New York: Carlton, 1995).

104. *Twenty-Fifth Annual Report of the Denver Charity Organization Society*, 912, 27, Western History Department, Denver Public Library.

105. Steven Loewenstein, *The Jews of Oregon, 1850–1950* (Portland: Jewish Historical Society of Oregon, 1987), 83–85.

106. Estelle M. Sternberger, "Careers of Jewish Women," in Jacob R. Marcus, *The American Jewish Women: A Documentary History* (New York: Ktav, 1981), 745–747.

107. Molly Cone, Howard Droker, and Jacqueline Williams, *Family of Strangers: Building a Jewish Community in Washington State* (Seattle: Washington State Jewish Historical Society, 2003), 198–199.

108. "Report of Executive Secretary, Annual Meeting, October 18, 1933, 2, Jewish Family and Child Service Collection, Box 6, University of Washington Libraries Special Collections.

109. Cone, Droker, and Williams, *Family of Strangers*, 198, 204.

110. Interview with Amy Steinhart Braden, *Child Welfare and Community Service*, 1965, ROHO, Bancroft Library, University of California, Berkeley, and interview with Amy Steinhart Braden, May 1975, Western Portraits Oral History Collection, Western Jewish History Center, Judah L. Magnes Museum, Berkeley.

111. William Toll, "Jewish Families and the Intergenerational Transition in the American Hinterland," *Journal of American Ethnic History* 12 (Winter 1993), 11–15.

112. Gordon, *Gender and Higher Education in the Progressive Era*, 5–6.

113. Glazer and Slater, *Unequal Colleagues*, 5.

114. "Professional Tendencies among Jewish Students in Colleges, Universities, and Professional Schools," in *American Jewish Yearbook* 22 (Philadelphia: Jewish Publication Society of American, 1920), 283–293.

115. Interview with Amy Steinhart Braden, May 1975.

116. Ruth Sapinsky, "The Jewish Girl at College," *Menorah Journal* 2 (December 1916).

117. "Professional Tendencies among Jewish Students in Colleges, Universities, and Professional Schools," 385.

NOTES TO CHAPTER 7

1. Belle Winestine, "Mother Was Shocked," *Montana* 24 (1974), 73.

2. "Jewesses of To-Day: Ray Frank, the Jewish Lady Preacher," *Jewish Magazine,* April 1899, 23–25.

3. "Work of a Woman Rabbi," *San Francisco Bulletin,* November 15, 1895.

4. "Interview with Belle Winestine," in Thomas N. Bethell, Deborah E. Tuck, and Michael S. Clark, eds., *The Native Home of Hope* (Salt Lake City: Howe Brothers, 1986), 20.

5. See Margaret Mary Finnegan, *Selling Suffrage: Consumer Culture and Votes for Women* (New York: Columbia University Press, 1999), 7. Finnegan discusses how politics and consumerism intersected in the suffrage movement.

6. Winestine, "Mother Was Shocked," 73–74.

7. Beverly Beeton, *Women Vote in the West* (New York: Garland Press, 1986), ii.

8. "Interview with Belle Winestine," 25–27; Rebecca J. Mead, *How the Vote Was Won: Woman Suffrage in the Western United States, 1868–1914* (New York: New York University Press, 2004), 16.

9. Nancy E. McGlenn and Karen O'Connor, *Women, Politics, and American Society* (Englewood Cliffs, N.J.: Prentice Hall, 1995), 69.

10. Winestine, "Mother Was Shocked," 79.

11. www.missoulian.com/specials/100/montanas/list/027.html.

12. See for example, Theda Skocpol, *Protecting Soldiers and Mothers: The Political Origins of Social Policy in the United States* (Cambridge, Mass.: Belknap Press, 1992).

13. Paula Baker, "The Domestication of Politics: Women and American Political Society, 1780–1920," *American Historical Review* 89 (June 1984), 622.

14. Hasia R. Diner, "A Political Tradition? American Jewish Women and the Politics of History," in Jonathan Frankel, ed., *Jews and Gender* (New York: Oxford University Press, 2000), 58–59.

15. Paula E. Hyman, "Two Models of Modernity: Jewish Women in the German and Russian Empires," in Frankel, ed., *Jews and Gender,* 44.

16. Suzanne Lebsock, "Women in American Politics, 1880–1920," in Louise A. Tilly and Patricia Gurin, eds., *Women, Politics, and Change* (New York: Russell Sage, 1990), 35.

17. Robert J. Dinkin, *Before Equal Suffrage* (Westport, Conn.: Greenwood Press, 1995), 1.

18. Michael McGeer, "Political Style and Women's Power, 1830–1930," *Journal of American History* 77 (December 1990), 867.

19. Theda Skocpol and Morris P. Fiorina, eds., *Civic Engagement in American Democracy* (Washington, D.C.: Brookings Institution Press, 1999), 15.

20. Jo Freeman, *A Room at a Time: How Women Entered Party Politics* (Lanham, Md.: Rowman and Littlefield, 2000), 3.

21. Anne Ruggles Gere, *Intimate Practices: Literacy and Cultural Work in U.S. Women's Clubs, 1880–1920* (Urbana: University of Illinois Press, 1997), 13.

22. Kathryn Kish Sklar, *Florence Kelley and the Nation's Work: The Rise of Women's Political Culture* (New Haven: Yale University Press, 1995), xiii.

23. Dinkin, *Before Equal Suffrage,* 59.

24. Freeman, *A Room at a Time,* 65. Despite the surname of Cohen, it is uncertain if Elizabeth Cohen was Jewish. According to census records for 1900 and 1910, her maiden name was Sutton and she was born in New York City, but her mother's birthplace was Ireland. Her husband's name is listed as Joseph Cohen, and he was also born in New York City to parents from Holland. To date, no obituaries have been located that might shed more light on her religious affiliation.

25. See Beeton, *Women Vote in the West,* 82–100.

26. Sherry J. Katz, "A Politics of Coalition: Socialist Women and the California Suffrage Movement, 1900–1911," in Marjorie Spruill Wheeler, ed., *One Woman, One Vote* (Troutdale, Ore.: NewSage Press, 1995), 250.

27. Mary McCune, *"The Whole Wide World, Without Limits": International Relief, Gender Politics, and American Jewish Women, 1893–1930* (Detroit: Wayne State University Press, 2005), 71–75.

28. See Elinor Lerner, "Jewish Involvement in the New York City Suffrage Movement," *American Jewish History* 70 (June 1981), 442–461.

29. Selina Solomons, *The Girl from Colorado, or The Conversion of Aunty Suffridge* (San Francisco: New Woman Publishing, 1912).

30. Finnegan, *Selling Suffrage,* 87.

31. Selina Solomons, *How We Won the Vote in California* (San Francisco: New Woman Publishing, 1912), 3, 57.

32. Ibid., 16.

33. McGeer, "Political Style and Women's Power, 1830–1930," 871.

34. Solomons, *How We Won the Vote in California,* 20.

35. Ibid., 61–62.

36. Mead, *How the Vote Was Won,* 160–161.

37. Felice Cohn, "Women of Nevada Interested in Politics," in Max Bernheim, *Women of the West* (Los Angeles: Publisher's Press, 1929).

38. Ava F. Kahn and Glenna Matthews, "120 Years of Women's Activism," in Ava F. Kahn and Marc Dollinger, eds., *California Jews* (Hanover, N.H.: University Press of New England, 2003), 144–145.

39. Obituary, *San Francisco Examiner,* November 17, 1948.

40. Glenna Matthews, "There Is No Sex in Citizenship: The Career of Congresswoman Florence Prag," in Melanie Gustafson, Kristie Miller, and Elizabeth

I. Perry, *We Have Come to Stay: American Women and Political Parties, 1880–1960* (Albuquerque: University of New Mexico Press, 1999), 133–135.

41. H. L. Butterfield, ed., *The Book of Abigail and John: Selected Letters of the Adams Family, 1762–1784* (Cambridge, Mass.: Harvard University Press, 1975), 121.

42. Dinkin, *Before Equal Suffrage*, 3–5.

43. *Salt Lake Tribune*, December 19, 1916.

44. Irena Penzik Narell, "Florence Prag Kahn: The First Jewish Congresswoman," in Jacob R. Marcus, *The American Jewish Woman: A Documentary History* (New York: Ktav, 1981), 755.

45. Glenna Matthews, "There Is No Sex in Citizenship," 135–137.

46. Kurt F. Stone, *The Congressional Minyan: The Jews of Capitol Hill* (Hoboken, N.J.: Ktav, 2000), 235–236.

47. Obituary, *Los Angeles Times*, November 17, 1948.

48. Obituary, *New York Times*, November 18, 1948.

49. *San Francisco Chronicle*, November 18, 1948, and unidentified clippings, Florence Prag and Julius Kahn Collection, 1975.009, Western Jewish History Center, Judah L. Magnes Museum, Berkeley.

50. Alice Roosevelt Longworth, "What Are the Women Up To?" *Ladies Home Journal* 51 (March 1934).

51. Minutes of the Denver Section of the NCJW, March 22, 1899, and May 6, 1901, NCJW Collection, Box 1, Beck Archives, University of Denver.

52. Steven Lowenstein, *The Jews of Oregon, 1850–1950* (Portland: Jewish Historical Society of Oregon, 1987), 169.

53. *Daily News* (Denver), August 27, 1888, and unidentified clipping, Frances Wisebart Jacobs File, Beck Archives, Special Collections, University of Denver.

54. Elizabeth S. Clemens, "Organizational Repertoires and Institutional Change: Women's Groups and the Transformation of American Politics, 1890–1920," in Theda Skocpol and Morris P. Fiorina, eds., *Civic Engagement in American Democracy*, 95.

55. Robyn Muncy, *Creating a Female Dominion in American Reform, 1890–1935* (New York: Oxford University Press, 1991), 41.

56. Undated newspaper clippings, Ray David Scrapbook, Beck Archives, University of Denver.

57. Spiegelberg Collection, Center for Southwest Research, University of New Mexico.

58. Lowenstein, *The Jews of Oregon*, 144.

59. Golda Meir Biographical File, Beck Archives, University of Denver; Golda Meir, *My Life* (New York: Putnam's Sons, 1975), 44–46.

60. Meir, *My Life*, 45, 46–47.

61. Henry Rand Hatfield, "Jessica Blanche Peixotto," in *Essays in Social*

Economics in Honor of Jessica Blanche Peixotto (Freeport, New York: Books for Libraries Press, 1935; reprinted 1963), 10–12.

62. Kathryn Kish Sklar, "The Historical Foundations of Women's Power in the Creation of the American Welfare State," in Seth Koven and Sonya Michel, eds., *Mothers of a New World: Maternalist Politics and the Origins of Welfare States* (New York: Routledge, 1993), 44–46.

63. Hatfield, "Jessica Blanche Peixotta," 1, 13.

64. For more on Hamilton's life, see her autobiography, *Exploring the Dangerous Trades: The Autobiography of Alice Hamilton, M.D.* (Boston: Northeastern University Press, 1985).

65. Koven and Michel, eds., "Introduction," in *Mothers of a New World,* 3.

66. John L. Rury, *Education and Social Change* (Mahwah, N.J.: Lawrence Erlbaum Associates, 2002), 106.

67. John L. Rury, *Education and Women's Work* (Albany: State University Press of New York, 1991), 2.

68. Rebecca Edwards, "Pioneers at the Polls, Women Suffrage in the West," in Jean H. Baker, ed., *Votes for Women* (New York: Oxford University Press, 2002), 90.

69. Skocpol, *Protecting Soldiers and Mothers,* 521–522.

NOTES TO THE CONCLUSION

1. Selina Solomons, *How We Won the Vote in California* (San Francisco: New Woman Publishing, 1912), 68.

2. Kathleen Harris, *Long Vistas: Women and Families on Colorado Homesteads* (Niwot: University Press of Colorado, 1993), 17.

3. Glenda Riley, "Twentieth-Century Western Women, Research Issues and Possibilities," in Gerald D. Nash and Richard W. Etulain, eds., *Researching Western History: Topics in the Twentieth Century* (Albuquerque: University of New Mexico Press, 1997), 125.

4. Lillian Schlissel, "Families and Frontiers: A Reading for Our Time," in Lillian Schlissel, Byrd Gibbens, and Elizabeth Hampsten, *Far from Home: Families of the Westward Journey* (New York: Schocken Books, 1989), 233.

5. Patricia O'Connell Killen and Mark Silk, eds., *Religion and Public Life in the Pacific Northwest: The None Zone* (Walnut Creek, Calif.: AltaMira Press, 2004), 7.

6. Patricia O'Connell Killen, "Patterns of the Past, Prospects for the Future: Religion in the None Zone," in Killen and Silk, *Religion and Public Life in the Pacific Northwest,* 13.

7. Theda Skocpol, "How America Became Civic," in Theda Skocpol and Morris P. Fiorina, eds., *Civic Engagement in American Democracy* (Washington, D.C.: Brookings Institution Press, 1999), 44.

8. Paula Petrik, *No Step Backward: Woman and Family on the Rocky Mountain Mining Frontier, Helena, Montana, 1865–1900* (Helena: Montana Historical Society Press, 1987), 136.

9. "Interview with Johnny Veta," in Mark Elliott and Marie Still, *Lest We Forget: Remembrances of Cheyenne's Jews* (Cheyenne, Wyo.: Aaron Mountain Publishing, 1990), 169.

10. Petrik, *No Step Backward,* xiii.

11. Rebecca Edwards, "Pioneers at the Polls, Woman Suffrage in the West," in Jean H. Baker, ed., *Votes for Women* (New York: Oxford University Press, 2002), 100. As an interesting historical aside, it is said that the first recorded instance in American history of a woman voting occurred in the West in November 1805 when Sacajawea, the young Native American woman who served as a guide on the Lewis and Clark expedition, cast her vote deciding where the party should winter when they reached the Pacific Coast.

12. Mary McCune, *"The Whole Wide World, Without Limits": International Relief, Gender Politics, and American Jewish Women, 1890–1930* (Detroit: Wayne State University Press), 71.

13. Moses Rischin and John Livingston, eds., *Jews of the American West* (Detroit: Wayne State University Press, 1991), 28.

14. Patricia Nelson Limerick, "Hope and Gloom Out West," *New York Times,* June 22, 2005.

15. Lee Shai Weissbach, *Jewish Life in Small-Town America* (New Haven: Yale University Press, 2005), 8–9.

16. Arthur Kiron, "Mythologizing 1654," *Jewish Quarterly Review* 94 (Fall 2004), 589.

17. William Toll, "From Domestic Judaism to Public Ritual," in Pamela S. Nadell and Jonathan D. Sarna, eds., *Women and American Judaism* (Hanover, N.H.: University Press of New England, 2001), 139.

18. Jonathan D. Sarna and Nancy H. Klein, *The Jews of Cincinnati* (Cincinnati: Study for the American Jewish Experience, 1989), 9.

19. Judith E. Endelman, *The Jewish Community of Indianapolis* (Bloomington: Indiana University Press, 1984), 3.

20. Karen Anderson, "Western Women: The Twentieth-Century Experience," in Gerald D. Nash and Richard W. Etulain, eds., *The Twentieth-Century West: Historical Interpretations* (Albuquerque: University of New Mexico Press, 1989), 101.

21. Patricia O'Connell Killen and Mark A. Shibley, "Surveying the Religious Landscape," in Patricia O'Connell Killen and Mark Silk, eds., *Religion and Public Life in the Pacific Northwest,* 39.

22. Rebecca Edwards, *Angels in the Machinery* (New York: Oxford University Press, 1997), 5.

23. Mary Prag, "Some Reminiscences of My Life among the Mormons," 20,

Florence Prag Kahn and Julius Kahn Collection, 1975.009, Western Jewish History Center, Judah L. Magnes Museum, Berkeley.

24. Hasia R. Diner, *The Jews of the United States, 1654 to 2000* (Berkeley: University of California Press, 2004), 1.

25. Rebekah Kohut, *My Portion (An Autobiography)* (New York: Thomas Seltzer, 1925), 37.

Bibliography

PERIODICALS

American Israelite (Cincinnati)
American Jewess
Arizona Miner
B'nai B'rith Messenger
California Jewish Review
Cheyenne-Wyoming State Tribune
Crosswinds (Albuquerque)
Denver Jewish News
Denver Jewish Outlook
Denver Post
Denver Republican
Denver Times
Emanu-El (San Francisco)
Eureka Daily Sentinel
Eureka Reporter
Hebrew (San Francisco)
Helena Herald
Helena Illustrated
Idaho Territorial Statesman
Intermountain Jewish News
Jewish Messenger
Jewish Progress (San Francisco)
Jewish Voice (Seattle)
Los Angeles Times
New York Times
Reform Advocate (Chicago)
Rocky Mountain News
Salt Lake Herald
Salt Lake Telegraph
Salt Lake Tribune
Sanatorium (Denver)

San Diego Herald
San Diego Jewish News
San Francisco Bulletin
San Francisco Chronicle
San Francisco Examiner
Sunday Oregonian (Portland)
Tombstone Epitaph
Weekly Gleaner (San Francisco)

MANUSCRIPT COLLECTIONS

Anspacher, Caroline, Interview May 13, 1979, Anspacher Collection, 1979 .0111, Western Jewish History Center, Judah L. Magnes Museum, Berkeley, California.

Benjamin, Carrie Shevelson, *Alumni Record and General Catalogue of Syracuse University, 1872–1910,* Syracuse University Archives, Special Collections.

Beck, Peryle Hayutin, Interview, February 1989, Beck Archives, University of Denver.

Bloom, Theodore, Interview, March 22, 1999, Women's Studies 200, University of Arizona, Tucson.

Braden, Amy Steinhart, Interview, 1965, *Child Welfare and Community Service* (1965), ROHO, Bancroft Library, University of California, Berkeley.

Braden, Amy Steinhart, Interview, May 1975, Western Portraits Oral History Collections, Western Jewish History Center, Judah L. Magnes Museum, Berkeley.

Cohen, Delphine, Biographical File, Beck Archives, University of Denver.

Cohn, Felice, Papers, Nevada Historical Society, Reno.

Congregation Ahavath Beth Israel Collection, Congregation Beth Israel Archives, Boise, Idaho.

David, Ray, Scrapbook, Beck Archives, University of Denver.

Drachman, Jennie, Biographical File, Bloom Southwest Jewish Archives, University of Arizona Libraries, Tucson.

Drachman, Rosa Katzenstein, Biographical File, Bloom Southwest Jewish Archives, University of Arizona Libraries, Tucson.

Durkheimer, Sylvan, Interview, 1975, Oregon Jewish Museum Archives, Portland.

Fashion Bar/Levy Collection, Beck Archives, University of Denver.

Ferrin, Clara, File, Bloom Southwest Jewish Archives, University of Arizona Libraries, Tucson.

Frank, Ray, Ray Litman Papers, Box 1, American Jewish Historical Society, New York City.

Garlett, Dave, Interview, 1968, "Biographical Sketches of Jewish Citizens of Wyoming," Communities Box 1, Beck Archives, University of Denver.

Gershtenson, Jack, Interview, 1987, National Asthma Collection, Box 12, Beck Archives, University of Denver.

Goldsmith, Rosa, Biographical File, Beck Archives, University of Denver.

Harris, Jennie, Collection 1983.013, Western Jewish History Center, Judah L. Magnes Museum, Berkeley.

Hillkowitz, Anna, Biographical File and Correspondence, Jewish Consumptives' Relief Society Collection, Beck Archives, University of Denver.

Hillkowitz, Elias and Philip, Biographical Files, Beck Archives, University of Denver.

Hirschfelder, Hanchen, Letter, 1856, Johanna Hirschfelder Collection, 2000 .015, Western Jewish History Center, Judah L. Magnes Museum, Berkeley.

Jacobs, Frances Wisebart, Biographical Files, Beck Archives, University of Denver.

Jaffa, Adele Solomons, Papers, Adele Solomons Jaffa and Meyer E. Jaffa Collection, 1969.010, Western Jewish History Center, Judah L. Magnes Museum, Berkeley.

Jewish Consumptives' Relief Society Collection, Beck Archives, University of Denver.

Jewish Family and Child Service Collection, 2003-1, University of Washington Libraries Special Collections, Seattle.

Jewish Shelter Home Minutes (Portland), Oregon Jewish Museum Archives, Portland.

Kahn, Florence Prag, Papers, Florence Prag Kahn and Julius Kahn Collection, 1975.009, Western Jewish History Center, Judah L. Magnes Museum, Berkeley.

Levin, Linda, Interview, 2002, Beck Archives, University of Denver.

Levine, Dora, Interview, 1975, Oregon Jewish Museum Archives, Portland.

Levy, Janet, Interview, 1972, No. 1824, University of Washington Libraries, Special Collections.

Litman, Ray Frank, Papers, 1865/6–1948, P-46, American Jewish Historical Society, New York City.

Lorber, Fannie, Biographical File and Papers, National Asthma Center Collection, Beck Archives, University of Denver.

Magnin, Cyril, Interview, 1976, Oral History Collection, Western Jewish History Center, Judah L. Magnes Museum, Berkeley.

Meir, Golda, Biographical Files, Beck Archives, University of Denver.

Moch, John and Regina, Clippings File, Nevada Historical Society, Reno.

National Council of Jewish Women Collection (Denver), 1895–1930, Beck Archives, University of Denver.

National Jewish Hospital Collection, Beck Archives, University of Denver.

Newmark, Mrs. Joseph S., "Autobiographical Notes," Papers, 72/223C, The Bancroft Library, University of California.

Pisko, Seraphine, Pisko Biographical File and Correspondence, National Jewish Hospital Collection, Boxes 32 and 33, Beck Archives, University of Denver.

Prag, Mary, "Early Days," and "Some Reminiscences of My Life among the Mormons," Florence Prag Kahn and Julius Kahn Collection, 1975.009, Western Jewish History Center, Judah L. Magnes Museum, Berkeley.

Rafish, Mel, interview with the author, July 6, 2005.

Rosenbaum, Bella Weretnikow, "My Life," and Diaries, Bella W. Rosenbaum Papers, 1896–1955, MS 170, American Jewish Archives, Cincinnati.

Rosencrantz, Esther, Papers, Special Collections/University Archives, University of California at San Francisco.

San Francisco Emanu-El Sisterhood for Personal Service Collection, 1970.011, Western Jewish History Center, Judah L. Magnes Museum, Berkeley.

Schnitzer and Wolf, Articles of Co-Partnership and Sam Schnitzer et al. v. Commissioner of Internal Revenue, Oregon Jewish Museum Archives, Portland.

Solomon, Anna Freudenthal, Memoirs, American Jewish Archives, Cincinnati.

Solomon, Anna Freudenthal, Papers, Freudenthal Family Papers, Box 1, University of New Mexico Special Collections, Albuquerque.

Solomon, Isidor Elkin, Autobiography, University of Arizona Libraries, Tucson.

Spiegelberg, Flora, Papers, MSS 18SC, Center for Southwest Research, University of New Mexico, Albuquerque.

Sky, Arnold, Interview, 1979, No. 46, Beck Archives, University of Denver.

Stern, Rosalie Meyer Collection, 1971.003, Western Jewish History Center, Judah L. Magnes Museum, Berkeley.

Wahrhaftig, Alma Lavenson Collection, 1979.004, Western Jewish History Center, Judah L. Magnes Museum, Berkeley.

Wiler, Roza R., "The History of Jewish Social Work in Portland," unpublished paper, June 1923, Oregon Jewish Museum Archives, Portland.

Zeckendorf Family file, Bloom Southwest Jewish Archives, University of Arizona Libraries, Tucson.

PUBLISHED PRIMARY SOURCES

Arden, Sylvia, ed. *Diary of a San Diego Girl, 1851–1856* (Santa Monica, Calif.: Norton B. Stern, 1970).

Benjamin, Carrie Shevelson. "Woman's Place in Charitable Work—What It Is and What It Should Be." In *Papers of the Jewish Women's Congress* (Philadelphia: Jewish Publication Society, 1894).

Benjamin, I. J. *Three Years in America, 1859–1862,* vol. 1 (Philadelphia: Jewish Publication Society of America, 1956).

Berry, Hannah Shwayder. *The Tale of a Little Trunk and Other Stories* (Denver: 1977).

Blochman, L. E. "Biographical Memoirs," c. 1870. In Ava F. Kahn, ed., *Jewish Voices of the California Gold Rush: A Documentary History* (Detroit: Wayne State University Press, 2002).

Blumauer, Blanche. "Council of Jewish Women in Portland—1905." Reprinted in *Western States Jewish History* 9 (October 1976).

Brown, Esther Lucille. *Social Work as a Profession* (New York: Russell Sage, 1938).

Brown, Joseph G. *The History of Equal Suffrage in Colorado, 1868–1898* (Denver: News Job Printing, 1898).

Cohen, Felice. "Women of Nevada Interested in Politics." In Max Bernheim, *Women of the West* (Los Angeles: Publisher's Press, 1928).

Cohen, Samuel H. "Letter to the *Jewish Chronicle.*" Reprinted in Ava F. Kahn, ed., *Jewish Voices of the California Gold Rush: A Documentary History* (Detroit: Wayne State University Press, 2002).

Croly, Jennie. *History of the Women's Club Movement* (New York, 1898).

Danoff, Hyman O. Interview by Norton B. Stern, February 24 and April 15, 1979, *Western States Jewish Historical Quarterly* 12 (July 1980): 291–303.

DeNelsky, Minnie Landman. *An Autobiography* (Cincinnati: American Jewish Archives, n.d.).

Drachman, Rosa K. "From New York to Tucson in 1868." Reprinted in *Western States Jewish History* 22 (October 1989): 18–21.

Fair Cookbook (Denver: Ladies of Congregation Emanuel, 1888).

Frank, Ray. "Women in the Synagogue." In *Papers of the Jewish Women's Congress* (Philadelphia: Jewish Publication Society of America, 1984).

Gradwohl, Rebecca. "The Jewess in San Francisco—1896." *The American Jewess* (New York), October 1896, 273–275.

"A Half Century: National Council of Jewish Women, Los Angeles Section, 1909–1959" (Los Angeles: NCJW, 1959), reprinted in *Western Jewish History* 37 (Winter 2004): 149–160.

Hamilton, Alice. *Exploring the Dangerous Trades: The Autobiography of Alice Hamilton, M.D.* (Boston: Northeastern University Press, 1985).

Katz, Virginia. "The Ladies' Hebrew Benevolent Society of Los Angeles." In Mrs. M. Burton Williamson, ed., *Ladies Clubs and Societies in Los Angeles in 1892* (Los Angeles: Historical Society of Southern California, 1892).

Kohut, Rebekah. *My Portion (An Autobiography)* (New York: Thomas Seltzer, 1925).

Litman, Simon. *Ray Frank Litman: A Memoir* (New York: American Jewish Historical Society, 1957).

Longworth, Alice Roosevelt. "What Are the Women Up To?" *Ladies Home Journal* 51 (March 1934).

Meir, Golda. *My Life* (New York: Putnam's Sons, 1975).

Memoirs of Frances Jacobs (Denver: Charity Organization Society, 1892).

Newmark, Myer. Diary excerpts, 1853, in Ava F. Kahn, ed., *Jewish Voices in the California Gold Rush: A Documentary History, 1849–1880* (Detroit: Wayne State University Press, 2002).

Ogden, Annegret S., ed. *Frontier Reminiscences of Eveline Brooks Auerbach* (Berkeley: University of California Press, 1994).

Papers of the Jewish Women's Congress (Philadelphia: Jewish Publication Society of America, 1894).

"Professional Tendencies among Jewish Students in Colleges, Universities, and Professional Schools." *American Jewish Yearbook* 22 (Philadelphia: Jewish Publication Society, 1920): 383–393.

Peixotto, Jessica B. *Getting and Spending at the Professional Standard of Living* (New York: Macmillan, 1927).

Sapinsky, Ruth. "The Jewish Girl at College." *Menorah Journal* 2 (December 1916): 294–300.

Solomons, Selina. *The Girl from Colorado, or The Conversion of Aunty Suffridge* (San Francisco: New Woman Publishing, 1912).

Solomons, Selina. *How We Won the Vote in California* (San Francisco: New Woman Publishing, 1912).

Spiegelberg, Flora. "Reminiscences of a Jewish Bride of the Santa Fe Trail." *Jewish Spectator,* August and September 1937.

Sternberger, Estelle M. "Careers of Jewish Women, 1923." In Jacob R. Marcus, *The American Jewish Woman: A Documentary History* (New York: Ktav, 1981).

Teller, Jacob Chester. *Report on the Problem of Combined Poverty and Tuberculosis in Denver, Colorado* (New York: National Conference of Jewish Charities, 1916).

Tannenwald, Caroline. "Sole Ownership Declaration Document." In Ava F. Kahn, ed., *Jewish Voices of the California Gold Rush: A Documentary History* (Detroit: Wayne State University Press, 2002).

University of Denver Bulletins, 1903–1913. Penrose Library Special Collections, University of Denver.

Winestine, Belle. Interview in Thomas N. Bethnell, Deborah E. Tuck, and Michael S. Clark, eds., *The Native Home of Hope* (Salt Lake City: Howe Brothers, 1986).

Winestine, Belle. "Mother Was Shocked." *Montana* 24 (1974): 70–79.

Wise, Isaac Mayer. William Kramer, ed. *The Western Journal of Isaac Mayer Wise, 1877* (Berkeley: Western Jewish History Center, 1974).

SECONDARY SOURCES

Abrams, Jeanne. "*Unsere Leit* ("Our People"): Anna Hillkowitz and the Development of the East European Jewish Woman Professional in America." *American Jewish Archives* 37 (November 1985): 275–289.

Abrams, Jeanne. "For a Child's Sake: The Denver Sheltering Home for Jewish Children in the Progressive Era." *American Jewish History* 79 (Winter 1989–1990): 181–202.

Abrams, Jeanne. *Blazing the Tuberculosis Trail* (Denver: Colorado Historical Society, 1990).

Abrams, Jeanne. *A Colorado Jewish Family Album, 1859–1992* (Denver: Rocky Mountain Jewish Historical Society, 1992).

Abrams, Jeanne. "Children without Homes: The Plight of Denver's Orphans, 1880–1930." *Colorado History* 5 (2001): 55–93.

Abrams, Jeanne. *A Grocery Store on Every Corner,* video (Denver: Rocky Mountain Jewish Historical Society, 2002).

Albert, Marta. "Not Quite 'A Quiet Revolution.' " *Shofar* 9 (Summer 1991): 62–77.

Anderson, Douglas Firth. "We Have Here a Different Civilization: Protestant Identity in the San Francisco Bay Area, 1906–1909." *Western Historical Quarterly* 23 (May 1992): 199–221.

Armitage, Susan. "Women and Men in Western History: A Stereoptical Vision." In Gordon Bakken and Brenda Farrington, eds., *The Gendered West* (New York: Garland, 2001).

Arsenault, Raymond. "Charles Jacobson of Arkansas: A Jewish Politician in the Land of the Razorbacks, 1891–1915." In Nathan Kaganoff and Melvin Urofsky, *Turn to The South—Essays on Southern Jewry* (Charlottesville: University of Virginia Press, 1979).

Ashton, Dianne. "Crossing Boundaries: The Career of Mary M. Cohen." *American Jewish History* 83 (June 1995): 153–176.

Ashton, Dianne. *Rebecca Gratz: Women and Judaism in Antebellum America* (Detroit: Wayne State University Press, 1997).

Babcock, Barbara Allen. "Women Defenders in the West." *Nevada Law Journal* 1 (Spring 2001): 1–18.

Baker, Paula. "The Domestication of Politics: Women and American Political Society, 1780–1920." *American Historical Review* 89 (June 1984): 620–47.

Barth, Gunther. *Instant Cities: Urbanization and the Rise of San Francisco and Denver* (New York: Oxford University Press, 1975).

Baum, Charlotte, Paula Hyman, and Sonya Michel. *The Jewish Woman in America* (New York: Dial Press, 1976).

Bauman, Mark. "Southern Jewish Women and Their Social Service Organizations." *Journal of American Ethnic History* 22 (Spring 2003): 34–78.

Beardsley, Julie. "Dr. Sara Vasen: First Jewish Woman Doctor in Los Angeles, First Superintendent of Cedars-Sinai Hospital." *Roots-Key* 23 (Los Angeles) (Summer/Fall 2003).

Beeton, Beverly. *Women Vote in the West* (New York: Garland, 1986).

Benson, Evelyn Rose. *As We See Ourselves: Jewish Women in Nursing* (Indianapolis: Center Nursing Publishing, 2001).

Berrol, Selma. "Class or Ethnicity: The Americanized German Jewish Woman and Her Middle Class Sisters in 1895." *Jewish Social Studies* 47 (Winter 1985): 21–32.

Biographical Introduction. "A Portland Girl on Women's Rights—1893." *Western States Jewish Historical Quarterly* 10 (January 1978): 146.

Blair, Karen. *The Clubwoman as Feminist: True Womanhood Redefined, 1868–1914* (New York: Holmes and Meier, 1980).

Blanton, Sherry. "Lives of Quiet Affirmation: The Jewish Women of Early Anniston, Alabama." *Southern Jewish History* 2 (1998): 25–53.

Bledstein, Burton J. *The Culture of Professionalism* (New York: Norton, 1976).

Bliss, Michael. *William Osler: A Life in Medicine* (New York: Oxford University Press, 1999.

Bodek, Evelyn. " 'Making Do': Jewish Women and Philanthropy." In Murray Friedman, ed., *Jewish Life in Philadelphia, 1840–1930* (Philadelphia: ISHI Publications, 1983).

Boonin, Harry D. *The Jewish Quarter of Philadelphia* (Philadelphia: Jewish Walking Tours of Philadelphia, 1999).

Brooks, Juanita. *History of the Jews in Utah and Idaho* (Salt Lake City: Western Epics, 1973).

Brumberg, Stephan F. *Going to America, Going to School* (New York: Praeger, 1986).

Buttnick, Meta, and Julia Niebuhr Eulenberg. "Jewish Settlement in the Small Towns of Washington State: Republic." *Washington State Jewish Historical Society Newsletter* 3 (March 1984): 1–9.

Castaneda, Antonia I. "Women of Color and the Rewriting of Western History." *Pacific Historical Review* 61 (October 1992): 507–533.

Chambré, Susan M. "Parallel Power Structures, Invisible Careers, and the Changing Nature of American Jewish Women's Philanthropy." *Journal of Jewish Communal Service* 76 (Spring 2000): 205–215.

Clar, Reva. "First Jewish Woman Physician of Los Angeles." *Western States Jewish Historical Quarterly* 14 (October 1981): 66–75.

Clar, Reva. "Tillie Lewis: California's Agricultural Industrialist." *Western States Jewish History* 16 (January 1984): 139–154.

Clar, Reva, and William M. Kramer. "Ray Frank: The Girl Rabbi of the Golden West." *Western States Jewish History* 18 (1986).

Cohen, Naomi W. *Encounter with Emancipation: The German Jews in the United States, 1830–1914* (Philadelphia: Jewish Publication Society, 1984).

Cohen, Steven M., and Paula E. Hyman, eds. *The Jewish Family: Myths and Reality* (New York: Holmes and Meier, 1986).

Coleman, Julie L. "Some Jews of Early Helena, Montana." *Rocky Mountain Jewish Historical Notes* 2 (March 1979): 1–5.

Coleman, Julie L. *Golden Opportunities: A Biographical History of Montana's Jewish Communities* (Helena, Mont.: SkyHouse, 1994).

Cone, Molly, Howard Droker, and Jacqueline Williams. *Family of Strangers: Building a Jewish Community in Washington State* (Seattle: Washington State Historical Society, 2003).

Cott, Nancy. "Across the Great Divide: Women in Politics before and after 1920." In Marjorie Spruill Wheeler, *One Woman, One Vote: Rediscovering the Woman Suffrage Movement* (Troutdale, Ore.: NewSage Press, 1995).

Crowder, David. "Biographical Sketch." In *The Moses Alexander Collection* (Boise: Idaho Historical Society, 2004).

Curry, Catherine Ann. "Public and Private Education in San Francisco: The Early Years, 1851–1876." In Carl Guarneri and David Alvarez, *Religion and Society in the American West* (Lanham, Md.: University Press of America, 1987).

Daniels, Roger. *Coming to America* (New York: HarperPerennial, 1991).

Dean, Patricia L. "The Jewish Community of Helena, Montana, 1866–1900." Honor's thesis, Carroll College, 1977.

Decker, Peter R. "Jewish Merchants in San Francisco: Social Mobility on the Urban Frontier." *American Jewish History* 68 (June 1979): 396–407.

Devine, Jean Porter. *From Settlement House to Neighborhood House: 1906–1976* (Seattle: Neighborhood House, 1976).

Diner, Hasia R. "A Political Tradition? American Jewish Women and the Politics of History." In Jonathan Frankel, ed., *Jews and Gender* (New York: Oxford University Press, 2000).

Diner, Hasia R. "American West, New York Jewish." In Ava F. Kahn, ed., *Jewish Life in the West* (Los Angeles: Autry Museum of Western Heritage, 2002).

Diner, Hasia R., and Beryl Lieff Benderly. *Her Works Praise Her: A History of Jewish Women in America from Colonial Times to the Present* (New York: Basic Books, 2002).

Diner, Hasia R. *The Jews in the United States, 1654 to 2000* (Berkeley: University of California Press, 2004).

Dinkin, Robert J. *Before Equal Suffrage: Women in Partisan Politics from Colonial Times to 1920* (Westport, Conn.: Greenwood Press, 1995).

Drachman, Virginia G. *Sisters in Law: Women Lawyers in Modern American History* (Cambridge, Mass.: Harvard University Press, 1999).

Drachman, Virginia G. *Enterprising Women: 250 Years of American Business* (Chapel Hill: University of North Carolina Press, 2002).

Droker, Howard. "A Coat of Many Colors: The History of Seattle's Jewish Community." *Portage* (Spring 1983): 4–9.

Dwork, Deborah. "Immigrant Jews on the Lower East Side of New York: 1880–1914." In Jonathan Sarna, ed., *The American Jewish Experience,* 2nd ed. (New York: Holmes and Meier, 1997).

"Early Nevada City Jewry." *Western States Jewish History* 16 (January 1998): 155–165.

Edrich, Elizabeth. "The Creation of a Jewish Community: Boise's Jewish Congregations," M.A. thesis, California State University, Sacramento, 2002.

Edwards, Rebecca. *Angels in the Machinery: Gender in American Party Politics from the Civil War to the Progressive Era* (New York: Oxford University Press, 1997).

Edwards, Rebecca. "Pioneers at the Polls: Woman Suffrage in the West." In Jean H. Baker, *Votes for Women: The Struggle for Suffrage Revisited* (New York: Oxford University Press, 2002).

Elliott, Mark, and Marie Still. *Lest We Forget: Remembrances of Cheyenne Jews* (Cheyenne, Wyo.: Aaron Mountain Publishing, 1990).

Elliot, Russell R. *History of Nevada* (Lincoln: University of Nebraska Press, 1973).

Endelman, Judith E. *The Jewish Community of Indianapolis* (Bloomington: Indiana University Press, 1984).

Ernst, Eldon G. "American Religious History from a Pacific Coast Perspective." In Carl Guarneri and David Alvarez, eds., *Religion and Society in the American West* (Lanham, Md.: University Press of America, 1987).

Eulenberg, Julia Niebuhr. "Jewish Enterprise in the American West: Washington, 1853–1909." Ph.D. diss., University of Washington, Seattle, 1996.

Evans, Sara M. *Born for Liberty: A History of Women in America* (New York: Free Press, 1989).

Faragher, John. *Women and Men on the Overland Trail* (New York: Yale University Press, 1979).

Farnham, Christie Ann. *Women of the American South* (New York: New York University Press, 1997).

Feld, Marjorie N. "An Actual Working Out of Internationalism: Russian Politics, Zionism, and Lillian Wald's Ethnic Progressivism." *Journal of the Gilded Age and Progressive Era* 2 (April 2003): 119–149.

Ferguson, Gary. *The Great Divide* (New York: Norton, 2004).

Fierman, Floyd. "The Drachmans of Arizona." *American Jewish Archives* 16 (November 1964): 135–160.

Finnegan, Margaret Mary. *Selling Suffrage: Consumer Culture and Votes for Women* (New York: Columbia University Press, 1999).

"First Jewish Girl Born, Educated and Married in Tucson." *Western States Jewish Historical Quarterly* 12 (January 1980): 165–169.

"First Jewish Lady Architect of the West." *Western States Jewish History* 17 (October 1984): 19–25.

Fitzgerald, Maureen. "Losing Their Religion: Women, the State, and the Ascension of Secular Discourse, 1890–1930." In Margaret Lamberts Bendroth and Virginia Lieson Brereton, eds., *Women and Twentieth-Century Protestantism* (Chicago: University of Illinois Press, 2002), 280–303.

Ford, Jean. "Biographical Sketch of Felice Cohn." www.unr.edu/wrc/nwhp/biograph/cohn.htm.

Freeman, Jo. *A Room at a Time: How Women Entered Party Politics* (Lanham, Md.: Rowman and Littlefield, 2000).

Friedman, Reena Sigman. "Founders, Teachers, Mothers and Wards: Women's Roles in American Jewish Orphanages, 1850–1925." *Shofar* 15 (Winter 1997): 21–40.

Gabaccia, Donna. *From the Other Side: Women, Gender, and Immigrant Life in the United States, 1820–1990* (Bloomington: Indiana University Press, 1994).

Gamber, Wendy. *The Female Economy: The Millinery and Dressmaking Trades, 1860–1930* (Urbana: University of Illinois Press, 1997).

Gamm, Gerald, and Robert D. Putnam. "The Growth of Voluntary Associations in America, 1840–1940." *Journal of Interdisciplinary History* 29 (March 1999): 511–557.

Gay, Peter. *The Bourgeois Experience: Victoria to Freud* (New York: Oxford University Press, 1984).

Gere, Anne Ruggles. *Intimate Practices: Literacy and Cultural Work in U.S. Women's Clubs, 1880–1920* (Urbana: University of Illinois Press, 1997).

Gerson, Ronald D. "Jewish Religious Life in San Diego, California, 1851–1918." M.A. thesis, Hebrew Union College, Cincinnati, 1974.

Glanz, Rudolf. *The Jewish Woman in America: Two Female Immigrant Generations, 1820–1929.* 2 vols. (New York: Ktav and the National Council of Jewish Women, 1976).

Glanz, Rudolf. *The Jews of California* (New York: Waldon Press, 1960).

Glazer, Penina Migdal, and Miriam Slater. *Unequal Colleagues: The Entrance of Women into the Professions, 1890–1940* (New Brunswick, N.J.: Rutgers University Press, 1987).

Glenn, Susan A. *Daughters of the Shtetl: Life and Labor in the Immigrant Generation* (Ithaca, N.Y.: Cornell University Press, 1990).

Goldman, Karla. *Beyond the Synagogue Gallery: Finding a Place for Women in American Judaism* (Cambridge, Mass.: Harvard University Press, 2000).

Goldstein, Eric. "Between Race and Religions: Jewish Women and Self-Definition in Late Nineteenth Century America." In Pamela S. Nadell and Jona-

than S. Sarna, eds., *Women and American Religion: Historical Perspectives* (Hanover, N.H.: University Press of New England, 2001).

Golomb, Deborah Grand. "The 1893 Congress of Jewish Women: Evolution or Revolution in American Jewish Women's History?" *American Jewish History* 70 (1980): 52–67.

Gordon, Lynn D. *Gender and Higher Education in the Progressive Era* (New Haven: Yale University Press, 1990).

Greenberg, Mark I. "Savannah's Jewish Women and the Shaping of Ethnic and Gender Identity, 1830–1900." *Georgia Historical Quarterly* 82 (Winter 1998): 751–774.

Groneman, Carol, and Mary Beth Norton. *"To Toil the Livelong Day": America's Women at Work, 1780–1980* (Ithaca, N.Y.: Cornell University Press, 1987).

Harris, Barbara J. *Beyond Her Sphere: Women and the Professions in American History* (Westport, Conn.: Greenwood Press, 1978).

Harris, Katherine. *Long Vistas: Women and Families on Colorado Homesteads* (Niwot: University of Colorado Press, 1993).

Hatfield, Henry Rand. "Jessica Blanche Peixotto." In *Essays in Social Economics in Honor of Jessica Blanche Peixotto*, 3–10 (Freeport, N.Y.: Books for Libraries Press, 1935; reprint, 1963).

Herr, Elizabeth. "Women, Marital Status, and Work Opportunities in 1880 Colorado." *Journal of Economic History* 55 (June 1995): 339–366.

Heinze, Andrew R. *Adapting to Abundance: Jewish Immigrants, Mass Consumption, and the Search for American Identity* (New York: Columbia University Press, 1990).

Heinze, Andrew R. "Advertising and Consumer Culture." In Paula E. Hyman and Deborah Dash Moore, *Jewish Women in America: An Historical Encyclopedia* (New York: Routledge, 1997).

Herman, Felicia. "From Priestess to Hostess: Sisterhoods of Personal Service in New York City, 1887–1936." In Pamela S. Nadell and Jonathan S. Sarna, eds., *Women and American Judaism: Historical Perspectives* (Hanover, N.H.: University Press of New England, 2001).

Higham, John. *Send These to Me* (Baltimore: Johns Hopkins University Press, 1984.)

Hine, Robert, and John Faragher. *The American West: A New Interpretive History* (New Haven: Yale University Press, 2000).

Hornbein, Marjorie. "Frances Jacobs: Denver's Mother of Charities." *Western States Jewish Historical Quarterly* 15 (January 1983): 131–145.

Howe, Irving. *World of Our Fathers* (New York: Harcourt Brace Jovanovich, 1976).

Hudson, Lynn M. *The Making of "Mammy Pleasant": A Black Entrepreneur*

in Nineteenth-Century San Francisco (Urbana: University of Illinois Press, 2002).

Hyman, Paula E. *Gender and Assimilation in Modern Jewish History: The Roles and Representation of Women* (Seattle: University of Washington Press, 1995).

Hyman, Paula E. "Gender and the Immigrant Jewish Experience in the United States." In Judith R. Baskin, ed., *Jewish Women in Historical Perspective* (Detroit: Wayne State University Press, 1998).

Hyman, Paula E. "Two Models of Modernization: Jewish Women in the German and the Russian Empires." In Jonathan Frankel, ed., *Jews and Gender* (New York: Oxford University Press, 2000).

Hyman, Paula E. "Gender and the Shaping of Modern Jewish Identities." *Jewish Social Studies* 8 (2002): 153–161.

Hyman, Paula E., and Deborah Dash Moore, eds. *Jewish Women in America: An Historical Encyclopedia* (New York: Routledge, 1997).

Irwin, Mary Ann. " 'Going About and Doing Good': The Politics of Benevolence, Welfare, and Gender in San Francisco, 1850–1880." In Mary Ann Irwin and James F. Brooks, eds., *Women and Gender in the American West* (Albuquerque: University of New Mexico Press, 2004).

Irwin, Mary Ann. " 'Jealous of Their Powers': The Emanu-El Sisterhood for Personal Service and the Jewish Center Movement in San Francisco." Unpublished essay, 2005.

James, Janet Wilson. *Women in American Religion* (Philadelphia: University of Pennsylvania Press, 1980).

James, Ronald M., and C. Elizabeth Raymond. *Comstock Women: The Making of a Community* (Reno: University of Nevada Press, 1998).

Jameson, Elizabeth. "Towards a Multicultural History of Women in the United States." In Gordon Bakken and Brenda Farrington, eds., *The Gendered West* (New York: Garland, 2001).

Jeffries, Julie Roy. *Frontier Women: The Trans-Mississippi West, 1840–1880* (New York: Hill and Wang, 1979).

Jensen, Joan M., and Darlis A Miller. "The Gentle Tamers Revisited: New Approaches to the History of Women in the American West." *Pacific Historical Review* (May 1980): 173–218.

Jeydel, Alana D. *Political Women* (New York: Routledge, 2004).

Jick, Leon A. *The Americanization of the Synagogue, 1820–1870* (Hanover, N.H.: University Press of New England, 1992).

Johnson, Joan Marie. *Southern Ladies, New Women: Race, Region, and Clubwomen in South Carolina, 1890–1930* (Gainesville: University Press of Florida, 2004).

Johnson, Val Marie. "Protection, Virtue, and the 'Power to Detain': The Moral

Citizenship of Jewish Women in New York City, 1890–1920." *Journal of Urban History* 31 (July 2005): 655–682.

Jones, Maggie. "The Roles of Jewish Women in Synagogues." Unpublished term paper, Women's Studies 200, University of Arizona, Tucson, 1999.

Joselit, Jenna Weissman. "The Special Sphere of the Middle Class Jewish Woman: The Synagogue Sisterhood, 1890–1949." In Jack Wertheimer, ed., *The American Synagogue* (New York: Cambridge University Press, 1987).

Kaganoff, Nathan. "Jewish Welfare in New York (1848–1860)." *American Jewish Historical Quarterly* 56 (September 1966): 27–61.

Kahn, Ava F. "To Journey West: Jewish Women and Their Pioneer Stories." In Ava F. Kahn, ed., *Jewish Life in the American West* (Los Angeles: Autry Museum of Western Heritage, 2002).

Kahn, Ava F. "Joining the Rush." In Ava F. Kahn and Marc Dollingers, eds., *California Jews* (Hanover, N.H.: University Press of New England, 2003).

Kahn, Ava F., ed. *Jewish Life in the American West* (Los Angeles: Autry Museum of Western Heritage, 2002).

Kahn, Ava F., ed. *Jewish Voices of the California Gold Rush* (Detroit: Wayne State University Press, 2002).

Kahn, Ava F., and Glenna Matthews. "120 Years of Women's Activism." In Ava F. Kahn and Marc Dollinger, eds., *California Jews* (Hanover, N.H.: University Press of New England, 2003).

Karp, Abraham, ed. *Golden Door to America: The Jewish Immigrant Experience* (New York: Viking Press, 1976).

Karsh, Audrey. "San Diego Pioneering Ladies and Their Contributions to the Community." *Western States Jewish History* 31 (Fall 1998): 21–32.

Katz, Sherry J. "A Politics of Coalition: Socialist Women and the California Suffrage Movement." In Margaret Spruill Wheeler, ed., *One Woman, One Vote: Rediscovering the Woman Suffrage Movement* (Troutdale, Ore.: NewSage Press, 1995).

Kaufman, Polly Welts. *Women Teachers on the Frontier* (New Haven: Yale University Press, 1984).

Kelson, Bernard. "The Jews of Montana." *Western States Jewish Historical Quarterly* 3 (April 1971): 170–189.

Kerber, Linda. *Toward an Intellectual History of Women* (Chapel Hill: University of North Carolina Press, 1997).

Kessler-Harris, Alice. *Out to Work: A History of Wage-Earning Women in the United States* (New York: Oxford University Press, 1982).

Killen, Patricia O' Connell, and Mark Silk, eds. *Religion and Public Life in the Pacific Northwest: The None Zone* (Walnut Creek, Calif.: AltaMira Press, 2004).

Kirshenblatt-Gimblett, Barbara. "The Moral Sublime: The Temple Emanuel

Fair and Its Cookbook, Denver, 1888." *Rocky Mountain Jewish Historical Society Notes* 13 (Spring/Summer 1995): 1–7.

Klapper, Melissa R. " 'Long and Broad Education': Jewish Girls and the Problem of Education in America, 1860–1920." *Journal of American Ethnic History* 22 (Fall 2002): 3–31.

Klapper, Melissa R. *Jewish Girls Coming of Age in America, 1860–1920* (New York: New York University Press, 2005).

Korelitz, Seth. " 'A Magnificent Piece of Work': The Americanization Work of the National Council of Jewish Women." *American Jewish History* 83 (June 1995): 177–203.

Koven, Seth, and Sonya Michel, eds. *Mothers of a New World: Maternalist Politics and the Origins of Welfare States* (New York: Routledge, 1993).

Kramer, William N., and Norton B. Stern. "Anna Meyers: Modern Fundraising Pioneer in the West." *Western States Jewish History* 19 (1987): 335–345.

Kramer, William N., and Norton B. Stern. "Hattie Hecht Sloss: Cultural Leader/ Jewish Activist of San Francisco." *Western States Jewish History* 35 (Spring/ Summer 2003): 175–183.

Kuzmack, Linda Gordon. *Woman's Cause: The Jewish Woman's Movement in England and the United States, 1881–1933* (Columbus: Ohio State University Press, 1990).

Lamb, Blaine. "Jewish Pioneers in Arizona, 1850–1920." Ph.D. diss., Arizona State University, Tempe, 1992).

Lawson, Michael. "Flora Langermann Spigelberg." *Western States Jewish Historical Quarterly* 8 (July 1976): 291–308.

Leaphart, Susan, ed. "Frieda and Belle Fligelman: A Frontier-City Girlhood in the 1890s." *Montana: The Magazine of Western History* (Summer 1982): 85–92.

Lebsock, Suzanne. "Women and American Politics, 1880–1920." In Louise A. Tilly and Patricia Gurin, eds., *Women, Politics, and Change* (New York: Russell Sage, 1990).

Lerner, Elinor. "Jewish Involvement in the New York City Suffrage Movement." *American Jewish History* 70 (June 1981): 442–461.

Lerner, Gerda. "The Lady and the Mill Girl: Changes in the Status of Women in the Age of Jackson." *Midcontinent American Studies Journal* 10 (Spring 1969): 5–15.

Levenson, Rosaline. "Oroville's Jewish Cemetery: Enduring Legacy of the Gold Rush." *Western States Jewish History* 23 (October 1990): 3–14.

Levinson, Robert. "American Jews in the West." *Western Historical Quarterly* 5 (July 1974): 285–294.

Levinson, Robert. *The Jews in the California Gold Rush* (New York: Ktav, 1976).

Levy, Harriet Lane. *920 O'Farrell Street* (New York: Arno Press, 1975).

Lewis, Susan Ingalls. "Women in the Marketplace: Female Entrepreneurship, Business Patterns, and Working Families in Mid-Nineteenth Century Albany, New York, 1830–1885." Ph.D. diss., Binghamton University, Binghamton, N.Y., 2002.

Libo, Kenneth, and Irving Howe. *We Lived There Too: In Their Own Words and Pictures—Pioneer Jews and the Westward Movement of America, 1630–1930* (New York: St. Martin's Press, 1984).

Limerick, Patricia Nelson. "Going West and Ending Up Global." *Western Historical Quarterly* 32 (Spring 2001): 4–23.

Limerick, Patricia Nelson. "Hope and Gloom Out West." *New York Times,* June 22, 2005.

Lippy, Charles. *Being Religious, American Style* (Westport, Conn.: Greenwood Press, 1994).

Livingston, John. "Editor's Note." *Rocky Mountain Jewish Historical Notes* 10 (Winter/Spring 1990): 1–3.

Loverin, Janet, and Robert A. Nylen, "Creating a Fashionable Society: Comstock Needleworkers from 1860 to 1880." In Ronald M. James and C. Elizabeth Raymond, eds., *Comstock Women: The Making of a Community* (Reno: University of Nevada Press, 1998).

Lowenstein, Steven. *The Jews of Oregon, 1850–1950* (Portland: Jewish Historical Society of Oregon, 1987).

Marcus, Jacob R. *The American Jewish Woman: A Documentary History* (New York: Ktav, 1981).

Markowitz, Ruth Jacknow. *My Daughter the Teacher: Jewish Teachers in the New York City Schools* (New Brunswick, N.J.: Rutgers University Press, 1993).

Marschall, John P. "Jews in Nevada: 1850–1900." *Journal of the West* 22 (January 1984): 62–72.

Marschall, John P. "Felice Cohn: Nevada Suffragist." Unpublished essay, 2003.

Matthews, Glenna. "There Is No Sex in Citizenship: The Career of Congresswoman Florence Prag." In Melanie Gustafson, Kristie Miller, and Elizabeth I. Perry, eds., *We Have Come to Stay: American Women and Political Parties, 1880–1960* (Albuquerque: University of New Mexico Press, 1999).

McCandless, Amy Thompson. *The Past in the Present: Women's Higher Education in the Twentieth-Century American South* (Tuscaloosa: University of Alabama Press, 1999).

McCarthy, Kathleen, ed. *Lady Bountiful Revisited* (New Brunswick, N.J.: Rutgers University Press, 1990).

McCune, Mary. "Social Workers in the *Muskeljudentum.*" *American Jewish History* 86 (1998): 135–165.

McCune, Mary. *"The Whole Wide World, Without Limits"*: *International Relief, Gender Politics, and American Jewish Women, 1893–1930* (Detroit: Wayne State University Press, 2005).

McGeer, Michael. "Political Style and Women's Power, 1830–1930." *Journal of American History* 77 (December 1990): 864–885.

McGlen, Nancy E., and Karen O'Connor. *Women, Politics and American Society* (Englewood Cliffs, N.J.: Prentice Hall, 1995).

Mead, Rebecca J. *How the Vote Was Won* (New York: New York University Press, 2004).

"Mina Norton: First Teacher at Santa Monica Canyon School." *Western States Jewish Historical Quarterly,* October 1981, 76–79.

Mitchell, Annie R. "Pioneer Merchants of Tulare County, California." *Western States Jewish Historical Quarterly* 2 (April 1970): 123–135.

Moore, Shirley Ann Wilson, and Quintard Taylor. "The West of African American Women, 1600–2000." In Quintard Taylor and Shirley Ann Wilson Moore, eds., *African American Women Confront the West, 1600–2000* (Norman: University of Oklahoma Press, 2003).

Morawska, Ewa. *Insecure Prosperity: Small-Town Jews in Industrial America, 1890–1940* (Princeton, N.J.: Princeton University Press, 1996).

Morawska, Ewa. "Assimilation of Nineteenth-Century Women." In Paula E. Hyman and Deborah Dash Moore, eds., *Jewish Women in America: An Historical Encyclopedia* (New York: Routledge, 1997).

Morris, Susan. *A Traveler's Guide to Pioneer Jewish Cemeteries of the California Gold Rush* (Berkeley: Magnes Museum, 1996).

Morrow, Dolores J. "A Voice From the Rocky Mountains: Helena's Pioneer Jewish Community, 1864–1889." M.A. thesis, University of Montana, Missoula, 1981.

Morrow, Dolores J. "Jewish Merchants and the Commercial Emporium of Montana." In Morrow, ed., *Montana and the West* (Boulder, Colo.: Pruett, 1984).

Muncy, Robyn. *Creating a Female Dominion in American Reform, 1890–1935* (New York: Oxford University Press, 1991).

Murphy, Lucy Eldersveld. "Business Ladies: Midwestern Women and Enterprise, 1850–1880." *Journal of Women's History* 3 (Spring 1991).

Myres, Sandra L. *Ho for California!* (San Marino, Calif.: Museum Reproductions, 1980).

Myres, Sandra L. *Westering Women and the Frontier Experience, 1800–1915* (Albuquerque: University of New Mexico Press, 1981).

Myres, Sandra L. "Victoria's Daughters." In Lillian Schlissel, Vicki Ruiz, and Janice Monks, eds., *Western Women: Their Land, Their Lives* (Albuquerque: University of New Mexico Press, 1988).

Nadell, Pamela S. *Women Who Would Be Rabbis* (Boston: Beacon Press, 1998).

Nadell, Pamela S. " 'Opening the Blue of Heaven to Us': Reading Anew the Pioneers of Women's Ordination." *Nashim* 9 (June 2005): 88–100.

Nadell, Pamela S., and Jonathan D. Sarna, eds. *Women and American Judaism: Historical Perspectives* (Hanover, N.H.: University Press of New England, 2001).

Nadell, Pamela S., and Rita J. Simon, "Ladies of the Sisterhood: Women in the American Reform Synagogue, 1900–1930." In Lucinda Joy Peach, *Women and Religions* (Upper Saddle River, N.J.: Prentice Hall, 2002).

Narell, Irena. *Our City: The Jews of San Francisco* (San Diego: Howell-North Books, 1981).

Narell, Irena Penzik. "Florence Prag Kahn: The First Jewish Congresswoman." In Jacob R. Marcus, *The American Jewish Woman: A Documentary History* (New York: Ktav, 1981).

Neu, Irene. "The Jewish Businesswoman in America." *American Jewish Historical Quarterly* 66 (September 1976): 137–154.

Nicoletta, Julie. "Redefining Domesticity: Women and Lodging Houses on the Comstock." In Ronald M. James and C. Elizabeth Raymond, eds., *Comstock Women: The Making of a Mining Community* (Reno: University of Nevada Press, 1998).

Norwood, Vera. "Women's Place: Continuity and Change in Response to Western Landscapes." In Lilliam Schlissel, Vicki Ruiz, and Janice Monks, eds., *Western Women: Their Land, Their Lives* (Albuquerque: University of New Mexico Press, 1988.

Nottage, James. "Forward." In Ava F. Kahn, ed., *Jewish Life in the American West* (Los Angeles: Autry Museum of Western Heritage, 2002).

Ogren, Christine A. "A Large Measure of Self-Control and Personal Power: Women Students at State Normal Schools during the Late-Nineteenth and Early-Twentieth Century." *Women Studies Quarterly* 18 (Fall/Winter 2002): 211–227.

Palmquist, Peter E. "Elizabeth Fleischmann-Aschheim, Pioneer X-Ray Photographer." *Western States Jewish History* 23 (October 1990): 35–45.

Pascoe, Peggy. *Relations of Rescue* (New York: Oxford University Press, 1990).

Petrik, Paula. *No Step Backward: Women and Family on the Rocky Mountain Mining Frontier, Helena, Montana, 1865–1900* (Helena: Montana Historical Society Press, 1987).

Phillips, Bruce. "The Challenge of Family, Identity, and Affiliation." In Ava F. Kahn and Marc Dollinger, eds., *California Jews* (Hanover, N.H.: University Press of New England, 2003).

Pratt, Norma Fain. "Immigrant Jewish Women in Los Angeles: Occupation, Family and Culture." In Jacob Marcus, ed., *Studies in the American Experience* (Cincinnati: American Jewish Archives, 1981).

Rabinowitz, Dayle Friedman. "The Saga of Leopold Henry Guldman: An Amer-

ican Jewish Success Story." *Rocky Mountain Jewish Historical Notes* 6 (Spring 1984): 4–7.

Ramenofsky, Elizabeth L. *From Charcoal to Banking: The I. E. Solomons of Arizona* (Tucson: Westernlore Press, 1984).

Riley, Glenda. *A Place to Grow—Women in the American West* (Arlington Heights, Ill.: Harlan Davidson, 1992).

Riley, Glenda. *Building and Breaking Families in the American West* (Albuquerque: University of New Mexico Press, 1996).

Riley, Glenda. "Twentieth-Century Western Women, Research Issues and Possibilities." In Gerald D. Nash and Richard W. Etulain, eds., *Researching Western History: Topics in the Twentieth Century* (Albuquerque: University of New Mexico Press, 1997).

Riley, Glenda. "American Daughters: Black Women in the West." In Monroe Lee Billington and Roger D. Hardaway, eds., *African Americans on the Western Frontier* (Boulder: University Press of Colorado, 1998).

Riley, Glenda. "Writing, Teaching, and Recreating Western History through Intersections and Viewpoints." In Gordon M. Bakken and Brenda Farrington, eds., *Where Is the West?* (New York: Garland, 2000).

Riley, Glenda. "The Future of Western Women's History." *The Historian* 66 (Fall 2004): 539–545.

Rischin, Moses. Introduction, "The Jews of the West: The Metropolitan Years." *American Jewish History* 68 (June 1979).

Rischin, Moses, and John Livingston, eds. *Jews of the American West* (Detroit: Wayne State University Press, 1991).

Rocha, Guy. "Stepping Up to the Bar: Female Attorneys in Nevada." *Sierra Sage* (January 2002).

Rochlin, Harriet. "Lalapaloozas: Nine Extraordinary Western Jewish Women." *Gilcrease* (2004): 4–17.

Rochlin, Harriet, and Fred Rochlin. *Pioneer Jews: A New Life in the Far West* (Boston: Houghton Mifflin, 1984).

Rogow, Faith. *Gone to Another Meeting: The National Council of Jewish Women, 1893–1993* (Tuscaloosa: University of Alabama Press, 1993).

Rogow, Faith. "Gone to Another Meeting: The National Council of Jewish Women, 1893–1993." In Pamela S. Nadell, ed., *American Jewish Women's History: A Reader* (New York: New York University Press, 2003).

Rohrbacher, Stefan. "From Württemberg to America: A Nineteenth-Century German-Jewish Village on Its Way to the New World." In Jonathan Sarna, ed., *The American Jewish Experience,* 2nd ed. (New York: Holmes and Meier, 1977).

Rose, Elizabeth. "From Sponge Cake to Hamentashen: Jewish Identity in a Jewish Settlement House." *Journal of American Ethnic History* (Spring 1994): 3–23.

Rosenbaum, Fred. "Zionism versus Anti-Zionism." In Moses Rischin and John Livingston, eds., *Jews of the American West* (Detroit: Wayne State University Press, 1991.)

Rosengarten, Theodore and Dale. *A Portion of the People: Three Hundred Years of Southern Jewish Life* (Columbia: University of South Carolina Press, 2002).

Rosenthal, Judith W. "Bella Weretnikow, Seattle's First Jewish Female Attorney." *Columbia Magazine* 18 (Spring 2004).

Rothman, David. *The Discovery of the Asylum* (Boston: Little Brown, 1990).

Rothman, Sheila. *Women's Proper Place* (New York: Basic Books, 1978).

Rudd, Hynda. "The Mountain West as a Jewish Frontier." *Western States Jewish Historical Quarterly* 13 (April 1981): 241–256.

Rury, John L. *Education and Women's Work* (Albany: State University Press of New York, 1991).

Rury, John L. *Education and Social Change* (Mahwah, N.J.: Lawrence Erlbaum Associates, 2002).

Ryan, Mary P. *Cradle of the Middle Class: The Family in Oneida County, New York, 1790–1865* (Cambridge, U.K.: Cambridge University Press, 1981).

Ryan, Mary P. *Women in Public: Between Banners and Ballots, 1825–1880* (Baltimore: Johns Hopkins University Press, 1990).

Sarna, Jonathan D. "A Sort of Paradise for Hebrews: The Lofty Vision of Cincinnati Jews." In Jonathan D. Sarna and Nancy H. Klein, *The Jews of Cincinnati* (Cincinnati: Center for Study of the American Jewish Experience, 1989).

Sarna, Jonathan D. "The Revolution in the American Synagogue." In Karen S. Mittleman, ed., *Creating American Jews: Historical Conversations about Identity* (Philadelphia: National Museum of American Jewish History, 1998).

Sarna, Jonathan D. *American Judaism* (New Haven: Yale University Press, 2004).

Sarna, Jonathan D., ed. and trans., *People Walk on Their Heads: Moses Weinberger's Jews and Judaism in New York* (New York: Holmes and Meier, 1982).

Scadron, Arlene. *On Their Own: Widows and Widowhood in the American Southwest, 1848–1939* (Chicago: University of Illinois Press, 1988).

Scharff, Virginia. "Else Surely We Shall All Hang Separately: The Politics of Western Women's History." *Pacific Historical Review* 61 (October 1992): 535–555.

Scharff, Virginia. *Twenty Thousand Rooms: Women, Movement, and the West* (Berkeley: University of California Press, 2003).

Schlissel, Lillian, Byrd Gibbens, and Elizabeth Hampsten. *Far from Home: Families of the Westward Journey* (New York: Schocken Books, 1989).

Schloff, Linda Mack. *"And Prairie Dogs Weren't Kosher": Jewish Women in*

the Upper Midwest since 1855 (St. Paul: Minnesota Historical Society Press, 1996).

Schoenberg, Nancy. "The Jews of Southeastern Idaho." *Western States Jewish History* 18 (July 1986): 291–304.

Schreier, Barbara A. *Becoming American Women: Clothing and the Jewish Immigrant Experience, 1880–1920* (Chicago: Chicago Historical Society, 1994).

Scott, Anne Firor. "As Easily as They Breathe. . . ." In Anne Firor Scott, *Making the Invisible Woman Visible* (Chicago: University of Illinois Press, 1984).

Scott, Anne Firor. *Natural Allies: Women's Associations in American History* (Chicago: University of Illinois Press, 1991).

Shepperson, Wilbur S. *Restless Strangers: Nevada's Immigrants and Their Interpreters* (Reno: University of Nevada Press, 1970).

Shilo, Margalit. *Princess or Prisoner: Jewish Women in Jerusalem, 1840–1914* (Waltham, Mass.: Brandeis University Press, 2005).

Shipps, Jan, and Mark Silk, eds. *Mountain West: Sacred Landscapes in Transition.* Walnut Creek, Calif.: AltaMira Press, 2004).

Silver, M. K. "Selina Solomons and Her Quest for the Sixth Star." *Western States Jewish History* 31 (Summer 1999): 301–318.

Sklar, Kathryn Kish. "The Historical Foundations of Women's Power in the Creation of the American Welfare State." In Seth Koven and Sonya Michel, eds., *Mothers of a New World: Maternalist Politics and the Origins of Welfare States* (New York: Routledge, 1993).

Sklar, Kathryn Kish. *Florence Kelley and the Nation's Work: The Rise of Women's Political Culture* (New Haven: Yale University Press, 1995).

Skocpol, Theda, and Morris P. Fiorina, eds. *Civic Engagement in American Democracy* (Washington, D.C.: Brookings Institution Press, 1999).

Skocpol, Theda. *Protecting Soldiers and Mothers: The Political Origins of Social Policy in the United States* (Cambridge, Mass.: Belknap Press, 1992).

Smith, Duane. *Rocky Mountain West* (Albuquerque: University of New Mexico Press, 1992).

Sochen, June. "Some Observations on the Role of American Jewish Women and Communal Volunteers." *American Jewish History* 70 (September 1980): 23–34.

Sochen, June. *Consecrate Every Day: The Public Lives of Jewish Women, 1880–1890* (Albany: State University of New York Press, 1981).

Solomon, Barbara Miller. *In the Company of Educated Women: A History of Women and Higher Education in America* (New Haven: Yale University Press, 1985).

Sparks, Edith. "Married Women and Economic Choice: Explaining Why Women Started Businesses in San Francisco between 1890 and 1930." *Business and Economic History* 28 (Winter 1999): 287–300.

Stern, Norton B. "The Founding of the Jewish Community in Utah." *Western States Jewish History* 18 (October 1975): 65–69.

Stern, Norton B. "The Charitable Jewish Ladies of San Bernardino and Their Woman of Valor, Henrietta Ancker." *Western States Jewish Historical Quarterly* 13 (July 1981): 369–376.

Stern, Norton B. "The Jewish Community of a Nevada Mining Town." *Western States Jewish History* 15 (October 1982): 48–78.

Stern, Norton B. "Harriet Ashim Choynski: A Western Arrival to San Francisco, 1850." *Western States Jewish History* 24 (April 1992): 214–220.

Stern, Norton B. "Six Pioneer Women of San Francisco." *Western States Jewish History* 30 (January 1998): 159–168.

Stern, Norton B., ed. *The Jews of Los Angeles: Urban Pioneers* (Los Angeles: Southern California Jewish Historical Society, 1981).

Stewart, Robert E., Jr., and Mary Frances Stewart. *Adolph Sutro: A Biography* (Berkeley: Howell-North, 1962).

Stone, Kurt F. *The Congressional Minyan: The Jews of Capitol Hill* (Hoboken, N.J.: Ktav, 2000).

Szasz, Ferenc Morton. *Religion in the Modern American West* (Tucson: University of Arizona Press, 2000).

Taylor, Quintard, and Shirley Ann Wilson Moore, eds. *African American Women Confront the West, 1600–2000* (Norman: University of Oklahoma Press, 2003).

Tee, Jody. *Rivers in the Desert: A Video Presentation on Ahavath Beth Israel* (Boise, Idaho: Jody Tee Creative Services, 2004).

Tilly, Louise A., and Patricia Gurin, eds. *Women, Politics, and Change* (New York: Russell Sage, 1990).

Tobias, Henry J. *A History of the Jews in New Mexico* (Albuquerque: University of New Mexico Press, 1990).

Toll, William. *The Making of an Ethnic Middle Class: Portland Jewry over Four Generations* (Albany: State University of New York Press, 1982).

Toll, William. "Judaism as a Civic Religion in the American West." In Carl Guarneri and David Alvarez, *Religion and Society in the American West* (Lanham, Md.: University Press of America, 1987).

Toll, William. "Gender and the Origins of Philanthropic Professionalism." *Rocky Mountain Jewish Historical Notes* 11 (Winter/Spring 1991): 1–9.

Toll, William. "Intermarriage and the Urban West." In Moses Rischin and John Livingston, eds., *Jews of the American West* (Detroit: Wayne State University Press, 1991).

Toll, William. "Jewish Families and the Intergenerational Transition in the American Hinterland." *Journal of American Ethnic History* 12 (Winter 1993): 3–35.

Toll, William. "Gender, Ethnicity, and Jewish Settlement Work in the Urban

West." In Jeffrey Gurock and Marc Raphael, eds., *An Inventory of Promises* (New York: Carlton, 1995).

Toll, William. "Pioneer Jewish Men and Women of the American West." In Karen S. Mittleman, ed., *Creating American Jews: Conversations about Identity* (Philadelphia: National Museum of American Jewish History, 1998).

Toll, William. "A Quiet Revolution: Jewish Women's Clubs and the Widening Female Sphere, 1870–1920." *American Jewish Archives* 61 (1999): 7–26.

Toll, William. "From Domestic Judaism to Public Ritual: Women and Religious Identity in the American West." In Pamela S. Nadell and Jonathan D. Sarna, eds., *Women and American Judaism: Historical Perspectives* (Hanover, N.H.: University Press of New England, 2001).

Topping, Gary. "Religion in the West." *Journal of American Culture* 3 (Summer 1980): 330–350.

Trattner, William, ed. *Social Welfare or Social Control?* (Knoxville: University of Tennessee Press, 1983).

Uchill, Ida. *Pioneers, Peddlers, and Tsadikim* (Denver: Sage Books, 1957).

Umansky, Ellen M. "Spiritual Expressions: Jewish Women's Religious Lives in the Twentieth-Century United States." In Judith R. Baskin, ed., *Jewish Women in Historical Perspective,* 2nd ed. (Detroit: Wayne State University Press, 1999).

Vecchio, Diane, "Gender, Domestic Values, and Italian Working Women in Milwaukee: Immigrant Midwives and Businesswomen." In Donna R. Gabaccia and Franca Iacovetta, eds., *Women, Gender and Transnational Lives: Italian Workers of the World* (Toronto: University of Toronto Press, 2002).

Vorspan, Max, and Lloyd P. Gartner. *History of the Jews of Los Angeles* (Philadelphia: Jewish Publication Society of America, 1970).

Walkowitz, Daniel J. "The Making of a Feminine Professional Identity: Social Workers in the 1920s." *American Historical Review* 95 (October 1990): 1051–1075.

Walkowitz, Daniel J. *Working with Class* (Chapel Hill: University of North Carolina Press, 1999).

Wall, Helena M. "Notes on Life since a Little Commonwealth: Family and Gender History since 1970." *William and Mary Quarterly* (October 2000): 809–825.

Weiner, Deborah. "Jewish Women in the Central Appalachian Coal Fields, 1890–1960: From Breadwinners to Community Builders." *American Jewish Archives* 50 (2000): 10–33.

Wenger, Beth W. "Jewish Women and Voluntarism: Beyond the Myth of Enablers." *American Jewish History* 74 (Autumn 1989): 16–36.

Wenger, Beth W. "Jewish Women of the Club: The Changing Public Role of Atlanta's Jewish Women." *American Jewish History* 76 (March 1987): 311–333.

Weissbach, Lee Shai. "East European Immigrants and the Image of Jews in the Small-Town South." *American Jewish History* 85 (1997): 231–262.

Weissbach, Lee Shai. *Jewish Life in Small-Town America* (New Haven: Yale University Press, 2005).

Wolf, Emma. *Other Things Being Equal,* edited by and with an Introduction by Barbara Cantalupo (Detroit: Wayne State University Press, 2002).

Wright, Robert E. "Women and Finance in the Early National U.S." *Essays in History* 42 (2000): 1–35.

Young, Louise M. "Women's Place in American Politics: The Historical Perspective." *Journal of Politics* 38 (August 1976): 295–335.

Zelinger, Michael. *West Side Story Relived* (Denver: Wandel Press, 1987).

Zweigenhaft, Richard L., and G. William Domhoff. *Jews in the Protestant Establishment* (New York: Praeger, 1982).

Index

About the Author

Jeanne Abrams is a professor at Penrose Library at the University of Denver. She received her Ph.D. in American history from the University of Colorado at Boulder with a specialization in archival management. Since 1982 she has served as director of the Beck Archives and the Rocky Mountain Jewish Historical Society, part of the Center for Judaic Studies and Penrose Library at the University of Denver. She is the author of *Blazing the Tuberculosis Trail* (1990, Colorado Historical Society) and co-author of *A Place to Heal: The History of National Jewish Medical and Research Center* (1987, Johnson Publishing) as well as numerous articles that have appeared in scholarly and popular journals and magazines.